WIMBLEDON WOMEN'S CHA

Year	Country	Champion
1884	GBR	Maud Watson
1885	GBR	Maud Watson
1886	GBR	Blanche Bingley
1887	GBR	Lottie Dod
1888	GBR	Lottie Dod
1889	GBR	Blanche Hillyard
1890	GBR	Lena Rice
1891	GBR	Lottie Dod
1892	GBR	Lottie Dod
1893	GBR	Lottie Dod
1894	GBR	Blanche Hillyard
1895	GBR	Charlotte Cooper
1896	GBR	Charlotte Cooper
1897	GBR	Blanche Hillyard
1898	GBR	Charlotte Cooper
1899	GBR	Blanche Hillyard
1900	GBR	Blanche Hillyard
1901	GBR	Charlotte Sterry
1902	GBR	Muriel Robb
1903	GBR	Dorothea Douglass
1904	GBR	Dorothea Douglass
1905	USA	May Sutton
1906	GBR	Dorothea Douglass
1907	USA	May Sutton
1908	GBR	Charlotte Sterry
1909	GBR	Dora Boothby
1910	GBR	Dorothea L. Chambers
1911	GBR	Dorothea L. Chambers
1912	GBR	Ethel Larcombe
1913	GBR	Dorothea L. Chambers
1914	GBR	Dorothea L. Chambers
1915–1918		NO COMPETITION (Due to World War I)
1919	FRA	Suzanne Lenglen
1920	FRA	Suzanne Lenglen
1921	FRA	Suzanne Lenglen
1922	FRA	Suzanne Lenglen
1923	FRA	Suzanne Lenglen
1924	GBR	Kitty McKane
1925	FRA	Suzanne Lenglen
1926	GBR	Kitty Godfree
1927	USA	Helen Wills
1928	USA	Helen Wills
1929	USA	Helen Wills
1930	USA	Helen Moody
1931	GER	Cilly Aussem
1932	USA	Helen Moody
1933	USA	Helen Moody
1934	GBR	Dorothy Round
1935	USA	Helen Moody
1936	USA	Helen Jacobs
1937	GBR	Dorothy Round
1938	USA	Helen Moody
1939	USA	Alice Marble
1940–1945		NO COMPETITION (Due to World War II)
1946	USA	Pauline Betz
1947	USA	Margaret Osborne
1948	USA	Louise Brough
1949	USA	Louise Brough
1950	USA	Louise Brough
1951	USA	Doris Hart
1952	USA	Maureen Connolly
1953	USA	Maureen Connolly
1954	USA	Maureen Connolly
1955	USA	Louise Brough
1956	USA	Shirley Fry
1957	USA	Althea Gibson
1958	USA	Althea Gibson
1959	BRA	Maria Bueno
1960	BRA	Maria Bueno
1961	GBR	Angela Mortimer
1962	USA	Karen Susman
1963	AUS	Margaret Smith
1964	BRA	Maria Bueno
1965	AUS	Margaret Smith
1966	USA	Billie Jean King
1967	USA	Billie Jean King
1968	USA	Billie Jean King
1969	GBR	Ann Jones
1970	AUS	Margaret Court
1971	AUS	Evonne Goolagong
1972	USA	Billie Jean King
1973	USA	Billie Jean King
1974	USA	Chris Evert
1975	USA	Billie Jean King
1976	USA	Chris Evert
1977	GBR	Virginia Wade
1978	USA	Martina Navratilova
1979	USA	Martina Navratilova
1980	AUS	Evonne Goolagong Cawley
1981	USA	Chris Evert Lloyd
1982	USA	Martina Navratilova
1986	USA	Martina Navratilova
1987	USA	Martina Navratilova
1988	FRG	Steffi Graf
1989	FRG	Steffi Graf
1990	USA	Martina Navratilova
1991	GER	Steffi Graf
1992	GER	Steffi Graf
1993	GER	Steffi Graf
1994	ESP	Conchita Martínez
1995	GER	Steffi Graf
1996	GER	Steffi Graf
1997	SUI	Martina Hingis
1998	CZE	Jana Novotná
1999	USA	Lindsay Davenport
2000	USA	Venus Williams
2001	USA	Venus Williams
2002	USA	Serena Williams
2003	USA	Serena Williams
2004	RUS	Maria Sharapova
2005	USA	Venus Williams
2006	FRA	Amélie Mauresmo
2007	USA	Venus Williams
2008	USA	Venus Williams
2009	USA	Serena Williams
2010	USA	Serena Williams
2011	CZE	Petra Kvitová
2012	USA	Serena Williams
2013	FRA	Marion Bartoli
2014	CZE	Petra Kvitová
2015	USA	Serena Williams
2016	USA	Serena Williams
2017	ESP	Garbiñe Muguruza
2018	GER	Angelique Kerber
2019	ROU	Simona Halep
2020		NO COMPETITION (Due to COVID-19 pandemic)

THE HISTORY OF
TENNIS

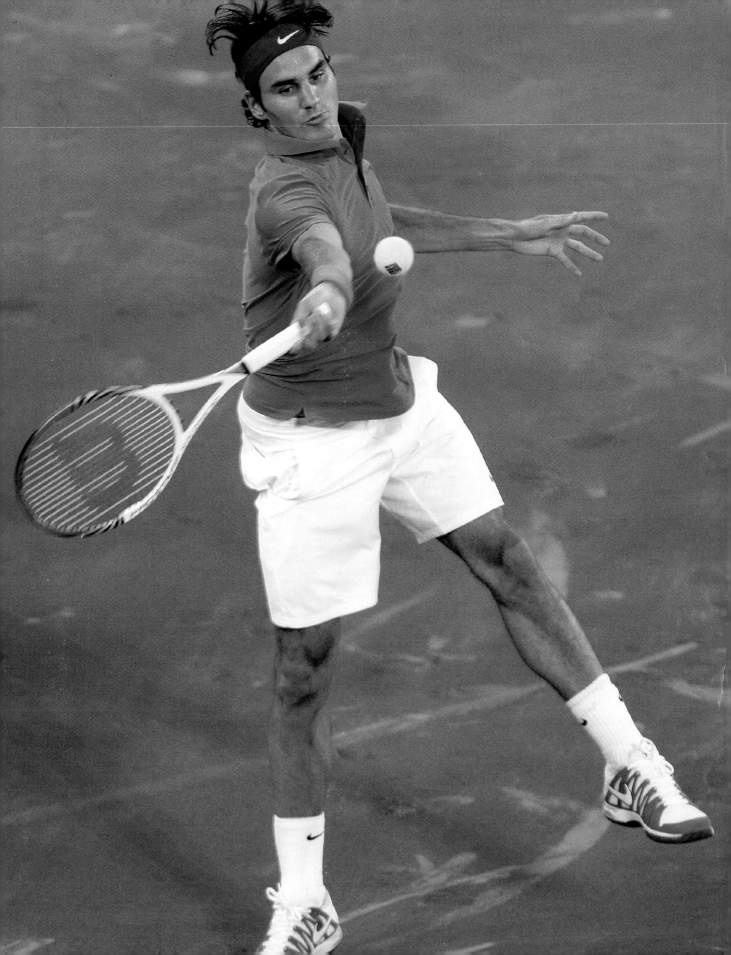

THE HISTORY OF TENNIS

LEGENDARY CHAMPIONS
MAGICAL MOMENTS

RICHARD EVANS

RIZZOLI
NEW YORK

New York · Paris · London · Milan

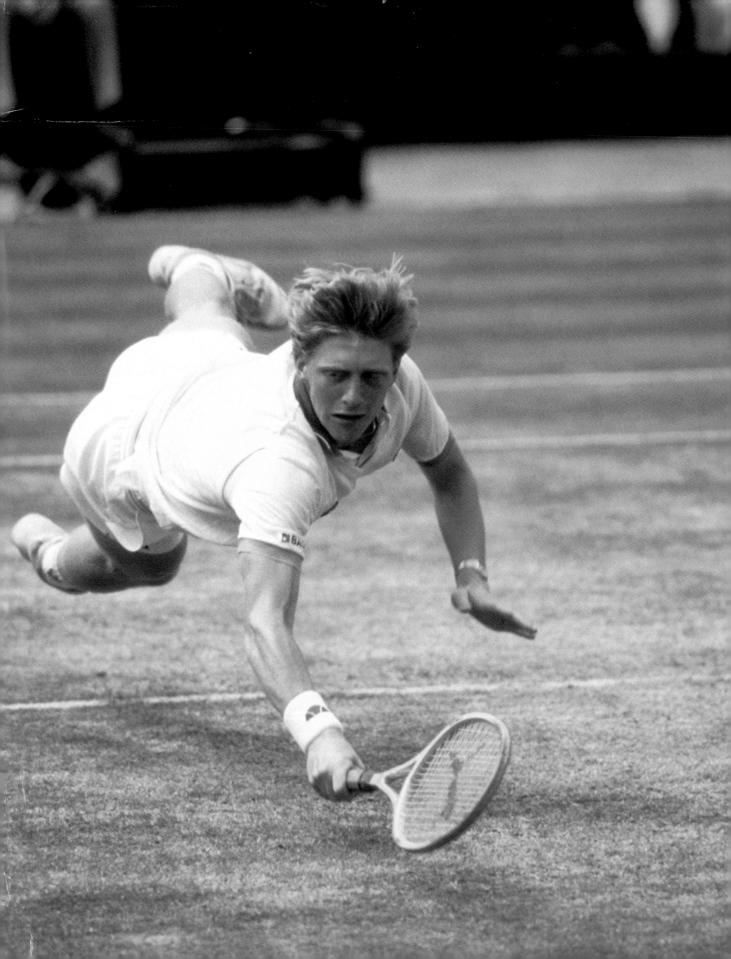

Dear Reader,

Previewing *The History of Tennis* was a truly memorable experience and a great privilege. As a huge tennis fan and a long-standing officer of an organization that is arguably the largest corporate supporter of professional, amateur, and community tennis, I enjoyed taking the fascinating journey down memory lane that this book provides. Being an avid player in my early years, I remember aspiring to the on-court greatness achieved by the likes of Bjorn Borg, Billie Jean King, John McEnroe, and Chris Evert. My life, however, took a different direction than becoming a professional player.

The book's reflection on tennis' most exciting moments and the charting of the rapid evolution of the sport over the past decades is magical. Although I consider myself a tennis connoisseur, I found the breadth and depth of the content to be eye-opening, and I, like many readers-to-come, will benefit from reading this detailed, portable history of tennis.

The book is as entertaining as it is comprehensive, documenting close to four hundred years of the sport since its inception in 1625. The chronological nature of the book, combined with fun features, provides the reader with both continuity and diversion. The photography and illustrations are first-class and offer valuable context to the narrative. I was especially pleased with the focus and prominence placed on women's tennis. The chapter on the Women's Tennis Association and the birth of professional women's tennis is particularly timely, given the fiftieth anniversary of the Original Nine. Finally, the book takes a truly global approach, darting across the Atlantic and beyond, to document the greatest individuals and moments in the history of tennis, which resonates especially well in today's world.

I am confident that readers of this book will benefit from the perspective of an esteemed historian and enjoy the many hours of insights on the greatest sport on earth.

JEAN-YVES FILLION

CEO, BNP PARIBAS USA
MEMBER OF THE BOARD OF GOVERNORS, INTERNATIONAL TENNIS HALL OF FAME

(above) *Jean-Yves Fillion.*

(opposite) *Boris Becker finished his career with permanently scarred knees. It is not difficult to see why. Nor was it only on Wimbledon grass that Becker threw himself about the court. He did it on hard courts, too. A contributing factor to the German's six Grand Slam titles, including three at Wimbledon in the 1980s.*

Contents

1

In the Beginning…

10

2

Lawn Tennis Comes to
America & The Davis Cup is Born

24

3

Post-World War 1 & The Twenties

48

4

The Thirties: Perry,
Budge, & Von Cramm

64

5

The Forties & Fifties

86

6

The Sixties

104

7

The Seventies

118

8

The WTA Is Born

144

9

The Eighties

166

10

Women in the Eighties

198

11

The Nineties: Men

208

12

The Nineties: Women

240

13

The 2000s &
The Big Four

258

14

A Spotlight on Doubles

290

15

The Williams Sisters

298

16

The Olympics

310

17

Women in the
Twenty-first Century

318

18

Men in the Twenty-first
Century and The Future

340

1

In the Beginning...

June 1520: Just outside the city of Calais—then a part of Britain—King Henry VIII and Francois 1er were holding a summit on the Field of the Cloth of Gold. The two great kings were contemporaries, their reigns stretching through much of the first half of the sixteenth century, and they shared a mutual passion. Both played the game of court tennis to a high level.

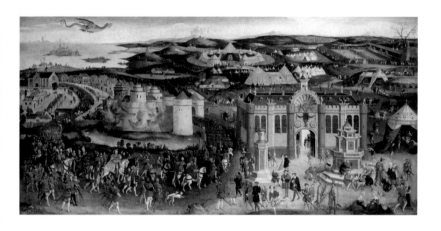

(above and opposite) *King Henry VIII & King Francois I meet at the Field of Cloth of Gold outside Calais in 1520.*

(preceding spread) *Yannick Noah* (left) *and Maria Sharapova* (right)—*effort was never lacking.*

So it was a shame that, during the lavish ceremonies, which took place over four days, they chose to joust against each other rather than compete with racquet and ball—although the lack of an available court might have made the idea impossible.

But, for sheer star power, King Henry VIII vs. King Francois 1er probably remains the greatest match that never happened.

Henry VIII had a court built at his palace at Hampton Court and its re-

placement, built in 1625 by Charles 1, stands to this day. It was there, while he was enjoying a game with his ill-fated Queen in attendance that Anne Boleyn was arrested and hauled off to the Tower of London. Rumor has it that Henry was back on court when Boleyn was executed.

In Paris, the game was thriving—in particular amongst the clergy—and courts numbered in the hundreds, especially in the cloisters of cathedrals and churches, which explains the feature of a sloping roof on one side of each court onto which the server projected the ball.

It could be said that the first hint of professionalism crept into the game when King Francois was pleased with the way his partner had hit a forehand winner.

"Ah! That was truly the shot of a priest!" Francois exclaimed.

"If Your Majesty so wishes, it could be the shot of an abbot!" his quick witted partner shot back.

It is not known whether promotion followed.

At the end of the eighteenth century, the game in France was almost obliterated by the French Revolution, and it took Napoleon III to revive interest in the sport around the 1860s when the Jeu de Paume, now a museum, was built in the Tuileries Gardens to house the game.

Meanwhile, across the English Channel, a social revolution was taking place in a more peaceful and productive man-

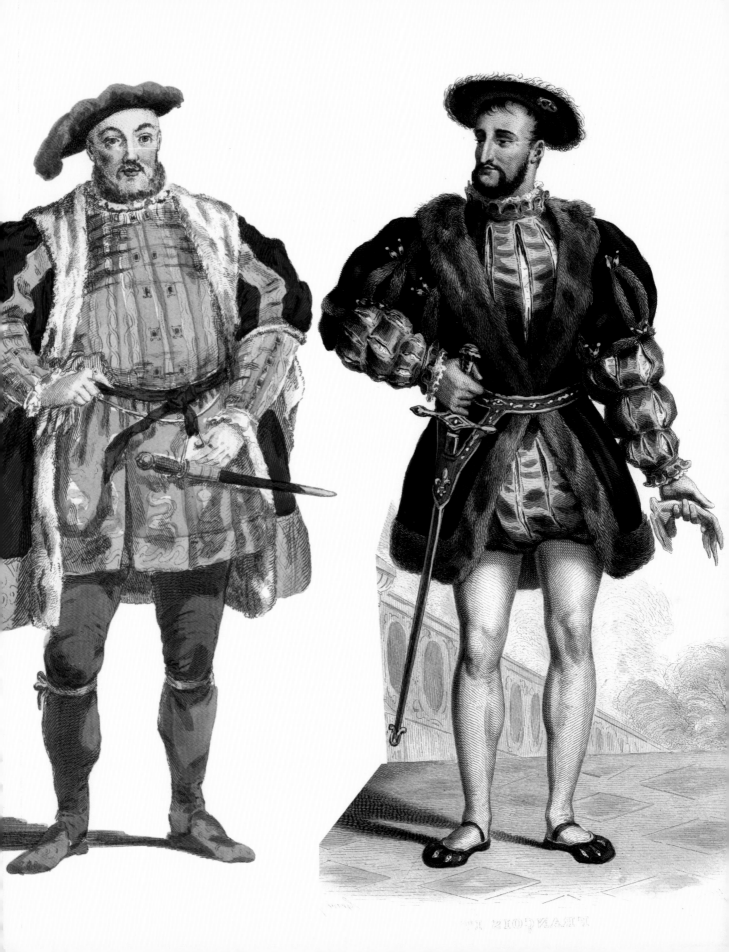

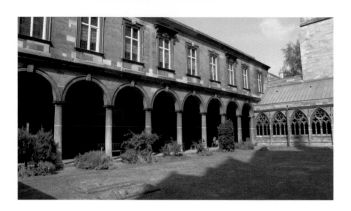

Anne Boleyn

Henry VIII had a court built at his palace at Hampton Court; its replacement, built in 1625 by Charles I, stands to this day. It was there, while he was enjoying a game with his ill-fated queen in attendance that Anne Boleyn was arrested and hauled off to the Tower of London. Rumor has it that Henry was back on court when Boleyn was executed.

(top) *Anne Boleyn.* (bottom) *The Boardwalk Tennis Court at Hampton Court Palace.*

ner. It was called the Industrial Revolution, and it changed the way the British lived forever. Steel and cotton mills sprung up in the north of England, while the coal industry saw mines dug ever deeper and more profitably in the northeast, Cornwall and Wales.

Suddenly, in the space of a couple of decades in the mid-nineteen century, you no longer had to be an aristocrat to have money. The middle class was being born.

Owners of mills and mines found themselves able to build large family homes and, this being England, virtually all of them had gardens. But you can only grow so many roses and, with cooks in the kitchen and housemaids upstairs making the beds, the wives and daughters of these families found they had time on their hands. They needed a pastime.

The game of croquet was the first choice, as it could be played on a relatively small patch of grass, as long as it was cut and leveled. Thus, the lawn was born.

Eyeing all this social development was a certain Major Walter Clopton Wingfield, a keen court tennis player whose family owned a large, if somewhat decaying, castle in Suffolk. He came from a long line of Wingfields and, by some extraordinary coincidence, had a forebear called Richard Wingfield, who was Marshal of Calais in 1511. Nine years later, he was pres-

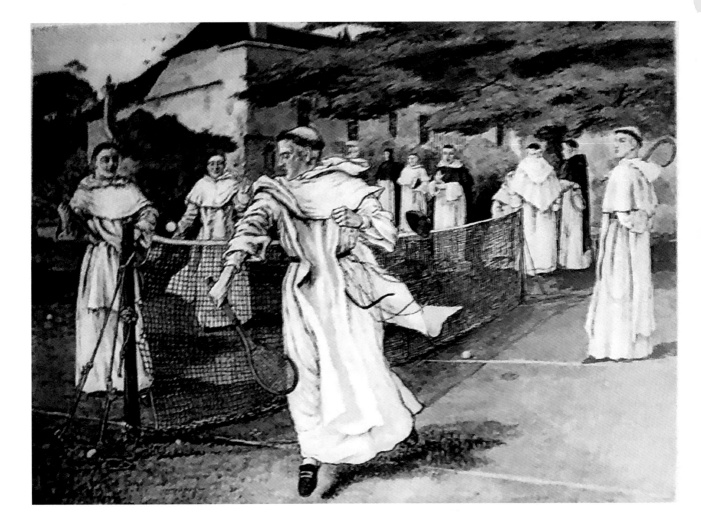

ent at the Field of the Cloth of Gold when the French and English kings missed their opportunity to play each other at tennis.

Major Wingfield had no intention of missing out on any opportunity concerning tennis and set about creating a new form of the game. He had spent many years in China as a cavalry officer and, on his return to England, he began investigating what else could be played on those pristine new lawns. His instinct was that something offering a greater athletic challenge than croquet was required, especially for the male members of those newly prosperous families whose weekends were long on leisure but short on inspiration and, indeed, perspiration.

He was right, and he soon invented a game that was based on court tennis but different in that it was designed to be played in the open air without walls. He decided to call it Sphairistike, a Greek name which, as Shakespeare's Casca might have said, remained Greek to most Englishmen and was soon to be renamed Lawn Tennis. You could buy Major Wingfield's invention in an oblong box from Messrs French & Company at 46, Churton Street in Pimlico, a district of London that backs onto Victoria Station. For a cost of five guineas (a guinea being one shilling more than a pound), the buyer would find the box contained poles, pegs and a net, a mallet, a brush, a bag of balls, and four tennis racquets. There was also a lit-

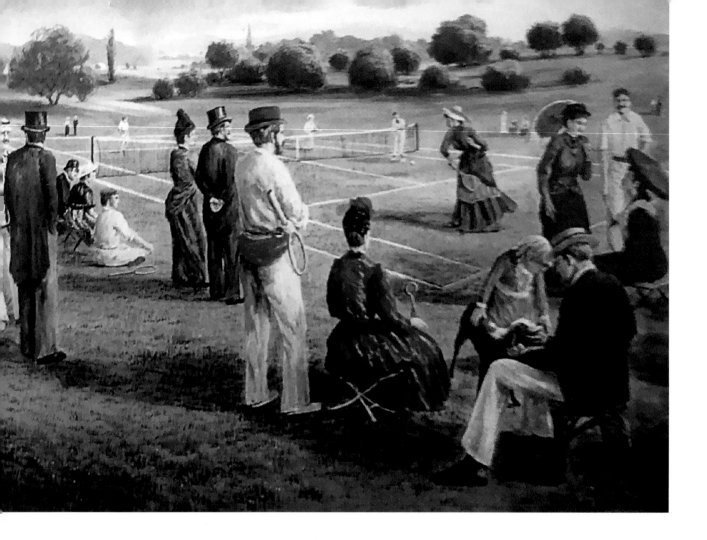

Painting of a late 19th century match.

tle pamphlet called "The Book of the Game." It was read avidly by the house party at Nantclwyd Hall, in the Welsh county of Denbighshire, which was owned by Wingfield's friend, Thomas Philip Naylor-Leyland. It was there in 1873 that the good Major formally introduced his game of Sphairistike.

There is no question that Wingfield was in this for profit—the family having fallen on hard times—and he was anxious to get the patent for his invention, which he finally received in February 1874, despite some people coming forward to claim that they had been playing something similar for years.

Initially, thanks to Wingfield's highborn contacts and salesmanship, the

boxed sets sold rapidly and, within months, he was ordering a second edition. By the time a third was required, he had modified some of the rules and bowed to the idea that Lawn Tennis might be a preferable name.

But his imagined fortune never materialized. Sales started to fall off as people discovered they could produce the contents of his boxes themselves for much less money. Nevertheless, the game was growing rapidly in popularity and, as it appealed to the same class of people, the Marylebone Cricket Club (MCC), based as it is today at Lord's in St John's Wood, began to get worried. They didn't want to kill the game, but they wanted to have some control

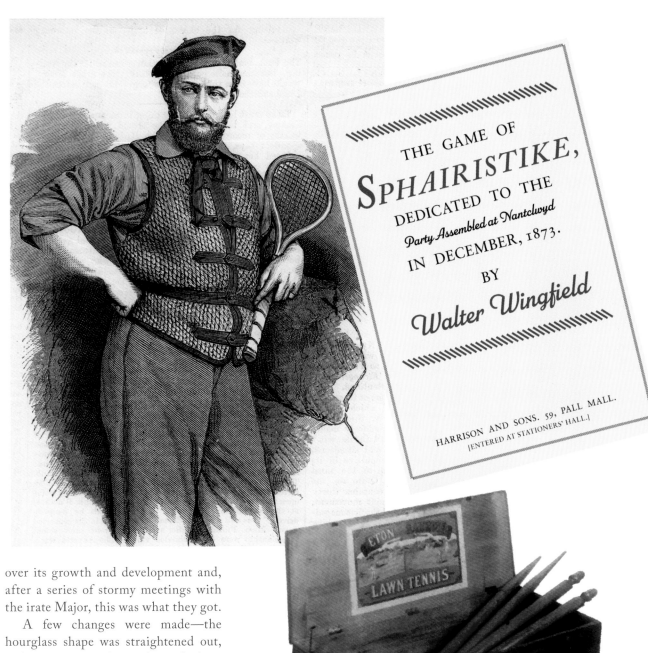

THE GAME OF
SPHAIRISTIKE,
DEDICATED TO THE
Party Assembled at Nantclwyd
IN DECEMBER, 1873.
BY
Walter Wingfield

HARRISON AND SONS. 59, PALL MALL.
[ENTERED AT STATIONERS' HALL.]

Major Walter Clopton Wingfield and his Sphairistike box, which could be bought in Pimlico, London, for five guineas.

over its growth and development and, after a series of stormy meetings with the irate Major, this was what they got.

A few changes were made—the hourglass shape was straightened out, and the net was lowered—and, from 1875, the MCC was officially in charge of the sport. But not for long. The All England Croquet Club had settled itself into new quarters at Worple Road, Wimbledon, a couple of miles from the present site at Church Road, and, as an experiment, had allotted enough space in a corner of the grounds for a tennis court. Suddenly, they discovered it was being used from dawn until the sun went down. So the club entered

(left) *Racquet from 1876.*

(right) *Cricket being played in 18th century in what was then called Marylebone Fields, now Regent's Park. Nearby, Lord's Cricket Ground was built and would become owned by the Marylebone Cricket Club which, in the very early days of lawn tennis, helped run the game and write its rules.*

into negotiations with the MCC. The three prime negotiators who wrested control of the new game from the governors of cricket were the first club secretary Henry Jones, who had surveyed a stretch of ground on Addison Road in Kensington before deciding it was too expensive; Julian Marshall; and C. G. Heathcote. After coming up with a set of rules, it was agreed that they should assume control of Lawn Tennis, which they intended to display in a proper manner by staging The Championships in 1877. By then, the committee had wisely changed the name to the All England Lawn Tennis & Croquet Club.

With just twenty-two players competing, the first ever championship was won (three days late because of rain!) by Spencer W. Gore over William C. Marshall 6–1, 6–2, 6–4 with tickets selling for a shilling (five pence today). Gore, a twenty-seven-year-old surveyor who cycled to the ground from his

home in Wandsworth, was said to have found the game a little monotonous, already having excelled at rackets and cricket, and made sure points did not last long by charging the net at every opportunity. His reign as champion did not last long either. Facing a fellow Old Harrovian, Frank Hadow, in the 1878 final, Gore found himself having to chase endless well-placed lobs and lost 7–5, 6–1, 9–7. Hadow, a twenty-three-year-old tea planter who was on holiday from Ceylon and only entered at the urging of some friends, took little note of his achievement of having won six matches without the loss of a set and disappeared back east, never to return. The second year of The Championships had created a rustle of interest as the draw increased to thirty-four (all British). Over arm serving made its appearance, and 700 people turned up to watch—a figure that tripled the first year's attendance!

(left) *Spencer Frederick Gore*, A Game of Tennis, *circa 1900.*

(right) *1877 Wimbledon Championship Draw.*

A ladies' event followed in 1884, but with only thirteen entries. It was a bit of a family affair with nineteen-year-old Maud Watson, a Londoner from Harrow in Middlesex, beating her sister Lilian Watson 6–8, 6–3, 6–3. The draw for the Ladies' Singles continued to be so small that only three victories were required to win the title, but that could hardly diminish the achievement of a phenomenal athlete from Cheshire called Lottie Dod, who won the title in 1887, at the age of fifteen years 285 days. No one of a younger age has won Wimbledon since. Lottie proceeded to win four more titles whenever she elected to play—she was absent in 1889-90—before getting bored with the ease of it all and going off in search of other challenges. She was not short of them. Lottie won the British Women's Golf Championships at Troon, Scotland in 1904, and played twice for England at field hockey. She was also a skilled skater. In the 1908 Olympic Games in London, she won a silver medal at archery.

It seems that there was nothing Lottie Dod could not do. She did the Cresta Run, played bridge brilliantly, played the piano beautifully, and could sing. Of course, she had much to sing about.

Despite the modest entrance fee, it is recorded that, in 1881, The Championships had enjoyed a profit of £540 ($756), a small acorn that grew steadily over the next hundred years so that, by the end of the twentieth century, the All England Club was able to hand over in excess of £25 million ($35 million) clear profit to the Lawn Tennis Association for the development of the British game. By 2020, that figure had risen to £46.21 million ($64.7 million).

And what of poor Major Wingfield? In his wonderfully researched article for *The New Yorker* magazine, the late Herbert Warren Wind, a superb essay-

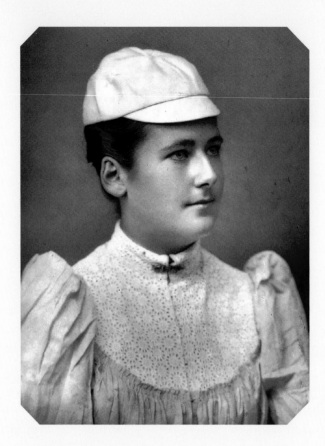

Lottie Dod, aged twenty.

Lottie Dod

LOTTIE WON THE FIRST OF FIVE WIMBLEDON TITLES IN 1887 AT THE AGE OF 15 YEARS AND 10 MONTHS.

No one younger has won Wimbledon since. Lottie proceeded to win four more titles whenever she elected to play—she was absent in 1889–90—before getting bored with the ease of it all and going off in search of other challenges. She was not short of them. In 1904, Lottie won the British Women's Golf Championships at Troon, Scotland, and played twice for England at field hockey.

ist on sport and other matters, recorded that Wingfield lived the last thirty-five years of his life in almost total oblivion—so much so that his obituary in *The Times* contained no mention of Sphairistike—or even tennis.

Wingfield died in 1912, and by then his invention had enjoyed more than three decades of growing popularity. The first Championships, won by Spencer Gore, set the ball rolling, but it was not until the arrival of the Renshaw brothers, William and Ernest, in 1881, that the game began to attract a real following. William won the title from 1881 to '86; his brother claimed it in 1888, before the siblings met in the 1889 final with William regaining his crown. Together, they won the doubles seven times.

The only break in this Renshaw domination of Wimbledon had come in 1887, when Herbert F. Lawford, a Scot who invented top spin by using an extreme grip, defeated Ernest after being two sets to one down. It was no more than the imposing Lawford deserved—he was runner-up no less than five times!

It took another pair of brothers, Reggie and Laurie Doherty, who appeared at the tail end of the century, to take the game up a notch. Their prowess was such that they totally dominated the sport between 1897 and 1906, winning nine of ten singles championships—Reggie taking four in a row and then Laurie five. Renown for their good looks and sportsmanship, as well as their tennis, they were leading members of Britain's Davis Cup team between 1902 to 1906. Both won gold medals at the 1900 Olympic games. Laurie,

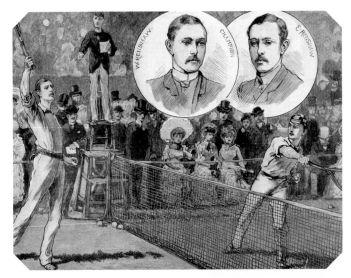

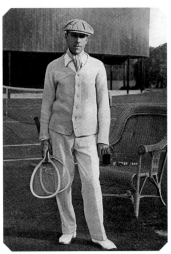

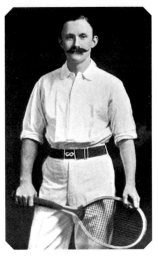

the younger by three years, followed his brother from Westminster School to Cambridge University, but sadly neither lived to old age. Reggie, frequently plagued by ill health, died at the age of thirty-six, and Laurie was forty-three when he died in 1919.

In 1907, the Australian left hander Norman Brookes—probably one of the most talented all round athletes to have played the game (cricket, golf, and billiards all came easily to him)—broke the monopoly by winning Wimbledon with a 6–4, 6–2, 6–2 victory over Arthur Gore. As a harbinger of things to come, Brookes partnered a young New Zealander who was studying at

Cambridge University called Anthony Wilding in the doubles, and they beat Beals Wright and Karl Behr in the final. Wright and Behr had travelled to England to play for the United States in the Davis Cup—the burgeoning team competition which we will study in depth in the following chapters.

Brookes, a businessman who would later, as Sir Norman, become president of the Australian Tennis Association, could not return to defend his crown. For the next two years, Wimbledon was won by the aging Arthur Gore (no relation to Spencer Gore) until he was defeated in the Challenge Round by Wilding in 1910.

(clockwise from top left) William and Ernest Renshaw, brothers who won eight Wimbledon singles titles between them; Herbert Lawford, Wimbledon champion in 1887 and four time runner-up; Arthur Gore, who won first of three titles in 1901 and Australia's Norman Brookes, champion in 1907 and 1914.

(following spread) Reggie and Laurie Doherty, who won nine Wimbledon singles titles between them.

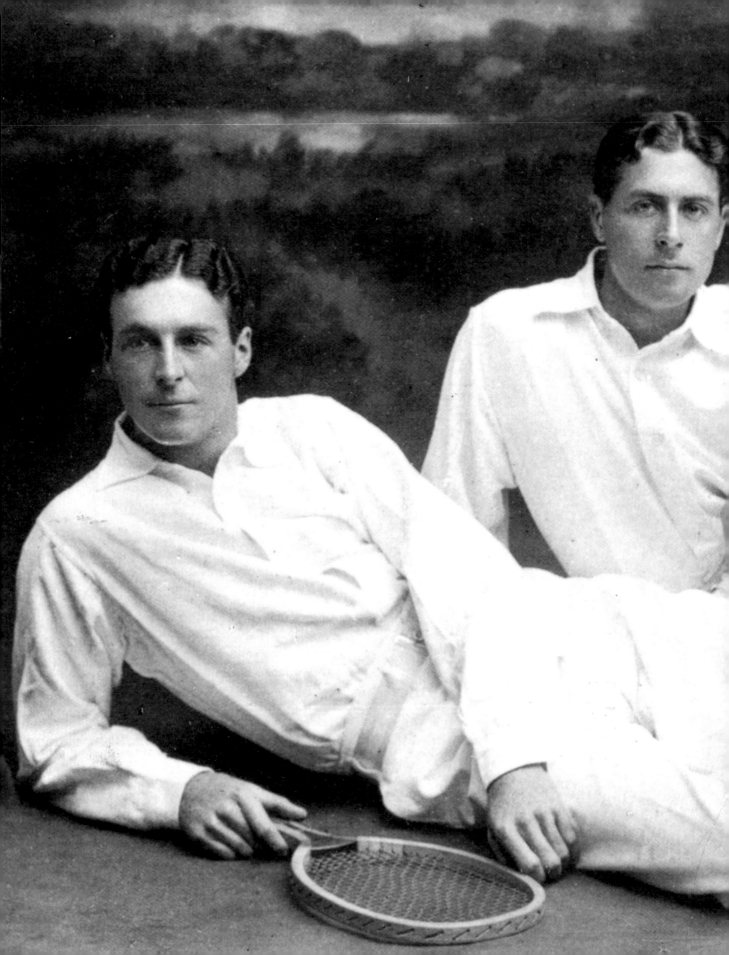

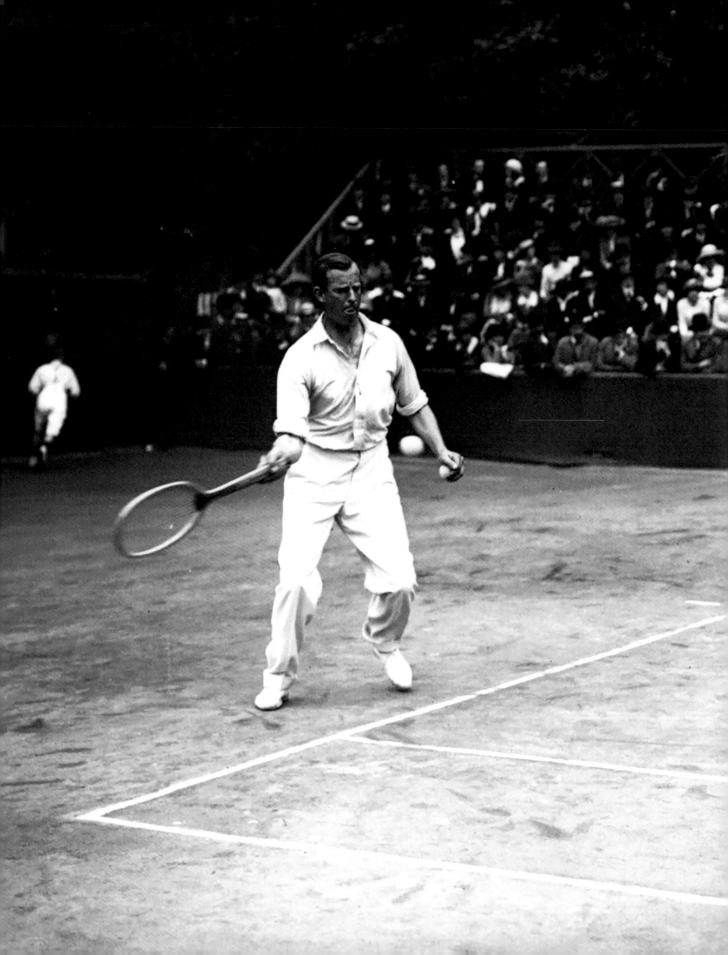

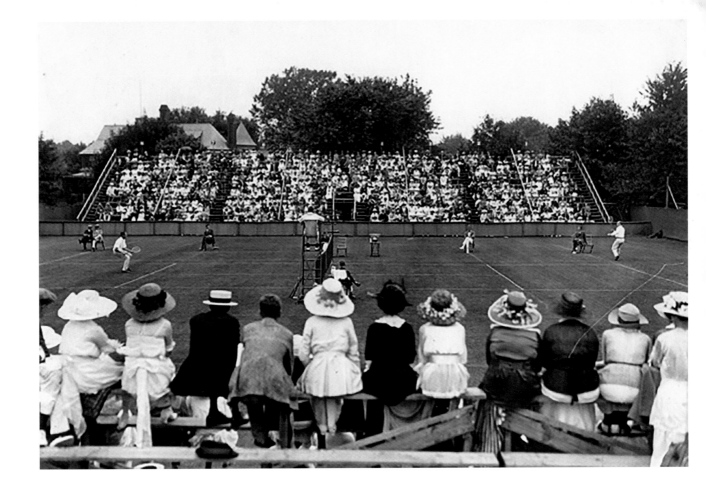

Pretty young things wept into their lace hankies with joy when Tony won the title. With his good looks, muscular physique, and almost shy charm, Wilding cut a swathe through European society as he traversed the Continent on his JAP motorcycle, ignoring poor roads and lack of gas stations (he carried petrol in wine bottles strapped to the back) to play tournaments in Hamburg, Baden-Baden, Paris, and Bordeaux, as well as Monte Carlo, where he was champion for five consecutive years.

More importantly, he reigned at Wimbledon for four years between 1910 and 1913, and such was the interest aroused by his Challenge Round match against the new red-headed American star Maurice McLoughlin—nicknamed "The Comet" because of his fast serve—that the All England Club panicked and had the Men's Singles Final brought forward from Saturday to Friday. They were afraid that a handful of "Bobbies" from the local police station would not be able to control the crowds if it were played on a Saturday afternoon when many people would be able to get off work.

As a result, the Men's Singles Final continued to be played on a Friday for decades with the Ladies' Final taking place on Saturday afternoon until the laws were changed in the 1970s as restrictive rules about the Sabbath were viewed as out of date and competitive sport was allowed on Sunday.

(opposite) Four-time Wimbledon champion Anthony Wilding.

(above) Big crowd at the Seabright Lawn Tennis and Cricket Club, in Rumson, New Jersey, which was founded in 1877.

2 Lawn Tennis Comes to America & The Davis Cup is Born

The stories vary, but there seems to be enough of a case to say that an American lady called Mary Outerbridge introduced the new game of Lawn Tennis to the United States.

In 1874, she had been visiting her family's summer home in Bermuda and had watched British army officers playing the game. It immediately caught her imagination, and she returned to her home on Staten Island, NY with one of Major Wingfield's box sets. Unfortunately, it did not get past US Customs. It required her brother, Emilius Outerbridge, who happened to be a shipping executive, to persuade the customs officers that there was nothing inherently dangerous about this strange box of tricks with its netting, nails, mallet, and balls.

Eventually finding a suitable lawn at the Staten Island Cricket and Baseball Club, close to where the Staten Island Ferry port stands today, Mary challenged her sister, Laura, in what was probably the first game of Lawn Tennis ever played in America. The score is not recorded.

Six years later, in 1880, the club staged a tennis championship, which was won by an Englishman, O. E. Woodhouse, who happened to be visiting New York at the time.

Meanwhile, things were stirring up north. After graduating from Harvard in 1874, James Dwight returned to France, where he had been born, for an extended visit and he, too, caught

sight of this new sporting craze. Bringing a box back to his home at Newport, Rhode Island, Dwight tried it out with a neighbor but couldn't seem to get the hang of it. "We felt the whole thing was a fraud," he wrote. "But then, bored on a rainy day about a month later, we took it out and tried again and it seemed much more interesting."

How much of that interest was enhanced by the fact that they were playing in rubber boots and raincoats is not clear but, in 1876, it is recorded that Dwight played a local friend, Fred D. Sears, and beat him 12–15, 15–7, 15–13 using the racquets scoring system. No longer thinking Wingfield's invention was a fraud, Dwight became so involved with the development of the sport in America that he was elected president of the United States National Lawn Tennis Association (USNLTA) when it was formed in 1881. He remained in that position for twenty-five years.

It was sheer coincidence that the other person to have a major and, one could say, even more lasting impact on the game, was also called Dwight—but that was his first name. Dwight Davis grew up in St. Louis, went to Harvard and, by the end of the 1990s had developed into one of the best lawn tennis players in the country.

Being young, adventurous, and a man of means, Davis persuaded three of his college teammates—Holcombe Ward, Malcolm Whitman, and Beals Wright—to accompany him on a jour-

They called the multitalented Norman Brookes "The Wizard."

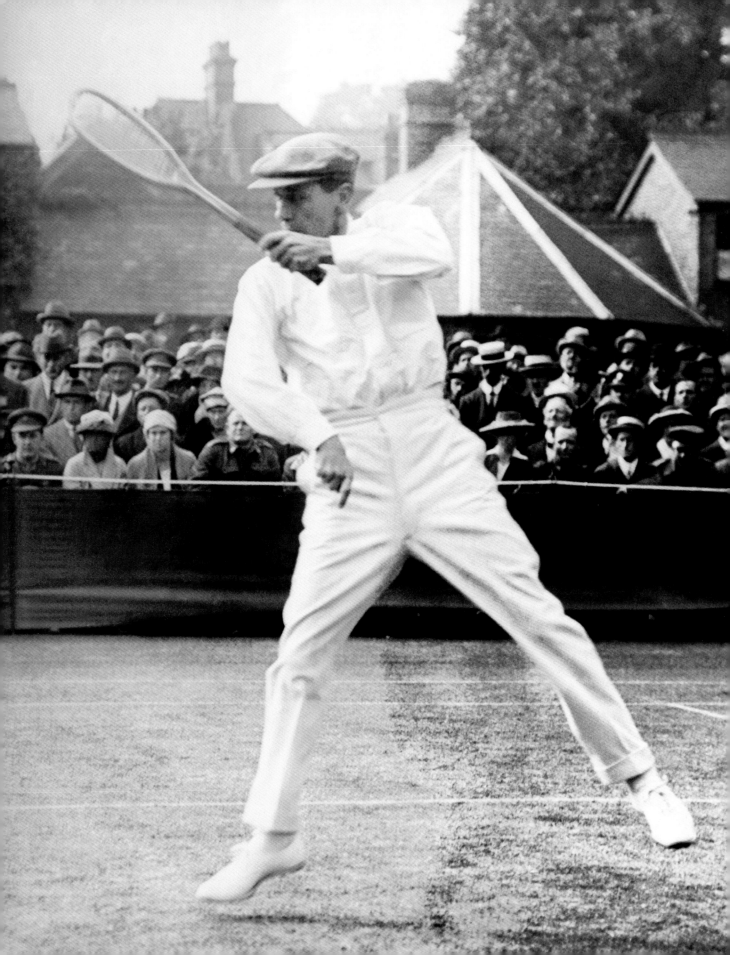

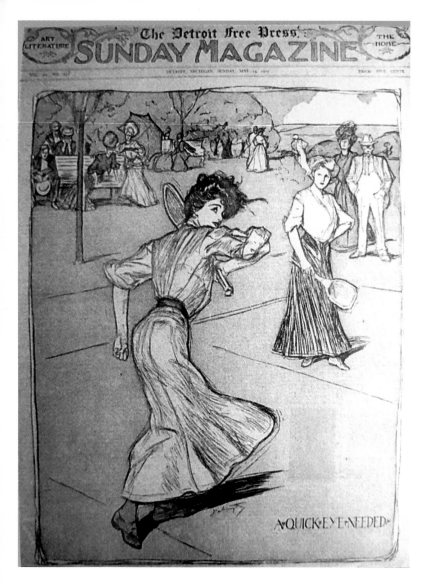

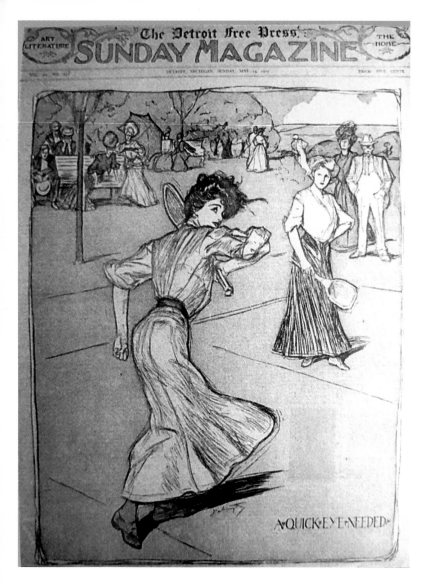

The Detroit Free Press

SUNDAY MAGAZINE

A·QUICK·EYE·NEEDED·

Detroit Free Press Sunday Magazine *from May 16, 1903.*

ney west, to play matches against the best that California had to offer. Part of the motivation for the trip revolved around the fact that tennis was starting to be viewed as a fad and, therefore, interest was waning. In the early 1880s, the sudden popularity of this new sport had witnessed the creation of 104 tennis clubs. But by 1885, that number had dropped to forty-four. Davis intended to arrest that decline with a little coast-to-coast competition.

The matches were played at the Del Monte Hotel in Monterrey. The results do not seem to have been recorded, but Davis had not failed to notice the amount of publicity the trials for the

America's Cup yacht race were generating. The sails would have been visible from the hotel as the boats skimmed the Pacific waves. Davis, touching on a thought that had been at the back of his mind for some time, talked to his travelling companions about what an international tennis match might do for the game as they rode the train home. And so the idea of the Davis Cup was born.

On returning to Harvard, Davis asked for a meeting with Dr. Dwight and put to him the concept of an international competition. So convinced was he of the veracity of his idea that Davis had already commissioned the well-known Boston firm of Shreve, Crump, Low & Co. to appoint a manufacturer to create a suitable trophy to serve as "The International Cup." It would be designed by a red-bearded Englishman called Rowland Rhodes, who was employed by the silversmiths William B. Durgin Company, based in nearby Concord, New Hampshire. Rhode's artistry produced the beautiful rose bowl masterpiece that has been travelling the world ever since.

After listening to Davis's presentation, Dr. Dwight issued this statement on behalf of his three man USNLTA committee: "Voted, to accept the International Cup offered to the Association and it was also voted that the appreciation of the Association be expressed to the donor."

The next job was to find a suitable opponent and that, inevitably, meant Great Britain. So Dr Dwight wrote this historic letter to the Lawn Tennis Association in London.

"Dear Sir,

I beg to call to your attention, as Secretary of the LTA, to an experiment which we are making that will, I hope,

26

increase the interest in lawn tennis. One of our players here has offered a Cup, to be a sort of International Challenge Cup. I enclose the conditions in rough form. I trust that we shall both take a deep interest in them for many years to come …"

The "rough form" that Dwight Davis had suggested was a contest played over three days with two singles played on Day 1; a doubles on Day 2, and the reverse singles on Day 3. By the year 2000, Dr. Dwight's hope of "many years" had reached the century mark and continued for another eighteen years before drastic—and some would say controversial—changes were made.

The British Isles, as the team was called at the time, accepted the offer and, on August 7, 1900, the first ever Davis Cup tie was scheduled to be held at the original Longwood Cricket Club in Brookline, Massachusetts, a little nearer downtown Boston than the site of the club where it stands today.

All things considered, it was not an auspicious start. Conflicts in South Africa, where the Boer War was at its height, and Cuba, where Teddy Roosevelt and his Rough Riders had been fully engaged, depleted both teams. The two top Americans, William Larned and Robert Wrenn, had both been in Cuba while Britain's Dr. W. V. Eaves was involved with the Boer War. And although the British brothers Reggie and Laurie Doherty were not in the army, both found an excuse to decline the invitation.

So it was a young American team that gathered in Boston. Malcolm Whitman, who lived a short distance from the club, was the oldest at twenty-three. He was supported by Davis, who would play second singles, and his doubles partner Holcombe Ward from South Orange, New Jersey, both of whom were twenty-one.

The British were considerably more experienced. Arthur W. Gore, who had won Wimbledon the previous year, was thirty-two while Ernest Black, the No. 2 singles player, was twenty-seven. The third man, Herbert Roper Barrett, was a twenty-six-year-old London solicitor.

Forgoing the need for as much practice as they could get in unfamiliar conditions after a long sea journey from Liverpool, the British team decided to head off for a sightseeing trip to Niagra Falls. They were not met with quite the same volume of cascading water on their eventual arrival in Boston, but heavy rain on Monday evening had continued through the next day, leaving groundsman Ike Chambers, a former Nottinghamshire county cricketer, with much work to do. Although the sun was shining on Wednesday in time for the scheduled start at 2 PM, the court was damp and the grass much longer than the British were accustomed to.

Nor were they prepared for the American twist serve that Davis and his colleagues had been developing assiduously in the preceding months. So, although the Boston papers had been making the British Isles clear favorites, conditions made the outcome far more problematical.

Let it be recorded that the first ever point played in the history of the Davis Cup was returned into the net by the competition's founder off the serve of Ernest Black. I went on to write in the International Tennis Foundation's book *The Davis Cup—Celebrating 100 Years* as follows:

H. Roper Barrett, who played for the British Isles in the first ever Davis Cup tie in 1900.

"Black, sporting a thickly sculptured moustache that matched both his name and physique, began well and took the first set 6–4. But Davis, who had every reason to be feeling extra tension—it was, after all, his cup, his idea and his friends sitting courtside—quickly settled down and began utilizing the twist serve he had practiced so diligently with Whitman and Ward on those very courts. The American levelled the match by taking the second set 6-2 and, after a far harder struggle, the third 6–4. As John McEnroe was to prove all over again so many years later, a great serve is a great serve in any hand but if it is delivered from the left side it can—for reasons no physicist has been able to explain—become even more deadly. Davis was left handed and Black found himself quite unable to counter the acute angles that were being sliced at him. The ball seemed to lose its shape as it spun off Davis's racket and skidded away off the still damp grass. In the stands, Roper Barrett shook his head in amazement. He had never seen anything like it. To the glee of the gallery, Davis rounded off the fourth set 6–4, having dropped his serve only once after the opening set."

Thus, the Davis Cup began. And it soon turned out to be a triumph for the originators of the competition. Playing on an adjoining court and wearing spikes that the British did not have, Whitman confounded Gore with his volleying and won 6–1, 6–3, 6–2. Black and Roper Barrett were unable to stem the Americans' momentum and went down to Davis and Holcombe Ward, 6–4, 6–4, 6–4. So Rowland Rhodes's rose bowl would not be setting off on its travels just yet. A 3–0 advantage ensured the United States would be the first holders of the Davis Cup and, after Davis had won a long first set before a downpour put an end to proceedings on the third day, everyone was able to retire to the Somerset Club and enjoy a sumptuous celebratory dinner, embellished, the menu tells us, by "Filets of Sea Bass au Vin Blanc and Yellow Leg Plover Salad."

Work commitments and travel being what they were, Britain was unable to send a team in 1901, but the following year, the Dohertys were persuaded to make the trip—this time to the Crescent Club in Brooklyn. But only Reggie played singles and, although he won his first rubber against William Larned 6–4 in the fifth, the aging Dr. Joshua Pim was overwhelmed by the athletic Whitman 6–0 in the fourth.

Davis and Ward put the United States ahead by winning the doubles, and then Whitman pulled off the first major upset in Davis Cup history by outplaying Reggie Doherty 6–1, 7–5, 6–4. Describing the match, Parmly Paret wrote: "Whitman managed to keep Doherty constantly on the move and the varying direction of his attack kept working the Englishman out of position. . . ."

There were changes in both teams when the British Isles returned for a third crack at the trophy in 1903. William Larned and Robert Wrenn, who had both been poorly since returning from their exertions in Cuba, were selected to play singles in this third Davis Cup Final, which was played back at the Longwood Cricket Club.

The Dohertys were still on the British team, but there was a problem. Reggie had injured his arm in an exhibition match, and the visiting captain, W. H. Collins, who was also president

of the LTA, asked if he could substitute his star player in the first singles in the hope he would be fit for the third day. But the rules forbade that, leaving Collins with a dilemma he solved in the most dramatic manner. He forfeited the first singles, thus keeping Doherty on the team.

Laurie Doherty leveled the tie by beating Wrenn with ease. Then, in partnership with an apparently recovered Reggie, Laurie put Britain ahead 2–1 by beating Wrenn and *his* brother, George. (It was not until Vijay and Anand Amritraj played for India against Sweden in 1987 that even one set of brothers next appeared in a Davis Cup Final.)

Britain won both the reverse singles—but not without a piece of luck. Laurie Doherty and Larned were tied at 4–4 in the fifth when Larned hit a fine passing shot on break point. There was no question it was in and would have left the American serving for the match. But Laurie walked up to umpire and questioned whether his own serve had been in. Looking for verification from his service line judge, the umpire, to his horror, discovered he was no longer there. Apparently, the gentleman had agreed to call the line on the understanding that he could leave in time to catch the boat for Nantasket Beach. This he had proceeded to do—with no one noticing!

The referee, who just happened to be Dr. Dwight, was called, and he sportingly ordered the point replayed. Doherty won it, leveling at 5–5 and winning the next two games to win the match. The Davis Cup no longer belonged to Dwight Davis and his country. Off went the rose bowl on the first of its travels to London.

In 1904, the USNLTA was so short of cash that it could not send a team to London to try and win back the Cup but, by then, other nations had started to show interest. France played Belgium at Worple Road, Wimbledon, for the right to meet the British Isles in the final. Despite the fact that Max Decugis, one of the first great European stars, was in the French team, the Belgians won. Led by the Dohertys, Britain beat Belgium 5–0. It was 111 years before the Belgians could reach another final, losing to a British team led by Andy Murray in Ghent in 2015.

During the remaining years, prior to the outbreak of World War One in 1914, the Davis Cup was swapped between Britain and Australasia with the United States being the only serious contender. But the matches were rarely lacking in excitement. Wallis Myers, the first sports writer to make lawn tennis his speciality, recounted moments of drama with a flourish that typified the journalistic style of the age.

We can find an example with this description of the first set between Norman Brookes and his young American opponent Karl Behr in the first round of the 1907 competition played at Worple Road, Wimbledon. With Australasia leading 2–1, a Brookes victory would take his team into the Challenge Round to meet Britain. In the end, the lean left-hander wrapped it up easily, 4–6, 6–4, 6–1, 6–2 but Myers's account was nothing if not breathless.

He wrote:

"With startling nerve the American won the first set, once more giving an electrical exhibition of close quarter volleying. From the dressing room window his colleague Beals Wright (who was due to play Wilding in the

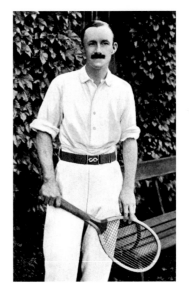

Three time Wimbledon champion Arthur Gore.

Early Racquet Designs

c. 1878

c. 1879

c. 1881 c. 1890

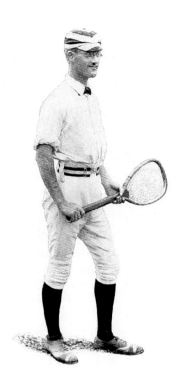

Richard Sears, winner of the first seven US Championships, starting in 1881.

fifth rubber) was watching the movement of the scoreboard in the Centre Court. Before he had dressed Brookes and Behr were three all in the second bout. Was it possible the Cup might. . . . ? Wait! There was a set to the Australian. He had got abreast. The Yale boys, gathered together in a corner of the stands, had ceased to yell. Old George Wright of Boston had stopped clapping. Now Brookes was gaining rapidly. His jaw was set like a vice. He served and volleyed as he had never served and volleyed before. Behr was passing his hand nervously through his black hair as he walked back to retrieve. His ordeal was too great. Hold! His powder was not quite exhausted. He would steady himself to fire his last shots. He would show those Yale fellows, whom he lately captained, that the Americans went down with their colors flying. But all the while the grim, iron-nerved Australian, conscious of victory, was nearing his goal."

It was Kiplingesque stuff, and Myers, whose copy was full of rugged heroes with firm jaws pulling off daring deeds, certainly embellished one's imagination for a public still coming to terms with this fledgling competition called the Davis Cup.

A few days later, Brookes and Wilding secured the Cup for the first time by overcoming the aging British team of A. W. Gore, thirty-nine, and H. Roper Barrett, thirty-three, who had been forced into service following the retirement from the sport of the all-conquering Doherty brothers the year before.

The Australasian triumph meant that the rose bowl would be making its way Down Under for the first time. The Challenge Round was to be held on the grass courts of the Warehouseman's Ground (now the Albert Ground) in Melbourne at the end of November 1908. The hosts' opponents were determined after Larned and Beals Wright had led the United States to a 4–1 victory over Britain in Boston. With Larned unable to take the time required to make the long sea voyage to the Southern Hemisphere, Wright was accompanied by Fred Alexander, a Princeton graduate who amassed the outstanding record of appearing in no less than ten doubles finals at the US Championships, winning five. He made the most of the long trip to Melbourne by winning the Australian Championships, his only major singles title, fighting back from two sets to love down in the final to beat Alfred Dunlop, with whom he promptly added the doubles title. Brookes, meanwhile, had his Kiwi colleague Anthony Wilding staying with him at his splendid mansion in Melbourne as excitement built for the much-anticipated Challenge Round, which carried all manner of significance.

Australia, as a nation, was still only seven years old with a population that had not yet reached four million and, apart from playing Test cricket against England, had not had much chance to demonstrate its sporting prowess on the international stage. The Davis Cup offered a wonderful opportunity, and people who barely understood what lawn tennis was all about were drawn to the contest through curiosity and patriotism. Brookes and Wilding felt the intensity of interest and set about getting themselves into the best possible shape.

Wilding, a muscular, well-honed athlete, was concerned that his partner

might not have the stamina to withstand the heat of a Melbourne summer through three rubbers played over five sets. So the New Zealander set his Aussie friend a training regimen that would probably suffice today. The pair rose at 7 AM, had a cup of tea, and went for a walk. A little running followed and at 8:30, they had a hit before playing five sets flat out. After lunch, it was three sets of doubles against teammates—some skipping, jogging, and hitting against the wall. A bath and massage followed before dinner. They were in bed by 10:15. A coach today might want to add a little gym work but otherwise would consider this an appropriate way to prepare.

The build-up continued and when all was ready, the stage was set in the most theatrical way. Norman Brookes and Fred Alexander had been drawn to play the first rubber and, on a day of blazing heat, they emerged from the pavilion wearing ankle-length overcoats, with towels knotted around their necks—arm in arm! As one observer suggested, having watched them shed their coats at the umpire's chair surrounded by a bucket of sawdust, a pail of iced water, a pair of jugs of barley water and tended to by a young ball boy, the whole scene resembled a prize fight more than a tennis match.

Few prize fights could have matched what followed for skill and excitement. Despite being billed as primarily a doubles player, Alexander had to face a man who was considered the most naturally gifted player of the decade. That nerves affected his play in the early stages was hardly a surprise and, as mistakes flowed, he found himself 0–4 down in the first set. No one seemed more surprised than Brookes when Al-

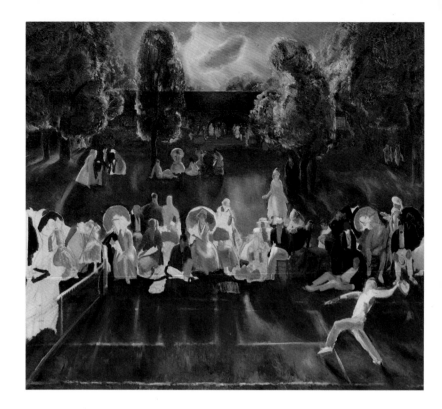

George Bellows, A Tennis Tournament, *1920.*

exander pulled himself together with a vengeance, propelling himself forward to the net to bring off a series of acrobatic volleys. To the astonishment of the packed gallery, the American not only levelled at 4–4 but won it 7–5. It was the first set Brookes had lost for two years!

He wasn't far away from losing the second either and had to sweat his way to 9–7 before winning it. The Australian dominated the third set but lost the fourth to Alexander, who refused Beals Wright's offer of a drink from a little bottle at the change over. In the spirit of the moment, Beals then chucked it over to Brookes who took a swig. The bottle's contents were never confirmed, but the assumption it was brandy. If so, it gave Brookes's dicky stomach the boost it needed, and he won the deciding set 6–3. Then, demonstrating how true sportsmen can behave as soon as the battle is done, off they marched again, arm in arm.

Beals Wright had never really done justice to his talent, but maybe he had

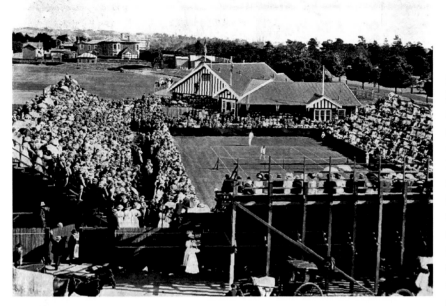

Scene of the 1908 David Cup Final between Australia and the United States at the Warehouseman's Ground in Melbourne, later to be called the Albert Ground.

been reserving it for this pivotal moment in Davis Cup history. Unleashing a dizzying collection of drop shots and lobs, the man from Massachusetts leveled the tie by beating Wilding 3–6, 7–5, 6–3, 6–1.

The doubles culminated in an amazing sequence of shots which R. M. Kidston, writing in Australia's *Lawn* tennis magazine, recorded in breathless style.

"At two sets all and two games to love down, Alexander serving and Brookes seemingly done, Australia's hopes were small indeed," Kidston wrote, noting that Wilding had kept the match alive with some steady play while Brookes found a second wind and broke back to leave Australasia serving for the match at 5–4.

Kidston continued: "Who that saw it will forget the final game of that double? Wilding, reaching 2 match points at 40–15 and double faulting. A universal 'Oh!' echoed around the arena. Wright scored with a smash. Deuce. Brookes netted. 'Vantage to America. A magnificent rally followed and, in it, Wright fell. Alexander, close in, alone played his two opponents. Jumping

from side to side like a cat, three times he volleyed fine volleys from his opponents, and at length netted a magnificent lift drive by Wilding, the over spin of which made it dive for the ground. He actually held his own until Wright, unperceived by him, had recovered his feet after his fall. Again America got the advantage but Brookes scored with a fine interception. Again Brookes intercepted, smashing hard to the corner; and now Alexander fell in a tremendous effort to reach the ball and slid into the side boards with a resounding thump."

Phew! It was match point again, and when Wright tossed up a lob that hovered before floating just over the baseline, an extraordinary duel was concluded in Australasia's favor by 6–4, 6–2, 5–7, 2–6, 6–4. But more was to follow.

On the third day, with a hot wind blowing off the interior, creating temperatures of 1020 Fahrenheit in the shade, Brookes, fearing for his stamina, tried to make short work of Wright and seemed to be well on the way to succeeding when he led the American 6–0, 6–3, 4–3, and 40–0 with the break. What Wright needed was a lucky break. He got it when a net cord slipped over into the Aussie's court. As it sank into the grass, so Brookes's heart went with it. He couldn't prevent a break back and seemed near to collapse as his legs began to wobble. But, with the crowd in his ears, the man who would be knighted for less exhausting contributions to his country's prestige, managed to recover and serve for the match at 6–5 and again at 10–9. To no avail. Wright was stronger and finally closed it out 12–10. Brookes, ashen-faced, needed assistance just to make it back to his nearby house.

Wilding, meanwhile, had been sprawled on his bed at his partner's home, hearing the umpire's calls faintly in the distance, and reading a novel while being cooled by an electric fan. With the Challenge Round tied at 2–2, it would now be up to him. In a tactical error that would cost him dear, Alexander had been sitting courtside in the blazing heat, cheering Wright's every move, expending nervous energy with every shot played.

Wilding took full advantage and ensured the rose bowl would remain Down Under with a resounding 6–3, 6–4, 6–1 victory.

In 1909, an American team managed to fight its way through to the Challenge Round with a decisive 5–0 victory over the British Isles in Philadelphia. Larned had a new colleague in Bill Clothier, whose son (also called Bill) would become a top player and promoter during the post– World War Two years in the States.

Trouncing the British was all swell and good, but reaching the Challenge Round meant heading off on a three-week boat ride to Australia, something neither Larned nor Clothier, both businessmen, had the time to do. So the USLTA sent a couple of youngsters in Maurice McLoughlin, soon to be nicknamed "The Comet" because of his whirlwind serve, and Melville Long to face the formidable duo of Brookes and Wilding. Leaving Vancouver on the Aorangi on October 8, 1909, the pair, unaccompanied by a USLTA official, arrived on the 31st and, appropriately, perhaps were billeted at the Royal Sydney Yacht Club, close to where the matches would be played at Double Bay.

The young Americans impressed everyone with their manners and good

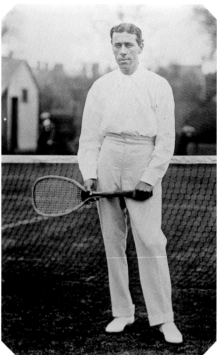

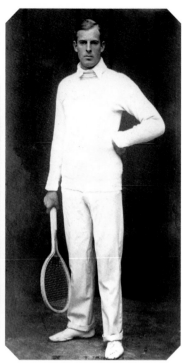

looks, and even their energetic tennis was applauded as they fought valiantly but vainly to offer a serious challenge for the Cup. In the end, the only set they managed to win in five rubbers came on the last day when McLoughlin's serve kept Wilding at bay long enough to win the first in a 3–6, 8–6, 6–2, 6–3 defeat.

So the rose bowl stayed in Melbourne and was put to good use. Mabel Brookes placed it on the sideboard of her dining room and floated red peonies in it, finding that they reflected pleasingly against the silver. In 1910, there was no danger of the Brookes household being deprived of its elegant ornament because no one came to challenge for it! For a while, the problem of distance seemed insurmountable. Nobody had envisioned the need to sail to the opposite ends of the earth every year to compete for the Cup and much squabbling broke out among officials of the leading nations. Mostly, it was about travel costs and eventually about the strength of the team that Britain eventually of-

(left) *Norman Brookes (later, Sir Norman, as the long-time president of the Australian Tennis Federation) and his New Zealand Davis Cup partner Anthony Wilding* (right) *in early days of the competition, when the two countries played as Australasia.*

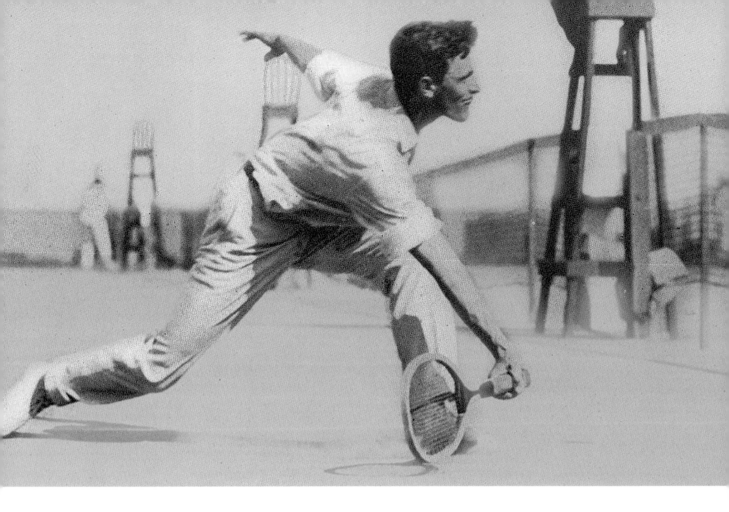

fered to send after the USLTA had refused to go to Australia.

Despite the fact that Charles Dixon and Arthur Lowe were among the best players of the day, the Australia LTA, using a clause in the Davis Cup rules, rejected the British Isles team on the basis of it being "too weak." So 1910 went down as "No Contest." Smarting from the insult, the British were determined to compete against the United States in New York the following year and did so despite the tie being delayed for two days as a result of a dock strike that prevented the SS Adriatic from leaving Liverpool. When it did finally get under way at the original site of the West Side Tennis Club on Broadway and 238th Street in Manhattan, Bill Larned and Maurice McLoughlin set the Americans on the way to a 4–1

victory by taking care of the opening singles against Dixon and Lowe, albeit in tough five setters.

To play in the Challenge Round, the Americans found themselves heading for New Zealand rather than Australia—it having been decided to honor Wilding by playing the tie in his home town of Christchurch. Unhappily for the locals, Wilding, who had a full-time job in London, decided that Brookes would be well capable of taking care of the Cup's defense without him. And so it proved.

In retrospect, Larned, suffering from bouts of rheumatism, should never have played and, after a bright start in the first rubber, went down to Wilding's replacement, Rodney Heath, in four sets. Even Beals Wright and McLoughlin could not stem the tide in

a close-fought four set doubles against Brookes and Alfred Dunlop. Australasia ended up 5–0 winners.

After the United States had failed to send a team in 1912, the British isles, led by Dixon and the venerable Gore, needed only to beat France at Folkestone, which they did 4–1, to book another passage Down Under for the Challenge Round. By the time they boarded ship, a little tennis history had been made with the formation of the International Lawn Tennis Association. The USLTA, squabbling about Wimbledon's determination to label itself as The World Championships, pouted for a few years before joining. It was not until 1923 that the Americans agreed that the world's four major championships should be played in Britain, France, the United States, and Australia. It has been ever thus.

The British team arrived in Melbourne in time for the Victorian Championships, which Brookes decided to skip so as to not reveal his style of play to the opposition. It was a strange and fatal mistake. The British had replaced Gore with an Irishman called James Parke, whose sporting pedigree rivalled, if not surpassed, that of the talented Brookes. Parke, Irish to the core, pinned two sprigs of shamrock to his shirt before matches, but it had not been a case of luck that had seen him play twenty times for Ireland at Rugby Union, represent his country at golf, and also play cricket to a first-class level. It was no surprise, then, that Parke took tennis in his stride.

To the contentment of the crowd, who had been told to expect a routine Australasian success, Brookes took a 4–1 lead in the first set. But like the Melbourne wind, fortunes suddenly swirled in another direction. Having gauged the speed of Brookes's left-handed serve, Parke started to return with penetrating power and broke back, eventually taking the first set 8–6 and going on to cause a major upset by a score of 8–6, 6–3, 5–7, 6–2.

The British captain Charles Dixon then beat Rodney Heath, who was standing in again for the absent Wilding, in four sets. After the home team had managed to stave off defeat by winning the doubles, Parke power drove shots all over the court to wrest the Cup from Australasia's grasp by crushing Heath 6–2, 6–4, 6–4.

There was a collective sigh of relief among competing nations over the British triumph because it removed the need to keep sailing round the world to play the Challenge Round. Australasia did manage to send a team to New York in 1913 but, without Brookes or Wilding, the United States was able to progress to the second round of a suddenly expanded entry by winning 4–1.

The remaining ties were played in England with the United States beating Germany at Nottingham and Canada 5–0 overcoming Belgium at Folkestone. The All Comers Final was played at Wimbledon's Worple Road ground where the United States made short work of Canada.

British Isles' hopes of retaining the trophy on home soil were dashed after a promising start. Parkes got the better of "The Comet" McLoughlin 7–5 in the fifth set but, after another long, hard-fought struggle, Dixon lost, also 7–5 in the fifth, to R. N. Williams, a fine player whose fame for his tennis was somewhat overshadowed by the fact that he was a survivor from the Titanic.

The original Davis Cup trophy, with Malcolm Whitman (left), *Dwight F. Davis* (center) *and Holcombe Ward* (right).

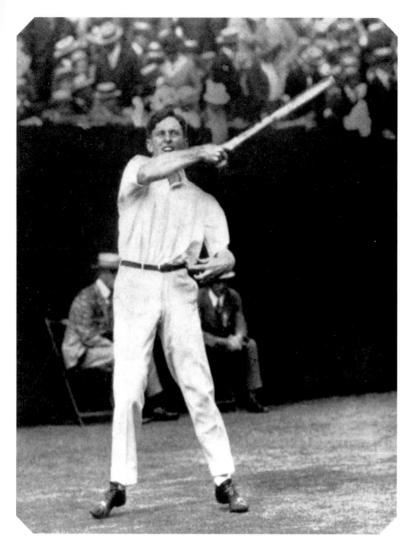

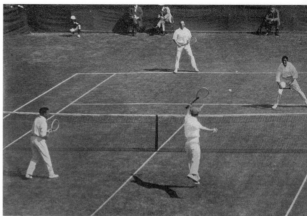

(left) *America's Maurice Mc-Loughlin shows off his low volley. Because of his fast serve, he was dubbed "The Comet."*

(right) *The 1912 Davis Cup Final being played at the Albert Ground, Melbourne. In the foreground is Australasia's Alfred Dunlop, on the left, partnered by Norman Brookes, while on the far side Britain's James Parke (left) is playing with Alfred Beamish.*

After the United States won the doubles, McLoughlin put the Cup out of Britain's reach by beating Dixon in straight sets. So the rose bowl was heading home for the first time in ten years.

Unhappily, matters of far greater import than policing a tennis crowd were afoot. Within a year, Britain's foreign secretary, Edward Grey, had offered his prophetic warning: "The lights are going out all over Europe and we shall not see them lit again in my life time."

The little world of tennis would not be immune from the enormity of the tragedy that was unfolding, although the sport continued virtually unhindered through the summer of 1914.

Finding time to travel to Europe for the first time since he won the Wimbledon title in 1907, Norman Brookes spent some weeks with Wilding playing the traditional European clay court tournaments at Menton, Monte Carlo, Beaulieu-sur-Mer, Nice, and Cannes before switching to grass in preparation for his return to Worple Road.

Once "The Wizard," as Brookes was called by his devotees, had worked his magic in the All Comers Singles—the former champion A. W. Gore being one of his victims—and reached the final, Wilding, of course, was waiting for him. It said much of this widely admired sportsman that Wilding had been trying to persuade the All England Club committee to allow the champion to play through the draw, even though that would have made life harder for him. But his pleas fell on deaf ears, and that would not happen until after the war.

Knowing Wilding as he did, Brookes realized what many pundits did not: that Wilding had not been able to maintain the high level of fitness training that had always been the key to his success and that, preoccupied with his job in the oil industry, his focus had wavered. The score line, which was shocking to some who had watched the New Zealander claim four successive titles, bore this out. Brookes's talent proved too much for Wilding's

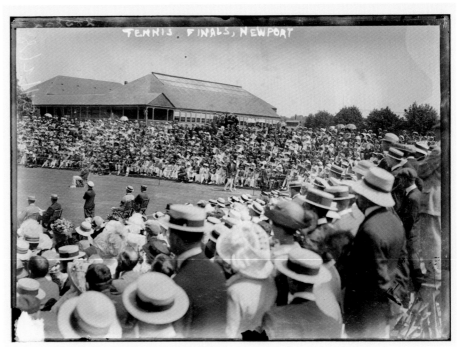

fading power, and the Australian won his second Wimbledon crown by the decisive score of 6–4, 6–4, 7–5.

In one of those gestures that spoke of the closeness of their friendship, Wilding, standing at courtside after the final was over, offered his back as a prop for Brookes to sign an autograph hunter's program. Soon, they were seafaring together again, heading for America and further rounds of Davis Cup play as the storm clouds of war began to envelope the world.

Arriving in Pittsburgh, a city settled largely by German-speaking peoples, Brookes and Wilding found themselves about to embark on a Davis Cup tie teetering on a knife edge of peace and war in a very literal sense. The second round of that year's competition had pitted Australasia against Germany at the Allegheny Country Club. Outwardly, it was all peace during the preceding days. Wilding had discovered an American motor bike to his liking and engaged in some hill climbing in between training. The

German team of Otto Froitzheim and Oscar Kreuzer found themselves much in demand as dance partners during dinners at the club. But Froitzheim and Kreuzer were both in the German Army reserve and, with their nation poised to invade Belgium, they had made it clear they would return home the instant war was declared.

News did not travel fast in those days, and it was not until the last day's play—August 1st 1914—that Germany declared war on Russia, making a European war official. The tie was already decided (Brookes and Wilding not having lost a set in any of the first three rubbers) but nevertheless a good crowd was expected for the final day, and the president of the Allegheny was determined news from afar should not diminish it. Evidently, a man of some determination, he went to extraordinary lengths to ensure that it didn't—first barring reporters from the club after imploring calls to local editors and then ripping out the club's phone lines!

(left) *Irishman James Parke played tennis for the British Isles and Rugby Union for Ireland. He also played first class cricket.*

(right) *Smart hats on show on Finals Day at the 1909 US National Championships at Newport, Rhode Island.*

(following spread) *The Newport Casino, now home of the International Tennis Hall of Fame, was founded by Jimmy Van Alen.*

Jimmy Van Alen
Tie Break

Jimmy Van Alen was a true tennis eccentric. Returning home to New England after studying at Cambridge University, Van Alen founded the International Tennis Hall of Fame at Newport, Rhode Island, and set about changing the game he played and loved. He changed it by inventing the Van Alen Streamlined Scoring System (VASSS), which we now call the tie break.

For twenty years, Van Alen badgered the tennis community and media (Frank Rostron of the *London Daily Express* used to get calls at 2 AM) until finally, in 1970, Forest Hills tournament director Bill Talbert relented and allowed the original nine-point tie break to be used in the US Championships. The sudden death aspect was so stark that a match could be won on the single remaining point at 4–4 in the 5th set breaker. New York crowds loved it; the players hated it.

So compromise was reached when Peter Johns, the LTA secretary in London and the Australian doubles champion Bob Howe came up with the "win-by-two" breaker that has been used since 1975.

So, in face of much pro-German abuse from some spectators who were still ignorant of the state of play in Europe, Australasia was able to wrap it up 5–0 although Kreuzer did actually manage to win a token set off Brookes. With few words spoken, the players embraced at the end and bid each other awkward farewells. Three days later, Britain and Germany were at war, but on August 6th, the British Isles was playing Australasia in the semi-final in Boston almost as if nothing had happened. Froitzheim and Kreuzer, meanwhile, had raced to catch a ship for Germany. Their vessel was apprehended in mid-Atlantic, and the pair spent the war as prisoners—Froitzheim, being an officer, in more comfortable surroundings than Kreuzer, who was put to work in the Gibraltar dockyards. Involvement in tennis had saved their lives. One wonders what they thought when they heard of Tony Wilding's fate.

At the Longwood Cricket Club, Brookes managed to avenge his defeat of two years earlier at the hands of James Parke, but it was not easy and might never happened without a piece of fine sportsmanship by the Irishman. Serving for the match at 5–4 in the fifth set, the score was 30–15 when Parke's racket grazed the net as he put away a winner. As neither umpire nor linesman noticed the infraction, Parke could have reached match point. But that was not his way; he told the umpire what had happened. The score became 30–30, and Parke did not win another game.

The Australasians, in fact, did not lose another set. With the score standing at 3–0, the reverse singles were cancelled in deference to the British

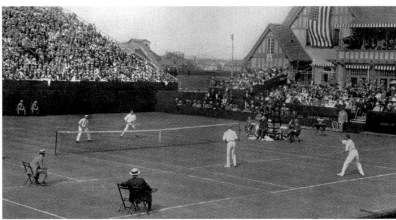

team, who had more pressing matters to attend to back home.

The Challenge Round was played in the splendid surroundings of the West Side Tennis Club's new home at Forest Hills. The half bowl of a stadium would come later so stands were erected around the grass court, which still exists today in front of the imposing Tudor-style clubhouse. Twelve thousand people showed up, making it the largest crowd ever to witness a tennis match up to that time.

Wilding made a quick start for the Challengers, beating Richard Williams in straight sets. The next set to be played late in the afternoon was the longest yet recorded in Davis Cup history. McLoughlin eventually claimed it 17–15 over Brookes, who was overcome by the humidity as much as the budding tennis writer Al Laney was overcome with the nail-biting excitement of the moment. In his book *Covering the Court*, Laney, a mere teenage fan of "The Comet" at the time, wrote: "My confidence was shaken many times before that terribly long first set was over. . . . About halfway through, after what seemed an eternity, Brookes, who had served first and thus was forcing McLoughlin to battle for his life every time the American served, was love forty against service. You would have to be a teenager again, I suppose, to suffer as I suffered then.

But at this crisis, McLoughlin served three balls that Brookes could not even touch. . . . Other crises came later, near the end we could not know what was near. Brookes was again within a point of winning the set and each time the answer was the same, an unreturnable service. Was ever a boyhood hero more worthy of worship?"

Although McLoughlin levelled the score at one rubber each by winning the next two sets 6–3, 6–3, Brookes had recovered sufficiently the next day to assist Wilding in a hard-fought doubles victory over McLoughlin and T. C. Bundy 6–3, 8–6, 9–7. With Wilding not as fit as he had been in his pomp, Brookes knew that he would need to clinch the tie for Australasia in the fourth rubber to save his partner from having to beat back "The Comet's" serve in a deciding fifth. Talent won the day, despite foul-mouthed New York epithets being hurled at him. Brookes recovered the cup with a 6–1, 6–2, 8–10, 6–3 win over Williams. Wilding then took the court for what would turn out to be the last competitive match of his life. With little to play for, he lost in four quick sets.

Back in London, Wilding immediately sought an audience with Winston Churchill, who had become First Lord of the Admiralty in H. H. Asquith's war cabinet. Wilding had been introduced to Churchill during the numer-

(left) *Newport Casino.*

(right) *Playing on the court that still exists in front of the West Side TC Clubhouse at Forest Hills. This was the doubles between the United States and Australasia in the 1914 Davis Cup Challenge Round on the eve of World War One.*

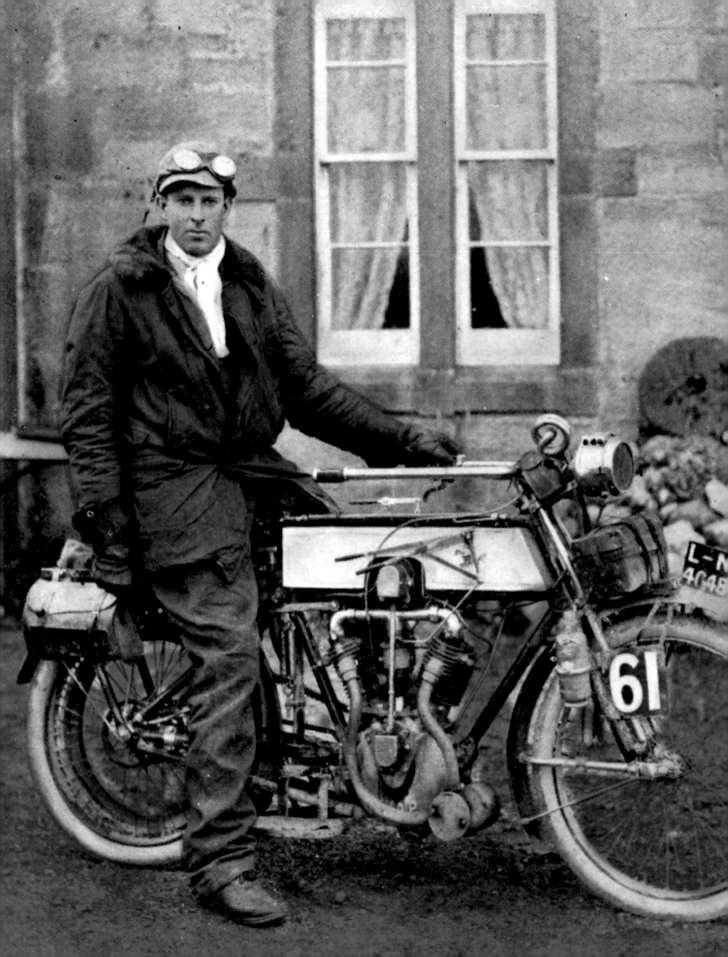

ous parties thrown by his long-time girlfriend Maxine Elliott, an American beauty who was a leading theater actress on both sides of the Atlantic. As a New Zealander, he was not required to enlist; however, Wilding felt that it was his duty after living for so many years in England. Churchill accepted his offer and found him a commission in a mechanized Royal Marines unit, perfectly suited to his ability to dismantle and repair motor engines. And so the die was cast.

In an age before the concept of sporting superstars had taken hold, Anthony Wilding had come closest to achieving that status. His good looks, charm, and winning ways, on court and off, had endeared him to a wide audience, especially in Britain, France, and back home in New Zealand, where he remains one of that country's great sporting heroes.

The last we know of him comes from a passage in *Crowded Galleries*, a remarkable account of life in the first decade of the twentieth century written by Norman Brookes's wife, who later became Dame Mabel. She writes of meeting Tony at a hotel in Boulogne when he rode over from the front in Belgium on his motor bike. She noticed a button dangling from his uniform and offered to sew it on for him. He waved her away, saying that his lady friend, Maxine, would take care of it when she arrived.

Wilding was more concerned with attempting to persuade Norman to sail for home rather than sign up with an Australian regiment in Egypt. He was concerned that his long-time partner would suffer with his chronically bad stomach in war-time conditions.

"Tony argued and reminded Norman of his age, family and responsi-

bilities more seriously than I had ever heard him speak," Mabel wrote. "But he knew nothing would alter Norman's mind so he gave up with a shrug and, after a while, bade him a shoulder-holding farewell, for they were very close."

The Brookses promised to be up at six o'clock to wave Wilding goodbye as he returned to the front. Mabel wrote movingly of the moment: "We watched the French scene below, the waiting trucks, filled and tarpaulin-covered, a few muffled townsfolk; bridges over a steely river. At a brazier in one of the open trucks, two Tommies crouched, cooking. Another lay, wildly gesticulating, resisting restraint from an orderly—a shell shock case possibly on his way to the hospital at Wimereux.

"Tony strode out onto the cobbled road, kicked the starter into action, contained, remote and lonely. It was a time of 'hail' and 'farewell'. He waved and wheeled over the paving to the bridge, and as he crossed and turned into the distance, he waved again. The smell of burning charcoal came up, mixed with the reek of exhaust from his bike, and drifted ephemeral as the passing moment, leaving only memory. We never saw him again."

Several months later on May 9, 1915, Captain Wilding, commanding a unit in the trenches in Flanders, lay down a barrage on enemy positions from his position near Neuve Chapelle and, later in the afternoon, found a place to rest in a bunker. Within minutes, the place took a direct hit, and a remarkable life was extinguished in a second.

At the Monte Carlo Country Club, all the past champions are listed on individual slabs of marble. Only one bears a notation. It reads, "Anthony F. Wilding. Mort pour la patrie."

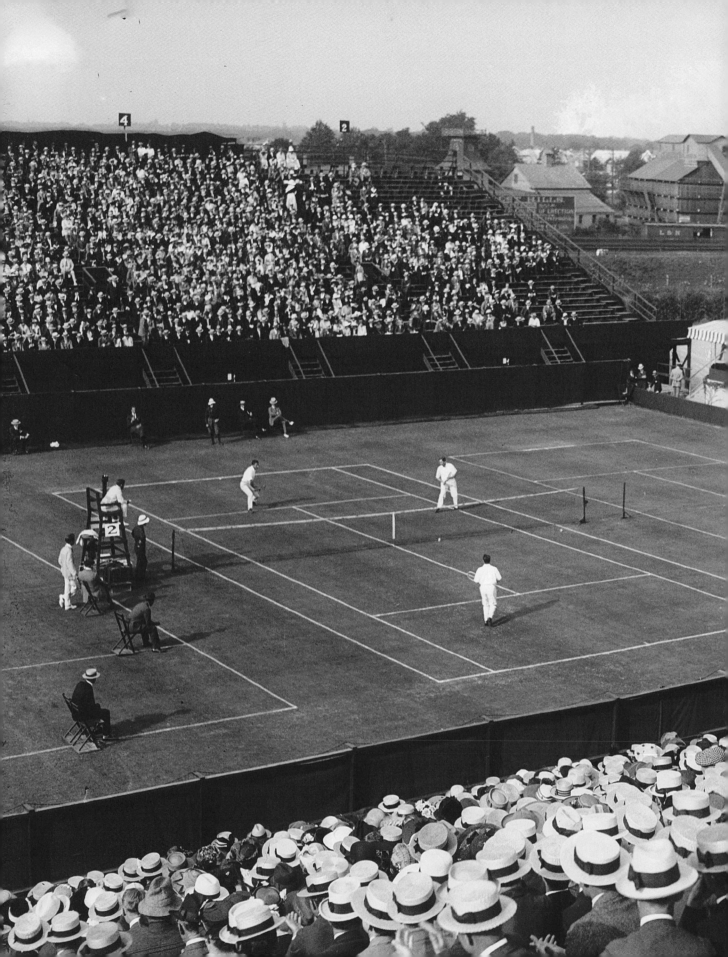

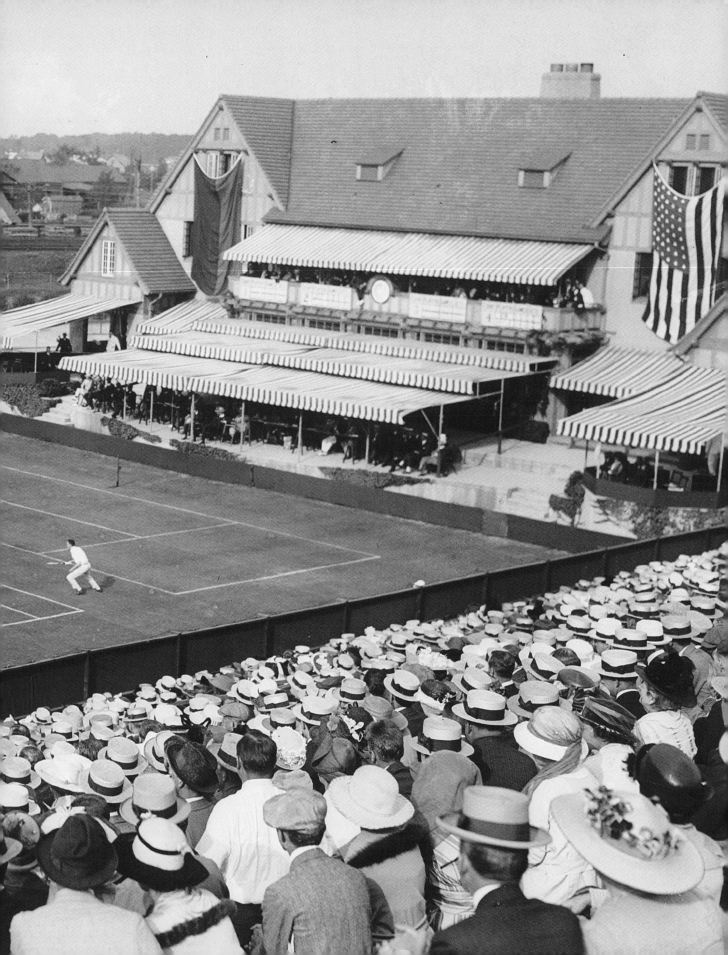

3

Post-World War I
& The Twenties

The decade following the First World War was dominated by seven extraordinary champions, five of whom were French. Bill Tilden, who was known for his towering personality as much as his brilliant game, was the American exception among the men, and Helen Wills, a beauty as well as a great tennis player, was among the women.

Two of the seven players became the game's first truly global stars: Tilden and Suzanne Lenglen, who swept all before her with a balletic style of tennis that proved invincible. The elegant, poker-faced Wills was the only player worthy of being mentioned in the same breath as Lenglen. Until she met Wills in Cannes, the French prodigy was so dominant that she rarely lost two or three games in a match, let alone a set. The remaining quartet were quickly dubbed "The Four Musketeers" as they imbued the phrase created by novelist Alexandre Dumas: "All for one and one for all."

René Lacoste, whose shirts people still wear to this day, Henri Cochet, Jean Borotra, and Jacques "Toto" Brugnon, the doubles specialist, brought so much success and glory to French sport that the government agreed to build Stade Roland Garros in Paris to accommodate the crowds who were clamoring to see them.

But some important changes were being made across the Channel too. By 1922, the All England Club had a new home. Even before the war, it was becoming obvious that Worple Road was not big enough to match the growing interest in the sport. Crowd control had become an issue, and it only grew

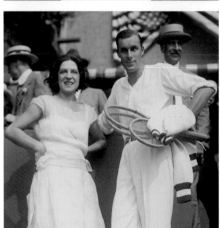

(at right, top) *Helen Wills: The American was the only woman player between the wars who could challenge Suzanne Lenglen as a player and a star.*

(at right) *A photo of Suzanne Lenglen and Bill Tilden that was posed in every sense. They were not friends. The two giants of the game developed an intense rivalry, fueled by sharing the same strong drive for success and the same extraordinary instinct for showmanship. Ted Tinling, who umpired Lenglen and played Tilden, reveals in his book* Sixty Years in Tennis, *that both players "had boundless technical knowledge of the game, induced by determination to excel and an unbelievable capacity for practice."*

(opposite) *René Lacoste (left) and Henri Cochet.*

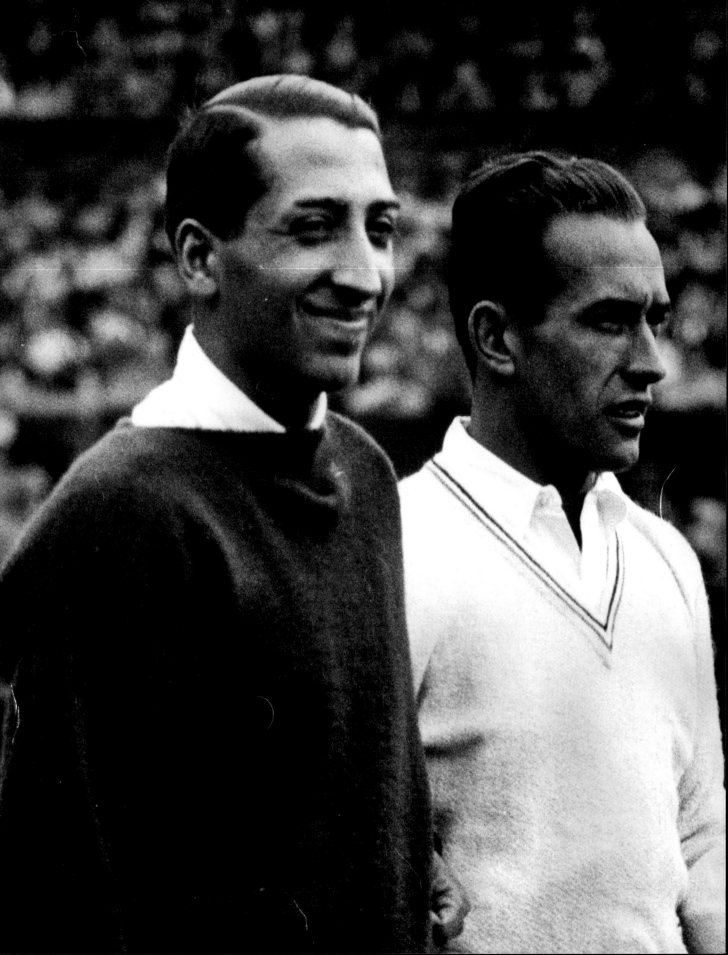

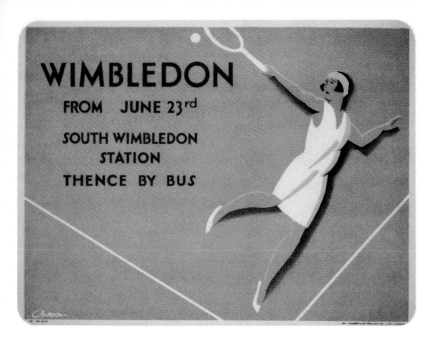

A Wimbledon poster from the thirties. From Southfields Station on the District Line, it is still a question of "Thence by Bus," although that useful phrase seems to have faded from the English language.

with the excitement created by the revival of the Championships in 1919. An alternative site had to be found.

Even as the powerful young Australian Gerald Patterson* was beating a clearly underprepared Norman Brookes in the first post-war Challenge Round, moves were afoot to find a suitable patch of ground somewhere in the vicinity. Happily, there was some farmland at the bottom of Somerset Road and, as John Barrett describes in his epic book *Wimbledon: The Official History of the Championships*, Eddie Fuller, the future head groundsman, was dispatched to find a surveyor who was already making a feasibility study.

Barrett quotes Fuller as saying, "I was asked by the club secretary, George Hillyard, to take a note to the surveyor in a field off Wimbledon Park Road, which is now known as Church Road. When I found the place, it was a farm. Somewhere amongst the cows, horses, chick-

* Patterson, whose father was a close friend of Brookes, had grown up watching his opponent play a weekly doubles match near both families' homes in Melbourne. He was also the nephew of the great Australian opera singer Dame Nellie Melba.

ens, and pigs was the man I was looking for. I found him in a ditch, sitting in the shade, making his plans for drainage."

Once the drainage (which is so important because of the constant need to water the courts in between England's plentiful rain) was deemed sufficient, the All England Club and the Lawn Tennis Association, in a joint venture, decided to purchase the land for £140,000 pounds sterling. By 1920, the well-known architect Stanley Peach was assigned to produce a design for a center court and other club facilities. By 1922, it was ready.

In the meantime, Bill Tilden had made his first appearance at the Championships' original Worple Road ground in 1920, using his clever back court game to work his way through the draw before overcoming Patterson's mighty serve in four sets. In so doing, "Big Bill" became the first American man to win Wimbledon. The following year, in the last Challenge Round ever played, he defeated his young South African protégé, Brian "Babe" Norton, in five uneven sets.

As we have noted earlier, Anthony Wilding had been a strong advocate for abolishing the Challenge Round during his four-year tenure as champion, but the Wimbledon committee had refused to listen. He had been killed in Flanders before the committee agreed to the proposal that he, and many others had been advocating.

Bill Johnston, who grew up on the courts of San Francisco's famous Golden Gate Park, was Tilden's persistent rival at the US Championships in the twenties—losing in five of the six finals Tilden won—then became the sec-

ond American winner at Wimbledon in 1923 before the Musketeers arrived. Allowing for the fact that the popular Jacques Brugnon was primarily a doubles expert, the other three Frenchmen were players of exceptional quality and varying skills. They seemed to enjoy handing major titles among them for the remainder of the decade.

Borotra, who was called the "Bounding Basque," frequently wore a beret as he pranced about court, bringing the kind of athletic panache to tennis that Gaël Monfils provides today, albeit with a great deal more success. Borotra was the first Musketeer to win the Wimbledon title in 1924. He won it again in 1926. Lacoste, in between designing Le Crocodile, which became his company's emblem, won in 1925 and 1928, while Cochet, the master of the half volley, took it in 1927 and 1929.

Cochet's second title was won against extraordinary odds. Two sets and 1–5 down to Tilden in one of Wimbledon's most memorable semi-finals, the little Frenchman proceeded to lose just one point as he caught up to 5–5 and went on to win 6–3 in the fifth. Tilden was at a loss to explain how he let the match slip from his grasp. Cochet ended up beating Borotra 4–6, 4–6, 6–3, 6–4, 7–5 in the final which, incredibly, was the third consecutive match that year which Cochet won from two sets down.

Meanwhile, the Davis Cup had been turning into an annual battle between Tilden and the Four Musketeers. Tilden had ensured that the Cup remained in the United States by beating back the challenge of Australasia in 1922 and 1923, and then Australia, after the split

from New Zealand, in 1924. By then, the French were ready to step up but, on unfamiliar ground at the Germantown Cricket Club in Philadelphia the following year, they could not deal with Tilden, despite Borotra pushing him to five sets in the opening rubber. It was the same story in 1926. Twelve months later, the tables finally turned.

Tilden, who was already well into his thirties, was having to play singles and doubles. Although he won the latter with Frank Hunter, he was a fading force when faced with Lacoste's relentless driving from the back court and went down in four sets. To Tilden's surprise, the Philadelphia crowd, which had never really taken this flamboyant character to their hearts, gave him a resounding send off as. Exhausted, he dragged himself from his hometown arena.

Now it was all down to Bill Johnston—"Little" Bill to Tilden's "Big" Bill—who had to save the Cup for the United States in the deciding fifth rubber as drops of rain dribbled out of low, glowering clouds. Cochet controlled much of the match, but Johnston broke the Frenchman's serve to love at 2–5 down in the fourth. "I suddenly felt

(top) *Stade Roland Garros in its early years. It was built in 1928 and named after a World War One flying ace who was the first man to fly the Mediterranean solo. He was killed two weeks before the end of the war.*

(bottom) *Wimbledon's All England Lawn Tennis and Croquet Club seal.*

(following spread) *Suzanne Lenglen, 1922.*

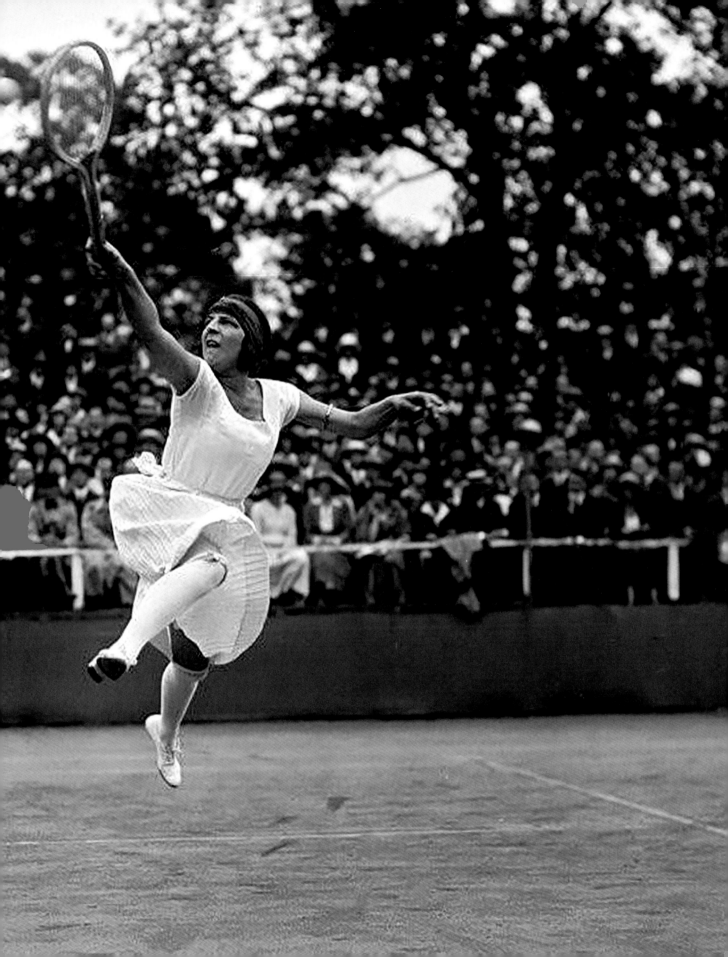

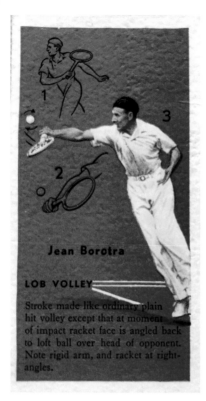

Jean Borotra

LOB VOLLEY

Stroke made like ordinary plain hit volley except that at moment of impact racket face is angled back to loft ball over head of opponent. Note rigid arm, and racket at right-angles.

(left to right, clockwise) *A poster of Jean Borotra, the "Bounding Basque" in his famous beret, alongside fellow Musketeers Henri Cochet and René Lacoste.*

The dazzling Davis Cup bowl, designed by the New England based Englishman Rowland Rhodes.

empty and uncoordinated," Cochet admitted afterward. He was saved by Lacoste, who had moved into the captain's chair because Pierre Gillou had been overcome by nerves. Although the baby of the team in age, Lacoste was the intellectual leader of the Four Musketeers and his soothing words enabled Cochet to get back on track and close it out 6–4, thus enabling France to become the first non-English speaking nation to hold the Davis Cup.

In his autobiography, Lacoste vividly described what it meant to the team: "Madame Cochet fainted; Pierre Gillou sprang up like a child; I took off my overcoat and sweaters; Brugnon dropped his pipe and Borotra—well, you can imagine him justifying his reputation as the Bounding Basque. Everything after that seemed like a dream. The Davis Cup presented to our team, a thousand photographs, uniting the players with the French Ambassador and the American Minis-

ter for War, Dwight Davis, the giver of the Cup. The memories of it all seem like a fantasy."

Meanwhile, plans to build a suitable stadium for the Four Musketeers was well under way. Anticipating the chance to stage a Davis Cup final, the French Federation had gone cap in hand to the French government and asked for the financial backing to build a 13,500-seat stadium on the edge of the Bois de Boulogne near Porte d'Auteuil (Paris Métro). Their request was granted on the condition that they accepted the government's name for the new stadium.

In its bureaucratic way, the government had compiled a list of French heroes whose names would adorn buildings, streets, and stadiums. It was pure chance that Roland Garros, a First World War fighter ace and the first man to fly the Mediterranean solo, was next on the list. Garros, who had been shot down and killed in the last weeks

of the war, had no particular affiliation to tennis except he enjoyed playing the game. But his name has now entered the lexicon of the French language. Every year in May, you hear Parisians ask friends, *"Vas-tu à Roland?"* Everyone knows that they are talking about the French Open.

So, thanks to their foresight, Stade Roland Garros was ready for the 1928 season. With the United States only having to defeat Italy in the semi-final, the stage was set for France and their Four Musketeers to receive Tilden and his colleagues for the showpiece Challenge Round.

But to the horror of the French Federation, a problem that had brewing for a long time between the Tilden and the USLTA suddenly blew up into a major crisis. The cause of it stemmed from the fact that, ever since leaving college and long before he started his tennis career, Tilden had been a journalist. Once he became a star at the game, he played with such élan, Tilden's name appeared on the top of newspaper columns like all the other star athletes of the era. But, as always, Big Bill was different. He wrote his own copy. His gaunt, willowy frame may have resembled a ghost on occasion, but he never employed one to write his articles, which put the USLTA in a very difficult position. Their rules stated that no player could write about the current game. But how could they stop a man following his career? They had tried but, in typical fashion, Tilden flouted a new rule issued in 1925 about players not being allowed to write about the game by signing a $20,000 contract to write a syndicated column.

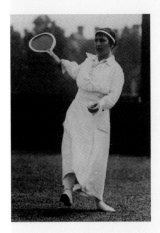

Hazel Wightman

The first year of the twentieth century had seen the birth of the Davis Cup, but it was not until 1923 that a formidable personality named Hazel Hotchkiss Wightman persuaded the tennis establishment that there was room for a sort of female equivalent. Unlike the Davis Cup, the Wightman Cup was restricted to matches between the United States and Great Britain.

The format consisted of five singles and two doubles. The championship produced some great contests, despite the rarely punctured domination of the American team. Wightman herself played for five years and was captain for thirteen. Having learned her tennis at Berkeley, California, she lived most of her life on the east coast, where she taught aspiring youngsters at her home near the Longwood Cricket Club in Boston.

Britain managed two memorable victories at the All England Club in 1958, when Christine Truman upset Althea Gibson in her prime, and in 1960, when Ann Haydon got Britain off to a winning start by defeating a fellow Wimbledon champion in Karen Hantze 2–6, 11–9, 6–1.

Britain won just three ties in the 1970s, most notably at Queensferry on Deeside, UK when Virginia Wade, Glynis Coles, and Sue Barker put Britain on the road to a rare 6–1 triumph. Yet, after winning at the Royal Albert Hall in 1978, the United States ruled and when they scored a not infrequent 7–0 whitewash in Williamsburg, Virginia in 1989, it was decided to terminate the event after attempts to include European players fizzled out.

Cups have grown in popularity since. The Association of Tennis Professionals (ATP) World Team Cup, which was run in Dusseldorf with great efficiency by Horst Klosterkemper until 2012 led the way. By then, the Hopman Cup, the master mind of Paul McNamee and Charlie Fancutt, was in full flow in Perth, Australia, but that popular event was eventually swallowed up by the ATP's Cup, involving three Australian cities in 2020.

In 2017, Roger Federer saw an idea of his become reality when the first Laver Cup was held in Prague. The drawing power of Federer and Rafael Nadal on the European team and John Isner and Nick Kyrgios playing for the Rest of the World packed the 17,000-seat stadium—a stunning first-off success for an event basically run by Craig Tiley's team from Tennis Australia. It was no fluke. The next year, a marginally bigger sellout crowd watched Europe triumph again in Chicago. By then, it had become a foregone conclusion that Geneva would be equally successful in 2019.

Federer told his agent Tony Godsick that he wanted to create a tribute to his idol Rod "Rocket" Laver and have Laver in attendance and Bjorn Borg and John McEnroe participating as captains on the bench. The star power was too much for tennis fans to resist. The cynics had wanted to dismiss it as an exhibition, but the way the players performed and behaved suggested it was rather more than that. Tennis is an individual sport, but it has become clear that players and fans enjoy the excitement of a team format.

(above) *Hazel Hotchkiss Wightman, born in California, the creator of the Wightman Cup— the women's equivalent of the Davis Cup—spent most of her life living near the Longwood Cricket Club near Boston, where she taught the game she played so well.*

(above) *A magazine cover featuring Pierre Gillou, the heavily built Frenchman who had a heavy influence on French tennis. Gillou became a national hero when he captained the French Davis Cup team, which won the Cup for the first time over the United States in 1927. He then had two ten-year terms as president of the French Federation.*

(opposite, top) *Bill Tilden, elegance personified.*

(opposite, bottom) *Before the redesign of the grounds in 2020, the Place des Mousquetieres, adorned by bronzes of Cochet (pictured), Lacoste, Borotra, and Brugnon, was a meeting place where crowds watched play on big screens. Romania's Andrey Pavel can be seen in action behind Cochet.*

Mike Myrick, sometime president of the USLTA, who ran American tennis through the twenties whether he was actually president or not, was apoplectic. When Tilden's articles from Wimbledon in the summer of 1928 were emblazoned all over papers in America, certain members of the USLTA saw it as an opportunity to clip the wings of the only bird in their aviary who not only flew about in his own sweet time but frequently pelted them with droppings from a great height. Meetings were called back in the States to ponder this situation

as soon as Wimbledon was over. The Davis Cup ties, first against Italy and then the Challenge Round, were due to be played in Paris in July. Tilden was not waiting around for men in tailcoats to come up with a new ruling.

Catching the famous boat train, The Golden Arrow, from Victoria Station to the Gare du Nord, Tilden immediately went to the Carlton Hotel, where the draw for the Italy tie was being made. To everyone's astonishment, Joseph Wear, the official conducting the draw, announced that Tilden, the playing captain of the American team, had been suspended and would not play.

As Tilden marched into the room, near hysteria broke out with journalists tripping up over themselves to reach the phones. Many people cheered Big Bill. The Italian baron Umberto De Morpurgo, who would have been playing him a few days later, embraced Tilden and said, "I'm sorry, Bill, this has taken all the fun out of it."

But no one was more appalled than the French Federation. They were not so much interested in the fun as the money. Tickets had been selling like hot croissants, but now people would be asking for their money back. The humiliating prospect arose of not being able to fill the spanking new Stade Roland Garros for the much-hyped Challenge Round.

Luckily for them, Tilden was not a man to go quietly. Big Bill had worked in the theater and knew how to make an entrance, and this was one of his most dramatic. "I refute all charges!" he cried out, as The Four Musketeers crowded around him. *"Ah! Mon pauvre Bill,"* said Borotra. *"Quel dommage!"*

The sentiments were sincere. The Four Musketeers had travelled the Atlantic three consecutive years, toiling long and hard to win the Cup. Now, they wanted the honor of defending it against a team led by one of the greatest players that the game had ever known.

But if Tilden was not going to take the situation lying down, nor were the French Federation. In an unprecedented move that has never been repeated in the annals of the sport, they contacted the French Foreign Office at the Quai d'Orsay to protest the situation while also letting Myron Herrick, the US ambassador to France, know of their extreme displeasure. Suddenly, it was an international incident with telegrams zinging across the Atlantic. The drama reached the desk of President Coolidge at the White House. He is thought to have quietly given his ambassador the authority to take over the selection of the team. To their disgust, the USLTA found themselves outranked, and Herrick duly reinstated Tilden as US captain.

"Zut alors!" was one phrase being bandied about at Stade Roland Garros as French officials wiped their foreheads. It may have seemed extraordinary that they should have gone to bat for the opposing team but, even apart from the financial aspect, the whole occasion would have lost much of its luster without Tilden. And anyway, with their own touch of arrogance, the French were confident of defending the Cup with or without Big Bill on the other side of the net.

With less than twenty-four hours to practice once the decision had been reversed, Tilden, who had not hit a ball

for days, struggled to find any rhythm when he finally got on court and stormed off after the most perfunctory practice. "He was practically hysterical," said Junior Coen, one of Tilden's boys who had been brought onto the team. "He couldn't hit a damn thing."

The weather was not kind either and a windstorm was kicking up the red clay once the Challenge Round got under way. It certainly did not help Tilden's timing; he quickly lost the first set to Lacoste 6–1. The odds on the thirty-five-year-old getting back into the match against the reigning Wimbledon and US champion should have been slim, especially as Tilden

had lost to Lacoste on their four previous meetings.

But this was Tilden on a grand stage, and he was not ready to "exit left." Ever the improviser, ever the artist, Tilden changed his make-up. If the role does not work one way, try another. He started slicing every shot and began out-steadying the most steady of opponents.

"If he could not beat Tilden as Tilden then he would beat him as Lacoste," wrote Frank Deford in his brilliant Tilden biography. And beat him he did. Tilden somehow gathered up sufficient strength to back up his tactical know-how and win the first rubber 1–6, 6–4, 6–4, 2–6, 6–3. Not until Arthur Ashe changed his game in the 1975 Wimbledon final to dismantle Jimmy Connors with soft ball tactics was there to be an equivalent example of a great champion playing against the grain to outmaneuver a deadly opponent.

Lacoste was in shock afterwards. "Two years ago, I knew at last how to beat him," he said, slumped in the locker room. "Now, on my own court, he beats me. I never knew how the ball

would come off the court, he concealed it so well. I had to wait to see how much it was spinning—and sometimes it didn't spin at all. Is he not the greatest player of all time?"

Many agreed with Lacoste, but Tilden's talent was not sufficient to save his team. Cochet defeated John Hennessy in four sets. Cochet then teamed with Borotra to beat Tilden and Hunter in the doubles. When Big Bill had to return on the third day to play the fourth rubber, he had little left. It was not easy, but Cochet was never in danger as he kept the Cup for France with a 9–7, 8–6, 6–4 win.

It was much the same story in 1929. Back at Stade Roland Garros, an officially reinstated Tilden won a rubber against Borotra, whom he beat routinely, but a win in the doubles by the new team of Wilmer Allison and John Van Ryn was still not enough to wrest the Cup away from the French. Lacoste won the deciding rubber against George Lott 6–4 in the fourth.

No matter how agonizing their Parisian experiences had been for Tilden

and his team, the Davis Cup itself had thrived on the change of hands and its introduction to the continent of Europe. It had developed into a truly international competition of growing stature. Dwight Davis must have glowed with inner pride when he saw what it meant to The Four Musketeers and their thousands of supporters to win his trophy.

In the meantime, Suzanne Lenglen had been busy giving the women's game greater exposure than it had ever enjoyed before. Coached and tended to by Papa Lenglen, who used to give her little sips of cognac at changeovers on chilly spring mornings on the Riviera, Lenglen grew up next to the Nice Lawn Tennis Club. Soon, she was overwhelming opponents with her athletic style of play. Her freedom of movement was enhanced by the fact that she threw away the corsets that all women players had worn under their long, flowing dresses. If her movement was that of a ballet dancer, it was no coincidence. Papa Lenglen had sent her to ballet classes. Her meticulous upbringing included having to hit pocket handkerchiefs laid out on court at the corners of the service box. In an amateur age, this sort of attention to detail was virtually unprecedented.

As soon as Wimbledon restarted after the war, Lenglen arrived to claim the crown, although her first Challenge Round was a tough one. At the age of twenty, she found herself playing Dorothea Lambert Chambers, a seven-time Wimbledon champion who was twenty years her senior. Despite her advancing years, the British player managed to reach match point twice

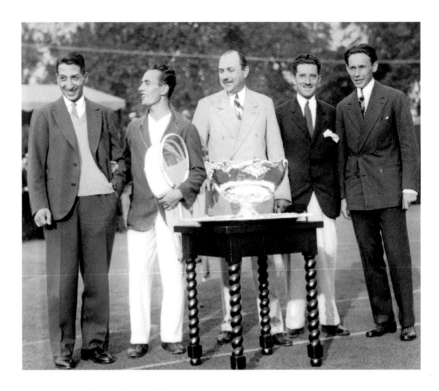

before Lenglen clawed her way to a 10–8, 4–6, 9–7 victory.

That was the last time Lenglen would be challenged (in a literal and technical sense because the Challenge Round was abolished in 1922, and she had to play through the draw) until 1924, when she was forced to withdraw at the semi-final stage because of illness. The following year, she beat Chambers 6–3, 6–0, which became an average sort of score for her until, in 1926, her Wimbledon career was brought to an unfortunate end for reasons that had everything to do with the etiquette of the day and nothing to do with her tennis.

Lack of communication between herself and the new All England Club secretary, Major Dudley Larcombe, led to Lenglen being unaware of when she was scheduled to play. Larcombe's predecessor, Commander George Hillyard, had always made a point of personally informing Lenglen of her schedule. Larcombe, however, did not follow this practice and inserted a dou-

bles match into the program after Lenglen had left the club on the evening of the first Tuesday. The result was that she arrived late for her singles against Evelyn Dewhurst which had been bumped up the program to accommodate her doubles.

A distraught Lenglen arrived at the club to be met by a bevy of photographers and much panic among officials because, sitting in the Royal Box, waiting to see Lenglen play, was the august figure of Queen Mary. Although it was later denied by Buckingham Palace, the word was that Her Majesty was "displeased." Jean Borotra, putting a towel over his head, entered the ladies' locker room to try and calm the near-hysterical champion. Lenglen finally got her nerves under control and beat Dewhurst before losing the doubles.

The furor continued and, to her horror, Lenglen, who had been the darling of Wimbledon for years, was booed when she entered the center court to play a mixed doubles with Borotra on the Saturday. When the jealous wife of the French ambassador suggested to Lenglen that she would not be welcomed at a Buckingham Palace reception that weekend, it all became too much for the highly strung star. She fled the scene, scratching from the singles, never to return.

In later years, Queen Mary would deny that she had ever been offended, but it was too late for the great Suzanne Lenglen, who turned professional later the following year.

Before she disappeared into the near anonymity of the nascent professional circuit, Lenglen stole the headlines one more time. In 1923, Helen Wills, who had begun her domination of the US Championships (seven titles in nine years), was the only player deemed worthy of challenging Lenglen. So, amid enormous fanfare, including front page articles in the *International Herald Tribune*, it was arranged for the pair to meet on the courts of the Carlton Hotel in Cannes.

Incredibly, Lenglen had not lost a singles match since being beaten by Marguerite Broquedis in April 1914, when she was only fourteen years old. Now, in 1926, that record seemed to be in serious danger. But it did not turn out that way despite the exquisite drama of the final moments of the match.

With Lenglen having taken the first set 6–3, she reached match point and was awarded the match by umpire George Hillyard when Wills's shot was called out. Then, amid growing uproar, the line judge, Lord Charles Hope, whose father was Australia's first governor general, informed Hillyard that the call had come from the crowd and that Helen's ball had been in.

Despite having shaken hands and being surrounded by bouquet-carrying well-wishers, Lenglen was ordered back on court. Bewildered and exhausted, she promptly lost the replayed point and then the game to allow Wills back into the match at 6 all. In his book *Sixty Years in Tennis*, the great couturier Ted Tinling, who had umpired many of Lenglen's matches, described the scene the he had witnessed himself: "It had become increasingly apparent that Suzanne's strength had been ebbing fast and that she would face almost certain defeat if forced to a third set. She was having frequent

Kitty McKane Godfree

British tennis legend and former Wimbledon champion Kitty McKane Godfree (right) poses with the singles champion Pam Shriver of the United States during the Edgbaston Cup tennis tournament at the Edgbaston Priory Club in Birmingham, England, on June 15, 1986.

We were reminded of Kitty McKane Godfree's exceptional athletic qualities when she emerged from the mists of time at the 1977 Wimbledon centenary celebration with a galaxy of former champions on the center court. That was the year Godfree's achievements were properly recognized with her induction into the International Tennis Hall of Fame. In 1986, Godfree was back in the spotlight when she presented Martina Navratilova with the champion's trophy after Navratilova had defeated Hana Mandlíková.

A year later, Godfree's achievements were fully revealed when the splendid *London Times* scribe Geoffrey Green wrote her biography, detailing her childhood growing up in Henley-on-Thames and later living on Kensington High Street. Her father sold grand pianos for a living, and her story was grand in many ways. Green writes that while Godfree was educated in Scotland at St Leonards School, "She was right-handed for field hockey, tennis and golf; left-handed at cricket, lacrosse, and writing; and played both handed at Fives. Later, Kitty was right-handed at badminton."

Not having played badminton at school did not hamper her prowess at it. She won the All England Badminton Championships

no less than eight times! She was also not slow to make her mark at Wimbledon. Partnered by her older sister, Margaret Stocks, she reached the doubles final in 1922, losing to the imposing pair of Suzanne Lenglen and Elizabeth Ryan. She then reeled off three consecutive mixed doubles titles with three different partners from 1924 to 1926—the last with Leslie Godfree, the man whom she had married a few months earlier. They remain the only husband and wife team to have won a Wimbledon title.

There was also the Olympics. In 1920, in Antwerp, Belgium, Godfree won gold with Winifred McNair in women's doubles, and silver in the mixed doubles, when she was partnered by Max Woosnam, who also played soccer for Manchester City and won the bronze in singles. Four years later in Paris, she added a silver for reaching the women's doubles final and a bronze for third place in the singles. A bag of five medals in two Olympic games had lifted her into a rare bracket of successful Olympians.

As Green relates, sardonically, Godfree never achieved much at golf because in her own words, "Trying to hit a stationary ball used to make me angry. I always preferred a moving ball."

spasms of her famous, dry tickle cough and was also clutching sporadically at her heart between points. Suzanne's silver flask of cognac was never more in evidence than in this match. During the first set, she took liberal sips during each change of ends. I wondered what Helen Wills thought of this procedure, it being so far removed from anything she might do herself."

Struggling to control herself, Lenglen somehow found the strength to break Wills's service at 7–6 with two blazing winners and so win the match, seemingly, for a second time. Overcome with the stress of it all, she collapsed sobbing onto the bench.

It was a triumph for the great diva, but something of a more lasting nature occurred in the life of Helen Wills. As befits the romantic setting of the Cote d'Azur in springtime, love was in the air. As she gathered up her things at courtside, trying to get over her loss, a young man leaped the fence and forced his way to her side. "You played awfully well," he said.

Helen Wills appreciated the gesture so much that she married Frederick Shander Moody Jr., a stockbroker from San Francisco, the following year.

In the meantime, Kitty McKane had become the beneficiary of Lenglen's misfortunes at Wimbledon. Seizing the opportunity offered when Lenglen's illness gave her that semi-final walk over in 1924, McKane used her natural athleticism and powerful forehand drive to beat a teenage Helen Wills in the final from the precarious position of a set and 4–1 down, becoming the first British champion at Wimbledon since Dorothea Lambert Chambers ten years earlier. It was also the last time Wills was ever beaten at Wimbledon, winning the title on each of the eight occasions she returned.

In 1925, Lenglen resumed her winning ways with her sixth title, sweeping through the draw for the loss of just five games. Embarrassingly, for the defending champion, McKane was not able to win one of them when she met Lenglen in the semi-final. To lose 6–0, 6–0 was a devastating blow to the usually ebullient McKane, but fate dealt her a helping hand the following year when Lenglen stormed off after the fracas over keeping Queen Mary waiting and was scratched in the third round.

With the center court giving her full support, McKane recovered from losing the second set and trailing 1–3 in the third when she met Lilí Álvarez in the final, beating the talented and popular Spaniard 6–2, 4–6, 6–3. It would the first of three consecutive Wimbledon finals that the unfortunate Álvarez would lose. For McKane, the manner in which she turned the tables—running through the last five games of the match with a flourish—established her as a favorite with the British sporting public.

(opposite) *Helen Wills Moody portrait by Edward Steichen.*

(above) *An art deco* Vanity Fair *cover of Helen Wills Moody.*

4 The Thirties
Perry, Budge,
& Von Cramm

Bill Tilden took to the Grand Stage for the last time as the thirties dawned amid the Great Depression. Having won the US title at Forest Hills the previous year, the imperious master returned to Wimbledon in 1930 and defeated his unseeded countryman Wilmer Allison in the final to win the title for the third time.

Soon after, Big Bill would turn professional and so become banned from the game's greatest arenas forever. If the USLTA's sigh was one of relief, it was one of disappointment for most tennis fans. Tilden was a star in every sense of the word, and his magnetic, laconic, even camp personality enthralled all who watched him.

Sportswriter Frank Deford illuminates his personality best with this tale from his biography of the great star: "Tilden was still a schoolboy when one of his friends, Frank Deacon, walked by his practice court and saw him hitting balls everywhere. Using a nickname Tilden hated, Deacon called out, 'Hey, June, take it easy!'"

"Tilden stopped dead," writes Deford, "and, with what became a characteristic gesture, he swirled to face the boy, placing his hands on his hips and glaring at him. 'Deacon,' he snapped, 'I play my own sweet game.'"

The sweet game would be lost to the thousands who poured into Roland Garros, Wimbledon, and US Championship each year, but tennis has always had the knack of renewing itself and soon there were new stars to admire. But not before Wimbledon suffered what, to this day, has been the only final to be left unplayed. Francis X. Shields, a tall, handsome womanizer and grandfather of the actress Brooke Shields, fought his way through to the final but twisted an ankle while defeating Borotra in the previous round. He would probably have played but for a directive from the US Davis Cup captain who was only interested in having Shields fit for the semi-final, which was to be played against Great Britain in Paris the following week.

Sidney Wood, who would go on to have a major impact on the game by producing the Supreme Court—a synthetic surface that was used extensively on the Grand Prix circuit in the 1970s and 1980s—became Wimbledon champion by default. It was a unique, if unwanted, achievement and the All England Club were not amused when Shields, who was volleying athletically, proved himself quite fit enough to beat Fred Perry in the first Davis Cup rubber the following weekend. It was not sufficient, however, to save the United States, and Bunny Austin clinched the tie for Britain by defeating Shields in the deciding rubber.

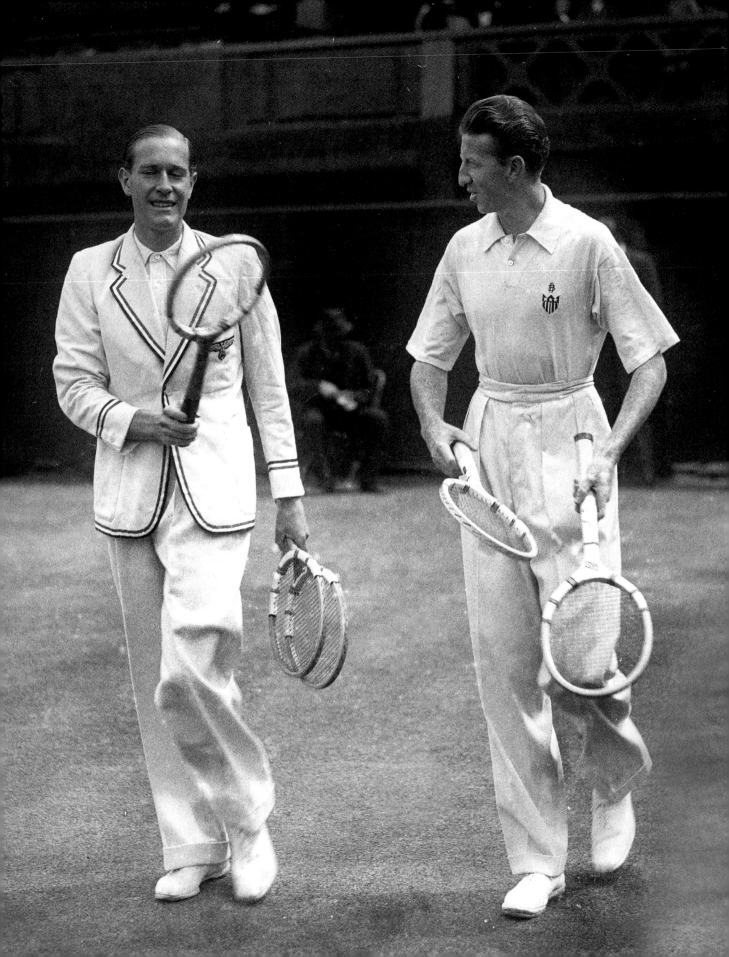

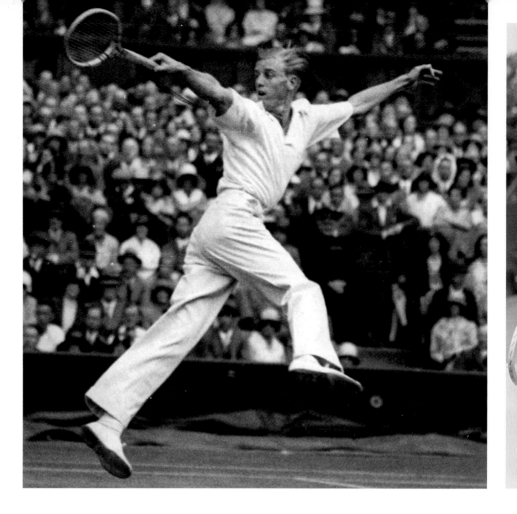

(clockwise from left) *Sidney Wood won the 1931 Wimbledon title by default in the final over Frank Shields. Although he appears not to have worried too much about what was under his feet, the American went on to design the synthetic Supreme Court, which was used extensively on the pro tour in the 1960s and 1970s.*

The French Open on July 25, 1932. In the InterZone Davis Cup tie between the United States and Germany, Ellsworth Vines, resplendent in cap, beats Baron Gottfried von Cramm 3-6, 6-3, 9-7, 6-3.

Fred Perry's winning smile.

Frank Shields, the grandfather of Brooke Shields and a heartthrob the ladies found difficult to resist.

Fred Perry was a new tennis star about to be born. Already an international table tennis champion, this son of a Labour member of parliament burst onto the tennis scene as a handsome, cocky young man with the wrong accent but the right talent for winning tennis matches. Perry who, like Lacoste, made shirts that people wear to this day, went on to become one of the great icons of British sport.

However, tennis was about to be blessed by another extraordinary performer in Ellsworth Vines, a lanky Californian whose powerful game took him to the US title in 1931 and 1932, and enabled him to conquer Wimbledon in 1932, pounding Bunny Austin to defeat in the final for the loss of just six games. A later champion, Jack Kramer

rated Vines as the best player whom he had ever seen, along with Don Budge, but Vines turned professional too early to cement his place among the all-time greats. Eventually, Vines became a top-class golfer. He was, however, a formidable figure at 6 feet 2 inches. He had excelled at basketball during his time at University of Southern California. He had as fast a serve as you could hit with a wood framed racket and a powerful forehand. A youthful Kramer was a little overawed when he first set eyes on Vines, who was immaculately clad in the long whites that most tennis players wore in 1935. "He dressed like Fred Astaire and hit the ball like Babe Ruth," remarked Kramer.

Vines, however, could not help the United States in the 1932 Davis Cup

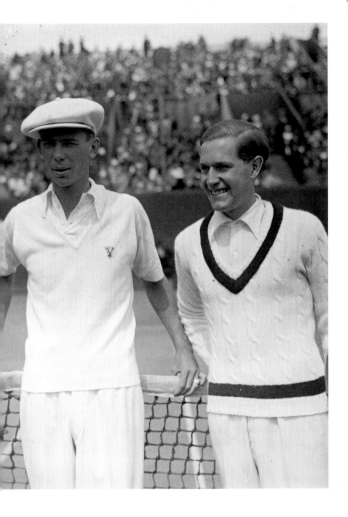

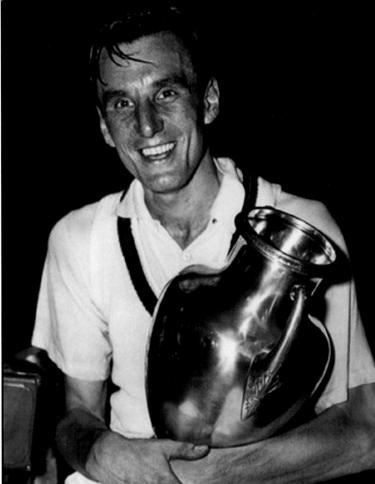

Challenge Round against France in Paris. His backhand collapsed under the pressure of Borotra's net-rushing tactics in the opening rubber. Cochet then beat Allison, who nevertheless kept the Americans in the tie by teaming with John Van Ryn to win the doubles against Cochet and Brugnon. But the drama was reserved for the final day when Allison, reaching match point for the fourth time against Borotra in the first reverse singles, started walking to the net as he watched the Frenchman's second serve land four inches out. But there was no call and no intervention from the umpire. Even some of the Parisian crowd booed the decision, and Allison, who was exhausted, won only one more point as Borotra came back to take the match 7–5 in the fifth. That

gave France a winning 3–1 lead, and the US team was left to ponder what might have been as Vines defeated Cochet in the dead rubber.

As I relate in *The Davis Cup: Celebrating 100 years of Tennis*, 1933 proved to be an historic year for British tennis, while also leaving a dark stain on the history of the Davis Cup. Soon after, Adolf Hitler became Chancellor of Germany, the Federation was ordered to remove their number one player, Dr. Daniel Prenn, a Jew of Polish origin, from their Davis Cup team. Clicking their heels, German Federation officials passed a rule that forbade non-Ayrians from future participation in the Davis Cup. Disgracing themselves, the leaders of the International Lawn Tennis Federation said nothing. It was, in fact,

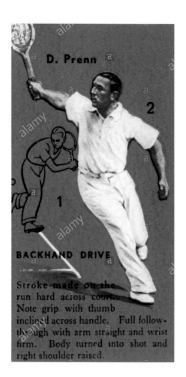

D. Prenn

2

1

BACKHAND DRIVE

Stroke made on the run hard across court. Note grip with thumb inclined across handle. Full follow-through with arm straight and wrist firm. Body turned into shot and right shoulder raised.

The German number one player, Dr. Daniel Prenn, a Jew of Polish origin, became a victim of Hitler's edict that no non-Ayrians could represent Germany in the Davis Cup. Not waiting for the horrors that followed, Prenn took his family to Britain, where he settled permanently.

(following spread) *As if practicing for the Olympic hurdles, Don Budge, Fred Perry, Bobby Riggs, and Frank Kovacs take a leap into professional tennis.*

left to two players to register the only public protest.

Bunny Austin and Fred Perry wrote a letter to *The Times of London*, decrying the ruling over Prenn, who wasted little time in packing his bags for Britain, where he remained for the rest of his life. Austin and Perry wrote, "We have always valued our participation in international sport . . . because it was a human activity that contained no distinction of race, class or creed. For this reason, if for no other, we view with great misgivings any action that may well undermine all that is most valuable in international competition."

Austin faced problems of his own once he joined in the Moral Re-Armament movement in the late thirties and spent the war in the United States as a conscientious objector. It cost him his membership of the All England Club, whose committees have often included senior armed services personnel, and he was not reinstated until the 1980s.

Perry had vowed to have nothing to do with politics after his father lost his seat in the House of Commons, but he had a fine sense of what was right and wrong. He had no hesitation in joining Austin in this condemnation of Nazi policy.

Opponents didn't like Perry because he quite openly tried every trick in the book to gain advantage within the rules. He was also not averse to making snide comments on court. Whenever an opponent hit a particularly brilliant shot, he would look over his shoulder and declare, "Very clevah!" in an exaggerated British accent. But that attitude did not prevent him from becoming good friends with rivals. He and Ellsworth Vines spend numerous trans-Atlantic journeys together, playing deck quoits

and listening to each other's gramophone records in their cabins.

Perry's socialist background ensured that everyone on the British Davis Cup squad were treated equally. Dan Maskell, who later became the voice of tennis on BBC television at Wimbledon, always accompanied the team as the professional coach. Being a professional in those "Upstairs Downstairs" amateur days, Maskell was billeted in a two-star hotel down the road from the five-star Hôtel de Crillon when Britain played in Paris. Perry would have none of that; he insisted that Maskell be upgraded to the luxury of the Crillon. His influence was already such that no one argued.

Perry's influence only grew after the events that unfolded in that hot Parisian summer of 1933. First, Britain met and defeated the United States in the Davis Cup semi-final after Austin, wearing shorts in a fashion statement that would inevitably become the norm, completely outplayed Vines 6–1, 6–1, 6–4 in the opening rubber. After George Lott and John Van Ryn had kept their team in the tie by winning the doubles, Austin then ensured Britain's progress to the Challenge Round by defeating Allison in four sets.

For the next ten days, Captain Herbert Roper Barrett's team relaxed in the splendor of the Hôtel de Crillon, tended to by Maskell on the practice court and Tom Whittaker in the locker room. Whittaker was then the physical therapist for Arsenal Football Club and would later become the team's manager. When in London, Perry would accept Arsenal's invitation to train with them. Perry credited his experience of pounding up and down the concrete terraces of their old ground at Highbury with

turning him into the top-class athlete he became. But, as we shall see, he still had work to do on his stamina in 1933.

The Challenge Round had caught the imagination of the French public. Perry and Maskell were aghast one evening when they stopped for dinner at the Café Royal near the Bois de Boulogne and were greeted by the orchestra striking up with "God Save the King." Dinner was on the house too, proving how generous the French can be to their sporting foes.

Mystery still surrounds the strange selection of the French team. Prior to the lavish draw ceremony that was to be conducted at the Hôtel de Ville later that day, Maskell was amazed when he ran into Jean Borotra on the stairs leading to the locker room at Stade Roland Garros.

"You and Henri for the singles?" Dan ventured, hoping to confirm the expected French lineup.

"No, I'm not playing," Borotra replied. "I will play doubles with Brugnon, of course, but André Merlin will play second singles."

Maskell was dumbfounded. Merlin was a nineteen-year-old who had never played a live Davis Cup singles. The reason for this strange decision was never made clear at the time. Borotra had given Maskell every indication in their brief conversation that he had been dropped, but Cochet, writing an article for the program at France–USA final in Grenoble all of forty-nine years later, stated that Borotra had decided that he was not fit to play.

Either way, it did not bode well for France. Austin made it worse when he thrashed the young debutant 6–3, 6–4, 6–0 in the opening rubber once the eagerly awaited Challenge Round got under way. Cochet did his best to get France back on an even keel by taking the first set 10–8 off Perry and leading 5–3 in the third with the match poised at one set a piece, but Perry fought his way back to take it 6–3 in the fifth. Although no one would have known from the way he marched off court, Perry was drained to such an extent on a stiflingly hot day that he passed out cold once he reached the locker room.

When he came around to find himself being fanned by Roper Barrett and Maskell, Perry could not remember who won the match. The captain swore everyone to secrecy but took the precaution of replacing Perry with Harry Lee for the following day's doubles.

Perry always maintained that his exhaustion was more mental than physical and described the scene vividly in his autobiography:

It is hard for anyone who was not there to understand the strain of playing the Challenge Round of the Davis Cup in Paris. We were trying to take the Cup away from the French and Paris was like a seething cauldron. You never knew what was going to happen and everything you did was like another step along the tightrope. There were 15,000 people jammed into that stadium and every time there was a bad call, it took four or five minutes to silence the eruption. Everyone was whistling and jeering. It's very nerve-racking to play tennis in that kind of charged atmosphere. And to try to beat Cochet who, let's face it, was my idol, in such a decisive match was a staggering responsibility. I think, when I beat him, the bottom dropped out of my act. I think it was the sheer joy and relief of thinking, "My God, we made it!"

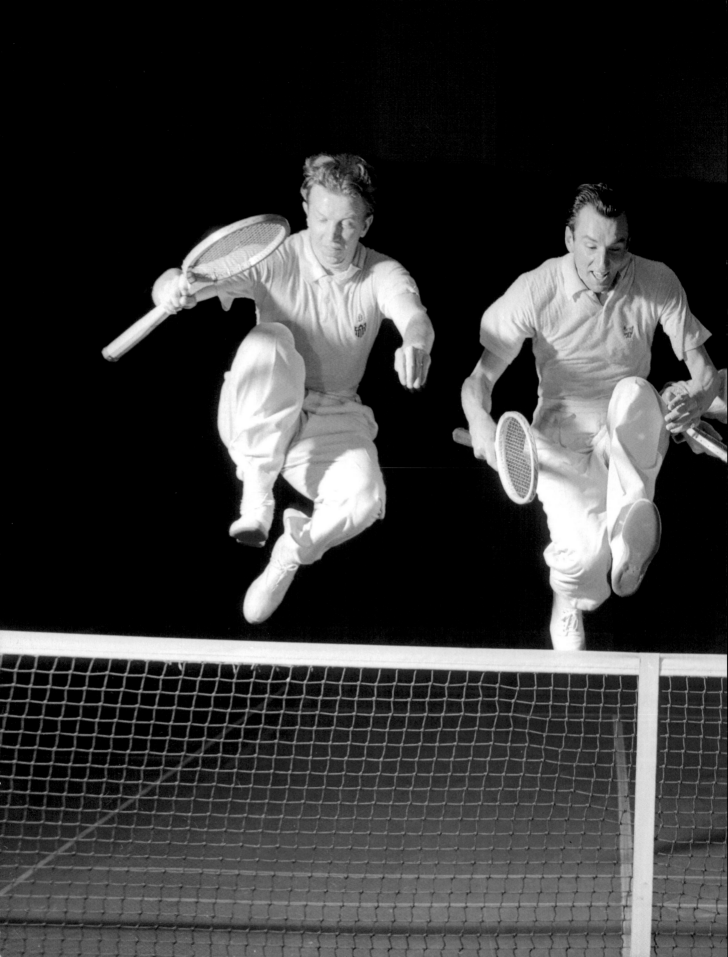

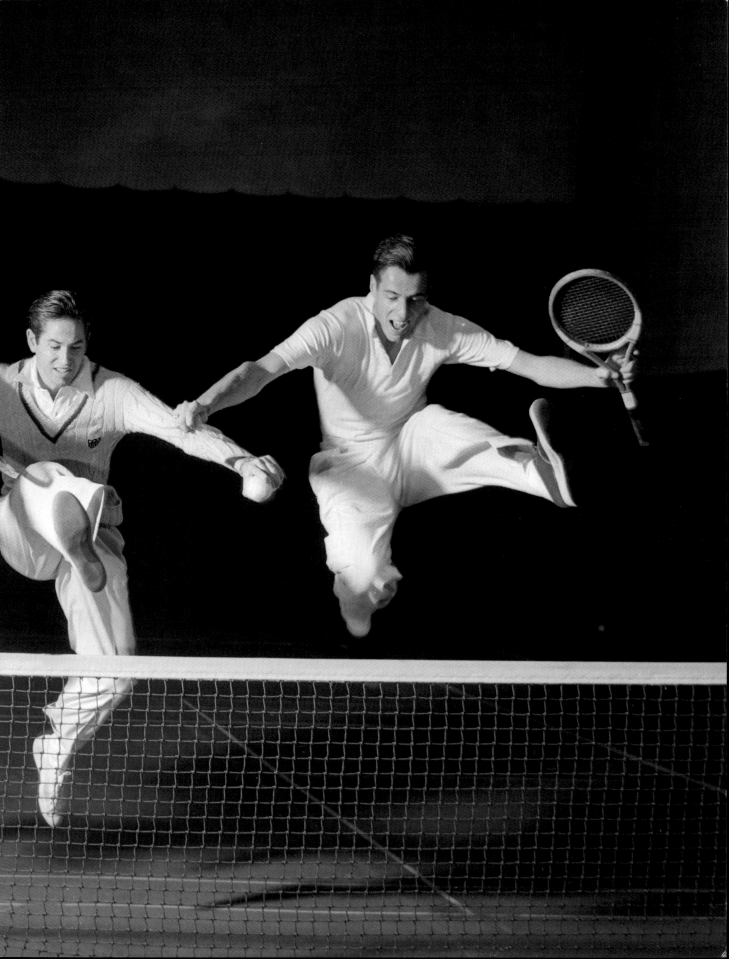

But it was not over. Borotra, looking perfectly fit alongside Brugnon, beat Lee and Pat Hughes in straight sets. On the third day, Cochet, who would be playing his last Davis Cup tie for France, used all his Gallic guile to outfox Austin in five tense sets.

So it all came down to Perry and the teenager. Perhaps it should have been rated as a no contest but for the fact that, as he admitted himself, Perry was feeling like "a wet sock that had been put through a wringer." For almost two sets, Merlin dampened Perry's skills by passing the Englishman as he tried to dominate from the net—never Perry's favorite position, especially on clay—and it seemed as if the youngster would take a two set to love lead when, having won the first 6–4, he twice reached set point in the second.

Given Perry's state of health, it seemed improbable that he would have had the stamina to recover from a two-set deficit. But he didn't have to, largely due to French honesty. On one of the set points, Perry went down Merlin's backhand side and saw his shot just catch the line. Despite yells of "Out!" from the crowd, the linesman correctly called the shot "Good!" Bedlam ensued. Whether on orders or from sheer panic, the good linesman had vanished the next time Perry looked over to his chair, but it could be said that he had left his mark. Perry recovered and got himself into the position of serving for the match and Cup at two sets to one up and 5–4 in the fourth.

Then, as he admitted, he got ahead of himself, pressed too hard in an effort to finish with a flourish and lost his serve. It is interesting that Perry, whose ego was as tall as the Eiffel Tower, took pains in his autobiography and, indeed, in stories he related to me when we commentated together at Wimbledon for BBC Radio many years later, to give full credit to his captain, Herbert Roper Barrett, for being able to get himself back on track.

At the changeover, waiting to serve for the Cup the second time, the veteran of the first Davis Cup tie ever

played in Boston thirty-three years earlier took his player by the elbow and said in those matter-of-fact tones that Englishman of a certain station are so good at: "Nice day . . . Big crowd . . . Look over there in that corner. Now there's a good-looking girl. I'll tell you what. Win this game, and I'll get you a date with her!"

Perry knew that his captain was just trying to lighten the moment but, as he admitted, "It certainly did the trick. It changed the whole picture for me. I wasn't straining any more. I held serve and won the match that brought the Cup back to Britain for the first time since 1912. After standing motionless for the national anthems, I managed to get myself back to the dressing room and passed out for the second time in three days, drained as before."

Perry had recovered sufficiently, however, by the time Cochet, holding no grudges, suggested that they hit the town that evening and take the Cup with them. For once, Fred was upstaged in the audacity stakes.

"We can't do that!" Perry replied as he and Cochet eyed the Davis Cup, sitting on its plinth in the lobby of the Crillon hotel after the official dinner.

"Oh, yes, we can!" Cochet replied mischievously. With the help of a couple of his pals, they lifted Rowland Rhodes's precious creation from its stand and hailed a cab. On one of the more exciting nights of its long life, the beautiful bowl found itself carried up the hill to Montmartre and back down to the Champs-Élysées, from one night club to the next, having champagne poured into its wide mouth at every stop. Perry, who barely drank, had an occasional sip, but most of the little party were quite tipsy by the time a pink dawn rose behind the Arc de Triomphe to witness Perry, Cochet, and their group weave their way across the Place de la Concorde toward the Crillon with a little band they had picked up along the way serenading their every step. If only someone had had a camera!

Oblivious to the night's activities, LTA officials woke up next morning and found nothing untoward on their way to breakfast. Dwight Davis's lovely bowl was back on its plinth, gleaming innocently.

By the time the British team had arrived in Dover after a rough channel crossing, a telegram was awaiting them from King George V. Such was the publicity the Davis Cup triumph had received, people gathered in their back gardens to wave at the train as it made its way to Victoria Station, where bedlam ensued. Perry and Austin were lifted onto supporters' shoulders as flash bulbs popped.

Despite some reservations from sections of a snobby upper class, Perry's stock soared with the British public when he defeated the reigning champion, Jack Crawford of Australia, in the 1934 Wimbledon final to become the first British champion since Arthur Gore in 1909. The victory could hardly have been more decisive (6–3, 6–0, 7–5), but, as an indication of what Perry had to put up with, the All England Club official who went into the dressing room to present the new champion with the club tie (singles winners automatically become members of the club) could not bring himself to hand it to Perry personally. Instead, he left

it draped over the bench near Perry's locker. Then, came the ultimate insult. Within earshot of Perry, the official turned to Crawford and said, "Bad luck, old man. Sorry the better man couldn't win."

Happily, the nation at large did not share this appalling attitude. Such was Perry's fame, the placards on the newspaper hoardings around Piccadilly Circus that evening acclaimed his triumph with just one word: "Fred."

Tennis fans had more to cheer shortly afterward, when Britain staged the Davis Cup Challenge Round at Wimbledon against the United States. A few days earlier, the Americans had defeated Australia in the Inter-Zone final on the number one court—Frank Shields beating Vivian McGrath in the final rubber—and they would now move to Centre Court for another showpiece encounter, as interest in the game of lawn tennis grew and grew.

Inevitably with Fred Perry, there was drama: he sprained his back while defeating Sidney Wood in the opening rubber of the Challenge Round. Britain's position seemed perilous when Lott and the newcomer Lester Stoefen kept the United States in the tie by beating Pat Hughes and Harry Lee in the doubles. Perry, who had difficulty getting up from the dinner table on the Friday night, was packed off to Hugh Dempster's surgery near Marble Arch the next morning. The manipulation on Perry's back worked. "I heard a couple of twangs like banjo string snapping," Perry joked afterwards. Dempster ordered Tom Whittaker to keep Perry warm until his match that afternoon. Accordingly, Perry was muffled in two large sweaters on the way back to the club despite it being a hot July day.

It was thought to be essential that Perry defeat Shields because Wood was considered favorite to beat Austin if it came down to a fifth rubber. Once again, the confident Englishman came up with the goods. Free of back pain, he defeated Shields 6–4, 4–6, 6–2, 15–13 in one of the longest Davis Cup matches played up to that time. The giant American fought to the end but, having saved two match points, Shields came in behind an approach shot at deuce and feinted right. Perry responded by pushing the ball to Shield's backhand side, beating the American's frantic dive. On the third match point, Shields charge the net again and gambled that, this time, Perry would go cross court. But Perry, with a classic double bluff that sent the crowd into hysterics, nudged the ball to the exact same spot on Shields's backhand side.

Always the good sport, Shields, who would have been Andre Agassi's grandfather-in-law had he lived that long, smiled at Perry as they shook hands at the net and said, "You son of a gun. Right in the same goddamn place!"

In 1935, the tennis world got its first real look at a long-legged red head from Oakland, California named Don Budge. After helping the US Davis Cup team work its way through the Inter-Zonal stages, Budge introduced himself to audiences at Wimbledon by beating Germany's Henner Henkel in the Zone Final. The tie had been decided in the Americans' favor before Budge played Baron Gottfried von Cramm in the last rubber. Budge won a long four setter, but far more pertinent duels lay ahead for these two talented players.

In the Challenge Round, Britain retained the Cup with a 5–0 whitewash that wasn't quite as simple as that score suggests. True, Perry proved too "clevah" for the young Budge, but Austin had to come back from two sets to one down before beating Allison 7–5 in the fifth while Hughes and his new partner, Raymond Tuckey, also needed five sets to beat Wilmer Allison and John Van Ryn.

In 1936, Australia decided to switch to the American Zone and, after receiving a walkover from Cuba, found itself playing the home nation in Philadelphia. Here, Budge stepped forward to leave his mark—albeit in a losing cause— by beating both Jack Crawford and Adrian Quist. But the new hope of American tennis could not quite manage a win in the doubles in partnership with Gene Mako, going down 6–4 in the fifth to Crawford and Quist.

The Australians then travelled to Wimbledon where they beat Germany despite McGrath having to deputize for the injured Quist. In the Challenge Round, a recovered Quist outplayed Bunny Austin in four sets in the first reverse singles to ensure that, once again, Perry would have to win it for Britain in the fifth rubber.

While waiting for the Quist–Austin match to finish, Perry found himself bombarded with all manner of well-meaning but needless advice from LTA officials, who insisted he needed to make a quick start against Crawford so that he could get on top early and get the match finished before darkness fell. Not for the first time, Perry became impatient with officialdom. "What time is it now?" Perry snapped. "5:45 pm?

Right. We'll be off court, finished, by 7:15 PM."

Once he got on court, Perry came in behind every shot, no matter how hard Crawford hit his returns, and rushed the experienced Aussie to a 6–2, 6–3, 6–3 defeat. The time factor became irrelevant but, in another sense, time had just run out for this remarkable player. Only Perry himself knew that he would soon be signing professional terms and would, therefore, never play on Centre Court again. With the place almost deserted, Perry handed Maskell his rackets and emerged from behind the green tarpaulin that shields the players' entrance to the famous arena and walked out to the edge of the baseline. He stood there for several minutes, as if surveying his kingdom before abdication. Maskell knew, instinctively, that Perry was saying goodbye.

After yet another six-day crossing on one of the Cunard Queens, Perry arrived in New York in time to win the US title for the third time in four years. Appropriately, it was Budge who fought through the other half of the draw to challenge him and only succumbed 10–8 in the fifth. A few weeks later, after losing in the final of the Pacific Southwest Championships at the Los Angeles Tennis Club, Perry turned pro and would soon be part owner of another equally famous club not so far away in Beverly Hills.

Perry loved the idea of mixing with the Hollywood elite and saw ownership of the Beverly Hills Tennis Club as a way to ensuring that he did so. He quickly persuaded Ellsworth Vines to be his partner in the venture. Soon, they could call upon a large contingent of mainly British actors like David Niv-

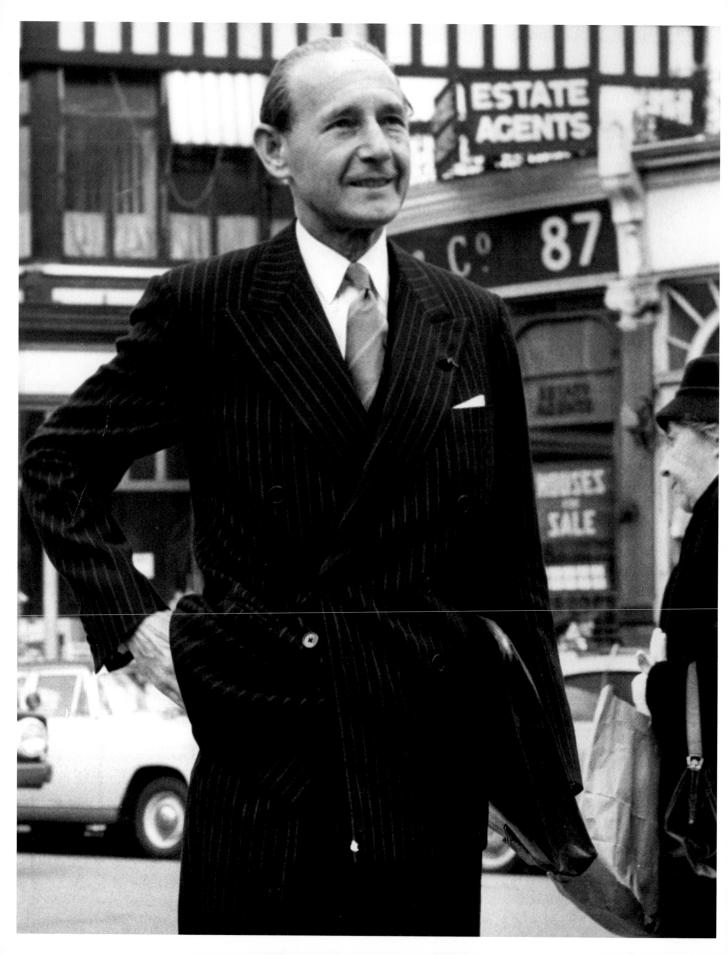

en, C. Aubrey Smith, Ronald Colman, and Charlie Chaplin as doubles partners. Groucho Marx and the swashbuckling Aussie Errol Flynn were also enthusiastic playing members. I have found no record of Charlie Chaplin playing Groucho Marx at tennis, but the mind boggles at the thought of it.

With Perry and Vines no longer there, the pathway to stardom in the amateur game was clear for Don Budge. Vines had been the young man's first hero but, as Marshall Jon Fisher chronicles in his fascinating book *A Terrible Splendor: Three Extraordinary Men, a World Poised for War, and the Greatest Tennis Match Ever Played*, that changed when a twenty-one-year-old Budge was invited to attend the third match of a nationwide tour between the new professionals, Vines and Perry, at the Chicago Arena on January 9, 1937. It proved to be a pivotal moment in Budge's development as a future champion. He had expected to see Vines blow Perry off the court with the power generated from the big wind up on the forehand, but was stunned at how Perry countered this onslaught.

While Vines waited for the ball to reach the apex of its bounce, or even start its descent, Perry was taking the ball on the rise "bounding about the court like a rabbit, taking the ball only six or eight inches off the floor."

Fisher quotes Budge as saying, "Before the match was over a new concept had begun to form in my mind: Suppose a man could hit the ball as hard as Vines and take it as early as Perry? Who could beat that man?"

Returning to work with his coach, Tom Stow, in Oakland, Budge started to inject aspects of Perry's game into his own. He practiced scooting around the court with quick steps and rushing the net. Taking the ball on the rise was at the core of his new strategy. He even started walking quicker between points. The makeover was completed when Budge chose to wear the same long whites as Perry: DAKS, which were made by Simpsons of London.

By the time Budge was ready to head off to Europe for the summer season, he worked with Stow for the last time. It had been Stow, a gruff, stern task master, who had been an inter-collegiate doubles champion, who had seen Budge's potential at a young age. Stow quickly got rid of the western grip on the forehand that Budge had been using on California's high-bouncing concrete courts. In those days, three of the four Grand Slams, and many other tournaments, were played on grass. Stow knew that Budge would need an eastern grip to deal with those slithering low bounces.

Having incorporated something of Perry's game into his own and worked hard on his skinny frame, Budge, in Stow's view, was now ready to become the number one player in the world. Stow instructed him to think of himself as exactly that. After their last work out, Stow told him, "I am convinced you are the best player in the world. Now you go out and prove that I'm right."

Budge did not fail his coach. Impressed by his form at the Queen's Club on the eve of Wimbledon, which Budge won without dropping a set, the committee seeded the young American number one for the Championships even though Gottfried von Cramm was ranked number one in the world. Again,

Budge proved them right. Sweeping past Australia's Vivian McGrath in the quarters and beating another rising American star, Frank Parker, in the semi-final, Budge found himself facing Von Cramm, who was appearing in his third straight Wimbledon final, having lost twice to Perry.

The contrast between the two could hardly have been more complete. The elegant, suave, German aristocrat and the slightly gawky working-class Californian. Unlike Perry, Budge was not pigeon-holed every time he opened his mouth because accents in America do not always classify one's social status. To a keen observer, like the great tennis writer Al Laney, the differences were obvious. "Whereas Cramm is all elegance," Laney wrote. "Budge represents an angular figure. It is strange that so great a player with so fine a game is yet so little graceful compared with the other great ones."

Elegance, however, did not win the 1937 Wimbledon final. Budge had the technique and the courage to put the quick-footed, early-strike style that he had perfected with Stow to good effect. Despite relinquishing his serve midway through the second set as Von Cramm tried to stem the Californian tide, Budge found himself serving at 6–3, 6–4, 5–2 for the Wimbledon crown.

Easy? Just ask anyone who has tried it. Years later, when Andy Murray found himself in a similar position against Novak Djokovic, he found that his arm was shaking uncontrollably. Budge, as quoted by Fisher, described how he felt: "Now I was literally shaking, drowning in my own sweat. The nearness of the possibility was beginning to overwhelm me."

But Budge didn't drown. On his fourth match point, his winning backhand volley made him Wimbledon champion, which, in those days, gave him the

unofficial title of number one player in the world. Back in Oakland, Tom Stow must have grunted with satisfaction.

But Budge's work was not finished. Later that day, he and Gene Mako defeated Cramm and Henkel in the doubles semi-final. Then, on the Saturday, Budge and Mako took the title by beating the British pair of Hughes and Tuckey. Finally, Budge appeared once again on Centre Court to win the mixed doubles alongside Alice Marble. In doing so, Budge had written himself into the history books by becoming Wimbledon's first triple champion.

Over the next two years, Budge would win everything that mattered, but few of his triumphs resonated as much as his historic duel in the fifth and deciding rubber against Von Cramm in the 1937 Inter-Zonal Davis Cup final at Wimbledon. Such was its lasting impact that Marshall John Fisher wrapped an entire book around it.

With Perry no longer available to the British, Budge knew that the United States had a great opportunity to reclaim the Davis Cup. He set about achieving it with relentless zeal. In the American Zone ties against Japan and Australia, Budge dropped just one set—to Australia's John Bromwich—in six rubbers of singles and doubles.

After Budge's Wimbledon triumph, US captain Walter Pate ensured that there would be no distractions for any of his team by renting a large flat overlooking the Thames just down the road from the exclusive Hurlingham Club. Restrictions on outside activities were severe: no movies, no theaters, and no nights out in the West End. After practice, the team of Budge, Mako,

Parker, and Bitsy Grant were allowed the thrill of an hour or two on the putting green at Hurlingham. Then, it was home for dinner. The only guest allowed to join them was Paul Lukas, a huge movie star at the time, who was a tennis fanatic.

As usual, the Inter Zonal final was to be played the week after Wimbledon. As anticipated, Germany, led by Von Cramm, who was living a freer existence at the Savoy, made it through the European Zone to play the Americans. The socially well-connected Von Cramm felt more at ease in London than in his home country, where Nazi restrictions were becoming more onerous not only for Jews but any group of people that Hitler found distasteful, including homosexuals.

But the Fuehrer's reach proved long. In a story recounted to me many times by Ted Tinling, who was in the locker room waiting to escort the players onto the Centre Court for the first Inter-Zonal rubber, Von Cramm was delayed—much to the punctilious Tinling's annoyance—by a call from Germany that was put through to the locker room. It was Hitler calling Von Cramm. Tinling watched as the Von Cramm's body stiffened. *"Ja, mein Fuehrer!"* he repeated several times as Hitler wished him luck.

It was unlikely that Von Cramm was inspired by the call, but that did not prevent him from giving Germany an excellent start by beating Grant—a surprise number two singles selection over Parker—in straight sets. Budge then returned the favor by dispatching Henkel, and the tie swung American's way when Mako, volleying brilliantly,

Ellsworth Vines, who followed Bill Tilden as America's next great tennis star, retired early to take up golf, a sport that didn't require him to leap quite so high. He played it, brilliantly, of course.

partnered Budge to victory over von Cramm and Henkel.

Grant could not prevent Henkel from levelling the tie in the first reverse singles in four sets, which set up the finale that all the neutrals in the crowd were anticipating so eagerly: a deciding rubber between Budge and Von Cramm. The Americans had plenty of support, however, not least from Paul Lukas, Jack Benny, and the combative newspaper columnist Ed Sullivan, who would go on to become a huge star as a television host. It was Sullivan who reacted with most anger when a tall, lean, familiar face was seen applauding Von Cramm winners from the German box. It was none other than Bill Tilden.

Possibly seeing it as some sort of payback for the way he had been treated by the USLTA, Tilden, who had always enjoyed playing in Berlin, had accepted an offer to coach the German team. Obviously, this left him open to charges of "turncoat." Sullivan expressed many people's feelings when, having spotted more extravagant applause from Tilden in support of Von Cramm, leaped to his feet and yelled, "Why, you dirty son of a bitch!"

Sullivan and the rest of America's support group had every reason to feel troubled as Von Cramm raced away to a two set to love lead before Budge's backhand started to make inroads on the German defenses. The tennis was exceptional, and a huge round of applause rang out as the two players left the court for the customary ten-minute break after Budge had won the third set.

Allison Danzig, the great tennis correspondent of the *New York Times*, was glowing in his praise when he wrote about this epic encounter later: "The brilliance of the tennis was almost unbelievable with the big preponderance of points being earned rather than won on errors. . . . Shots that would have stood out vividly in the average match were commonplace in the cascade of electrifying strokes that stemmed from the racquets of two superb fighters until the onlookers were fairly surfeited with brilliance."

The exceptional level was maintained when the players returned to the court with Budge, going for more and more winners off his backhand, dominated the fourth set. But that only in-

spired the dynamic German to raise his level yet again. Von Cramm led 4–1 in the deciding set to leave Captain Pate at a loss as to what to say next to Budge at the changeover. Patting his man on the back, Pate said, "Don, I think you can still win this match." Looking his captain in the eye, Budge replied, "Don't worry, Cap. I won't let you down. I'll win this one if it kills me!"

It didn't kill Budge because he was true to his word—charging the net behind do-or-die approach shots to level at 4–4 and break for a 7–6 lead. Fighting to last, Von Cramm saved five match points before succumbing 8–6. The effect that the result of this remarkable duel had on the two contestants was cruelly different. Budge became an even bigger star and enjoyed all the trappings that went with international fame. But, on returning from Australia, where he had been critical of the Nazi regime, Von Cramm was arrested on charges of improper conduct with a German Jew and imprisoned for a year. It is inconceivable that would have happened had Von Cramm won the match and brought glory to the Fatherland. He was everything Hitler admired—German, Aryan, and a sporting hero—but he had failed, and his ruthless Fuehrer vented his anger.

Of course, no one came to Von Cramm's rescue. There were even rumors that Henkel had informed on him during a meeting behind closed doors. After serving his sentence, Von Cramm returned to the tour in 1939 and entered the Queen's Club Champi-

Frank Shields turned to acting and had a role in Come and Get It, *a 1936 drama directed by Howard Hawks and William Wyler.*

onships, where he outplayed the young American Bobby Riggs 6–0, 6–1 in the semi-final. Riggs, a hugely cunning and talented player who would eventually make his name far beyond the confines of tennis by losing to Billie Jean King in "The Battle of the Sexes," won Wimbledon that year. In fact, he emulated Budge—a professional by then—by winning all three titles. But Von Cramm was not there. The All England Club, in one of its less glorious moments, had refused his entry. Once again, it took a player, rather than cow-towing amateur officials, to take a stand against tyranny. Furious at the treatment of his great rival, Don Budge cancelled a proposed engagement in Germany in 1938.

Von Cramm had only two French titles, which he won in 1934 and 1936, to show for a career and a talent that deserved more, but he will be remembered as much for his charm, honesty, and strength of character as his tennis. During the war, he was conscripted and fought on the Eastern Front until being discharged with frostbite in both legs. He remained in Berlin, making several trips to Stockholm, ostensibly to play tennis with the aging but still

active King Gustav. It became clear in Marie "Missie" Vassiltchikov's fine book *Berlin Diaries* that the good baron was involved in more than tennis. As the 1944 plot against Hitler developed, he was apparently involved with the conspirators and was almost certainly carrying messages to groups being formed in Scandanavia. Somehow, he managed to escape the purge that saw hundreds executed after the coup failed and went on to enjoy full reinstatement in the tennis world after the war, including being offered the captaincy of the German Davis Cup team. Tragically, he was killed in a car crash in Egypt in 1977.

Having deposed of Germany in the Inter-Zone final, the United States went on to regain the Davis Cup by beating Britain in the 1937 Challenge Round. With Perry absent, the British were, as Dan Maskell put it aptly, "like Hamlet without the Prince." Despite Austin getting the holders off to a good start by defeating Parker, Budge eventually crushed a debutant, Charles Hare, after battling through the first set 15–13. When Budge and Mako won the doubles, it was left to Parker to lay America's hands on the rose bowl by beating Hare in the fourth rubber in straight sets.

The Cup was on parade again a week later as the triumphant team was given a ticker tape welcome in New York after a comfortable crossing on the aptly named steamer *SS Manhattan*. The rose bowl had spent the journey nestled on the spare bed in Walter Pate's cabin.

Budge's year, however, was far from finished. Yet another meeting with Von Cramm awaited him after both had made their way through to the final in the US Championships. The German was making his first and last visit to the United States. He was refused a visa after the war as a result of his arrest on moral charges under the Nazi regime (so much for fighting a war for freedom). In the pre-war years, he was welcomed wherever he went and became a favorite at Forest Hills where he ran Budge much closer than in the Wimbledon final. He still could not get the better of his American rival, however, and went down 6–1 in the fifth.

In 1938, Budge achieved the first ever Grand Slam, a term reputedly borrowed from Bridge by Allison Danzig, to mark the feat of winning all four major titles: the Australian Open, French Open, Wimbledon, and the US Open in one calendar year. It was an extraordinary performance that has only been emulated by Rod Laver among male players, who did it twice in the sixties.

Even taking into account the fact that, in the thirties, three of the four Slams were played on grass and that the opposition, especially in Australia where the foreign entry was thin, was much weaker than it would become in the post-war years. The manner of Budge's clean sweep would rightly establish the Californian as one of the greatest players of all time.

Budge began by beating John Bromwich 6–4, 6–2, 6–1 in the Australian final; defeating the Czech Roderich Menzel 6–3, 6–2, 6–2 in the French Open final; humiliating Bunny Austin 6–1, 6–0, 6–3 in the Wimbledon final; and then completing the triumph by defeating his good friend Gene Mako in the US Open final at Forest Hills. Only there was he unable to win in

straight sets with Mako scrapping his way to an 8–6 win the in the second before losing 6–3, 6–8, 6–2, 6–1.

For a young man from a modest background, the urge to earn money was always a factor for Budge, who turned pro toward the end of 1938. He soon became World Professional Champion, winning several series of matches against both Vines and Perry. After serving in World War Two, he found little Bobby Riggs too quick and clever in their head-to-head tours and never dominated again. Budge spent the rest of his life coaching juniors in California and enjoying the accolades that came his way when he was invited to celebrity functions. In the sixties, Jack Kramer called him the best of all time for consistency, stating that Budge "had the perfect set of mechanics."

With sad irony, Budge's life, like Von Cramm's, ended as a result of an automobile accident. He died six weeks after crashing his car in the Pocono Mountains in eastern Pennsylvania at the age of eighty-four.

The great rivalry of the thirties in the women's game had carried over from the twenties, indeed, from the moment two young ladies named Helen were born. As Ted Tinling relates in his autobiography *Sixty Years in Tennis*, the coincidences were huge.

"The story of two young girls with the same first name, who were reared on the same street, were educated at the same school and college, were coached by the same man, who lived at different times in the same house and were both to become American and Wimbledon champions, is one of the strangest of all tennis sagas."

Tinling was referring, of course, to Helen Wills and Helen Jacobs. Most extraordinary of all, despite mixing in the tight little world of lawn tennis, Tinling insists they exchanged no more than a few dozen words their entire lives. They were rivals but not friends. Wills, extremely class-conscious, was only interested in meeting the "right" people—royalty, famous politicians, and top names in the arts world. She was a talented painter and exhibited her works on both coasts.

In contrast, Helen Jacobs was a friendly person, who was always anxious to please. She was innovative too, becoming the first woman player to take to the court in shorts. Jacobs ended up having a most distinguished record in World War Two. She rose to become a commander in naval intelligence—one of only five women to achieve that rank. She also wrote books about tennis as a well as a novel *Storm Against the Wind* in 1944.

In the big championships, Little Helen, as the press dubbed Jacobs, could never beat Wills. She lost to her once in the French Open final, once in the US Open final, and no less than four times in the Wimbledon final. Only on one occasion did Jacobs secure a win, but it was tainted by Wills's retiring with a back injury when trailing 0–3 in the final set of the US Open final in 1933. Wills was severely criticized for what appeared to be a deliberate attempt to deny Jacobs the satisfaction of a proper victory, but Tinling felt that the injury was genuine.

Inevitably, the press tried to build up the coldness that existed between the two Helens, but Jacobs always insisted there was no feud. They were just very different people.

In between a heavy social life with her husband, Freddie Moody, which

included ordering dresses from the top couture houses in Paris, Wills dominated major championships whenever she felt inclined to play. She won her first Wimbledon title as Mrs. Moody—her fourth overall at that stage—in 1930 and added others in 1932, 1933, 1935, and on her last appearance in 1938. She won her seventh US title in 1931. After the debacle against Jacobs in 1933, she never appeared at the US Championships again.

It was hardly surprising Helen Wills Moody was called "Miss Poker Face." She rarely showed any trace of emotion on her classical features. Tinling admitted to being stunned when he accompanied her back to the members' area immediately following her toughest victory over Jacobs in the 1935 Wimbledon final. She had needed to save match point at 3–5 in the third set before winning 6–3, 3–6, 7–5. Tinling shared: "I was fumbling for the key of the security door when to my amazement, Helen flung her arm around me and embraced me. 'Isn't it wonderful?' she said. This occasion as well as the match against Suzanne [Lenglen] in Cannes were the only times I ever saw Helen allow any outward show of emotion on that poker face."

Meanwhile, yet another tennis prodigy was growing up in northern California, honing her game on the public cement courts at Golden Gate Park, the San Francisco nursery of many a top player. Alice Marble's life was so far removed from that of either Helen—but Wills in particular—as to be laughable. One night, when she was fifteen, Marble was attacked and raped on her way home from the courts. Surviving that, she moved in with the strict teaching pro called Eleanor "Teach" Tennant, who raised her game to such a level that she was able to win the US Championships in 1936 and go on to claim the Wimbledon crown in 1939.

By then, Marble's life had taken many a twist. She was always welcome at William Randolph Hearst's California mansion, where she became good friends with Clark Gable and Carole Lombard. Soon, she was taking lovers of both sexes. Drama was never far from her life and, just days after suffering a miscarriage, her husband, a US Air Force fighter pilot, was killed in World War Two. Soon after, Marble was recruited by the Office of Strategic Services (OSS), the wartime forerunner of the CIA, and became a spy. Her life's script continued to outdo any Hollywood melodrama when she was sent to Switzerland to take up with a former lover who just happened to be a millionaire banker that was helping the Nazis with stolen riches. It was not an easy assignment. Marble was shot by a Nazi agent, rescued by the OSS, and returned to the tennis world once the war was over. Although her title winning days were over, she was still in-

Had it not been for the sudden and tragically brief appearance of Maureen Connolly in 1951 to 54, Louise Brough (left) and Doris Hart (right) would have dominated the women's game after World War Two. Considered one of the greatest women volleyers, Brough, who grew up on the Roxbury Park courts at Beverly Hills, California, won Wimbledon three years in a row from 1948 to 1950. Alongside Margaret Osborne duPont (who won Wimbledon singles in 1947), she added four doubles titles. Brough won nine straight US Open doubles with Osborne duPont from 1942 to 50. This remarkable pair added three more titles from 1955 to 57. Doris Hart won Wimbledon in 1951, and the US title at Forest Hills in 1954 and 1955.

volved in the game and played a crucial part in helping Althea Gibson become accepted in the lily-white world of amateur tennis. After Gibson started winning all the black-only tournaments in the United States in the early fifties but was still denied entry to the US Championships at Forest Hills, Marble wrote a stinging letter to the USLTA criticizing their attitude toward race relations and shaming them into finally allowing the tall, athletic black woman to play in the US Championships. After knowing

what it felt like to be chased by Nazis, she probably felt it was the least she could do.

As they would say in Hollywood, Alice Marble was quite a gal.

Footnote:
Two Australians who won their national championships, Vivian McGrath (1937) and John Bromwich (1939 and 1946) in this era became the first players of top caliber to use a two-handed backhand. McGrath, in fact, was double-handed on both flanks.

5

The Forties & Fifties

When hostilities finally broke out between Nazi Germany and Britain in the autumn of 1939, sport all over the world was deeply affected. Tennis at the highest level almost came to a standstill. Between 1940 and 1945, only six Grand Slam championships were played. The US Championships continued uninterrupted at Forest Hills, albeit with virtually no non-American players, while Down Under, the Australians did manage to hold their Championships in 1940 before joining Wimbledon and Roland Garros in closing down until 1946.

Don McNeill, who had beaten Bobby Riggs in the final of Roland Garros in 1939 in straight sets, had to work harder against the scrappy baseliner at Forest Hills in 1940, beating Riggs 7–5 in the fifth. Riggs reclaimed the US title that he had won in 1939 by beating Frank Kovacs in the 1941 final.

After losing to Ted Schroeder in 1942, Frank Parker emerged as a leading force in American tennis by beating Bill Talbert in two successive finals in 1944 and 1945—a prelude to his success in Paris a few years later when his steady back court skills enabled him to win successive French crowns in 1948 and 1949 against illustrious opponents—first, Budge Patty and then Jaroslav Drobný.

The 1943 US Championships final will be remembered for its bizarre ending: Joe Hunt won the title while prone on the ground with a cramp as Jack Kramer put his shot long. Kramer, who was just starting to make his mark with his exceptional power and athleticism, was on leave from the US Coast Guard. He went on to become one of the major figures in tennis history, more as a promoter and developer of the professional game than as a player, which is saying something because Big Jake was an incredible player.

Fate had something very different in store for the handsome and hugely popular Joe Hunt. A graduate of the Naval Academy at Annapolis, Hunt was a versatile athlete who was given the game ball after the Army–Navy game in 1940 for his powerful display as a running back. Hunt served on US aircraft carriers as a Navy pilot for a year in the Pacific and a year in the Atlantic. He was just fifteen days short of his twenty-sixth birthday when, on a routine training flight off the coast of Florida in February 1945, the engine on his Grumman Hellcat failed. He was killed as it plunged into the ocean. Like Roland Garros, who was shot down right at the end of World War One, Hunt had failed to survive his war by a matter of weeks.

Neither of Europe's two great tennis stadiums emerged from the conflict unscathed. On October 11, 1940, a bomb

(top) *Mrs. Ernest Bevin, wife of the British foreign secretary, presents cups to Bobby Riggs and Alice Marble, doubles winners in the Indoor Tournament at Empire Pool, Wembley, London, in June 1947. In the background are Mary Hardwick and Don Budge.*

(bottom) *USAF fighter pilot Joe Hunt beat Jack Kramer to win the 1943 US Championships final before being killed in the last weeks of World War Two. Bobby Riggs is on the right.*

(opposite) *Resplendent in his letterman's sweater, US Davis Cup star Vic Seixas beat Denmark's unseeded Kurt Nielsen to win Wimbledon in 1953.*

destroyed a corner of the Wimbledon's Centre Court—one of sixteen bombs that fell on the club, all told. The stiff British upper lip prevailed, however, and, as John Barrett describes in his Wimbledon history, the club kept functioning under the watchful eye of acting-secretary Norah Cleather, despite the fact that all but four of its staff had been called to active service. One of the car parks was ploughed up to grow vegetables. Pigs, ducks, geese, and rabbits were housed in temporary wooden homes, and the main concourse was used as a parade ground by the East Surrey Regiment. Occasionally, there were tennis tournaments, too,

Dan Maskell, the club's head professional before the war, went on to distinguish himself while working at an Royal Air Force (RAF) Hospital in Torquay and later at the RAF Rehabilitation Centre at Loughborough. He rose to the rank of squadron leader and was awarded the Order of the British Empire (OBE) by King George VI for his work in rehabilitating the wounded.

In Paris, Stade Roland Garros suffered a more sinister fate. Although some tournaments were held there at the start of the war, the occupying German forces eventually used it as a staging post for Jews who were to be sent to the gas chambers. Despite this horror that still haunts people's memories, French tennis recovered quickly and managed to put a smile on the faces of the Parisian crowds as Marcel Bernard beat Czech Jaroslav Drobný in a classic five-set clay court duel to win the title in 1946.

A few weeks later, another Frenchman, the giant Yvon Petra, won a five setter in the Wimbledon final over the double-handed Australian Geoff E. Brown. Despite the appearance of Cédric Pioline in the 1997 final, which he lost to Pete Sampras, no Frenchman has won Wimbledon since.

The fact that Petra emerged as the winner put a hold on the well-laid plans of Jack Kramer. Feeling that he had the game to win the title, Kramer envisaged using the prestige of being Wimbledon champion to create his own professional tour in partnership with Bobby Riggs. But the wily left-handed Drobný upset Kramer over five long sets in the fourth round.

"So, kid, that sort of put my plans back twelve months!" said Kramer, laughing when we reminisced about his remarkable career. "Had to go back in 1947 and make sure I won the darn thing!"

Kramer did just that, breezing past Tom Brown 6–1, 6–3, 6–2 in the final after dropping only one set—to Australia's Dinny Pails—in the entire tournament. Returning home, Kramer had to work a little harder to retain his US crown, but eventually he did so by roaring back from a two-set deficit to beat Frank Parker 4–6, 2–6, 6–1, 6–0, 6–3 in the US Championships final.

Only then did Kramer feel he had acquired enough fame and prestige to make a go of it as a professional. Teaming up with Riggs, the pair began playing matches against an aging Don Budge and the young firebrand Pancho Gonzalez, whom Kramer had signed soon after the Mexican-American won his second consecutive US Championships title in 1949. It was only after Riggs dropped out of the partnership that the Kramer Tour, as it became known, really got going.

From the early fifties, world tennis became divided into two entities until

the advent of Open Tennis in 1968. The traditional game continued and blossomed to a limited degree through the Grand Slam Championships and some riveting Davis Cup ties, while Kramer used all his promotional skills to keep the pro game alive.

This was easier in some parts of the world than others and, throughout, the cynics questioned the legitimacy of their matches. From personal experience, having been in their locker rooms at the old Madison Square Garden and at Wembley in London, where the Kramer tour played every winter, I can attest to the fact that almost all their matches were totally legitimate. The champions that Kramer signed were mostly first-degree champions and that breed of human being hates to lose almost more than he or she loves to win.

There was an occasion, when little Ken Rosewall—all five feet eight inches of him—had been signed up and was due to play the six feet three inches Gonzalez on a head-to-head tour in Australia, when Kramer, who was usually so sure of his own judgment, started to panic at the thought of how one-sided the duel might be and suggested that Gonzalez ease up a little. As it turned out, he didn't have to worry because Rosewall's incredible ability on the return of serve ensured that most matches were very competitive.

An incident recorded in the autobiography Gonzalez wrote with Cy Rice in 1959 gives an accurate picture of the standards that Kramer demanded from his pros. In the very early days, Kramer, still a formidable force on court himself, took a twenty-one-year-old Gonzalez on a head-to-head tour of the United States and

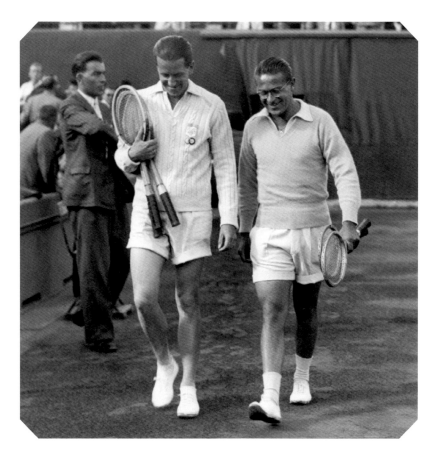

Marcel Bernard, who would go on to win 6-3 in the fifth, and the soon-to-be exiled Czech Jaroslav Drobný, walk out to play the first post-war French Championship final at Roland Garros in 1946. Later, Bernard was president of the French Federation.

started off winning all the matches with embarrassing ease.

Just before a match in Chicago, an acquaintance of Kramer, trying to offer some advice, suggested Kramer let Gonzalez win a few games. Gonzalez, who was within ear shot, saw Kramer stiffen.

"What do you mean?" asked Kramer.

"You know, toss Pancho a few matches," the man replied. "Keep the match score closer. You'll draw bigger crowds."

"The only thing I'll toss on this tour is you, if you don't get out of here" was Kramer's furious reply.

Then turning to Gonzalez, Kramer went on to say, "Now let me tell you something. I don't care if we lose money every night. I'll never let down one single point against you or anybody else on any tour. The public pays their money, and they're going to see me at my best. And you too."

That was Kramer's Code and, if on occasion financial circumstanc-

(top) *Bobby Riggs and Jack Kramer plot the birth of the Kramer pro tour in the late 1940s.*

(opposite) *On one of her rare visits to Wimbledon, Her Majesty Queen Elizabeth presents Lew Hoad with a trophy on the Centre Court in 1957.*

es forced a little fudging around the edges, it was very rare. Anyone disputing that should have witnessed the scene at Madison Square Garden when Kramer staged his last big promotion in the mid-sixties. Gonzalez had just lost—to Rosewall, I think it was—and was livid that some idiot had hitched strobe lighting, which flashed every time a photographer took picture, to the first-row balcony of the old Garden on Eighth Avenue and 48th Street.

"Those goddamn idiots!" Gonzalez roared as he returned to the locker room. "I was blinded half the time!"

Then, he proceeded to start zinging his rackets around the room. As they bounced off walls and tables, Ken Rosewall was under the massage table and Pierre Barthès was hiding behind the shower curtain. For a few seconds, the place was a war zone. Gonzalez had lost, and he hated the feeling with every fiber of his being.

Kramer's tactics during the fifties infuriated the amateur establishment—in particular, the Australian Tennis

Federation, where a tough little coach named Harry Hopman was churning out champions like a production line at Holden Motors. Frank Sedgman, a pigeon-toed speedster with a crunching volley, won Wimbledon in 1952 with a four-set victory over Jaroslav Drobný to whom he had lost in the French final a few weeks before.

After much wrangling and soul searching, Sedgman signed professional forms with Kramer in a Melbourne café, turning a deaf ear to the howls of anguish from Australian tennis fans, who wanted him to go on winning Davis Cups for them along with his fine doubles partner Ken McGregor, who also turned pro.

In fact, they needn't have worried in the short term because a couple of amazing teenagers, the powerful blond Lew Hoad and the little, dark-haired wizard Ken Rosewall were ready to step forward and continue Australia's dominance of the amateur game. Before they also succumbed to the logical lure of being able to make an honest living, Hoad and Rosewall had participated in two of the most dramatic and well-attended Davis Cup Challenge Rounds ever seen.

In 1953, Coach Hopman had little option but to throw the Sydney Twins into the cauldron of a Challenge Round in Melbourne. With Sedgman and McGregor no longer available, Hoad and Rosewall were clearly the best players he had in his stable despite their tender years. Both were eighteen years old.

The powerfully built Tony Trabert and the skillful Vic Seixas were not only several years older but also had been

battled hardened through the Zonal Rounds. A 4–1 win over Belgium in a Zonal final played on grass at Brisbane's Milton Courts took the United States into a Challenge Round that would draw 17,500 people at Kooyong Lawn Tennis Club after extra stands had been built. Those locked out were not to be denied. Trams run on Glenferrie Road alongside the club. Risking electrocution, one driver climbed onto the roof of his cab so that he could peer over the wall and relay the score of Hoad and Seixas to his passengers. Those of us who have commentated on the game all over the world can certainly not claim to have done so from such a perilous

position. I think the local phrase would be "Good on ya, mate!"

There were rather more pertinent accolades for Lew Hoad. Showing not the slightest sign of nerves, Hoad powered his returns so flat and hard back over the net that Seixas was forever lunging for his volleys, stretched and beaten. The score was stunning: 6–4, 6–2, 6–3. More predictably, Australia's lead was short-lived. Trabert took full advantage of Rosewall's weakness on the serve and leveled the tie with and equally one-sided score of 6–3, 6–4, 6–4.

There was some disagreement in the Australian camp as to who should partner Hoad in the doubles. Given the

A great athlete, with smooth, deadly strokes, Pancho Gonzalez won two US Championships titles at Forest Hills in 1948 and 1949, but was forced to turn pro with Jack Kramer's tour before he had the chance to win Wimbledon. He needed the money.

captain's growing stature in the game, it was surprising that Hopman did not have the final say in team selection. His desire to throw Rosewall back into the fray was overruled by the LTAA selection committee. They felt Ken, with his quiet demeanor, would not have recovered from the disappointment of a crushing defeat and opted for Rex Hartwig, a farmer's son who had not played with Hoad much, primarily because they were both right court players. Although they were to win Wimbledon together two years later, their inexperience as a team at this stage of their careers proved too big a handicap. The United States moved ahead 2–1 as Trabert and Seixas dominated the doubles 6–2, 6–4, 6–4.

Up to that point, the matches had been one-sided, but that was soon to change. Hoad and Trabert, who would become lifelong friends, set about each other in blistering fashion on the third day. Lew had saved no less than eleven break points by the time he finally got Trabert break point down at 11–12 in the first set. Showing court craft and racket skill, Hoad changed the direction of his volley at the last minute after he had rushed forward behind a chipped return and put the ball out of Trabert's reach.

The momentum was with the young Aussie, and that only increased as light rain started to fall. Trabert asked for permission to wear spikes on the slick grass; however, it started to affect his movement, and he lost the second set 6–3. The rain became so heavy that the budding Melbourne tennis writer Alan Trengove, who would spend a lifetime chronicling the game, found his notebook became saturated. It was hardly surprising that Hoad also decided to ask for spikes, despite the fact that he had never practiced in them. A beautifully balanced athlete, Hoad now found himself somewhat hobbled and could not prevent Trabert from sending the duel into the fifth set by winning the fourth 6–3.

The crew cut American was now just one set away from claiming the Cup. Trabert seemed well placed to do so as he started holding serve with greater ease than his opponent. The crowd, damp but enthralled, drew a gasp of breath as their man went sprawling and lay inert. Hopman rushed on the court with a towel, which he threw over Hoad's head, as soon as he realized his man was not hurt.

"Come on Musclebound!" the captain joked. "You can't lie there forever!"

Hoad looked up with that crinkly eyed grin of his, climbed to his feet, and began playing with greater freedom. The moment had relaxed him, and he started to regain some of his earlier rhythm. Then, a string broke. Again, Hopman played his captain's part, telling the eighteen-year-old, "The dry and tighter strings will give you an advantage on a wet court." It was true. Hoad got more accuracy on his shots and, serving first, moved ahead 6–5. A dipping topspin return put Trabert in trouble at 0–30. A double fault followed, and Hoad dealt with the first of three match points by moving in and forcing the American to half volley. The ball landed in the net, and the crowd were delirious. "Give him a knighthood, Bob!" someone yelled, addressing Prime Minister Robert Menzies, who was in the stands.

Hyperbole was inevitable because the contest had gripped the nation, but Rosewall, with his shy grin and black hair parted as neatly as any mother would wish, suddenly started getting telegrams from all over the country. One read "Australian mothers are behind you!" Most importantly, perhaps, Rosewall's own mother was flown down from Sydney after the rain had forced play into a fourth day. Gerald

Patterson, who understood the pressures of Davis Cup play, had persuaded the International Tennis Federation to pay for her airfare.

Her son made Mrs. Rosewall's journey worthwhile. Showing a maturity way beyond his years, little Kenny put the thrashing that he had received from Trabert behind him and proceeded to outplay Seixas 6–2, 2–6, 6–3, 6–4. The American was the victim of some dubious line calls in the third set, but it was the pinpoint accuracy of Rosewall's backhand returns and his neat volleying that made it a performance to remember.

Two teenagers from the Sydney suburbs had enabled Australia to hold on to one of the world's most prestigious sporting trophies. Quite apart from

(top left) *One night I asked Lew Hoad over a beer at his Campo de Tenis what had been the most difficult stroke he had ever had to handle. "Segoo's double-handed forehand," he shot back without hesitation. Pancho Segura, the small Ecuadorian, born in poverty and suffering from rickets, emerged as one of great players and characters of his generation. No one knew how his bandy legs carried across the court so fast, but everyone wanted his opinion on the game. Coach to Jimmy Connors, Segura was one of the greatest analysts tennis has known.*

(top right) *Madison Square Garden in the 1950s.*

(bottom) *Gonzalez was soon making plenty of money by the time he played Ken Rosewall at the old Madison Square Garden on Eighth Avenue and 48th Street in 1957.*

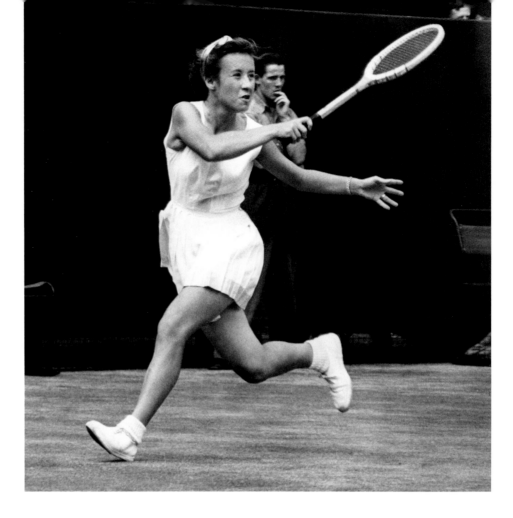

their personal achievements, Hoad and Rosewall injected yet more fervor for tennis in the minds of a sport-obsessed nation. They remained friends but were never close, especially as Hoad and his growing family bought a farmhouse near Mijas on the Costa del Sol in Spain and turned it into a magical little tennis club.

Fate also dealt them very different hands. Hoad, who spent many years coaching Spain's Davis Cup team, contracted leukemia in the 1990s and died at the age of fifty-nine. Rosewall, at the age of eighty-five, saw in a new decade in 2020. In January, he was still sprightly enough to put on a pair of shorts and hit some balls under the roof of the big stadium at the Sydney Olympic Park Tennis Centre that bears his name.

Partially because of political disruption, which contributed to the fact that he never won Wimbledon, and partially because of his small stature and shy demeanor, Ken Rosewall tends to be underestimated when talk turns to the greatest players of all time. But his place in that pantheon should be unquestioned. His achievements at Roland Garros alone should make that clear. At the age of eighteen, prior to the Davis Cup triumph, he beat Vic Seixas at the height of his powers with shocking ease 6–3, 6–3, 1–6, 6–2 in the French Championships final and then teamed up with his mate Lew to win the doubles for good measure. All of fifteen years later, Rosewall returned to reclaim his crown at the first French Open, beating Laver in the final. In

1973, at the age of thirty-nine, he appeared in his fourth Wimbledon final, losing to a rampant Jimmy Connors. In addition, Rosewall won four Australian and two US titles before and after the advent of Open Tennis. To this day, his peers and those who watched him in his prime still drool at the thought of that exquisite backhand.

With one victory—in the final of the US Championships in 1956—Rosewall left a major imprint on the way tennis history is written. Had he not won that match, Lew Hoad would have achieved the Grand Slam. At the start of the second decade of the twenty-first century, Don Budge and Rod Laver, twice, remain the only male players to have managed that seemingly impossible task.

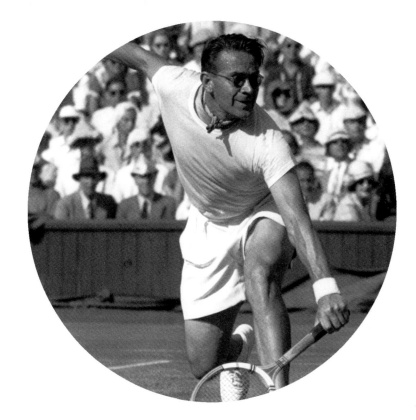

Hoad had begun by beating Rosewall 7–5 in the fourth set of the Australian final and then famously winning at Roland Garros with a 6–4, 8–6, 6–3 defeat of the talented Swede Sven Davidson. In the Wimbledon final, it was Rosewall once again. Hoad again emerged the winner in four sets. The stage was set for a repeat performance at Forest Hills. Hoad seemed well on his way to the Grand Slam when he won the first set 6–4. Two to go and, had Lew not relaxed or let his concentration slip a little, his name would have been forever etched in the pantheon of the game as one of the three greatest players of all time. But nothing should be taken away from Rosewall, who started hoisting lobs as Hoad charged in and, returning with his usual accuracy, turned the match around, reeling off the next three sets 6–2, 6–3, 6–3.

Knowing Lew, he probably went off and had a few beers and forgot about it. He was not one to seek fame and

adulation and, with the game receiving far less media attention that it does today, not much fuss was made of the fact that this extraordinary player had come within touching distance of such an elusive target.

The manner in which Lew Hoad won the French title over Sven Davidson became part of the game's folkore. Having won the doubles final with Ken Rosewall late on the Friday night, Hoad and his wife Jenny went off in search of dinner near the Champs-Élysées. Around midnight, they fell into the company of some Russian diplomats, who were eating at the next table. Vodka started to flow, toasts were made, and the Russians persuaded their new friends to retire to their apartment where the vodka was on tap. Time passed, and it was just before 6:00 AM that Lew and his wife made it back to their hotel.

"I lay down, but the ceiling was spinning," Hoad recounted. "So I put on a track suit and ran to Roland Garros."

The stadium was not exactly adjacent, but Hoad made it before the gates were opened. He trotted around the Bois de Boulogne for a while and, on gaining entry, tried some breakfast but threw up. Eyeing a little red-headed Aussie sitting shyly in the corner of the locker room, he asked Rod Laver to give him a hit. "But I was seeing three balls, so I decided to lie down for a bit of a kip."

Breakfast stayed down at the second time of asking, and only one ball came into view when he got Laver back on court. After a shower and a gulp of coffee, Lew emerged blinking into the sunlight of the Centre Court and proceeded to win the title in straight sets. For the average mortal, as a means of preparing oneself for a Grand Slam final, it is not recommended.

Rosewall succumbed to Kramer's dollars before the year was out, but Hoad hung on to help Australia win another Davis Cup Challenge Round against the United States in 1957, after retaining his Wimbledon crown with a blistering victory over Ashley Cooper, Hopman's next protégé, for the loss of just five games. The verdict among his peers was that, on his day, fully focused and free of the back pain that would haunt his career from there on in, Hoad was the greatest player anyone had known to that date. Possessor of every stroke in the book and a few no one had ever seen, this blond young man from Sydney backed his talent with a body strength that even Olympic weight lifter Stan Nicholes, whom Hopman hired as his Davis Cup trainer, found awesome.

Lew Hoad was the prize Kramer was waiting for as it gave him the chance to send the still raw but hugely talented Australian off on a 100-match tour

against Gonzalez. With his Adonis looks and casual Aussie charm, Hoad was a superstar in the making. He proved it by winning eighteen of the first twenty-seven matches that they played. Realizing he was finally facing someone who could take his title of the world number one professional away from him, Gonzalez started doing some serious work on his backhand and turned it around, winning forty-two of the next sixty meetings, as the pair hit city after city across America.

They drove between venues, playing on surfaces that were often no more than tarpaulins stretched across basketball courts in high school gyms. Long hours in a car did nothing to help the back problem that was beginning to restrict Hoad's mobility. (As any sufferer knows, backs act up on some days and

not on others.) The problem became chronic, and it affected Hoad for the rest of his career.

Hoad and Gonzalez started off hating each other, but the sentiment soon turned into mutual respect. Whenever I had a conversation with Gonzalez in later life, I found him talking about Hoad within a matter of minutes. "That Lew was a tough son of a bitch," he would say with a grin spreading across his face. "But, damn, he was a good player."

Hoad was the only player, one suspected, that Gonzalez ever truly respected.

To the consternation of the amateur Federations, Kramer continued to sign up Grand Slam champions—Mal Anderson, the next Australian on the Hopman conveyer belt after Rosewall had turned pro in 1956, won the US title in 1957. The following year another

(opposite, top) *Dinner time at Aix-en-Provence in 1969. Joy Emerson, on the left, sits next to her husband Roy and opposite her mother Mavis Auld. Eduardo Sarmiento, who ran the Caracas tournament at the Alatamira Club at the time, is on Mrs Auld's right and Mal Anderson on her left. Standing at the back, from left to right, 1967 Roland Garros Champion Francoise Dürr, Carolyn Barthès, and her husband Pierre Barthès. Photo by Lili Wollerner.*

(opposite, bottom left) *A hearty Aussie handshake from Rod Laver, who had just lost his first Wimbledon final to Peru's mercurial Alex Olmedo in 1959.*

(opposite, bottom right) *1957 Wimbledon ticket.*

(above) *Having won Grand Slam doubles titles with other partners, southpaw Neale Fraser and Lew Hoad teamed up to beat Mal Anderson and Ashley Cooper at the Australian Championships in 1957.*

(above) *Paris at night was a playground for the tennis players in the 1960s, with lack of sleep not apparently of any hindrance to performance. Fred Stolle, however, once needed a friend to provide Alka-Seltzer before a doubles final after a night on the town.*

(below) *The Aussies of the 1950 and 1960s were a popular bunch—none more so than Mal "Country" Anderson, the Queenslander who won the US title at Forest Hills in 1957.*

(opposite) *Stepping off another flight like a couple of film stars, Lew Hoad and his wife Jenny were married at St. Mary's Church next to the All England Club in 1957, with Rex Hartwig as best man.*

Queenslander, Ashley Cooper, won both Wimbledon and the US Championships. Kramer signed Cooper as well. In 1959, he was ready to grab Alex Olmedo after the fleet-footed Peruvian won Wimbledon, denuding still further the talent in the amateur ranks.

The process continued into the sixties—Rod Laver was next—and, as we shall see, eventually led, after huge arguments and much bitterness, to the advent of Open Tennis in 1968.

6

The Sixties

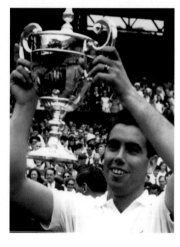

(top) *Hotel Scribe, opposite the Paris Opera, where a lunch between Jean Borotra, French Federation president at the time, and Jack Kramer failed to create the breakthrough for Open Tennis. The game had to wait another five years for sanity to prevail.*

(bottom) *Manuel Santana holds aloft the Wimbledon Cup, creating a new era for Spanish tennis. This former ball boy showed how tennis, previously a sport confined to country clubs, could be a game for everyone.*

(opposite) *"You'd be having a nice rally, and suddenly you realized Kenny was at the net," said WCT pro Marty Riessen, describing just one of the problems of playing Ken Rosewall.*

The decade began with a feeling of a sport marking time—unable to break free of its restrictive, prejudiced past and unsure of its future. The amateur leaders, which included the presidents of most of the national federations, were fearful of what the much-discussed possibility of Open Tennis might mean, while Jack Kramer—his touring pros and all those progressive thinkers who realized that the status quo would mean stagnation—were urging change.

To be fair, there was no shortage of delegates among those attending the International Tennis Federation AGM (Annual General Meeting) in Paris in 1960, who felt the time for change had come. A two-thirds majority was required to pass a motion favoring a move toward Open Tennis, but if anyone required proof that the game needed a touch of professional organization, the motion failed because three delegates failed to vote. One was in the toilet, one fell asleep, and one was absent arranging the evening's dinner entertainment on the *bateaux mouches*. The three culprits may have paid better attention had they realized that, in holding back this move toward progress for eight long years, they had simply deprived Pancho Gonzalez and Ken Rosewall of their best chances of ever winning Wimbledon—which neither did. One can only surmise how many more Grand Slam titles Lew Hoad and Rod Laver would

have won, but one thing is clear: the game's record books are distorted as a result of carelessness and stupidity.

One could not accuse Kramer of failing to try in his attempt to break the deadlock. He knew that Jean Borotra, who had become president of the French Federation, was at least partially sympathetic to the idea of bringing the pros and amateurs together. On a visit to Paris a couple of years later, he accepted Borotra's invitation to lunch at the Hotel Scribe, which sits next to the Paris Opera House. Despite listening to everything Kramer had to say and agreeing with much of it, Borotra admitted that he simply did not have enough support to push for such revolutionary ideas. The game's arias remained in discord.

So amateur tennis continued on its less-than-transparent way with more and more under-the-counter payments leading to the use of a new word: *shamateurism*. It soon became rife. By the time Roy Emerson had won Wimbledon twice in 1963 and 1964, and Manuel Santana had become the first Spaniard to win at the All England Club in 1966, these two champions had come to an agreement. They would remain "amateur" and charge tournaments a $500 appearance fee on top of expenses—not a great sum by today's standards, but enough to make them a little bit of money if they kept on dominating the amateur game.

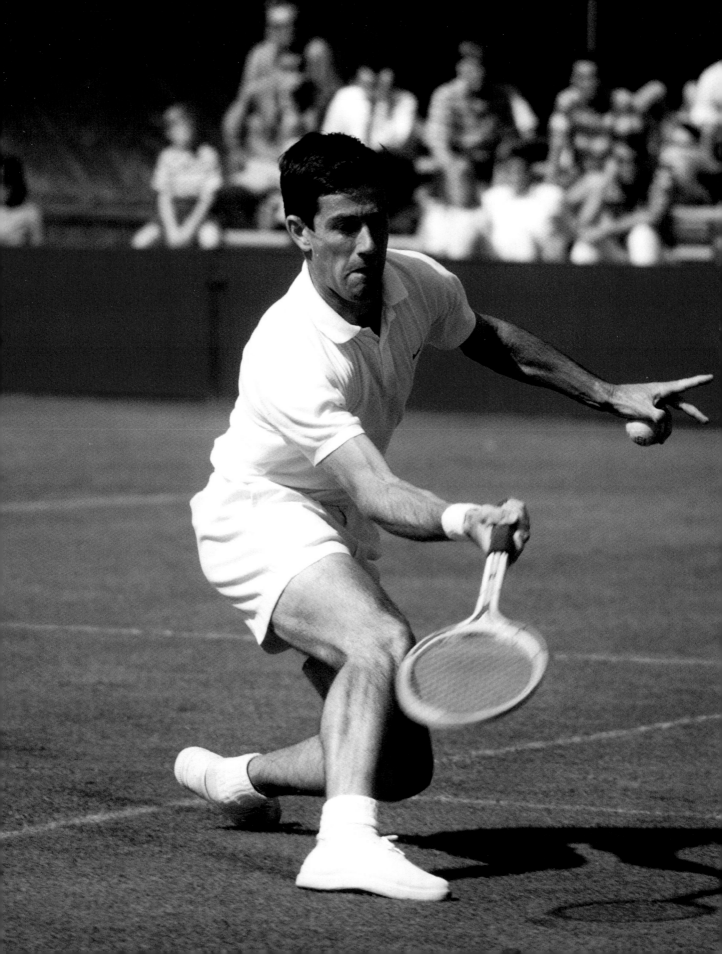

(above) *The New Yorker cover of June 25, 1960. A good value for 25 cents!*

(opposite) *The always chic Nicola Pietrangeli, his wife Susanna, and the little clay court wizard Beppe Merlo were well equipped for a rain shower at the Foro Italico.*

Other amateurs went about it in a more explicit way. The Italian star Nicola Pietrangeli accepted money from his own Federation to remain amateur, which was ironic as its president, Giorgio de Stefani, was one of the fiercest critics of the professional game and publicly railed against Britain's LTA when it promoted the idea of Open Tennis. Evidently, hypocrisy was not a word de Stefani understood in any language.

Meanwhile, Kramer had handed over the running of the tour to the Wimbledon and Roland Garros champion Tony Trabert. Kramer loved making money, but he loved the game of tennis more. He had come to realize that his own notoriety could be standing in the way of progress, because amateur officials resented the way he kept picking off their best players.

Trabert based himself in Paris and became close friends with a young official at the French Federation named Philippe Chatrier. A former Davis Cup captain, Chatrier was a visionary who was as frustrated as the pros at not being able to end the game's de facto apartheid. After helping Marcel Bernard, the first post-war Roland Garros champion, to succeed Borotra as president and so become his stalking horse, Chatrier went to work on the presidents of all the district leagues. He was elected Federation president himself when Bernard willingly stepped down three years later. That left Chatrier free to champion the concept of Open Tennis in France before setting about the expansion and modernization of Roland Garros. Later, he would become president of the International Federation.

By 1967, outside entrepreneurs were starting to realize the opportunities that professional tennis offered. George MacCall, a former US Davis Cup captain, formed his own pro troupe, which included Rosewall, Emerson, and Fred Stolle, while Lamar Hunt, who was already owner of the Kansas City Chiefs football team, bought out Dave Dixon, who had brought the concept to him, and formed World Championship Tennis.

After making a few inquiries, Hunt took a gamble on Mike Davies, the former British number one player and member of Kramer's tour, as his first CEO. It was a shrewd choice because Davies had a creative mind. Suddenly backed by Hunt's oil money, Davies immediately put into practice what he had been contemplating for years.

The concept was three groups of thirty-two players, who were evenly divided as far as skill levels were concerned, touring the world, earning World Championship Tennis (WCT) points as well as money so that, by November, there would be a top eight, who would compete in the WCT finals in Dallas. But Davies needed time to get the tournaments lined up. To keep the pot boiling, he formed what became known as "The Handsome Eight," a group of players comprising John Newcombe, Tony Roche, Cliff Drysdale, Butch Buchholz, Dennis Ralston, Pierre Barthès,

Roger Taylor, and Niki Pilić to tour as a single entity.

They began on a carpet court laid over an ice rink next to the stockyards in Kansas City. If that proved to be a less than auspicious beginning, Davies's ideas certainly caught the headlines. He wanted yellow balls, colored clothing, and ninety seconds at changeovers, so that television could fit in commercials. For a young Welshman who had left school in Swansea at the age of fifteen, he was not doing badly, rubbing shoulders with oil millionaires whenever Lamar Hunt took him to lunch.

"I said very little, and they thought I was intelligent," said Davies, who was always able to laugh at himself. But soon it was the players and tennis fans who were laughing hardest. The players were earning more money than Kramer had been able to offer. Most of the tournaments, with the Dallas finals as a shining show piece, were presenting the sport at levels of glamor and efficiency that it had never seen before.

By this time, the amateur game was descending into chaos. Two British LTA officials—Derek Hardwick, who was to precede Chatrier as president of the ITF, and his cohort Derek Penman—took themselves off on a world tour in an attempt to try and persuade other associations that Open Tennis was inevitable.

By the time they arrived in San Diego, California, from Australia, the USLTA president, Judge Robert Kelleher, was in the thick of an arm-twisting exercise with his own delegates. Many of them didn't have a clue about the importance of the issues at hand. Kelleher needed all his political skill to

shepherd them in the right direction. Tall, distinguished, and as articulate as his Harvard legal training would suggest, Kelleher was firmly of the opinion that the time for pussyfooting around the subject of Open Tennis was long gone. However, he knew that his vast and diverse body of delegates might not be ready to embrace the revolutionary path that Britain was advocating.

He quickly hid Hardwick and Penman away in a downtown hotel when they arrived so that he could continue the educational work he had embarked on at the landmark Hotel del Coronado by the Pacific shore.

Kelleher even sent his staff out around the city to buy up every copy of *Sports Illustrated* because he was rightly afraid that some people might take umbrage at an interview that he had given Bud Collins a few weeks before. In it, Kelleher had suggested he had only taken on the presidency "to stop it going to one of those backward old goats." As he was about to ask some of those backward old goats for their vote, he went to some pains to avoid offending them.

Eventually, when he felt enough people were getting the message, he let Hardwick and Penman loose on the meeting; the Brits did not mince words. Penman, an upright, patrician figure, used much the same language he had unleashed at the LTA meeting in England a month before.

"For too long now, we have been governed by a set of amateur rules that are quite unenforceable," Penman said. "We know that the so-called amateur players bargain for payments grossly in excess of what they are entitled to, but without which they cannot live. We know the tournament committees connive at this, else there would be no players at their tournaments. We feel we owe it not only to ourselves but to our players to release them from this humiliating and hypocritical situation, and that the players should be able to earn openly and honestly the rewards to which their skill entitles them."

Put so eloquently, even ill-informed and reactionary delegates found it difficult to suggest that it was not time for change. But there was still some puce-faced spluttering. It took a final salvo from Kelleher himself to get the reaction that he wanted.

Pounding at the core of a resolution that empowered him to break away from the International Federation,

(opposite) *Ilse Buding, whose sister Eda also played tennis for Germany, arrives at Wimbledon with her husband Mike Davies, who was then the British number one player and, later, CEO of Lamar Hunt's World Championship Tennis.*

(top) *Before launching the full World Championship Tennis tour out of Dallas in 1967, CEO Mike Davies gathered a troupe of pros who came to be known as "The Handsome Eight." Thirty years later, time had treated them reasonably well as they gathered for a reunion at the tournament on Key Biscayne that one of their number, the visionary Butch Buchholz, had created. Back row: Dennis Ralston, Roger Talyor, Tony Roche, Pierre Barthès. Front: John Newcome, Niki Pilić, Buchholz and Cliff Drysdale.*

(bottom) *Slazenger Victory tennis balls.*

the judge delivered a final salvo: "This isn't an empty threat, nor is it merely a vote saying we favor open tournaments. Our resolution directs me to say to the ILTF, 'You have failed to promulgate and enforce realistic and practical amateur rules. Therefore, the time has come to take away from the ILTF all but small responsibilities.'"

If this left some people choking, they were in a minority. Although rejecting a second resolution calling for the complete abolition of the distinction between amateurs and professionals, Kelleher won an historic victory by getting the main resolution passed by sixteen sections to one—a total of 102,064 votes to 9,978. Open Tennis

Toast & Marmalade

As Mike Davies relates in his book *Tennis Rebel*, there had been a time when he was sleeping on his brother's floor at a tiny flat in London and existing largely on toast and marmalade. He was so undernourished that he had to borrow some money to send a friend in search of a sandwich when he started feeling faint before one of his matches. In the 1950s, British players almost literally had no money.

(top) Tennis Rebel *(London: Stanley Paul, 1962).*
(bottom) *World Championship Tennis logo.*

(above top) *Eugene L. Scott, one of Yale's greatest athletes, Forest Hill semi-finalist, founder of* Tennis Week, *and widely considered to be the conscience of the game, chats with another great advocate for tennis sanity, Judge Robert Kelleher, in Las Vegas in 1995.* (above bottom) *The historic Hotel del Coronado in San Diego, where in 1967, at Judge Kelleher's urging, the USLTA voted to bring in Open Tennis.* (opposite) *Leaping the net after winning Wimbledon seems to have gone out of fashion, but John Newcombe was pretty good at it.*

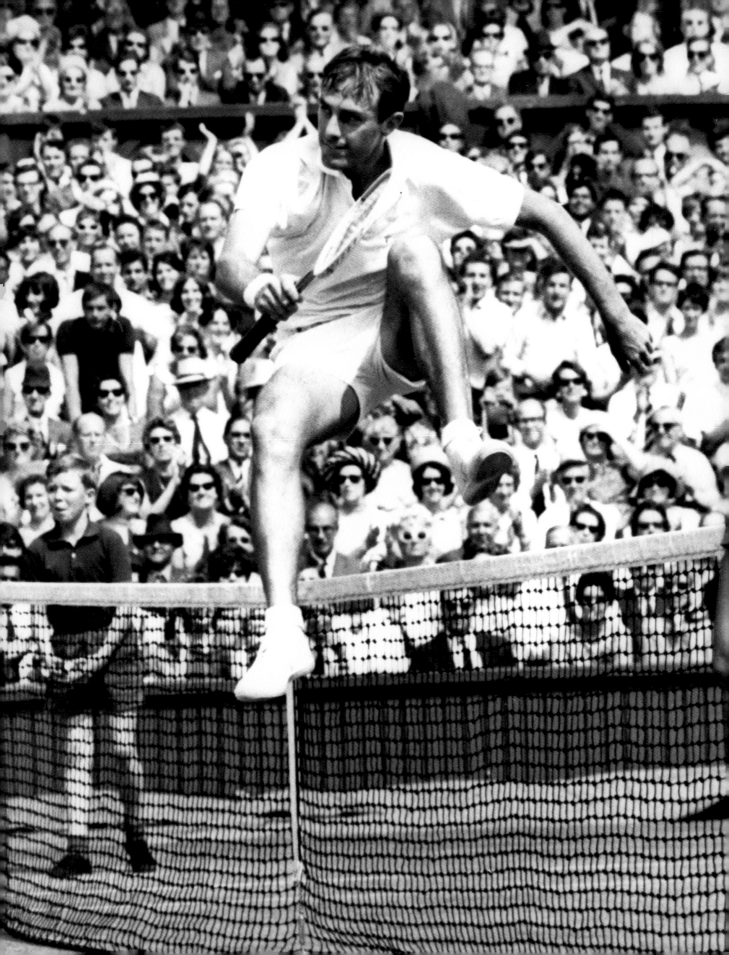

was not a fait accompli, but with two powerhouses like the United States and Britain advocating it so strongly, the ILTF meeting, which was held in Paris in March 1968, did not need students on the streets (which actually occurred for other reasons just a matter of weeks later) to reach a compromise.

Although Hardwick and Penman poured scorn on the idea to start with, a creature called an "authorized player" was created. This meant that associations could nominate players they felt worthy of accepting prize money and who would still be able to play in the Davis Cup. Those players opting to become fully fledged professionals would not.

Hardwick put out an official LTA statement that read, "The authorized player is the quintessence of hypocrisy. It is no cure for *shamateurism*, and we shall still get players who are not authorized but are still receiving money under the table."

Of course, Hardwick was right and the authorized player, an anachronism at birth, died after a short and useless life a couple of years later. However, a resolution was finally passed at an

emergency meeting of the ILTF in Paris on March 30, 1968, to accept the basic concept of Open Tennis, and the sport was never the same again.

Meanwhile, Herman David, another enlightened leader, was making sure that the reactionaries had nowhere to go by announcing that the 1968 All England Club Championships, of which he was chairman, would be open to any player of sufficient ranking and talent who wished to compete. The dam had burst. Wimbledon remains the world's most prestigious tournament; however, in those days, it stood head and shoulders above the rest, and all the opponents to Open Tennis knew the game was up. If Wimbledon was to go Open, the rest would follow.

Herman David had laid the groundwork for this historic decision the summer before. In 1967, he discovered from Bryan Cowgill, head of sport for BBC Television, that the corporation was ready to produce its first live, outdoor, color broadcast. David saw it as an opportunity to put into practice an idea that had been formulating in his mind for some time.

"If I get eight of the world's top pros to play a tournament on the Centre Court in August, will you cover it?" David asked Cowgill. The idea fitted both party's needs, and the deal was done.

Herman David was a little nervous as to whether his controversial event would draw a crowd. He needn't have worried. Hoad, Gonzalez, Rosewall, and Laver might have been lost to the world's major championships for years, but they had not been forgotten. The Centre Court sold out, the standard of tennis was brilliant, Rod Laver won, and Herman David had his answer.

That's what the tennis public wanted, and ten months later, that was what he would give them.

No longer plagued with the thought that he was offering up a second-class event, David welcomed every great male player in the world to the All England Club in 1968. The atmosphere it created was like a class reunion. There were smiles and backslaps and much reminiscing as the whole tennis world came together for a happy celebration. And Rod Laver won. It took the left-handed Queenslander less than an hour to beat his fellow Australian Tony Roche in the final as the great Grand Slammer returned to reclaim the crown that he had held in 1961 and 1962 before he had turned pro.

Wimbledon was not the first Open tournament. That honor fell to the traditional British Hard Court Champi-

(opposite, left) A backhand that probably didn't come back: Tony Trabert was a powerful presence in the amateur and professional game, on and off the court. Having won Roland Garros in 1954 and 1955 as an amateur, he returned Paris in the 1960s to take over the running of the Jack Kramer Pro Tour.

(opposite, right) Winning titles or telling jokes, Fred Stolle's Aussie humor kept everyone amused. The French and US champion went on to become one of the game's most incisive commentators, mostly with ESPN.

(above) The great Richard "Pancho" Gonzalez, also known as "Gorgo" to his colleagues on the Kramer tour—some of whom were terrified of him—did not always trust the stringers to handle his rackets, so he strung them himself.

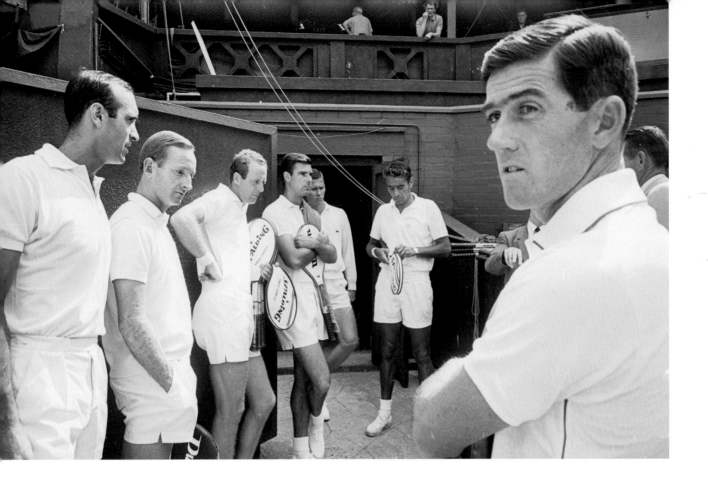

(above) *Waiting to go on Centre Court for Herman David's experimental Professional event at Wimbledon in August 1967. Left to right: Andrés Gimeno, Rod Laver, Fred Stolle, Butch Buchholz, Dennis Ralston, Pancho Gonzalez, and Ken Rosewall. They were probably waiting for the eighth member of the draw, Lew Hoad.*

(opposite, top left) *The Pro event staged at Wimbledon in 1967 was the BBC's first-ever live outside broadcast in color. It was watched on sets that looked like this.*

(opposite, top right) *In 1966, Roy Emerson, right, was odds on favorite to win his third straight Wimbledon crown; however, he chased a wide ball, skidded on slippery grass, and crashed into the umpire's chair, injuring his shoulder. Barely able to serve, he went on to lose to fellow Aussie Owen Davidson, a great doubles player, who reached his only Grand Slam singles semi-final as a result.*

onships, which were held at the West Hants Club in Bournemouth every spring. They weren't actually played on a hard court but on shale—Britain's version of red clay, a tricky slippery surface that took a little getting used to. Seizing on that advantage, the British Davis Cup player Mark Cox beat thirty-nine-year-old Pancho Gonzalez to become the first amateur to beat a pro in tournament competition. Then, using his big left-handed game to good effect, Cox beat Roy Emerson before losing to Ken Rosewall in the semi-final. Rosewall then went on to win the first ever Open title with a victory over Laver. His reward: $2,400.

To settle any Trivial Pursuit question anyone might have, the first ever victory in an Open tournament came in the first round at Bournemouth, when Owen Davidson, an exceptional

doubles player but also a Wimbledon singles semi-finalist, defeated Britain's John Clifton on April 22, 1968.

All through the sixties, the amateur game had been doing its best to maintain the standards required to do justice to its great traditional events. There is no doubt that some significant performers grabbed the opportunities presented by absent stars. At Roland Garros, a young man who would change the perception of tennis in his country emerged in 1961 to beat Nicola Pietrangeli, the defending champion, in a five-set duel of beauty and skill. Manuel Santana was the son of a groundskeeper at a club in Madrid. With his fine first serve and lethal forehand, Santana would go on to win a second French title in 1964; demonstrate his versatility by winning at Forest Hills against Cliff Drysdale

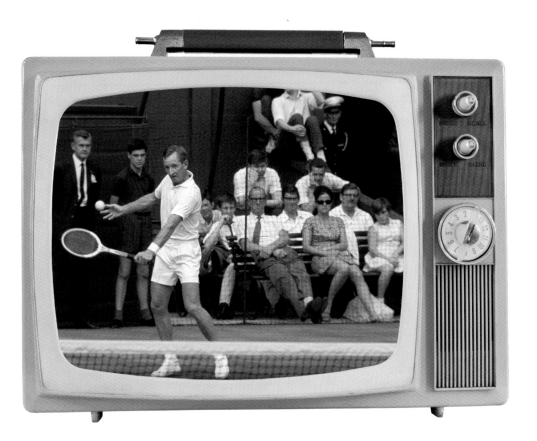

(above) *Manuel Santana beat Davidson in the semi-final 7-5 in the fifth set and went on to defeat Dennis Ralston of the United States (above) in the final.*

on grass in 1965; and then, the following year, become the first Spaniard to win Wimbledon, when he outplayed Dennis Ralston in the final.

That latter victory opened the floodgates for tennis in Spain. Everyone had heard of Wimbledon. When Santana returned home to be embraced by the country's leader, Francisco Franco, in front of tens of thousands of people in Madrid, the idea that tennis was an exclusive sport reserved for the aristocracy no longer applied. Manuel Orantes, José Higueras, Carlos Moyá, Juan-Carlos Ferrero, Albert Costa, and Rafael Nadal know who they have to thank.

Santana's victory in New York ended a seven-year run of domination by Australians at Forest Hills. Ken Rosewall had begun it with that victory over Lew Hoad in 1956. He was followed by Malcolm Anderson, Ashley Cooper, Neale Fraser, who won in 1959 and 1960; and Roy Emerson and Rod Laver, who completed his first Grand Slam by winning in 1962.

It was the delightful Mexican Rafael Osuna who broke the Aussie chain of success the following year by beating the unseeded American Frank Froehling in the final. Osuna, a small, light-footed, mercurial volleyer, who always tugged at a gold chain that hung from his neck between points as he skipped back to the baseline, remains the greatest player his country has ever produced. Tragically, he was killed in an air crash in Mexico in 1969 at the age of thirty.

The Australians did their best to dominate Wimbledon during this decade that spanned the arrival of Open tennis. Laver, with victories in 1961 and 1962, and then again in 1968 and 1969, was, of course, the stand-out

(opposite) *Rod Laver clutches the Wimbledon Cup in 1969, the year he won his second and most demanding Grand Slam. Unlike the first in 1962, all the world's best players provided his competition as Open Tennis had arrived the year before. "The Rocket," as this native of Rockhampton, Queensland became known, beat John Newcombe in the final. As of 2020, no man has emulated Laver's feat (shared with Don Budge) of winning all four Slam titles in a calendar year.*

(top) *The charming and wonderfully talented Mexican Rafael Osuna is escorted off court after winning the US Championships title at Forest Hills in 1963, after defeating America's Frank Froehling.*

(bottom) *Having lost to Ashley Cooper in the 1958 Wimbledon final, Neale Fraser finally got his hands on the Cup two years later by beating a young Rod Laver. "Frase" went on to devote his tennis life to the Davis Cup, captaining Australia for an even longer period than Harry Hopman.*

performer, but Fraser, who was also a left hander, had won in 1960. In 1967, John Newcombe emerged as the leading member of Harry Hopman's last generation of Aussie superstars by serving and volleying the German Wilhelm Bungert off court in the final 6¬3, 6-1, 6-1.

There was some brilliant tennis played through the sixties, but it only got better once a few brave and enlightened souls won the battle for Open Tennis and sent the game off on the road to the glory and riches that we know today.

7 The Seventies

Open Tennis was becoming an accepted fact as the seventies dawned, but few insiders doubted that troubled times lay ahead. Lamar Hunt, with millions at his disposal, was now a major player in the sport with his World Championship Tennis group, and Jack Kramer was soon to make a reappearance as a leading force in the battles that would follow.

On the other side of a battered fence stood Allan Heyman, the president of the International Tennis Federation, a Danish lawyer whose underestimation of player power would ruin his legacy. Heyman was a bright and personable man, but he happened to come up against a moment in the history of the sport when tennis had some exceptional young men performing at the top of the game. When they put their minds together and backed their intellect with a champion's need to succeed, there was only going to be one winner.

Amid all the backroom bickering, it should be noted that tennis was about to explode in the United States. Television was at the core of its sudden popularity, with Boston's public broadcasting station WGBH-TV being the first to make a serious attempt to give the game proper coverage. With the inimitable Bud Collins as its cheerleader in the commentary box, and the innovative and ebullient Greg Harney in the producer's hut, tennis fans could suddenly see their heroes in action.

The US Open also signed an important contract with CBS, one that was to last for decades with Pat Summerall and Tony Trabert as the on-air voices. But it was NBC, with Dick Auerbach producing, that lit the fuse with its coverage of two unforgettable WCT Finals in Dallas. Ken Rosewall, the ageless spoiler who had prevented his mate Lew Hoad from winning the Grand Slam back in 1956 by winning the Forest Hills final from a set down, was at it again in 1971 and 1972, as he defeated another pal, Rod Laver, in both Dallas Finals. The first was pretty good, but it was the second that lives more powerfully in the memory, with Laver standing two points from victory at 5–4 in the fifth set tie-break with two serves to come.

I described what happened next in *Open Tennis*:

The crowd in Moody Coliseum waited breathlessly for the end. Laver fans shouted encouragement. The air was thick with tension. Rod needed just two good serves for the $50,000, the diamond ring, the gold cup, the Lincoln Continental and, probably most of all to Laver, the pride and the glory. It was, after all the only title worth talking about that had eluded him.

Two good serves might have been good enough against most players but not against Kenneth R. Rosewall. Moving into a solid first delivery, Ken swept his cross-court return off that incredible backhand, way down to Laver's forehand side. Rod saw it coming, as he had seen thousands of them coming off Rosewall's racket in the past, and from the moment Kenny hit it, he must have known it was hopeless. He streaked after it, a blue-clad blur

(above) *With his informed wit and wisdom, Bud Collins began promoting tennis as a Boston Globe columnist and WGBH TV commentator (later with NBC). Here, at Indian Wells, it's the Breakfast with Bud Show, with Coachella Valley's Aussie resident Mark Woodforde.*

(opposite) *Knowing his back had gone, Tom Gorman's gesture of defaulting from match point up in the semi-final of the Barcelona ATP Masters finals in 1972 against Stan Smith rightly earned the future Davis Cup captain a sportsmanship bonus. That put Smith into the final, where he lost to Ilie Năstase.*

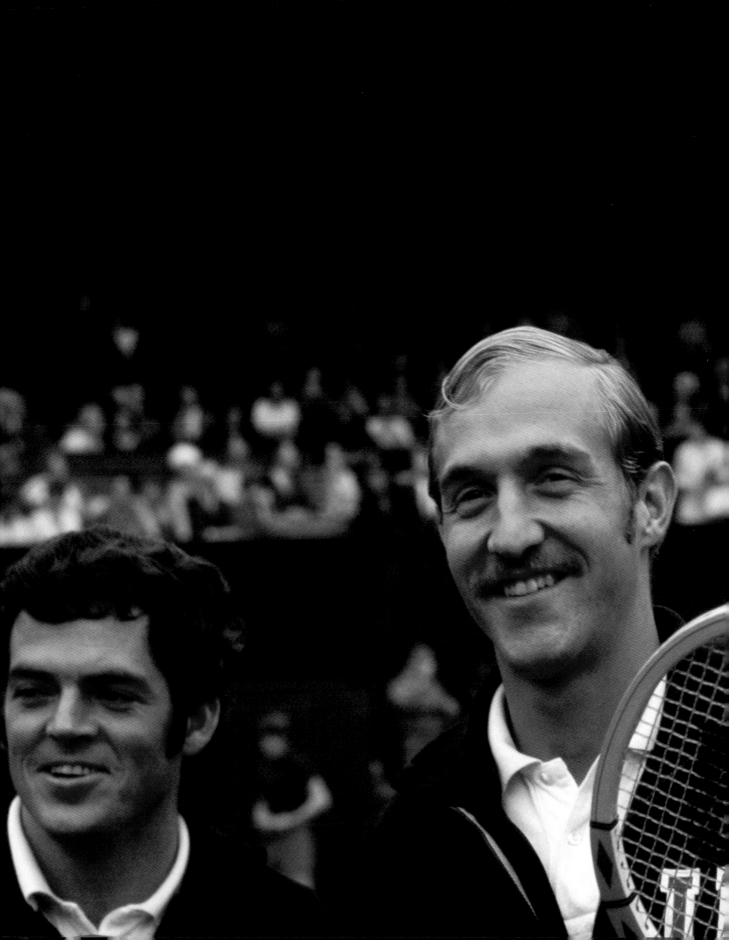

LIFE

He topped the tennis world

THE ICY ELEGANCE OF ARTHUR ASHE

SEPTEMBER 20 · 1968 · 40¢

(left) *Getting a cover of* Life Magazine *was a big deal, especially so for the advancement of African American sport, which Arthur Ashe did so much to enhance by beating Tom Okker to win the first US Open at Forest Hills in 1968. Following Althea Gibson's trailblazing, Ashe became the first male black player to win a Grand Slam title.*

(right) *A reflective John Newcombe.*

topped with streaming copper-colored hair, and thrust his racket towards the ball as it flashed towards the carpet. But he couldn't control the volley and it sailed out of court. Five all.

Again Laver attacked Rosewall's lethal backhand ("I would serve there again if I had to do the whole thing over," he insisted afterwards) and cracked in a good first serve and again the legendary stroke did everything its master asked of it. Taking the ball on the rise, Rosewall hit it straight and true for an outright winner. Laver, stranded in midcourt, could do nothing but stand and watch. At 6-5, Rosewall was back at match point (he

had hit a lob long on a previous match point at 5-4 in the fifth) and the end came almost before the crowd could grasp what had happened. Ken served, Rod blooped a return into the net and the WCT Champion, a master of his craft, had retained his crown.

"Tennis was the real winner today," said Mike Davies, growing into his role as CEO of WCT. "That was the greatest match I have ever seen."

No one was about to argue. More importantly, it had been a sporting encounter that had turned a good little slice of the American public onto tennis. They knew about the growling splendor of Pancho Gonzalez, and they were starting to warm to the elegance of Arthur Ashe, but these two little Aussies, with their quiet, sporting demeanor and mesmerizing skills, lifted interest in the game to a new level. Tennis became a fad. Middle-class households of varying social stripes all across America from the suburbs of Atlanta and little Randolph, New Jersey, to Florida's opulent Boca Raton began organizing their weekends around tennis parties. Leagues were created, rivalries established, and, to prove the new level of awareness, Rod Laver started getting recognized at airports.

Later in the decade, when a young blond Swede called Bjorn Borg began winning Wimbledon, people could be seen walking down New York's Fifth Avenue in his Fila gear, racket bag over their shoulder, whether they were off to actually play tennis or not.

Had there been a greater awareness and cohesion among the game's leaders at that time, the fad might have grown deeper roots, but America's attention span had never been long. Without teams to support and meaningful colors to wear, the sporting focus drifted back to football, basketball, and ice hockey. People started leaving their rackets in the cupboard.

Adding to the fact was that the game of tennis was far too splintered to be cohesive about anything. Despite the fact that Lamar Hunt signed a short-lived agreement with Heyman and the ILTF in early 1972, threats to a unified front kept on coming. When Billie Jean King and her husband Larry invented World Team Tennis in 1974, the establishment was rocked to its core. But two events of even greater significance had taken place before that bombshell hit the tennis scene.

The first was the formation of the Association of Tennis Professionals (ATP) in September 1972, and the second was the fledgling organization's boycott of Wimbledon the following year.

There had been various attempts to form a player's association since the breakup of the Kramer tour. Over drinks at Jacky O's discotheque off the Via Veneto in Rome one night in 1970, John Newcombe and Charlie Pasarell were enjoying a late-night scotch and the view of Roman beauties gyrating on the dance floor. They started talking about how great life was and how much greater it could become if their profession could be safeguarded by a proper players' organization.

By the time the tour moved onto Bristol in England, Pasarell, never a man to let a vision turn into a mirage (the Grand Champions Resort and then the Indian Wells Tennis Garden in the Californian desert stand as proof of that) had gone to work and, with Newcombe as chairman and himself as secretary, had formed the International Tennis Players Association (ITPA). If it had survived, the ATP tour everyone enjoys today would have been called the ITPA.

There was a maverick character in the game at the time, named Bill Riordan, whose brother incidentally would

(left) *Spain's Manuel Orantes, a gifted left-handed stylist who beat Jimmy Connors in straight sets after a sleepless night in 1975 to win his only Grand Slam title at the US Open.*

(right) *Jan Kodeš, a powerful base line hitter, won back to back French Opens, as well as Wimbledon in the ATP boycott year of 1973. Unfairly, critics put an asterisk against that win, but the Czech proved his grass court pedigree by reaching the final at Forest Hills twice in three years, losing to Stan Smith in 1971, and to John Newcome over five tough sets in 1973.*

end up as mayor of Los Angeles. Riordan, who headquartered in Salisbury, Maryland, was awarded an Eastern Seaboard circuit under the auspices of the USTA. It soon became known as Riordan Circuit because Riordan did it his way. He was not averse to pulling a hundred dollar bill out of his pocket if he felt a favorite player needed encouraging, and he made up rules as he went along. There was no ranking system in those days to determine who should get accepted for sanctioned tournaments. It was all at the tournament director's discretion, and sometimes Riordan made promises he didn't keep, like telling a certain Raymond Moore that he had a place in the draw, only to change his mind when he found someone whom he thought was a bigger name.

Riordan's ear was always close to the ground. As soon as he heard of the formation of the ITPA, he got himself invited to the association's meeting at Forest Hills in 1970. There, he announced

that he represented all the players who did not already have either Donald Dell or Mark McCormack as their agent. This was not true, although he did have an agreement with Jimmy Connors.

"He was disruptive, and we were not strong enough to counter his arguments," said Pasarell. "We couldn't come to an agreement, and the whole thing fell apart."

Undeterred, another US Davis Cup player, Frank Froehling, took up the cudgel, but after a few months, he too found there were too many divergent forces pulling in too many directions to get a consensus. Rather than coming together, the animosity was growing. Some less-than-diplomatic scheduling on Davies's part in 1971 meant that thirty-two of his WCT pros did not play in the French Open. Naturally, that infuriated Philippe Chatrier, who had worked so hard to be the players' friend.

It was against this background of frustration that Kramer and Dell ham-

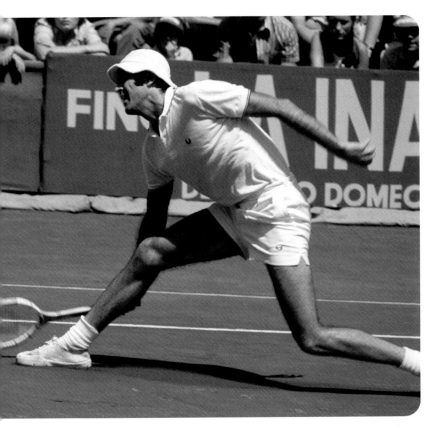

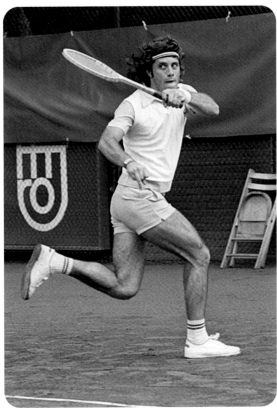

mered out a deal between Hunt and Heyman, which ostensibly brought the two biggest forces in the game together. The deal would allow Hunt's WCT troupe to play ILTF-sanctioned events—that is, the Grand Slams—after they had been banned in January 1972. At a meeting in Copenhagen on April 17 that year, it was agreed that the first six months would be given over to Hunt's WCT tour, culminating in the Dallas Finals in May with the Grand Prix circuit, essentially the brainchild of Kramer and Dell, providing the main tour for the rest of the year. In addition, Hunt would not sign any more players to binding contracts and would not renew existing ones. For the sake of the players, and not least the fans who were longing to see all their favorites play in the major tournaments, one would have expected the agreement to be put into immediate effect. Not so. Under the rules established just a few months before, no player under contract to WCT was eligible to play in an ILTF event—not at least until that rule was changed. Didn't the Copenhagen change it? "Oh, no," said Heyman—not until it had been rubber stamped at the ILTF annual general meeting. And when would that be? Four days *after* Wimbledon.

There were many involved in the game at the time who blew a fuse over this, not least John Newcombe, who was being denied the chance to defend his Wimbledon title. Newcombe pleaded with the All England Club, the ILTF, and anyone who would listen, but few would. As the best grass court player in the world, the Australian would have been favorite to win his fourth title (having first claimed it as an amateur in 1967 and won it again in 1970/71), but he ended up in the commentary box as Stan Smith defeated Ilie Năstase in one of Wimbledon's most memorable finals.

In all, twenty-nine WCT pros, including Laver, Rosewall, and Tony

(left) *Andrés Gimeno's career was overshadowed by the emergence of fellow Spaniard Manuel Santana and the fact that Gimeno, who was just as talented, disappeared into the pro ranks at the height of his powers. Once Open Tennis arrived, the charming Catalan proved his worth by becoming the oldest man at thirty-four to win Roland Garros.*

(right) *Guillermo Vilas, a tireless worker on court and something of a poet off it, always kept his eye on the ball.*

Roche, did not play Wimbledon in 1972—a fact that is often overlooked because of the far bigger pullout at Wimbledon the following year. The game, as one can see, was basically in chaos. It desperately needed some new organization to come in and provide a balance of power.

With that in mind, I concluded an article in *World Tennis* magazine with these words: "The officials who have run tennis for the past several decades still scoff at talk of a players' association, but I firmly believe that they are in for a nasty shock in the not too distant future. And if the players turn out to be more militant and more demanding than good sense would allow once they are properly organized, officialdom should sit down and contemplate its own navel for a while before deciding who is to blame."

I wish I could have been as accurate in all my predictions over a long career, but this was one that came to rapid fruition. The Association of Tennis Professionals (ATP) was formed three months later.

As I have related, there had been various attempts at making the idea work over the previous two years, but the first properly organized effort to form what would become the ATP occurred at a meeting held amid the glitter and glitz of Caesar's Palace in Las Vegas, where one of the game's great friends, the comedian Alan King, was staging a tournament that even upstaged the WCT Dallas Finals for glamor. There had been informal locker-room talks the previous week in Quebec City with Britain's Cambridge-educated Mark Cox chairing a meeting with the tour's other budding politicians: Cliff Drysdale, John Newcombe, and Charlie Pasarell.

In Las Vegas, it got serious. Donald Dell flew in with his law partner Frank Craighill and laid it all out at a meeting under the chandeliers. Dell explained the details of the Hunt-Heyman agreement and emphasized the need for the players to have an organization to protect their own interests. Craighill had the bylaws all ready. There was general consent from the floor, and everyone accepted that Dell was the right man to look after the legal details. But who would be the CEO?

That question was not answered until the tour descended on Forest Hills for the US Open in late August. There, under the green-and-white-striped canvas of the Open Club, which sat right next to the stadium bowl, Jack Kramer agreed to become the ATP's first boss. It was an inspired choice and one for which Dell must take most of the credit. Dell worked on his great friend for the most of one night. ("Practically bringing tears to my eyes," Kramer joked later.) He eventually succeeded in giving the new organization a leader who would offer instant clout and credibility. From the baseline to the bargaining table, no one knew the game better than Jack Kramer.

So, the Association of Tennis Professional came into being, and the first board of directors found they had plenty of work on their hands. Cliff Drysdale, the articulate South African who had been a Forest Hills finalist in 1965, was elected the first president. The remainder of the eleven-man board was filled by Arthur Ashe, Mark Cox, Stan Smith, Jim McManus, Jaime Fillol, Niki Pilić, Ismail El Shafei, John Barrett, and Pierre Darmon, who agreed to head up a Paris office. Kramer, who opened a small office at the May Co. store on Pico Boulevard in Los Ange-

les, took charge of the day-to-day running of this worldwide organization, but strictly on a non-paid basis. "I felt the amateur officials I would have to be dealing with would have to take me more seriously if they realized I was not in this for the money," said Kramer.

While Dell and Craighill worked on the constitution, the ATP board set about devising an item that was so badly needed: a ranking list that would be accepted as fair and accurate by all the players. It took a while; the first-ever ATP ranking was not published until the following year. But it achieved its goal far beyond anyone's dreams. Although there was one major change a few years later that switched it from an average system to a more straightforward points earned for matches won, the basic formula remains in place today. It works on a fifty-two-week rotating cycle with points earned fifty-two weeks previously dropping off. So, for instance, a player who had won Indian Wells the previous year would lose all those ranking points if he lost in the first round or did not show up to defend them.

The most pleasing aspect of the ATP ranking has been its universal acceptance. The reason is clear. With the exception of Davis Cup points, which were added as a compromise with the International Tennis Federation in 2009, opinion cannot affect the ranking list. It is based entirely on fact. You gain entry into a tournament if your ranking is above the cut-off mark and, if not, you go into the qualifying. You earn points by winning matches. Nothing else. Under the rules of the ATP tour, no one whose ranking is high enough can be barred from entering an ATP event, unless he has been suspended for some misdemeanor un-

der the Code of Conduct. Some people think all players are interested in is the prize money. That's wrong. They are more interested in their ranking points. Earn enough of those and the money will follow.

And so the tour moved on through the early part of 1973 with Newcombe beating the New Zealander Onny Parun in the final of the Australian Open at Kooyong. In the absence of all those WCT pros, Ilie Năstase grabbed the French title over the Yugoslav Pilić, who would become the epicenter of the storm that was brewing.

The rumbling was first heard when Pilić, having given his Federation a tentative promise to play Davis Cup for Yugoslavia in April, eventually had to pull out because he and his Australian partner Allan Stone, had qualified for the WCT Doubles Finals, which were being played in Montreal a week before Dallas. Pilić saw it as a straightforward professional commitment, but the president of the Yugoslav Federation, who happened to be the uncle of Pilić's wife, was not interested in professionals and promptly suspended him for nine months.

The problem was straightforward. Had Pilić given General Korac, the Yugoslav Tennis Federation president, a categorical promise to play or not? The letter Pilić had sent, translated from Croat, which Drysdale showed me at our hotel in Rome, where the Italian Championships were in full swing, did not appear to offer a categorical promise of anything. It was shot through with conditions. Pilić would play *if* Željko Franulović, then a highly promising young player, had recovered from a shoulder injury and could play number two singles. Pilić would play *if* he and Stone did not qualify for the WCT doubles. It seemed fairly clear to

Drysdale and me that the promise had not been unqualified. And the rest of the ATP board agreed.

Allan Heyman, however, did not. He saw this incident as a glorious opportunity to show the tennis world that the ILTF was still in charge of the game. However, being a not totally unreasonable man, Heyman bowed to pressure from Kramer and Dell and agreed to let Pilić play Roland Garros, while two other senior ILTF officials—Walter Elcock of the United States and Robert Abdesselam of France—reviewed the matter.

Pilić was called to give evidence at the hearing, and he did so while flanked by the two heavies from his association: Kramer, who had flown in at the last minute from Los Angeles, and Dell. It seemed clear to the pros in the room that Pilić should be acquitted. But Heyman had other ideas. Cunningly, he would show great magnanimity by reducing the suspension from nine months to one. How nice of him! Except the timing meant that the suspension would carry right through the first week of Wimbledon.

In retrospect, it became clear that Heyman was spoiling for a fight and thought he had chosen the perfect battleground. Later, when the first murmur of a boycott started to emanate from the locker room in Rome and then at the Queen's Club in London, Elcock boasted to Dennis Ralston, the US Davis Cup player and future captain, "You guys might boycott any tournament in the world, but you'll never boycott Wimbledon!"

It turned out to be a fatally flawed assumption. The future of the game hinged on the players proving Heyman and Elcock wrong. But, to say the least, the decision was not taken lightly.

Drysdale, who had been canvassing opinion in Europe, was surprised at the level of militancy in the locker room. The majority of players were fed to the teeth at having to bow to the whims of amateur officials when it came to their professional careers. It had nothing to do with their love for Niki Pilić who, in fact, was not the most popular player on the tour; it had everything to do with the feeling that a priceless moment had arrived for them to make stand and, like the competitors they were, they intended to grab it. As soon as the British media got hold of the story, they tried to pin the blame on Kramer. With Wimbledon, a British institution, threatened, they had to find bad guys, and Fleet Street editors were smart enough to realize that trying to turn such sporting heroes as John Newcombe, Arthur Ashe, Stan Smith, and Rod Laver into villains was going to be a stretch.

So the cigar-chomping American at the head of the ATP became the obvious target, and the vitriol poured on Kramer's head became a little embarrassing. "Go Home Kramer! We Do Not Want Your Kind Here!" screamed one front-page tabloid headline. The media were desperately trying to paint a picture of Kramer urging greedy pros to extract more money out of lily-white amateur Wimbledon, which was totally untrue. The players never mentioned money. They just wanted to break the stranglehold the ILTF had on their careers.

"The press tried to blame Kramer, but our members didn't need Jack to tell them what to do," said Drysdale. "It was the players' revolt, not Jack's, although he was certainly with us all the way."

The meetings started in the basement conference room of the Westbury Hotel in Mayfair, as everyone gath-

1972 ATP logo.

ered in England for the grass court tournament in Nottingham and the traditional event at the Queens' Club the following week. Inevitably, emotions ran high. Players were struggling with their consciences and their priorities. Any tennis player dreams of playing Wimbledon, and many had realistic dreams of winning it—like Ken Rosewall, who had been trying for twenty years and knew his time was running out, or John Newcombe, who had been denied the chance to defend his crown the year before and was loathe to miss another opportunity. But the strength of feeling could be gauged by a phone call Newk made to Kramer on the eve of the final vote. He was not a board member that year, but he wanted to make his feelings plain. "If you chicken out and vote to play, I will resign from the ATP immediately," Newcombe said.

The decision was even tougher for some of the board members. John Barrett, the former British Davis Cup captain and executive of Slazenger, who supplied the Wimbledon balls, was horrified at the thought of a boycott. So was Mark Cox, who was totally torn by national allegiance and the needs of an organization he had done so much to create.

As the week dragged on, every effort was made by the players to end the impasse. Three times Drysdale phoned Heyman and suggested that the ILTF president appoint an independent arbitrator to look into the case. Three times Heyman refused. Kramer met with Heyman but found the Dane immovable. Kramer's verdict: "I think he wants a showdown."

The story was getting bigger and the stakes getting higher with every passing day. Drysdale, a tennis pro who suddenly found himself in talks

An acrimonious 1972 press conference at the All England Club with the British press asking Texas promoter Lamar Hunt hard-nosed questions regarding his intentions. Herman David, seated far left, and his committee were fearful that Hunt wanted to buy into the championships and were needlessly hostile. But Russ Adams's photo offers s snapshot of some of the greatest sports writers, starting with the back of Peter Wilson's head. Two up from the Daily Mirror's *star columnist was Laurie Pignon* (Daily Sketch). *David Gray* (Guardian) *is seated, and behind him is white haired Roy McKelvie* (Daily Mail). *To his left, J. L. Manning* (Daily Mail), *pipe-smoking Rex Bellamy* (The Times), *Bill Edwards* (Press Association) *and Bob Harris* (Thomson Newspapers). *Standing behind Edwards is Barry Newcombe* (Evening Standard). *To his right is John Parsons* (Daily Telegraph) *and the author, who needed a haircut.*

Owen Williams

The cover of Owen Williams's autobiography which I helped edit, and the cover of Gordon Forbes best-selling A Handful of Summers, *which needed no help because Gordon Forbes has a whimsical writing style all of his own. At right is Forbes's long-time doubles partner and rambunctious travelling companion, Abe Segal.*

The Open Club at Forest Hills was the brainchild of Owen Williams, the former South African number one player, whose imagination stretched as wide as the veldt. As soon as he stopped playing, Williams began promoting professional tennis tours, luring some of the Kramer pros to his sports-mad nation. He persuaded the South African Lawn Tennis Association to give him total control over the running of their championships at Ellis Park in Johannesburg. In 1965, the tournament attracted a mere 4,600 spectators and, unsurprisingly, ran at a loss. In 1966, Williams performed the near miracle of getting 62,000 spectators through the gates. That lifted the South African Championships to number two in the world behind Wimbledon, which was then out on its own with crowds of 250,000. That year, Forest Hills had an attendance of 32,000 and Roland Garros 25,000. So how was Williams's miracle brought about? By introducing all the things that we take for granted today—not only sponsors, but sponsors boxes and tents, marketing promotions, and ticket sold at prices people of all economic status could afford. With the erudite Gordon Forbes and rambunctious Abe Segal as local draw cards and most of the world's top ten men and women's players invited, Williams proved that tennis was a great draw card if properly promoted.

To ensure that it was, Williams, of course, needed a major sponsor. He secured one in South African Breweries, whose product was consumed in quantities at the suburban tennis parties that sprang up at Williams's urging. The ladies of Johannesburg were such willing hostesses! The tournament was held in April, so bumper stickers appeared on hundreds of cars, reading "Easter Time Is Tennis Time!" There may have been a trick or two that Williams didn't think of, but not many.

Building on that initial success, attendance spiraled to 126,000 in 1967 and, by then, the word was spreading. Philippe Chatrier, about to become president of the French Federation, flew to Johannesburg to find out what Williams was up to. Sir Brian Burnett, chairman of the All England Club at the time, soon followed. Burnett, quick on the uptake, introduced sponsors tents at Wimbledon the following year.

The US Lawn Tennis association went further. They invited Owen Williams to run Forest Hills. He did so in 1969, thus the appearance of the US Open Club. Despite efforts to offer him a long-time contract, Williams did not know how he could handle the problem of running his numerous small businesses back in South Africa. He declined the offer.

A decade later, he would eventually move to America after accepting Lamar Hunt's offer to succeed Mike Davies as boss of World Championship Tennis.

that would have tested the skills of a professional negotiator, went off to Westminster to meet with Eldon Griffiths, the minister of sport. But that came to nothing too.

When I visited Kramer in his room at Westbury the week before Queens, I learned of the next move. "We are being advised by a lot of apparently knowledgeable people that we should get Pilić to take out an injunction against the ILTF," Kramer said. "That will throw it into the courts and, providing the injunction is granted, it will get us through Wimbledon. The case would never get heard in a couple of weeks and, until a judge rules, the ILTF would not be able to prevent Niki playing."

Using his legal skills, Heyman threw in the next roadblock to a solution by challenging the idea of an injunction and asked that Mr. Justice Forbes rule on whether one was justified. On the Monday of Queen's, much fun was made in the media of the tennis players finding themselves in another kind of court: Justice Forbes's High Court chambers. The judge read each ILTF rule in great detail and cross-questioned counsel at length. After three days of deliberation, he announced he was rejecting Pilić's application for an injunction on the grounds that the ILTF was within its rights to suspend the player. Significantly, he said he would not pass judgment on whether Pilić was actually guilty because the case had been tried abroad and involved a foreign association.

"Players' Case Thrown Out of Court!" screamed the headlines. Editorials in all the major newspapers lectured Drysdale's union on how they were now honor bound to play Wimbledon. But the judge's summation had been ambivalent on the actual point of

Big on reach, imagination, wit, and talent, the one and only Ted Tinling created dresses for all these stars—Virginia Wade, Evonne Goolagong, Rosie Casals, and Billie Jean King—making sure they were suitable for top-class tennis as well as the catwalk.

guilt; therefore, the ATP board did not feel bound to abide by a decision that had not been clearly stated.

On the Thursday evening, the board met yet again, and this time voted to boycott Wimbledon. "We knew what we were doing," Ashe told me many years later. "In fact, we were so conscious of the momentous decision we had taken that we all decided to go home and sleep on it, and come back and have another vote the following day."

In the intervening twenty-four hours, Drysdale made two decisions. First, he would make a final suggestion of compromise at the meeting and, secondly, he would broaden the discussion and allow more voices to be heard. Rosewall, Pasarell, and Cliff Richey were the three players invited to attend.

The ATP's compromise proposal was that ATP members owed their first allegiance to their association and not to their national federations. It never got past the discussion stage, which, in retrospect, was a mistake. No one seriously thought Heyman would have

THE WORLD CHAMPIONSHIP OF TENNIS

1973 ROSTER

ADDISON , Australia
ALEXANDER , Australia
ASHE , United States
BARTH , France
BARTHES , Great Britain
BATTRICK , Sweden
BENGTSSON , United States
BOROWIAK , United States
CARMICHAEL , France
CHANFREAU , France
CORNEJO , Chile
COX , Great Britain
CREALY , Australia
DENT , Australia
DIBLEY , Australia
VAN DILLEN , United States
DRYSDALE , South Africa
EDLEFSEN , United States
EL SHAFEI , U.A.R.
EMERSON , Australia

FAIRLIE , New Zealand
FILLOL , Chile
FRANULOVIC , Yugoslavia
FROEHLING , United States
GORMAN , United States
GOTTFRIED , United States
HEWITT , South Africa
HOLECEK , Czechoslovakia
JOVANOVIC , Yugoslavia
KODES , Czechoslovakia
LALL , India
LAVER , Australia

LEONARD , United States
LOYO-MAYO , Mexico
LUTZ , United States
MANDARINO , Brazil
MAUD , South Africa
McMANUS , United States
McMILLAN , South Africa
MOORE , South Africa
OKKER , Netherlands
PALA , Czechoslovakia
PARUN , New Zealand
PASARELL , United States

PATTISON , Rhodesia
PHILLIPS-MOORE , Australia
PILIC , Yugoslavia
RAHIM , Pakistan
RALSTON , United States
RICHEY , United States
RIESSEN , United States
ROCHE , United States
ROSEWALL , Australia
RUFFELS , Australia
SOLOMON , United States
SMITH , United States
STILWELL , Great Britain
STOCKTON , United States
STOLLE , Australia
STONE , Australia
TANNER , United States
TAYLOR , Great Britain
ULRICH , Denmark
ZEDNICK , Czechoslovakia

(above) *Followers of the game in the 1970s will recognize many of these names, all signed up by Lamar Hunt and sent in groups by CEO Mike Davies around the world to see who could make the top eight and thereby qualify for the WCT Dallas finals. Some of the players, nationalities are incorrect. Who can spot them?*

(opposite) *Onny Parun, a quixotic New Zealander who writes songs and collects vintage wine, took John Newcombe to four sets in the 1973 Australian Open final. He coached for a while at David Lloyd's first club near London Airport.*

agreed to it, but the gesture would have thrown the ball back into his court. He would have been forced to reveal the real nub of the argument, which was not money but control.

Unsurprisingly with Pasarell and Richey, a fiery Texan, in the room, this second meeting was even less interested in compromise than the first. Pasarell and Richey, in particular, had plenty to say.

"Looking back, I am still not sure whether I was right or not to let Charlie and Cliff into the room," Drysdale admitted long afterward. "They were not board members so, of course, they couldn't vote, but they certainly made their presence felt and could have influenced the others."

A majority of those present (Pilić, horrified at the furor, had flown home to Yugoslavia) were needed to overturn the boycott vote, and this time it was closer. Mark Cox sided with the other Englishman, John Barrett, and voted to

play. So did Stan Smith. But Kramer, Ashe, and McManus voted for the boycott. Three all. Everyone turned to the president. "I abstain," said Drysdale.

Kramer nearly fell off his chair. "It was brilliant," Kramer was to write later. "What a politician the kid turned out to be!"

"I just felt instinctively, as of that moment, that it was the right thing to do," said Drysdale. "To an extent, we had a divided association and, as president, I did not want to align myself on such a huge issue with one side or the other. But I also knew that if we reneged on our original stance and kowtowed to the establishment, at least twenty-five members would have walked out of the association the next morning, and the ATP would have been dead. You must remember we had been in existence only nine months, and we all knew that it offered the one chance the players had of being able to direct their own careers."

The midnight hour had passed by the time the meeting broke up, but there were still a posse of journalists hanging around the Westbury lobby to fire off questions that the exhausted players really didn't want to answer. Most of the media were hostile, if not to Drysdale personally, then certainly to the decision that had been made. The young South African answered them all with quiet dignity and restraint before climbing into the car to be driven back to the Gloucester Hotel, where he and most of the players were staying. Then, the oaths tumbled forth. He had not wanted this. None of them had. "But we've got no choice," Drysdale kept muttering. "We've got no goddam choice."

The job was not done. The most important thing was to ensure that no one broke ranks because numerous players were being lobbied by their national associations to change their minds. Ilie Năstase was certainly under pressure from the Romanian Federation, which, according to Năstase, was ordering him to play. Roger Taylor, Britain's leading player along with Cox, was being torn every whichway. The media were on his back morning, noon, and night to remain loyal to Wimbledon, but his father, a Sheffield steelworker and dedicated union man, was telling him just the opposite.

In the end, Năstase and Taylor, along with a lower-ranked Australian named Ray Keldie (who insisted he needed the prize money), turned out to be the only three ATP members who broke ranks and defied the boycott. The media had been predicting a 30 percent rejection of the ATP's decision, but Wimbledon, and the entire sporting world, was stunned when McManus handed the referee, Captain Mike Gibson, a list of

eighty-one names that needed to be extracted from a draw that had been made on previously in the day. Obviously, the draw needed to be redone with the majority of blank spaces being filled by players from Communist nations—most of which had not allowed their players to be members of the ATP. This included Jan Kodeš of Czechoslovakia,

(above) *Bjorn Borg rarely said a word on court, but here on the WCT tour, he actually complained about a line call. British umpire Mike Lugg was quite surprised.*

(below) *A typically cosmopolitan group on the tour watch the action on the Foro Italico's beautiful Camp Centrale. Left to right: Orlando Sirola, the giant Italian doubles champion who fought with the Yugoslav partisans during World War Two; Sweden's Tenny Svensson; Trey Waltke, who later managed the Malibu Tennis Club outside Los Angeles; Chile's Belus Prajoux; and the popular Lincolnshire farmer, Fred Hoyle, who was also the Wimbledon referee.*

who would go on to beat Alex Metreveli of the Soviet Union 6–1, 9–8, 6–3 in the final. (Wimbledon tie-breaks that year were played at 8–8.)

Taylor, sensing a chance to become the first Englishman to win Wimbledon since Fred Perry in 1936, battled past a youngster named Bjorn Borg, who was seeded sixth in the revised draw, beating the future champion 7–5 in the fifth, but then proceeded to lose 7–5 in the fifth to Kodeš in the semi-final. The pressure that Taylor was playing under was considerable, with the public and the media urging him on, but Kodeš was a class player who had adapted rapidly to grass. He had lost to Stan Smith in the 1971 US Open final on grass at Forest Hills and, two months after his Wimbledon win, repeated the effort before losing to John Newcombe. There will always be an asterisk against Kodeš's name as a Wimbledon champion, but the two-time French Open champion was a player of considerable stature on all surfaces.

Whipped up into a patriotic frenzy by the press, the British public ensured that Wimbledon did not suffer at the gate as the crowds poured in to support the "loyal" players as opposed to those nasty pros. It was all sad and unnecessary. No one was sadder than Herman David, the man who had forced Open Tennis into being so bravely in 1968 and now saw his championships diminished by this huge defection.

At least the truth came out soon afterward. The immediate result of the boycott was to highlight a fact that reactionaries in the amateur establishment did not want to countenance—namely, that the players had to have a say in the running of the game. To that end, Donald Dell flew into London with a proposal he and Kramer had been working on. It was the frame-work for a council that would include players, tournament directors, and the ILTF. This idea was eventually adopted. It would run the game for many years with three representatives from each constituency. But, of course, it was not easy to get it approved. The stumbling block? Allan Heyman. The ILTF president countered with his own vision of how tennis should be run: FOUR members of the ILTF and three from the ATP with no tournament directors, and himself as chairman. Dell, who had been unusually quiet up to this point, was fuming and said so.

"How much fairer can we be?" Dell raged. "We are prepared to place ourselves under the total control of the council, but we feel it is vital to have the tournament directors represented because they play such an important part in the running of the professional game. If we are to be in a minority, we want the swing votes to be in the hands of knowledgeable people who have a real stake in the game. We cannot be expected to sit on a council that has four rigid ILTF officials and three of us. We will accept a lot but not a stacked deck."

The facts, as I wrote in *World Tennis*, were no longer cloaked in the emotionalism of Wimbledon and were becoming embarrassingly transparent. The players wanted a democratic council with all facets of the pro game represented, whereas the ILTF was primarily interested in retaining control. Heyman was not being coy about this. When he agreed to answer questions at a press conference toward the end of Wimbledon, he answered my question about whether his primary goal was to retain control for the ILTF.

"Yes," he answered bluntly. "We do want to retain control. We have a responsibility to the smaller nations and the

Communist countries, who would nev-er accept the major tournaments having so big a say in the running of the game. That is why we do not feel the tourna-ment directors should sit on the council. We feel we must retain control because pro tennis is just the tip of the iceberg, and we have to look after all those hun-dreds of thousands of amateurs as well as juniors. We realize, as our proposal says, that many of the present rules are out of date. We are willing to work with the ATP in a spirit of cooperation and harmony to get them changed. But we want a majority vote."

The irony was complete. Allan Heyman, sitting in the All England Club two weeks after it had given him

its support in one of the biggest crises the game had ever known, was saying, in effect, that he was more interested in ensuring that a bunch of part-time amateur officials retain arbitrary con-trol over professional athletes than in allowing Wimbledon a say in the run-ning of the professional game. The players wanted Wimbledon's repre-sentatives on the council. The ILTF wanted them off. Poor Herman David could be excused for wondering who his friends were.

Once the dust started to settle and some of the emotional debris was cleared away, it also became clear that Heyman did not have any friends left among those who realized that tennis

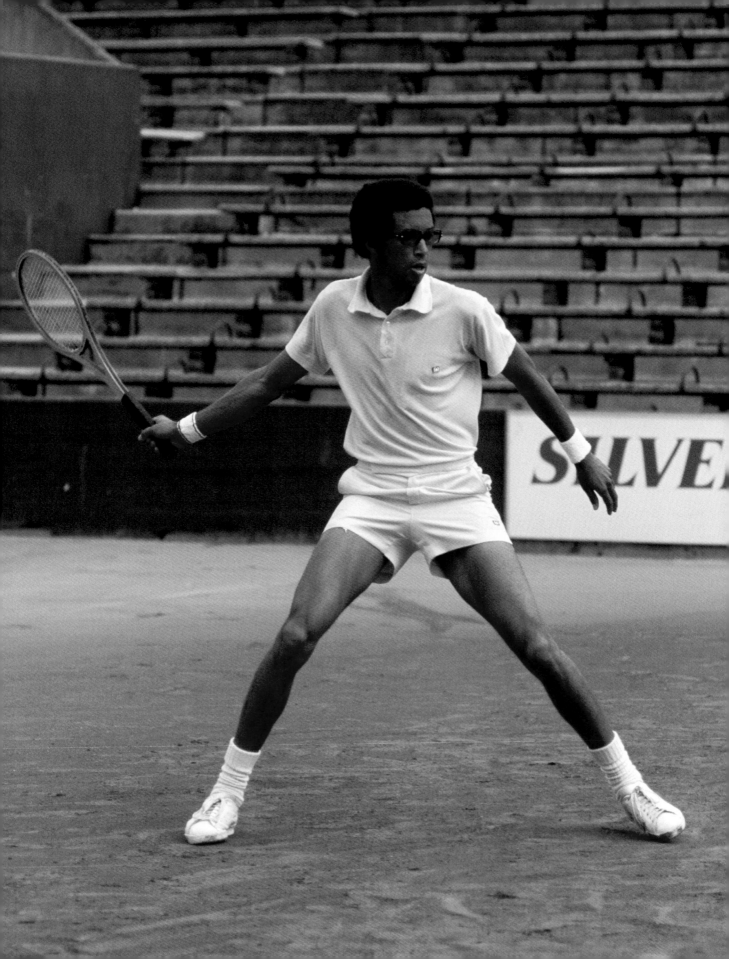

had to move forward into a new era. Despite his wishes, the Men's Professional Tennis Council was constructed in the exact form that Kramer and Dell had stipulated, with three members each representing three constituencies. The ever-progressive Derek Hardwick was elected chairman in 1974. A year later, Hardwicke succeeded Heyman as president of the ILTF.

Throughout all this turmoil, there had been quite a bit of tennis being played! Two young talents emerged in Jimmy Connors and Bjorn Borg. Both, in their totally contrasting styles, would have a huge impact on the game for the remainder of the decade and beyond.

Connors had a dream year in 1974, winning the Australian Open, Wimbledon, and the US Open, but was denied the chance to add the French Open as a result of being banned by the French Federation president, Philippe Chatrier, along with other players who were contracted to play World Team Tennis. Despite reaching the final of Monte Carlo against Guillermo Vilas in a match that was never completed

because of rain, Connors finished a glorious career never having won a title of any kind on red European clay. Even allowing for the form he was showing in 1974, it was not a given that he would have completed the Grand Slam had he played Roland Garros.

Connors's aggressive, cocky style, which allied to flat hit drives taken early, made him a formidable opponent. He absolutely demolished the aging Rosewall, then thirty-nine years old, in both Wimbledon and US Open finals. It was to be a very different story a year later, when Connors found Arthur Ashe facing him across the night in what turned out to be one of Wimbledon's most memorable and extraordinary finals.

For a start, the two players were in litigation with each other. Connors and his manager Bill Riordan had sued the French Federation, the ATP, and its president (Ashe had succeeded Drysdale in that role) over the ban Philippe Chatrier had imposed on Connors at Roland Garros the previous year. It was a grandstanding ef-

(opposite) *Arthur Ashe—elegant on court and off.*

(top) *The players always enjoy the Stockholm Open. One year, they got a little extra surprise. Invited to join King Gustav at the palace were, left to right, Frew McMillan, Ove Bengtson, Wojciech Fibak, Ilie Năstase, Mark Cox, Arthur Ashe, the King, Stan Smith, Adriano Panatta, Bob Hewitt, Tom Okker, and Raymond Moore.*

(bottom) *Channel 7 Crew at N.S.W. Open Tennis Championship, White City. Allan Stone, left, and Michael Williamson, right.*

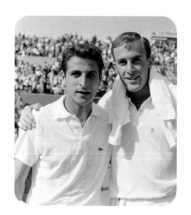

fort by Riordan to keep himself in the limelight. Of course, it did little to foster relations between Connors and the ATP players—least of all Ashe.

The buildup to the final was exceptional in many ways, but virtually no one who thought they knew what they were talking about gave the thirty-one-year-old Ashe any hope of beating the brash young man from Illinois, who was seven years his junior. Everyone had seen what Connors had done to Rosewall. In the preceding years, Ashe himself had not had much success in dealing with Connors's fire power.

"The opinion in the locker room was that Jimmy was unbeatable," said the veteran pro Marty Riessen. Ashe was under no illusions as to the enormity of his task, but he was not going to allow himself to walk into a hail of gunfire unprepared. He knew this was going to be the biggest match of his life—his one and only chance of becoming Wimbledon champion. On the eve of the final, he went into a strategy session with his two closest friends, Dell, his manager, and Pasarell, who was his college roommate at UCLA. Over dinner at the Playboy Club on Park Lane, they came up with a plan that made every prediction look stupid.

From the first ball, Ashe, a flashy, go-for-broke type of player who liked to hit the ball as hard as he could, started pushing the ball back over the net with no pace at all. Suddenly, Connors had nothing to feed off. He was not a big man and needed his opponent's speed to generate power of his own with his unerring eye and impeccable timing. Now, his timing was shot to pieces. He found himself chasing drop shots and being beaten by the lobs that Ashe lofted delicately over his head. He found himself lunging low on the

forehand volley in an attempt to reach the dinked returns that Ashe was making him play (he knew that Arthur had found his weakness). Connors's grip on that forehand side made it almost impossible for him to get a low return back from below the height of the net and keep it inside the baseline.

Suddenly, Connors had lost the first set 6–1, and the Centre Court was stunned. Could Ashe keep this up? Twenty minutes later, this tall, implacable athlete, who was showing not a flicker of emotion, had the second set in his pocket. Also by 6–1. It was extraordinary, but it was not over. Connors, to his credit, battled back and took the third set, 7–5, after two superb service returns had broken Ashe's delivery. Connors then jumped to a 3–0 lead in the fourth. Ashe supporters—a clear majority among the 14,000 crowd—held their breath. Was this the turning point? How would Ashe react? The manner in which he did react said everything about the man and the champion he was. So many players would have panicked and resorted instinctively to their natural style of play. Ashe did not. Continuing to play totally contrary to his nature, Ashe continued to slow ball to Connors and deny him the pace that he craved, thus regaining control.

Ashe did so by breaking back with a beautiful forehand down the line and then, at 4–4, like a boxer going for the big one-two after softening up his opponent, he let rip with a backhand down the line followed by a backhand cross-court winner that Connors barely saw. At 5–4, Ashe was serving for the championship, and he did not fail, putting away a forehand volley on match point to win 6–1, 6–1, 5–7, 6–4.

Only then did Arthur Ashe react to

the enormity of what he had achieved. With a raised, clenched fist, he turned to the players' box and smiled. Afterward, speaking to an incredulous press corps, he said, "When I walked on court, I thought I was going to win. I felt it was my destiny."

If so, it was a destiny richly deserved. It was also a triumph that spread happiness and satisfaction throughout the sporting world, because it had been a triumph in which intellect and character had called the shots. Ashe had become the first black man to win Wimbledon. No one could have worn the crown with greater dignity.

The following year, Bjorn Borg started his incredible run of five consecutive Wimbledon victories beginning with a 6–4, 6–2, 9–7 win over Ilie Năstase. Two victories over Connors followed before Roscoe Tanner took him to five sets in the 1979 final. The great tiebreak final against John McEnroe came in 1980, but by then, the quiet, slimhipped Swede with the rolling gait and flowing blond hair had become the game's first popstar, as squealing teenage fans followed his every move.

Maybe Borg got a little lucky in that there was no great serve and volley player to challenge him during the mid-seventies—Newcombe's star having waned and McEnroe's not yet risen—but the adaptability that he showed by crossing the Channel for three of those title-winning years, directly from claiming the French Open on clay, was remarkable and elevated him to one of the greatest players of all time. It is impossible to gage the extent to which Borg was assisted by Lennart Bergelin, the rugged, amiable former Swedish number one player, who became Bjorn's travelling coach—a position unknown on the tour up to that

point in the game's evolution. The pair developed a sort of father-son relationship. There is no doubt that Bergelin played a major part in the younger man's ability to fulfill his potential.

Borg's strings were strung so tight that, on clay where the rotation of Borg's top spin shots caused them to fray, he needed a newly strung racket every forty minutes. The man who did the stringing was Bergelin—sometimes in the middle of a match if it went five sets and reserves were used up. Once Roland Garros was over and the need to adapt quickly to grass became paramount, Borg, on Bergelin's advice, bypassed the Queen's Club tournament and instead spent two weeks wearing

(above) *Adriano Panatta followed Nicky Pietrangeli as the heartthrob of Italian tennis, winning the Italian Open in 1976, the same year that he won Roland Garros.*

(opposite, top) *Chile's popular Jaime Fillol, a future ATP president.*

(opposite, middle) *ATP board member Ismail El Shafei, the best player Egypt has ever produced.*

(opposite, bottom) *French number one player Pierre Darmon, who ran the ATP European office in Paris during the 1970s before I took over, with John Newcombe.*

out a grass court at the Cumberland Club in Hampstead, specifically hired for the purpose. Lennart acted as coach, hitting partner, and companion. The results speak for themselves.

Borg was, of course, by nature a clay court specialist, which he proved somewhat conclusively by winning Roland Garros six times between 1974 and 1981, a run that was only interrupted by a loss to Adriano Panatta in 1976, and his absence the next year when he was away playing World Team Tennis in America.

Strangely, Borg never did well in Australia, where Newcombe and Connors dominated the early part of the decade until Mark Edmondson's shock victory over Newcombe in 1976, while Tanner, Vitas Gerulaitis, and Guillermo Vilas, who won back to back titles in 1978/79, ended the Aussies long-held dominance of their own championships. Borg also found the US Open a tough and ultimately impossible nut to crack, even though he had a great op-

portunity against Connors in the 1976 final when it was played on grey American clay at Forest Hills, the West Side Tennis Club having taken the decision to tear up the grass a year earlier.

American Har-tru, as it was known, plays faster than the red clay in Europe. Most observers failed to understand why a player of Borg's proven adaptability could not adjust to a surface that was not nearly as different as grass. When the US Open, under President Slew Hester's guidance, moved to its new location at Flushing Meadows in 1978, Borg reached the second of four finals on what had become a hard, cement surface. He lost to Connors again, this time by the embarrassing score of 6–4, 6–2, 6–2, and also failed to get his hands on the trophy when he lost to McEnroe in successive finals in 1980 and 1981.

Meanwhile, recognition should be given to Connors for achieving something no one will be able to repeat: winning the same Grand Slam championship on three different surfaces.

Connors had beaten Rosewall on grass at Forest Hills in 1974, Borg on clay at the same venue in 1976, and Borg again on cement at Flushing Meadows in 1978. They say records are made to be broken. That one is secure.

As a prelude to winning Wimbledon the following year, Stan Smith, the tall and powerful serve and volleyer out of USC, had won his first Grand Slam title on the grass at Forest Hills in 1971 by beating an unseeded Jan Kodeš in four sets. The following year, Ilie Năstase revealed the strength of Eastern European tennis by upsetting Ashe in the final 6–3 in the fifth. Ashe was less than impressed with the Romanian's on-court antics but could not complain about the result. Năstase's speed, racket skills, and his touch on the volley earned him a deserving victory.

John Newcombe won his second US crown over Kodeš the following year before Connors crushed Rosewall in 1974. On clay in 1975, the skillful Spanish left-hander Manuel Orantes won an unbelievable encounter with Guillermo Vilas in a rain-interrupted match in Saturday's semi-final, which ended near midnight. Vilas had won the first two sets and seemed to have the match wrapped up when he took a 5–0 lead in the fourth. Orantes started running the Argentine all over court with his angles and drop shots, and somehow won it 7¬–5 before closing out the match in the fifth. However, his problems were not over. Returning to his hotel, Orantes found the bathroom flooded. After a plumber had been produced in the dead of night, Orantes did not get to sleep until 3:00 AM. Returning to the court to play Connors in the final a few hours later, Orantes was too tired to be nervous—an affliction that deprived this exceptional player of

many big wins—and proceeded to give the American a clay court lesson, winning 6–4, 6–3, 6–3. It was the Spaniard's only Grand Slam title.

A varied cast had triumphed at the French Open before Borg took over. With his straight-backed posture and lethal hitting from the baseline, Jan Kodeš dominated Roland Garros in 1970 and 1971, winning finals against Željko Franulović and Ilie Nătsase. An "old" pro from the Kramer tour, Andrés Gi-

Tony Trabert, one of the great figures of American tennis, won Roland Garros, Wimbledon, and Forest Hills in 1955. He went on to become the voice of the game on CBS television at the US Open with Pat Summerall and John Newcombe.

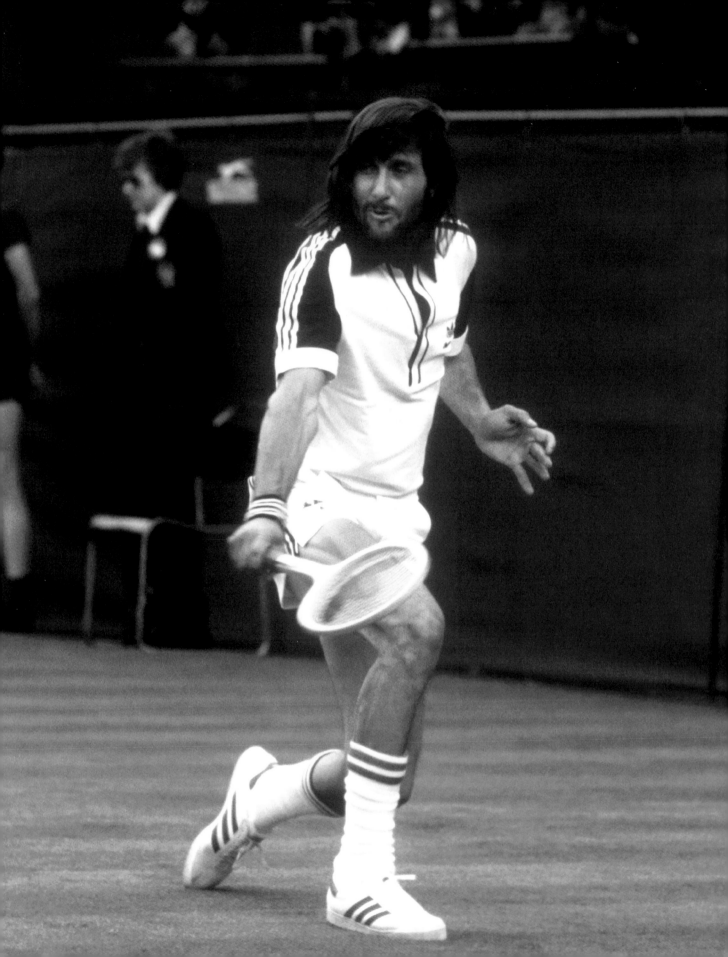

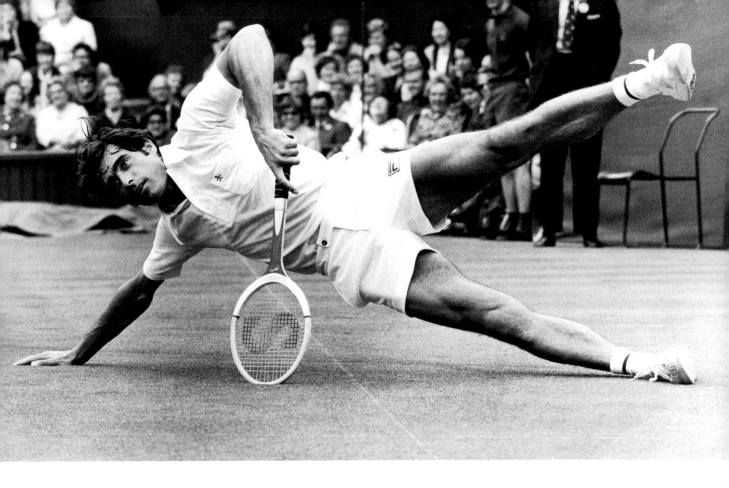

meno, grabbed his moment in the sun by beating Frenchman Patrick Proisy in the 1972 final to become the oldest man, at thirty-four years and ten months, ever to win the French title. Năstase, in his pomp, was far too clever for a depleted field the next year, allowing Pilić only four games in the final, which led to Borg's first two years as champion.

In 1975, Borg ran into the only man who had the game to beat him on clay—the Italian heart-throb Adriano Panatta—in the quarter finals and went down 6–3, 6–3, 2–6, 7–6. Panatta had the combination required to beat the Swede on his favorite surface; he was the only man of his generation who did. To pressure Borg, you needed to get into the net and volley decisively, while also being able to stay with Borg in long backcourt rallies. Panatta, a natural serve and volleyer who was brought up on clay—a very rare spec-

imen—could do both. Having proved himself able to knock the Swede out of his metronomic baseline rhythm, Panatta went on to win his only Grand Slam title by beating the little American clay court expert Harold Solomon in the final. It was a miracle Panatta got that far. Arriving in Paris fresh from a deliriously acclaimed success in Rome, where he had won the Italian Open, Panatta was drawn to play the two-handed Czech Pavel Hut'ka on Court One in the first round. Panatta, finding it difficult to come down from his triumph at the Foro Italico, had not played well and found himself completely outplayed in the fourth set, losing it 6–0. Worse was to follow. Deep into the fifth, Hut'ka reached match point and sent up a lob that had the Italian stretching to bloop back a weak overhead off the frame. Hut'ka had the court open and, playing the

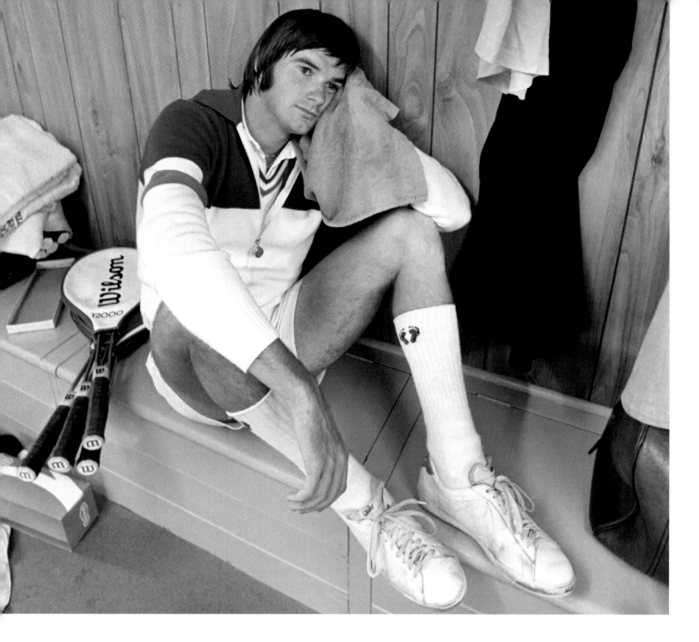

(above) *Jimmy Connors discovers that you can't win them all.*

(opposite) *Adriano Panatta, a big but agile man who proved clay court players can volley.*

percentages, Panatta covered down the line. Hut'ka angled his return away to Panatta's backhand. It was a cleanly hit cross-court shot, and it was going to be a certain winner. Panatta, however, simply refused to allow that to happen. Taking off like a goalkeeper, he was in mid-air, horizontal with the net, when the ball hit the frame of his outstretched racket and fell limply into Hut'ka's court. The Czech never recovered, losing the set 12–10. Panatta went on to win his only Grand Slam title. Rex Bellamy, the great *London Times* tennis correspondent, described the match point Panatta saved against Hut'ka as the most memorable point he ever saw. It certainly changed the dashing Italian's career.

As we have seen, there were winners and losers during this turbulent, game-changing decade in the men's game, but the women were not standing still either. We will examine how Gladys Heldman and Billie Jean King changed the face of their side of the sport game in the next chapter.

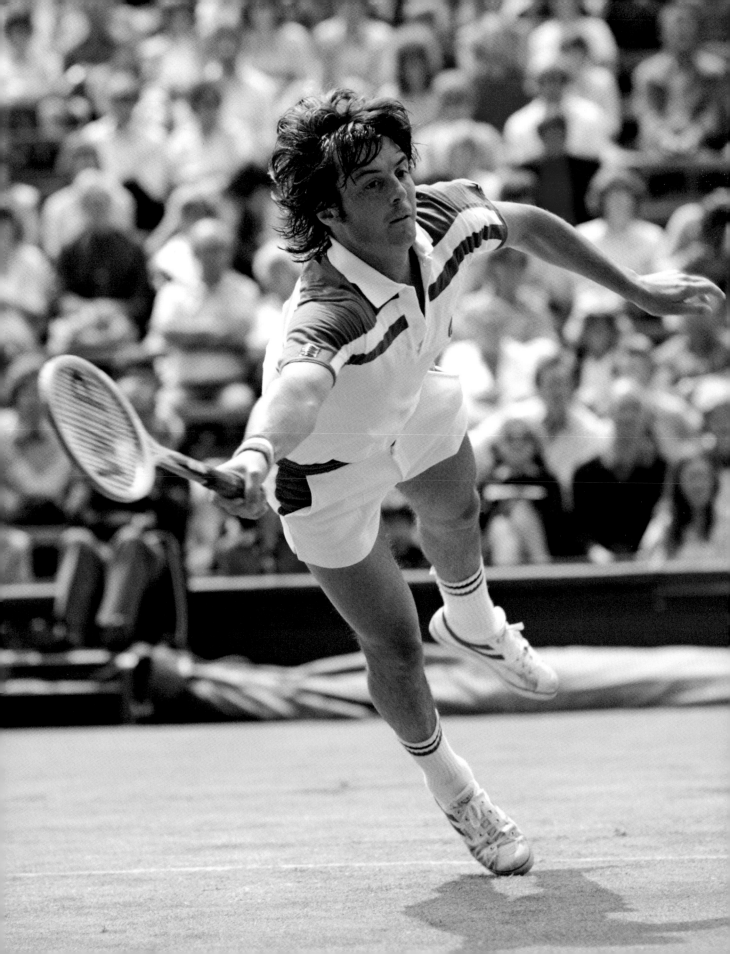

8 The WTA Is Born
Evert & Navratilova
Wade & UK Success

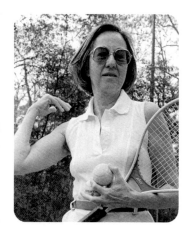

(above) *Gladys Heldman, publisher of* World Tennis Magazine *and driving force behind the creation of the Women's Tennis Association.*

(opposite) *Career-long rivals and great friends, Chris Evert and Martina Navratilova.*

Whichever way you turned, it was very difficult to keep Jack Kramer out of the equation as pro tennis struggled to flap its wings in the sixties and seventies. So much—one could almost say everything—was influenced by something Kramer did and, in one case especially, it happened almost by accident, but in retrospect, fortuitously.

It was not Kramer's intention to influence the formation of the women's pro tour and the eventual creation of the Women's Tennis Association (WTA) but if he hadn't been such a hard-nosed promoter, it would not have happened nearly as fast.

It came about because Kramer knew who sold tickets and who didn't. Given the late developing appreciation of women's sport and poor promotion, not even proven champions like Billie Jean King and Margaret Court had people flocking to the box office in the early seventies. So Kramer, then the tournament director for the Pacific Southwest Championships at the Los Angeles Tennis Club, offered a first prize of $12,500 to the men's champion and $1,500 to the women's winner.

Billie Jean King and her doubles partner Rosie Casals were incensed to such a degree that they refused to play and turned to someone they knew who

had the brains, drive, and hutzpah to help them. That person was Gladys Heldman, publisher of *World Tennis Magazine*, which she had started in 1953. It was the most influential tennis publication in the world in those days and Mrs. Heldman was about to prove herself to be one of the most influential people in the sport.

Outwardly, Heldman cut an extremely stylish, feminine figure that hid her inner backbone of steel. She would seem somewhat nervous in a charming way as she stared out at you through a pair of thick black lenses, but if she wanted something—like money—and you were rich enough to offer it, several of her friends suddenly found themselves writing quite large checks.

The 1962 US Championships was a case in point. In those pre-Open days, the tournament was facing the embarrassment of attracting practically no overseas players because they simply couldn't afford the airfare. Horrified at the thought of America's premier tournament turning into little more than a domestic championship, she came up with an obvious, if somewhat outlandish, solution: to fly in some foreign players. How? By chartering a plane in Amsterdam and getting her friends to pay for it.

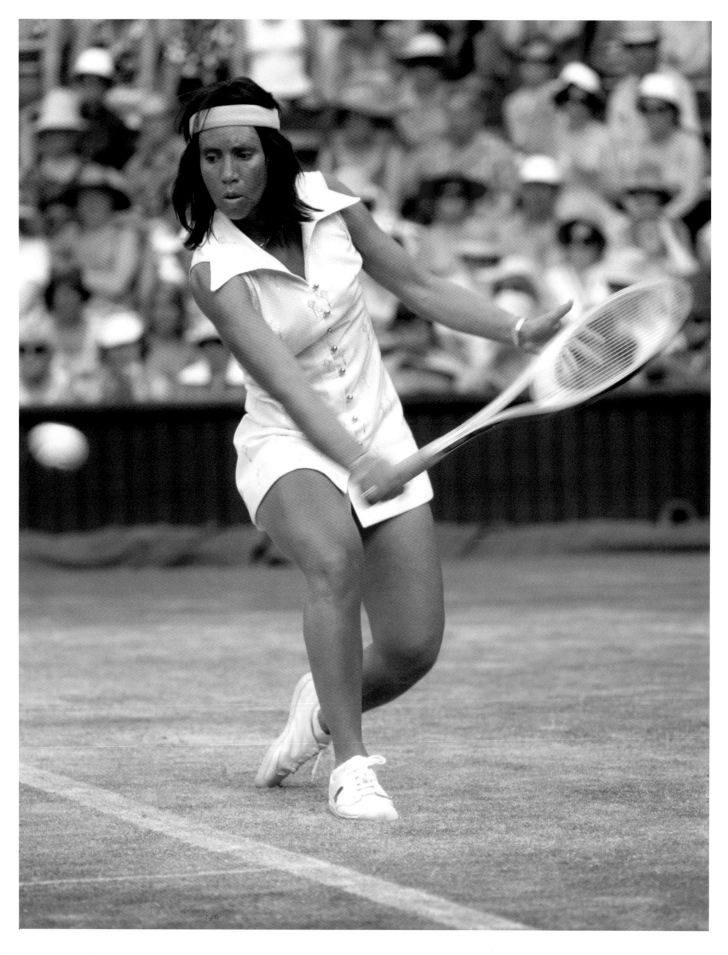

In those days, you could hire a plane for $18,000 so she hit the phones and called ten of her most affluent contacts. They each needed to cough up $1,800 and out of the ten calls, only one refused to do so. Heldman threw in the final $1,800 herself and, a few weeks later, eighty-five of Europe's top men and women players were flying to New York.

So it was no exaggeration to call Gladys Heldman a mover and a shaker and she was about to shake the women's game to its core. As soon as Billie Jean King told her that she and Casals had pulled out of the Pacific Southwest, Heldman went into action. Calling Jim Hight, the president of the Texas Tennis Association, and Dolores Hornberger, of the Houston Racquet Club, she managed to persuade them to create a professional women's event at two-weeks notice. As anyone who has tried to put together a tennis tournament in six months will tell you, that is an impossibility. Not for Gladys Heldman! Naturally, Hight and his team played a huge part. As soon as $5,000 in prize money had been secured, they rented seating facilities and sold tickets.

Heldman was intending to invite just eight players, so Kramer would still have plenty of top-class women for his own event but he obviously didn't like the idea of being upstaged, so he made an official complaint to the USLTA. Stan Malless, a leading committee man, reacted immediately by telling Heldman that, as Kramer was objecting, he would not grant the tournament a franchise. Furthermore, he would suspend any player who participated in it.

It was time for Heldman to make another phone call. Joe Cullman, chairman of Philip Morris, was a long-time friend and tennis partner at the Century Club in upstate New York.

Cullman had been one of the businessmen who had answered her call for the airplane in 1962, but now Heldman was wanting a great deal more than $1,800. She wanted title sponsorship for an organization that she and Billie Jean had been dreaming about: The Women's Tennis Association. And she wanted it fast.

Initially, she asked for only $2,500 to add to the Houston event so that it could be called the Virginia Slims Invitational—the new brand of cigarettes that Philip Morris were marketing for women. Athletes and a tobacco sponsor? Not an issue in those days. Despite a growing realization that smoking was seriously bad for you, millions of Americans smoked and a huge percentage of them were women. The partnership made sense for both sides.

Meanwhile, things were moving fast. The agreement with Philip Morris was only signed at 10:00 AM on the Tuesday, the day before the tournament was due to start. As Heldman related it later, it was 4:00 PM that day that Hight received a sanction from Malless, but only to run the event as an *amateur* tournament. That would mean paying everyone under the table, just as they did in the bad old days of shamateurism.

So the ball was back in Heldman's court, which was a dangerous place for it to be as far as the USLTA were concerned. At 1:30 PM on the Wednesday, two hours before play was due to begin, the Houston Racquet Club officials and nine players met in the clubhouse and Heldman asked them what they wanted to do. With the exception of Patti Hogan, who said she was committed to a series of tournaments in Britain the following month, the remaining eight players all said that they would prefer to play for prize money and risk suspen-

(opposite) *Feisty advocate for the women's game, Rosie Casals was a perfect partner for Billie Jean King, on court and off.*

(above) *The Ken Rosewall backhand on show at the WCT Dallas finals, which he won twice, adorns the cover of* World Tennis Magazine.

(following spread) *Billie Jean King: If you want to display your tennis trophies, you'll find no better place to do it than Wimbledon's Centre Court.*

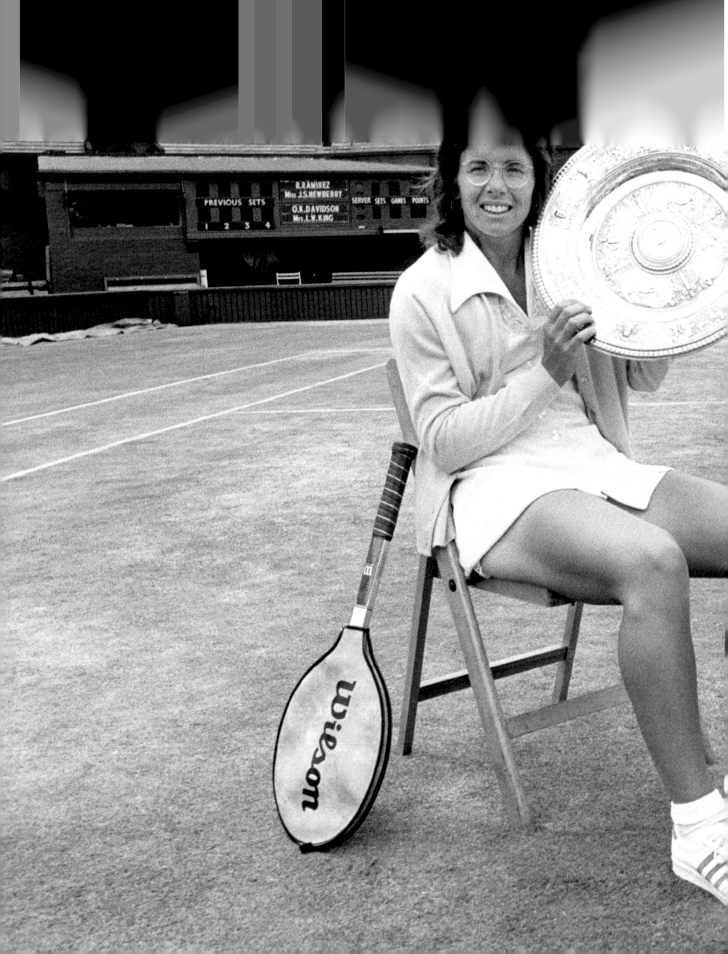

(above) *Virginia Slims ad.*

(below) *Joe Cullman, CEO of Philip Morris, answered Gladys Heldman's call to sponsor the fledgling WTA Tour with Virginia Slims, his new cigarette brand for women.*

(opposite, top) *All smiles on the balcony of the Queen's Club in London. From left to right: BBC commentator Bill Threlfall; Sue Barker, who won the French Open in 1976, but became far more famous presenting Wimbledon on BBC Television; David Lloyd, founder of the clubs that bear his name; and commentator Marcus Buckland, who has a special way with the English language.*

(opposite, bottom) *The Original Nine, who signed pro terms with Gladys Heldman for a token dollar to ward off the clutches of the USLTA, reunite decades later to celebrate the incredible growth of the women's game, Back row left to right: Valerie Ziegenfuss, Billie Jean King, Nancy Richey, Jane "Peaches" Bartkowicz, Kristy Pigeon. Front row: Judy Tegart Dalton, Kerry Melville, Rosie Casals, and Julie Heldman.*

sion rather than accept money under the table.

That stance reflected Billie Jean's leadership and pugnacity, but the club would also be dragged into the conflict and would suffer penalties from the USLTA if they went ahead with a pro tournament. However, understanding the byzantine world of tennis politics as it stood at the time, Heldman thought up a way out of that thicket. With the clock ticking and crowds assembling in the stands, she came up with her master stroke.

If all the players signed professional forms with an organization, such as *World Tennis Magazine*, which she owned, they would become contract pros (like the men under contract to WCT), and the club would then be running an all-pro event that would not require a sanction because, like WCT, it would be outside the auspices of the amateur governing body. Ace!

After a piece of paper had been hurriedly written up and signed, Billie Jean King was able to walk into the press room at 3:00 PM and announce that the eight women players who would play the event had just signed professional forms with *World Tennis Magazine* for a token fee of one dollar. A few minutes later, Heldman's daughter, Julie, a highly ranked player who was injured at the time, walked in to add her name to the list of newly designated pros. So the nine players who thrust themselves into the history books in such dramatic fashion were

Billie Jean King, Rosie Casals, Julie Heldman, Jane "Peaches" Bartkowicz, Kristy Pigeon, Nancy Richey, and Valerie Ziegenfuss—all of the United States—as well as two Australians, Judy Tegart Dalton and Kerry Melville Reid.

Had she not been pregnant back in Europe, Ingrid Löfdahl Bentzer of Sweden would also have signed and she turned pro later, along with two more Americans, Mary-Ann Eisel and Denise Carter. When Barry McKay, the old Kramer touring pro who was turning into Northern California's leading tennis promoter, supported the movement by finding an additional sponsor for his event at Berkeley so that he could increase his total prize money for the women to $11,000, it suggested the fledgling movement might survive. But it was still a very worrying time for Heldman and her players.

"We had taken a real risk," said Billie Jean looking back on a pivotal moment in the women's game. "We would have looked pretty silly if we had failed. If no one had come to see us play, we would have been dead. But they did come. The timing was right."

Meanwhile, back at her home on Timberwilde in Houston, Heldman was on the phone. For the next few months, she was rarely off it. When she slept, no one knew. Her husband moved into an adjacent room and slept on a camp bed. The one he had shared with his wife, a huge circular bed, had been turned into a master control headquarters, not only for the women's tour Heldman was setting up but also as a publisher's office for *World Tennis Magazine*. She had a perfectly good office downtown but preferred to do the layouts, choose the photos, write the captions and editorials, and assign articles propped up against the pillows with everything arrayed in front of her. Occasionally, she would get up to hit some balls on the tennis court just outside the window, but there was not much time for that.

For the rest of 1970 and much of the following year, Heldman was caught in a never-ending catalog of threats, fights, suspensions, and thinly veiled

hints of legal action as the women battled to establish their own tour. Blindly, the USLTA kept trying to force the women, who had been augmented by the former Wimbledon champion Ann Jones of Britain, to play their $5,000 events instead of the Virginia Slims tournaments—some of which were already offering as much as $40,000.

Getting desperate, the USLTA started threatening the young players coming into the game and Chris Evert's parents were told that their sixteen-year-old daughter, already a Forest Hills semi-finalist, would be banned from playing for her country in the Wightman Cup and Federation Cup if she joined the pro tour. The whole thing started to descend into farce when the USLTA, having seen a tentative Virginia Slims schedule Heldman had drawn up for 1973, suddenly announced it was

(clockwise from left) *Julie Held-man (Gladys Heldman's daugh-ter), who reached the Forest Hills semi-final and later wrote a book about her demons with depression titled* Driven.

Lesley Turner Bowrey won Roland Garros in 1963, and then created a major shock by beating the defending champion, Margaret Smith (Court), in straight sets in 1965.

As tough to beat as her feisty brother Cliff Richey, Nancy Richey appeared in six Grand Slam singles finals, winning the Australian in 1967, and Roland Garros in 1968. The Texan also won four doubles at Grand Slam level, two with America's Carole Graebner and two with Maria Bueno.

Ingrid Lofdahl-Bentzer, the Swed-ish number one player who settled in London and became an All England Club member, would have expanded the group to the Original Ten had she not been awaiting the birth of her daughter.

going to run a big money women's cir-cuit of its own, based almost entirely on tournaments in cities that appeared on the Virginia Slims schedule.

Using the invaluable weapon of her editorial page in *World Tennis*, Heldman took aim and fired. "Dorothy Chewning picked up the Richmond paper and read that she was running a USLTA wom-en's tournament in first week of Janu-ary," Heldman wrote. "She was furious. (She is scheduled to run a $25,000 tour-nament with *World Tennis* in March). Orlando was on the USLTA circuit but didn't know how or why. St Petersburg and Fort Lauderdale turned down the offer to go with the USLTA but were still listed on the release." And so it went on with the editorial ending with

this biting observation: "The only things that this super $600,000 prize money circuit announced by the USLTA lacks are players, cities and sponsors."

Despite all the political absurdi-ties, the women's game was flourishing throughout the seventies, thanks ini-tially to the eye-catching performanc-es of the great Australian Margaret Smith Court and the inimitable Bil-lie Jean King. Court's powerful game, enhanced by her huge reach at the net when she charged in behind a massive serve, brought her the calendar Grand Slam in 1970, emulating Maureen Con-nolly's feat in 1953. Only Steffi Graf has done it since.

Straddling the pre- and post-Open era, this tall, shy Western Australian

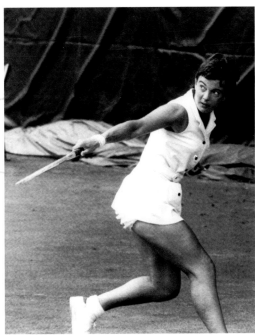

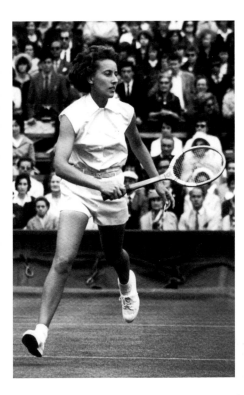

racked up extraordinary records in the game from the moment she won her first singles Grand Slam title at the Australian Championships in 1960. "Big Marge" completed an amazing career with twenty-four Slams in singles—more than any other player—nineteen in doubles and twenty-one in mixed. And she did it despite missing all four Slams in 1967 and 1974 while having babies. Although grass was her natural surface, Court's all-round dominance can be measured by her record on clay at Roland Garros in the Open era, where her match record between 1969 and 1973 was twenty wins and one loss. Always a devout person, Court was ordained as a minister in 1991.

Billie Jean's tireless work off court to ensure the success of the women's tour did not detract from her performances on it and, having won Wimbledon twice in the sixties, she added three more titles at the All England Club in 1972, 1973, and 1975. She claimed four US titles in all and enjoyed her best year in 1972, when only the Australian Open eluded her.

By 1974, the nineteen-year-old Chris Evert was starting to fulfill the promise that she had been showing for several years on the Har-Tru clay of Florida at Boca Raton and emerged as an omnipresent force in the game. Hiding her cheeky sense of humor behind an ice-maiden image on court, Evert began an extraordinary run of success on the red clay of Roland Garros by winning the first of seven French Open titles with a 6–1, 6–2 victory over the Russian, Olga Morozova, in the 1974 final.

The following year, Evert defended her title, but this time she found herself facing a player with whom she was in the process of establishing one of the greatest rivalries in all of sports. The Czech-born Martina Navratilova, two years her junior and starting to get to

(left to right) Australia's ever-cheerful Judy Tegart Dalton, one of the Original Nine, catches up with Stefan Edberg's coach, Tony Pickard, in Melbourne in 1993.

Kerry Melville, who married the Australian player Raz Reid, was a fine player who won the Australian Open in 1977 and was a finalist at the US Open. She won the Wimbledon doubles with fellow Aussie Wendy Turnbull in 1978.

A baseliner by instinct, Britain's Angela Mortimer proved she could win on grass by taking the Australian title at Kooyong in 1958, and beating Christine Truman in an all-British Wimbledon final in 1961. She also won Roland Garros in 1955.

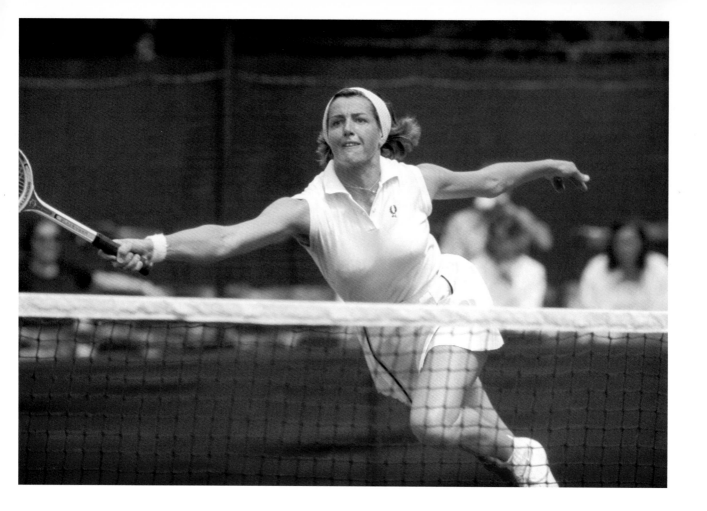

(above) *Margaret Court uses her long-armed reach to handle a forehand volley.*

(opposite, top left) *After helping her with the articles that she wrote for the* London Evening Standard *in 1960, Althea Gibson signed this photograph for me.*

(opposite, top right) *Father Jim did the coaching, while Chris Evert's mother, Collette, did much of the travelling. She made sure her daughter started the day with that glass of milk.*

(opposite, bottom) *WTA logo.*

grips with a very different lifestyle as an American resident, fought her way to the final in Paris before losing to Evert 6–1 in the third.

The pair had first played each other in 1973, before Navratilova hit the gym and trimmed down with the help of the Haas diet and turned herself into one of the most formidable athletes in the history of women's sports. Evert won eight of their first ten meetings, including the Roland Garros final but, as the years unfolded, she was only able to maintain her dominance on clay.

It said much for both players' skill, stamina, and passion for the game that this rivalry would continue for fifteen years. Their domination of women's tennis from the beginning of the WTA rankings in 1974 was such that, over the first 615 weeks, Evert and Navrati-

lova held the number one spot between them for 592 of those weeks.

They played each other eighty times, sixty-one of them in finals. The influence of surface was clearly demonstrated by the final tally. On hard courts, Navratilova led 9–7; on clay, Evert led 11–3; on grass, it was Navratilova by 10–5; and on indoors carpet, it was Navratilova 21–14.

In style and personality, they were polar opposites but, throughout most of their time as deadly rivals, they established a friendship that would last a lifetime. They inspired each other to produce some memorable duels on some of the game's great stages—not least, in finals on Wimbledon's Centre Court, where Navratilova's four wins in four were by no means easy—three of them going to three close sets.

But for sheer drama, nothing surpassed the 1985 final at Roland Garros, which Evert seemed to have wrapped up at 6–3, 4–2 on her favorite surface, despite having lost to Navratilova easily in the previous year's final. In the seventh game of that second set, Evert led 0–40 on her rival's serve and scribes in the press box were poised to complete their stories of an Evert triumph.

But, as I wrote in *Open Tennis* later, "Cornered, the left-hander struck back with some devastating serves, and backed up by equally punishing volleys, Navratilova was able to hold serve and then break back before grabbing the tie-break by seven points to four."

It was a remarkable turnaround, but the damage had been done. Those opening games had lifted the air of inferiority that had hung over Evert in her matches with Navratilova in the previous couple of years and suddenly, she was her old assertive self again.

"Right from the start, I realized I was playing even with her, unlike the year before when she had killed me," Evert recalled. "It was an unfamiliar position to be in, but it felt good, especially when I realized the tactics John [Lloyd] had thought out for me were working."

After their separation the year before, Evert's first husband, John Lloyd,

the British number one player who had reached the Australian Open final in 1977, was back at her side as coach in Paris that June and, having watched the pair play so many times through the expert eyes of a top player, he had devised some unorthodox tactics in an attempt to disrupt Navratilova's game.

"John suggested I stay back and hit more balls to the forehand," said Evert. "Before, I had been hitting flat and that had enabled her to chip and come in. She'd do that off the backhand very effectively too, so switching the point of attack helped."

Refusing to be disheartened by Navratilova's sudden revival, Evert quickly regained the initiative at the start of the third set and led 3–1 before the left-hander broke back again to level at 3–3. Again, Evert edged in front, threading backhand passes down the line after punishing returns of serve to lead 5–3. By now, the tempo was quickening with every step, like a cancan of the courts—hearts a flutter, the sensation of a swirling skirt or a flashing racket upping the beat until it seemed the whole match had been transported onto the great windmill of the Moulin Rouge. But there was no choreographer to bring us to the end of this cabaret. The magic of sport is that no one can

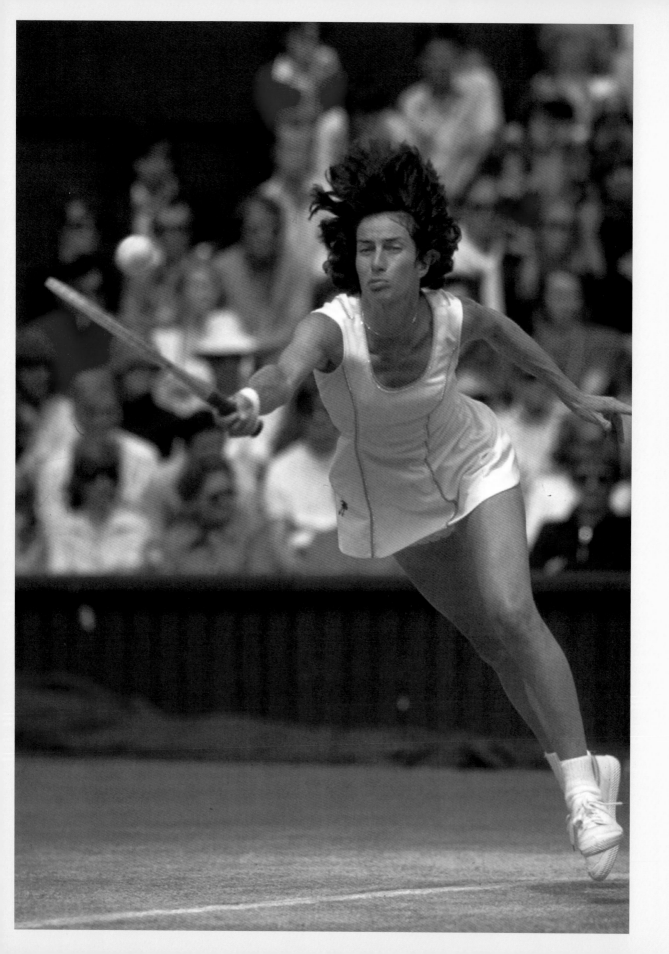

Virginia Wade

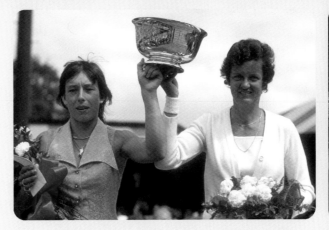

Such was the dominance of Margaret Court and Billie Jean King, to be swiftly followed by the emergence of Chris Evert and Martina Navratilova, that Virginia Wade's contribution to the growing popularity of the women's game tends to get overlooked. Unfairly so, because this daughter of a clergyman, who would become Archbishop of Cape Town, enjoyed a remarkable career that spanned three decades and included three Grand Slam titles among the fifty-five that she won on the tour.

Wade welcomed the advent of Open Tennis by upsetting Billie Jean King in the final of Forest Hills in straight sets in 1968, having already celebrated the game's new freedom by winning the British Hardcourt Championships at Bournemouth, the town in which she was born.

Wade went on to win the Australian title in 1972 and, after losing in the quarter-finals at Wimbledon four times and at the semi-final stage twice, this superb athlete, with a serve that came thundering down from an exceptionally high toss, finally achieved her goal.

Arriving in the press room after her first-round victory at Wimbledon 1977, she caused a few titters by declaring with absolute certainty, "I am going to win this year. The Queen's coming."

Queen Elizabeth was not a habitual visitor to the Championships, but this was Centenary Year and, as in 1968, Wade had already shown a penchant for winning at meaningful moments. So she did what she said she was going to do: she became Wimbledon Champion and received the silver bowl from Her Majesty.

Chris Evert had proved her biggest stumbling block in the semi-final, but after two incredibly tense sets with the Centre Court full of fans screaming, "Come on, Ginny!" Wade was able to sweep through the final set 6–1. It was much the same story in the

final where the powerful Dutch player Betty Stöve was not expected to upset the celebration but made a pretty good effort at doing so, winning the first set before going down 4–6, 6–3, 6–1.

Stöve had deprived the crowd of an all-British final by beating Sue Barker, who had won the French Open the previous year, in the semis at a time when women's tennis in Britain was enjoying far greater success than the men's. Another much-loved player, Christine Truman Janes, won Roland Garros in 1959, and she was followed by the determined Birmingham left-hander Ann Haydon Jones, who took the French title in 1961—the same year that Angela Mortimer Barrett, a shy but highly competitive player from Devon who had won her first Grand Slam title in Paris in 1955, won Wimbledon in a nerve-racking final that divided British loyalties as her opponent was Christine Truman.

Writing about the player whom he would marry some years later, John Barrett remarks in his book *Wimbledon: The Official History of the Championships*: "It was an emotional final that included a break for rain at the end of the first set and a much-discussed fall by Christine which appeared to affect her psychologically more than physically. Angela finally fulfilled her life's ambition at the eleventh attempt at the age of twenty-nine with a 4–6, 6–4, 7–5 victory."

In 1969, Haydon Jones also showed how hard work could turn a natural clay courter into a Wimbledon champion by beating Margaret Court 10–12, 6–3, 6–2 in the semis and Billie Jean King 3–6, 6–3, 6–2 in the final. Turning tables so decisively on those two great champions after losing the first set in both matches ensured that Haydon Jones would be recognized as one of the great competitors of her era.

(opposite) *Virginia Wade.*

(above, left) *Martina Navratilova did not win all her doubles titles with Pam Shriver. Here, she holds the US Open doubles trophy aloft with Holland's Betty Stöve in 1977.*

(above, right) *Christine Truman Janes, the darling of British tennis during a long career that was highlighted by her triumph at Roland Garros in 1958. She lost to Angela Mortimer Barrett in Wimbledon's last all-British final in 1961. Later, she was a popular summarizer for BBC Radio at Wimbledon. It was a pleasure to share the commentary box with Christine. I never knew what she was going to say next!*

(below) *No one beat Ann Haydon Jones easily. A born competitor, the Birmingham left-hander made the most of her abilities to win the French title in 1961 and 1966, and Wimbledon in 1969, signing off with an unforgettable swan song, beating Margaret Court in the semi-final and Billie Jean in the final. Haydon Jones reached six other Grand Slam finals and became a respected official and tournament director of the WTA event at Edgbaston.*

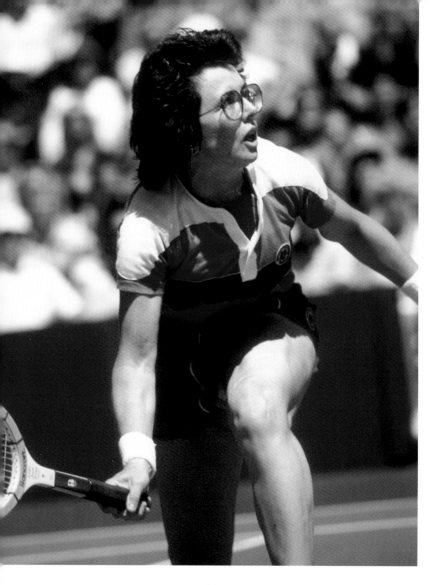

design the ending; no one knows who will end up at the top of the windmill.

One minute, the money was on Evert, and then, once again, Navratilova pounced, allowing a shocked opponent only one point out of the next twelve to pull back to 5–5 and 0–40 on the Evert serve.

"I thought I'd blown it," Evert admitted. "On the next point, I went for a winner, like you do when you are so far behind."

"And Martina missed the forehand volley," said Ted Tinling some time later, using his innate understanding of the game and instant recall to pinpoint the *moment juste*. "That was the shot

that lost her match. It was one of the most outstanding cases I have ever seen of a match being lost on one point."

Maybe Evert sensed it because her chin came up, the eyes narrowed, and the dainty little strut appeared once again in her walk. With the crowd in a state of Gallic frenzy, Evert held serve and when Navratilova chipped an approach to her backhand on match point in the next game, the lady from Fort Lauderdale hit the backhand that she may remember most when she finally throws the racket in the closet: the ripping two-hander that sped up the line to earn her the French title for the sixth time.

"I was ecstatic," said Evert. "Beating Martina is always rewarding, but doing it in a Grand Slam final is enough to keep you going for another six months."

Chris Evert kept going for a lot longer than that. She returned to Paris to win a seventh title the following year—this time, getting the better of Navratilova with 6–3 in the third—and continued on until she had reached the Wimbledon semi-final and the US Open quarter-final in 1989, before calling it quits.

Navratilova, of course, went on and on, appearing in the singles draw at Roland Garros and Wimbledon in 2004, when she was forty-eight and becoming the oldest woman to win a Grand Slam title when she partnered with Bob Bryan to triumph in the mixed doubles at the US Open in 2006, one month short of her fiftieth birthday.

The Evert–Navratilova rivalry seemed as if might last forever, but that couldn't happen and, in 1985, a Parisian spring was producing buds that would

bloom in the not-too-distant future. On her way to the final, Evert had needed to beat a striking teenage Argentine named Gabriela Sabatini in the semi-final and, earlier, a young German named Steffi Graf. Sabatini, at the age of fifteen, had become the youngest player ever to reach a Grand Slam semi-final, while Graf was embarking on a career that would see her win twenty-two Grand Slam singles titles.

Another player of rare grace and talent would charm tennis fans throughout the seventies: Evonne Goolagong Cawley. An aboriginal by birth, Cawley was brought up in Melbourne by her coach and foster parent, Vic Edwards, who

took a young girl who seemed barely aware of her talent and taught her how to become a champion. Everything appeared so effortless with Cawley that neither spectators nor, more importantly, her opponents seemed to understand what she was achieving on court with her smooth, flowing groundstrokes and perfectly placed volleys.

Soon, everyone started to recognize a formidable competitor who proved herself capable of winning Grand Slam titles. There were seven in all, beginning with Wimbledon in 1971, and ending all of nine years later with another Wimbledon triumph, having missed numerous tournaments through

(opposite) *Billie Jean King, already a vocal advocate for innovation and women's rights.*

(above) *Chris Evert—already a star in her teens.*

The Battle of the Sexes

Despite a growing appreciation and better promotion—much of it as a result of the hard PR work put in by the likes of Billie Jean King, Rosie Casals, and Ann Jones—nothing put tennis on the world's front pages like a match that was quickly dubbed "The Battle of the Sexes" between Billie Jean and Bobby Riggs. Nothing came close. In fact, it seems impossible to imagine one tennis match capturing the imagination of the public at large so forcefully ever again.

It was staged amid incredible hoopla at the Houston Astrodome in front of more than thirty thousand people, thought to be the biggest crowd ever to watch a tennis match, on Sep-

tember 20, 1973. And such was the interest that it was viewed on television by ninety million people worldwide, including fifty million in the United States.

Why? Like everything, the timing helped. In America particularly, the women's liberation movement, which was led by Gloria Steinem and others, was on the move in the early seventies and Billie Jean King was already becoming a recognized voice in support of the cause. She also found it impossible to resist a challenge and there was no one better than throwing down outlandish challenges than fifty-six-year-old former Wimbledon champion called Bobby Riggs.

Setting himself up deliberately as the ultimate male chauvinist pig, Riggs insisted that he could beat any woman player on earth and proceeded to lend credence to the fact by playing—and beating—Margaret Court at Ramona, California. Court was not up for the fanfare and American-style banter that surrounded the match, and Riggs played it to the hilt. When they walked on court, Riggs presented Court with a Mother's Day bunch of red roses. Court curtsied. Psychologically, he had the match won already and, using drop shots and lobs to great effect, proceeded to humiliate the tall Australian 6–2, 6–1.

Gleefully, Riggs then threw the gauntlet at Billie Jean's feet. But, this time, he had chosen a very different type of opponent. Male chauvinism flowed off the feisty Californian's back like water, and Billie Jean, who was fired by the need to stand up for her sex, seized the opportunity with all her customary gusto.

The publicity build-up to the event was extraordinary. Hundreds of reporters descended on Houston, while Ted Tinling, who was making dresses for all the top women's stars in those days, sat up half the night personally sowing thousands of sequins onto Billie Jean's dress. She glittered, and not even Las Vegas could have staged it with greater over-the-top pizzazz.

Billie Jean was born aloft into the arena by four bare-chested musclemen dressed as slaves in a scene that would have met with Cleopatra's approval. Riggs followed in a rickshaw. This time, he presented his opponent with a giant lollipop. But Billie Jean was ready with the perfect response: a toy piglet.

Once the symbolism had been somewhat obviously established, the tennis began. It was clear from the start that King was not going to allow Riggs to play his favored game and stayed back, making him run from side to side with measured groundstrokes. The tactics did not help the older player, especially as it had been agreed to play the match over the best of five sets.

After Billie Jean had won a hard-fought first set, Riggs felt the need to start charging the net and the outcome became a foregone conclusion. Billie Jean won 6–4, 6–3, 6–3 and Riggs, shattered by the severity of his defeat, was forced to tell her, "I underestimated you."

The extent of the media coverage the next day was extraordinary. It seemed as the whole of America was talking of little else. *The Los Angeles Times* was not alone in leading its front page with an article that must have exceeded three thousand words.

If nothing else, it established Billie Jean King as a uniquely committed sports star who was prepared to put herself and her beliefs on the line. Without doubt, feminism and women's tennis were the ultimate winners.

(opposite) *"There, there dear . . ." Bobby Riggs, playing the chauvinist to hilt with Billie Jean King in "The Battle of the Sexes." It didn't work. Riggs lost.*

(above, left) *"The Battle of the Sexes" stuck in the imagination of the American public for so long that decades later they made a movie about it.*

(above, right) *Billie Jean King "Battle of the Sexes" pin.*

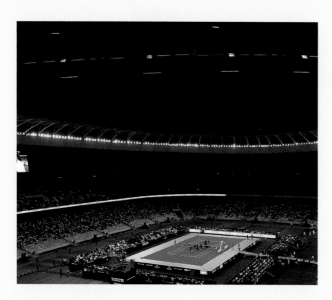

50,954
Largest Crowd Ever

Although largely undocumented, the largest crowd ever to watch a single tennis match at the time was the approximately forty-six thousand spectators who crammed into a soccer stadium in Peru to watch their native son, Alex Olmedo, who had just won the Davis Cup in USA colors and was the 1959 Wimbledon champion, play his teammate Butch Buchholz. The exhibition match was played in March 1959 and Buchholz has in his possession a picture of the match with the vast crowd in the background. Exact attendance figures are questionable, but Roger Federer played Sascha Zverev in an exhibition match in Mexico City in 2019 that attracted forty-two thousand, and then established the world record by a distance in February 2020, when he played Rafael Nadal in front of 50,954 people at the Cape Town football stadium, raising more than $3 million for his African charities. Organizers said that the interest in Federer playing his first-ever match in his mother's home country was such that it had attracted two hundred thousand inquiries for tickets.

(above) *Zverev v. Federer in Mexico City.*
(opposite) *Margaret Court.*

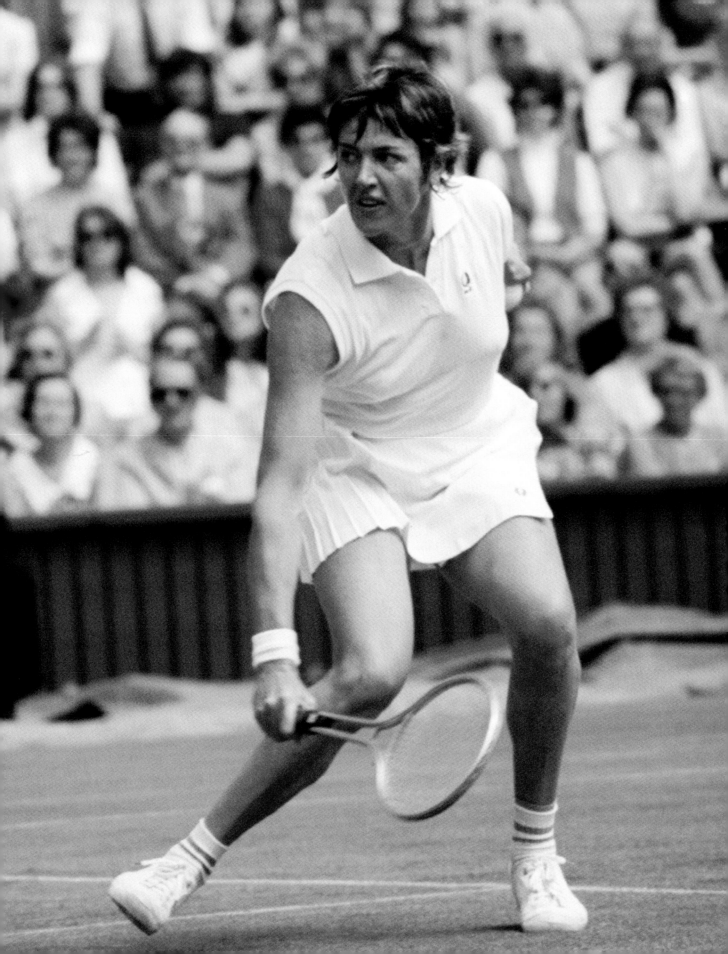

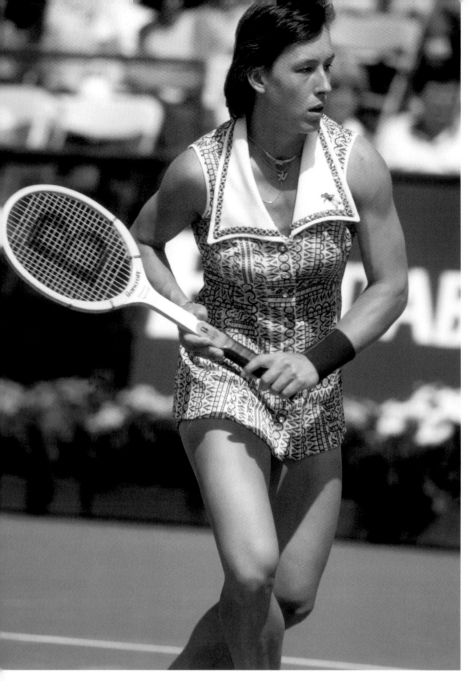

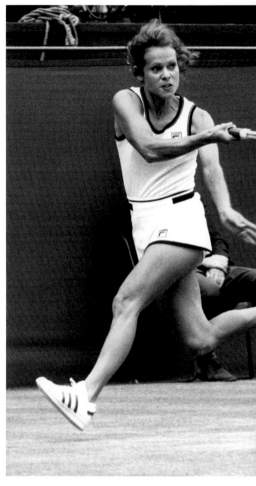

(above, left) *Martina Navratilova, in her early days on the tour, lining up a backhand volley with her wood-framed Bancroft racquet.*

(above, right) *Evonne Goolagong Cawley became Australia's first Aboriginal sporting star. Her graceful game brought her two Wimbledon crowns—before and after motherhood—and a total of thirteen Grand Slams in singles, doubles, and mixed.*

(opposite) *Tall, tanned, young, and lovely—the girl from Argentina, Gabriela Sabatini, was all those things as well as a US Open singles champion in 1990.*

marriage and babies. Sweet and shy in her twenties, Cawley took her British husband and their family back to Australia after she retired and became a forceful and much-admired advocate for Aboriginal rights in her homeland.

So, like the decades that followed, the sixties and seventies saw women's tennis thrive through the diversity of its great champions. Their vastly dif-

fering personalities and backgrounds captured the public imagination and enabled Gladys Heldman and Billie Jean King to establish women's tennis as the most international and popular sport for female athletes in the world.

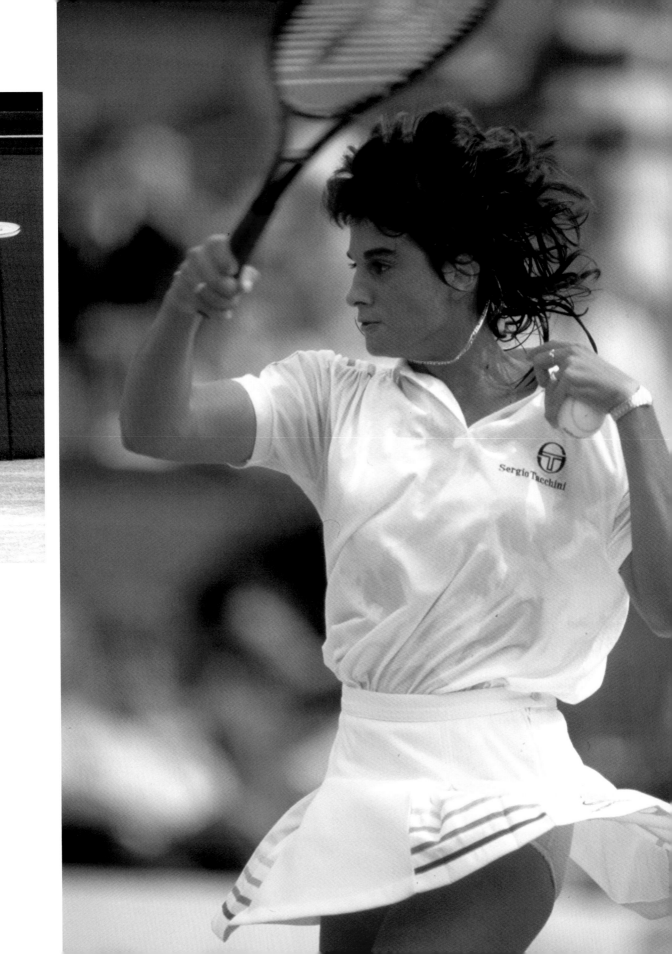

9

The Eighties

It was *the* tie break. For anyone who was enjoying even a peripheral interest in professional tennis in the early eighties, it needed no explanation. It was Bjorn Borg vs. John McEnroe. It was the Wimbledon final. It was sporting theater. It was *unforgettable*.

The spectacular happening of Billie Jean King playing Bobby Riggs was an extraterrestrial occurrence as far as the game was concerned—a social phenomenon played outside the normal confines of the sport. The Borg vs. McEnroe tie break, however, was woven into the fabric of the game, played out on what is considered the very epicenter of tennis, Wimbledon's Centre Court. And not in any match of any round, but the final—the contest every boy or girl who ever picks up a racket fantasizes about participating in. And not between any two players, but the two greatest stars of the era: the quiet, unflappable, steely-eyed Swede and the wild, rambunctious, and sometimes ugly American. Only sport at the highest level could script such drama.

The match took place on Sunday, July 5, 1980. Bjorn Borg was the reigning champion of the previous four years—a king apparently secure on his throne. John McEnroe was the young upstart who had crashed the garden party in alarming style as an unseeded and almost unheard of meteor in 1977, reaching the semi-final by playing a brand of unorthodox left-handed serve-and-volley tennis no one had ever seen before.

In the two intervening years, McEnroe had disappointed himself at Wimbledon, losing to fellow American Erik van Dillen in the first round in in 1978, and to another American, Tim Gullikson, in the fourth round the following year. He had, however, given credence to his extraordinary talent by winning the US Open in 1979, with a straight-set win over his New York neighbor and great friend, Vitas Gerulaitis.

During this time, the Borg–McEnroe rivalry had been developing apace as the twenty-one-year-old American overtook Jimmy Connors to rise to number two on the ATP ranking list. By the time they arrived at Wimbledon, Borg had a narrow 4–3 edge in head-to-head matches—the Swede having managed to deal with McEnroe's fiery aggression in the ATP Masters at Madison Square Garden the previous January 6–7, 6–3, 7–6 in their most recent encounter.

So pundits were expecting and hoping for the pair to meet in the Wimbledon final and when McEnroe served well enough to beat back a typically intense challenge from Connors in one semi-final, while Borg accounted for yet another American, Brian Gottfried, in the other, the stage was set. It was, wrote John Barrett in his extensive book *Wimbledon: The Official History of the Championships*, a "final fit for the gods."

And the gods delivered. The packed fifteen thousand crowd in Centre

(top) *A fifth straight Wimbledon title for Bjorn Borg, having survived the epic tie break against John McEnroe.*

(bottom) *John McEnroe—a complaint, maybe?*

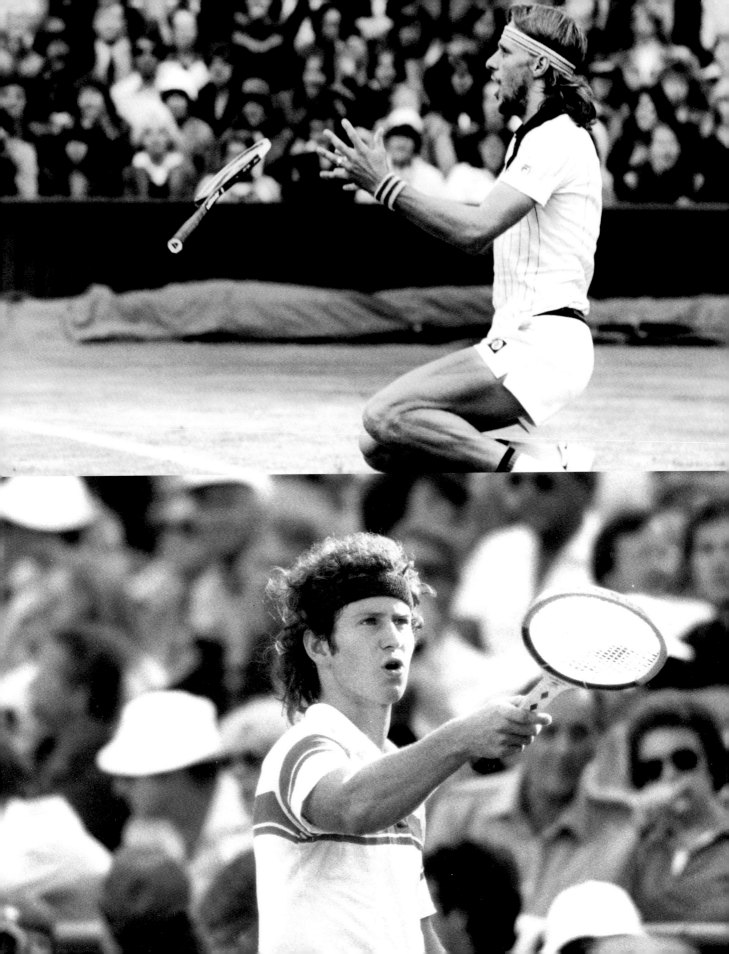

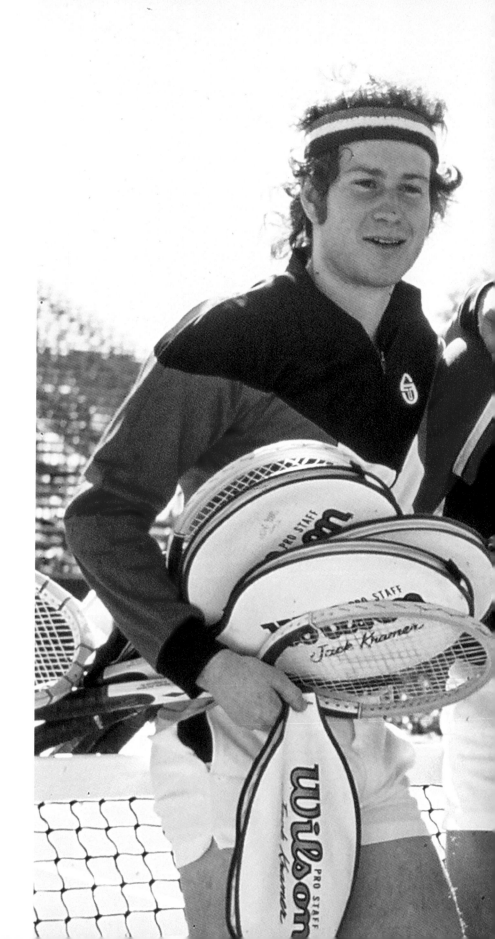

How many balls did this quartet hit against each other? Too many to count. Left to right, John McEnroe, Vitas Gerulaitis, Guillermo Vilas, Bjorn Borg. (Photo by Art Seitz)

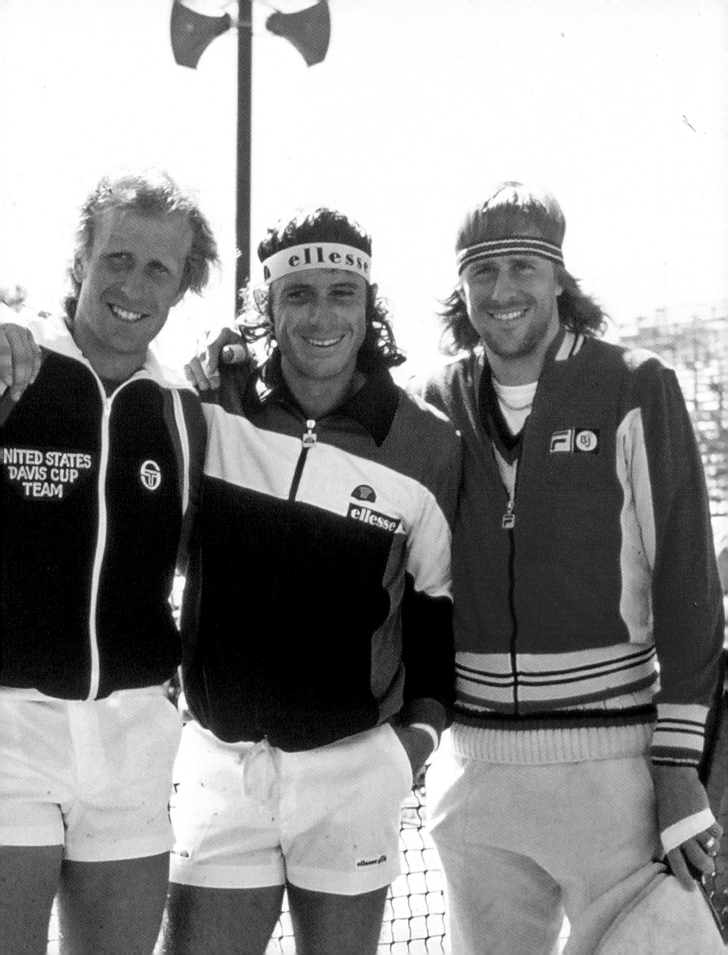

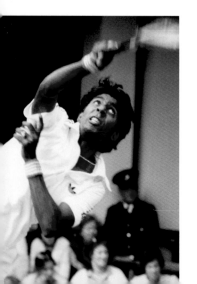

(above) *When Bjorn Borg became engaged to the Romanian number one Mariana Simionescu, Rick Fagel, a Florida player who knew how to organize a celebration, hired a penthouse at a Miami hotel for Borg's bachelor party. The jacuzzi, which Vitas Gerulaitis is enjoying here, was only one of the attractions. (Photo by Art Seitz)*

(below) *Vijay Amritraj, India's greatest ever player, lines up a smash on Wimbledon's Centre Court. The middle of three tennis playing brothers from Madras, Vijay later captained India in the Davis Cup and became a UNICEF ambassador and businessman, as well as featured in a James Bond movie* Octopussy *with Roger Moore.*

Court were offered a master class in grass court tennis by McEnroe in the first set, which he swept through 6–1, losing only seven points in four service games. Borg, searching for his rhythm, remained outwardly implacable and concentrated on staying with the New Yorker as the second set unfolded. But he was teetering on the edge of what would have been a critical loss of serve in the ninth game, when the precision of McEnroe's volleying took him to the brink of three break points.

Nerveless under pressure, like all great champions, Borg reached for one of his most lethal—and underestimated—weapons and, on each occasion, he came up with unreturnable first serves. Holding for a 5–4 lead, Borg started to gain the desired length on top-spun returns and, at 6–5, he finally produced a couple of dipping service returns that forced errors out of McEnroe's low volley. Suddenly, it was one set all, and the champion seemed empowered.

Jumping to a 3–0 lead in the third set, Borg staved off break points at 4–2

and closed it out 6–3. The duel had become a classic contest between a player whose instincts were to stay back and pass against the all-out aggression of a natural serve and volleyer. Speed of eye and foot were of the essence and both men were so fast that it was impossible to determine who was reacting quicker to the thrust and counterthrust.

After two and a half hours of enthralling combat, Borg seemed to have made the crucial breakthrough when he broke McEnroe to lead 5–4 in the fourth and then reached two match points at 40–15 on his own serve. McEnroe took care of the first with a backhand winner and then, in a moment that so typified his style and temperament, saved the second with a forehand drive volley plucked out of the air. Was it the act of a madman or a genius? Barrett wanted to know. It was a question that we found ourselves repeating again and again throughout this extraordinary player's career.

All that mattered in this instance was the fact that it helped McEnroe run off six straight points and set up a tie break that, as tennis historian Steve Flink said in his book *The Greatest Tennis Matches of the Twentieth Century* became a match in itself.

It lasted twenty minutes and drenched the Centre Court in drama and emotion. By the time McEnroe reached his first set point at eight points to seven with a sizzling passing shot, Borg had been deprived of two more match points. But a forehand pass saved the Swede and, when he needed to save another set point at 9–8, he came up with a winning volley of his own. At 9–9, McEnroe couldn't handle a penetrating first serve, and the Swede had match point number five. More breath was stifled and gasps caught in

the throat as the American's swinging left-handed serve got him out of trouble again and on it went, the ultimate roller coaster swinging from match point to set point and back with a net cord coming to McEnroe's aid on the sixth match point.

The players changed ends for a fourth time at 12–12 and a fifth at 15–15. Without the need to lock themselves into a vice of concentration, the spectators were looking more emotionally disheveled than the two young athletes as they continued to test each other's skills to the limit. At 16–16, Borg's forehand dropped an inch long, and McEnroe had his seventh set point. Borg put in a good first serve and charged in behind it only to see his attempted drop volley fall into the net. 18–16. It was over. The crowd rose, and the players seemed dazed. But, of course, it was not the end of the match.

"So many people I meet think I won the match because I won that tie break," McEnroe told me many years later. "But, in fact, Bjorn controlled the fifth, and I couldn't find a way to get at his serve."

In fact, Borg produced one of the greatest serving performances ever seen in a fifth set of a Wimbledon final. After recovering from 0–30 in the opening game, the Swede served five love games and won twenty-eight of his next twenty-nine service points. McEnroe, who had been frantically digging himself out of 0–40 situations, finally succumbed at 15–40, 6–7 when his tired volley sat up invitingly and Borg swept it away for a backhand cross-court winner before sinking to his knees.

Two months later, McEnroe got his revenge in the final of the US Open on hardcourts at Flushing Meadows. It was a strange encounter with Borg once

again being outplayed by the aggressive American at the start and Borg actually went down two sets to love before resetting his metronomic baseline play to claw his way back to parity. However, in the fifth, McEnroe pounced, broke for 4–3, and ended up a deserving winner by 7–6, 6–1, 6–7, 5–7, 6–4.

So the rivalry was on a knife edge and as neither man played the Australian Open, which was struggling to attract the top names for a couple of years, it was Borg's turn to regain the ascendancy when he won his sixth French Open title with a 6–1 in the fifth victory over the new Czech star Ivan Lendl, whose clay court expertise had proved too solid for McEnroe in the quarter-finals.

At Wimbledon, Borg struggled to keep his winning streak alive when he went two sets to love down against Jimmy Connors in the semi-final but Connors, who had needed five sets to overcome the elegant Vijay Amritraj in the quarters, tired toward the end and with Borg coming up with sixteen aces when he needed them most. Connors lost the last three sets 6–3, 6–0, 6–4.

So Borg went into his sixth consecutive Wimbledon final with an unbeaten streak of forty-one matches on the grass courts, which were not supposed to be ideal for his game. But his chances of extending this amazing run were being eroded by the ever-more-potent opposition being provided by McEnroe, who was not merely a grass court natural but a bit of a genius to boot.

It was the Swede who got off to the better start for a change, taking the first set 6–4, with some incisive returns but this time, however, the match did hinge on tiebreaks and although neither matched the drama of the previous year's epic, McEnroe's ability to grab

No nonsense Ivan Lendl usually kept his feet on the ground, but he's airborne for this thumping forehand.

the big points earned him a two set to one lead. The die was cast, the tide had turned, and the irascible young man with the red head band was poised to become a very different sort of Wimbledon champion. Serving and volleying with sublime skill, McEnroe closed it out 4–6, 7–6, 7–6, 6–4 and some members of All England Club establishment didn't know whether to laugh or cry.

Although McEnroe usually behaved himself when playing Borg, for whom he had the utmost admiration, phrases that went into the lexicon of the game such as "You cannot be serious!" (and others less quotable) had spilled from his lips consistently in early round matches through the years and headlines branding him a brat followed him everywhere.

McEnroe's inability to control his hopelessly volatile temperament hurt no one more than himself, and he was quite intelligent enough to realize it. But, in his early years, that did not help. Time and again, the explosive nature of his emotions allowed the volcano to erupt, and it was not a pretty sight. Instances were many, but one of the worst came in the first round of that 1981 Wimbledon when he found himself facing Tom Gullikson on the old Number 1 Court, which no longer exists. In retrospect, it is surprising that the fury of his temper did not demolish it there and then. In the chair, Scottish umpire Edward James was so confused about what he was hearing that he wrote down, "He said, 'You're the piss of the world.'" In fact, McEnroe had said "pits," but it would not be the last time that he was misunderstood.

"I lost control of myself," he told me later. "I probably didn't realize it was as bad as it looked. I didn't feel I had done anything that terrible by the time I got the second warning. But there were all sorts of things that were building up

inside that I couldn't control. Everything aggravated me because I had put so much pressure on myself to do well."

No one could ever accuse McEnroe of not being honest about himself. Once, after a loss in the ATP Masters at Madison Square Garden, he walked into press conference where reporters were preparing to take him to task and opened up. "If I play like that, I have no right to call myself a professional tennis player."

There was no fiercer critic of John McEnroe than the man himself. But, especially in America, where middle-class tennis fans were embarrassed by the image of the ugly American that he was transporting abroad, mea culpas were not enough to bring people to his side. Even those who realized and even appreciated that we were in the presence of sporting genius could not bring themselves to warm to him. But did he care? Not really.

In another soul-searching talk we had at the time, he said, "I don't really consider myself a celebrity. I don't like what goes with it. I want to be myself. I want to be known as a top tennis player, but not all the other bullshit that goes with it. I don't like being a phony—and that's what happens when you start meeting hundreds of different people all over the place. I prefer to be honest. I think that's more important than

(opposite) *"Excuse me?" or some other the polite enquiry from John McEnroe.*

(above and below) *The age-old London Grasscourt Championships at the Queen's Club struggled for a few years before a brilliant advertising campaign, which was designed by Sir Frank Lowe, was backed up by the return of top players like Jimmy Connors, Ilie Năstase, and the guy with the headband. That was all John McEnroe, already so famous, needed. Queen's has been a sellout ever since.*

Super

Brat

JOHN MCENROE WAS A WINNER AND A WHINER. A SUPER TALENT NICKNAMED SUPERBRAT. A LEFTHANDER WITH ALL THE STROKES, HE NEVER FELT A NEED TO STROKE ANYBODY.

being liked by everyone. But I know I have to learn to handle people, and you could say there is room for improvement there!"

There was indeed, and the improvement was slow—in stark contrast to his soaring talent. McEnroe was playing a brand of tennis that no one had ever seen before. His sliced serve to the advantage court, delivered with the acute angle that only left-handers seem able to conjure up, and took opponents so far out of court that their return—if they could muster one—became a sitting duck for the lethal McEnroe volley. And, when returning, McEnroe would shuffle in to pick up second serves on the half volley, startling and confusing opponents in the process.

Despite a very laid-back attitude toward training, which ensured that his thighs remained pudgy well into his twenties, the Trinity High School soccer player was exceptionally fast, and when this asset was added to his delicate racket skills and quick brain, opponents found themselves being out paced, out hit, and out thought. Bjorn Borg was no exception.

The defeat in the Wimbledon final had flagged a turning point in the great Swede's career. Two months later, in the final of the US Open, it was plain for all to see. I described what happened in my McEnroe biography, titled *McEnroe: A Rage for Perfection*:

In less than four minutes on a blustery afternoon at Flushing Meadow in September 1981, John McEnroe uncorked four knockout blows that finally and irrevocably stripped the mantle of supremacy from Bjorn Borg's shoulders. The score in the final stood at one set all and 4–3 to Borg in the third with the Swede's serve to come. For the first time in a fluctuating and far from

error-free match, Borg was starting to find an easy rhythm with his baseline drives, and the packed Stadium Court crowd of twenty thousand was giving him every encouragement as he glided toward a two set to one lead.

Then, suddenly, McEnroe turned everything inside out. Five points later McEnroe was a different player and we were watching a different match. John admitted afterward that the way he played that game made him feel as if he could hit any shot he wanted. Those who saw it could understand why.

McEnroe won four of those five points with outright winners: the first was a scorching backhand cross-court pass on the return of serve; the second a top spin lob deep into Borg's backhand corner that the Swede, caught very close to the net, never bothered to chase. They were both exquisite shots that would have been difficult to reproduce at any stage. But, after allowing Borg one point, the defending champion reproduced both instantly, in sequence, as if he was providing his own live version of instant replay—backhand pass, top spin lob. Borg looked stunned and no wonder. Even he, who had taken a longer, closer look at McEnroe's talent in the past few years than anyone else in the game, was shocked by the streak of genius that had just flashed before him. The power of one shot and the precision of the other, each repeated in perfect harmony at a crucial, pivotal moment of the match, revealed a rare and instinctive gift shared only by the greatest champions. Borg has that gift and seeing it so clearly and so cruelly reflected in his opponent's play made it much more psychologically damaging.

Borg never recovered. Two games later, a stinging forehand winner clinched the set 6–4 for McEnroe.

They could be mistaken for three young account executives out for a stroll, while in fact, this rare shot shows the three greatest champions of their generation walking across Wimbledon's Centre Court, where they wrote tennis history. John McEnroe (three), Jimmy Connors (two) and Bjorn Borg (five) racked up ten Wimbledon titles between them. McEnroe and Borg remained fast friends—Connors not so much—but all three could chuckle at past rivalries. (Photo by Art Seitz)

So the New Yorker, who was in the habit of driving to what is now known as the Billie Jean King Tennis Center from his home in Douglaston, controlled the remainder of the match to retain his crown and leave an indelible mark on his great rival. In becoming the only man apart from Bill Tilden since World War One to win the US title in three successive years, McEnroe elevated himself to new heights but, to his genuine disappointment, he never again was able to test his skills against the man he called a friend because Borg retired.

McEnroe himself was partially to blame because Borg could not stomach the thought of further humiliation. But it was more than that. Bjorn, by then twenty-six, had been playing tennis nonstop all over the world since he was sixteen and he was both mentally and physically exhausted. So he went to the Pro Council and asked for a reduction in the number of tournaments that he was mandated to play each year. He pleaded not just for himself, but for any top player who inevitably was being asked to play more matches than most, because consistent winning means you have to play more matches each week.

But, remarkably, he was turned down. Despite the ITF president, Philippe Chatrier, understanding full well what the players were going through, he and his committee felt that no exceptions could be made. It was a fatal mistake that did no service to the game. Borg told them that, if he was not offered a reduction, he would quit. They didn't believe him. And he called their bluff. They had forgotten one of the most-ingrained characteristics of all champions: they are exceptionally stubborn. Push, and they push back. So Bjorn Borg packed up his rackets and did just what he had threatened to do. And the game was poorer for it.

A year later, the Pro Council recognized the error of its ways and allowed players of a high ranking, who had played a certain number of years of the tour, to play a reduced schedule. It was too late. The career of one of the world's greatest-ever players had been cut short by blind bureaucracy.

Eight years later, Bjorn Borg did attempt a comeback, but it was far too late and the fact that he insisted—stubbornly, of course—in playing with a wood racket did not help his cause. Re-appearing at Monte Carlo, where he had won so many titles, he lost in the first round to the Spaniard Jordi Arrese.

Given the amount of talent he possessed, McEnroe might have made a better job of dominating the men's game in the two following years, but he was not at peace with himself. The temperament and the talent were in constant conflict and it was a travesty that he won only one Grand Slam title—1983 Wimbledon—during those years immediately following Borg's retirement. Subconsciously, it is possible his intensity dropped a fraction. For McEnroe, Borg was the greatest rival that he would ever have and now, the Swede was not there to provide a barometer of his own greatness.

In 1982, he missed both the Australian and French Opens; lost his Wimbledon title to Connors in what, for him, was a mediocre performance on his favorite grass court; and then, to his disgust, allowed himself to be outplayed by Ivan Lendl, a player whom he never liked, 6–4, 6–4, 7–6 in the semi-final of the US Open. Lendl, who went on to lose to Connors in the final, was at the beginning of an extraordinary run at Flushing Meadows that saw the strapping Czech reached eight consecutive finals between 1985 and 1987.

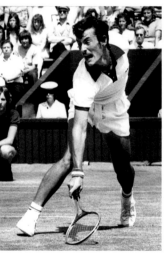

(opposite) *Flamboyant and funny Vitas Gerulaitis was one of the game's most popular stars.*

(top right) *Vijay Amritraj, India's Davis Cup captain, shares a joke with Peter McNamara, the popular two-time Wimbledon doubles champion with Paul McNamee, who became a top-class coach before dying far too young from cancer.*

(bottom right) *Sandy Mayer, who won the French Open in 1979, in partnership with his two-handed brother Gene, beating Ross Case and Phil Dent in the final.*

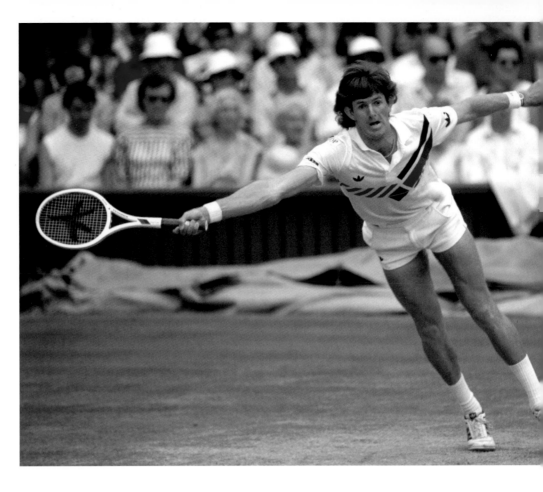

A semi-final showing at Kooyong, where the Australian Open was played on grass in those days, and a quarter-final again in Paris offered some encouragement before McEnroe regained his dominance at Wimbledon, crushing the unlikely finalist from New Zealand, Chris Lewis, 6–2, 6–2, 6–2.

However, the US Open remained out of reach for a second straight year and, once again, he lost to a player who irritated him beyond measure. Bill Scanlon was a bright, brash young Texan who was not intimidated by McEnroe and let him know it. In addition, Scanlon had talent and, with his ability to handle the New Yorker's serve, he scored a major upset in the fourth round by defeating the three-time former champion, 7–6, 7–6, 3–6, 6–4.

In less than obvious fashion, all this led to 1984—the year that should have

been John McEnroe's master canvas. But being who he was, it could not be delivered without blemish. The two large blotches came at Roland Garros, where he had the French Open title virtually under lock and key before allowing his wayward temperament to hand it to Lendl on a plate and then, much later in the year when the US Davis Cup team disgraced itself in the final while losing to Sweden in Gothenberg.

The statistics tell part of the story. McEnroe won thirteen titles in 1984, including Wimbledon, the US Open, the WCT Dallas Finals, and the ATP Masters at Madison Square Garden. His overall singles record was 82–3. Apart from the loss to Lendl in Paris, he went down to Vijay Amritraj in Cincinnati and Henrik Sundström during *the Davis Cup* fiasco in Gothenburg. Other than that, he was un-

touchable and statistics don't tell the whole story.

As a player, he was living every athlete's dream. If he was not actually invincible, the locker room felt that he was. It wasn't just the winning but the manner of it. McEnroe had always been striving for the impossible—namely, to win a tennis match 6–0, 6–0, 6–0 without losing a point. The game is too difficult for that but, in the Wimbledon final, he came close, considering the standard of the opposition. Jimmy Connors, a man who fought for every point, never knew when he was beaten and had won more titles than anyone else in history, but he was wiped off the Centre Court 6–1, 6–1, 6–2 by McEnroe. Despite being one of the best returners the game has ever known, Connors won just eleven points off the McEnroe delivery the entire match.

It was a mesmerizing performance, and for once, McEnroe kept a fierce grip on his concentration and temper. He found the manner in which he won his third and last Wimbledon title deeply satisfying but the extent to which he was able to enjoy the occasion remained shrouded inside the soul of this complex man.

Eugene L. Scott, publisher and editor of *Tennis Week* magazine and a former Forest Hills semi-finalist, alluded to this in his report on the Championships. "McEnroe may not look as if he is having fun, but he should be because his game is so playful," wrote Scott. "He has hiding places for the ball that other little boys cannot possibly find. His angles are the apotheosis of hide-and-seek, with no seek currently available for his rivals. . . . McEnroe's virtuosity simply left no room for any-

(opposite) *Kevin Curren, with a whiplash, skidding serve from a low toss, beat Stefan Edberg and Jimmy Connors on his way to reaching the 1985 Wimbledon, where he lost to seventeen-year-old Boris Becker. In recent years, Curren has been captain of South Africa's Davis Cup team.*

(left) *One of several fine Swedish players of his era, Henrik Sundström, caused one of the great Davis Cup upsets when he defeated John McEnroe in the 1974 final at Gothenburg and helped Sweden win the Cup for the second time.*

(right) *With his small framed T-2000 Wilson steel racket, Jimmy Connors was able to add power to his volley—even at a stretch.*

(above left) *Mats Wilander's smooth, intelligent game enabled him to win Roland Garros as a teenager in 1982 and in 1988, he achieved the rare feat of winning three of the four Grand Slams. Only Wimbledon eluded him before he became one of the game's shrewdest television analysts.*

(above right) *Erik van Dillen, a Grand Slam doubles finalist and a member of the winning US Davis Cup team in Bucharest, Romania, in 1972, van Dillen kept the locker room amused by re-enacting half the dialogue of* Blazing Saddles.

(opposite) *You need to be big and strong to hold up that Cup, but exceptionally so to win Wimbledon at the age of seventeen, as Boris Becker did in 1985.*

one else on stage. If Eric Clapton were McEnroe that day and Connors Pete Townshend, Townshend would have unplugged himself and listened."

It was McEnroe's good fortune to be coached on the guitar by Eric Clapton and his misfortune never to become remotely good enough to live his dream of becoming a rock star. So he had to be content with being the rock star of his sport. But that, of course, did not mean he could rid himself of the self-destruct button.

The French Open final provided the classic example. Feeling confident on red clay for the first time in his career, after overcoming Connors in the semi-final, McEnroe proceeded to weave his magic against Lendl's more rigidly constructed game in the final. The Centre Court crowd were with him all the way as

he wove intricate patterns on the clay, breaking the Czech serve three times as he raced to a 6–3, 6–2 lead. Spectators at Roland Garros are largely players themselves of one sort or another, and they know how difficult it is for attacking players to adapt to the requirements of this special surface. Or simply override them. That, of course, required talent, and McEnroe had it in abundance, which was why he was in control of the match but not his temperament.

In the third game of the third set, with Lendl already struggling on serve at 0–30, a disembodied voice started crackling in a cameraman's earpiece at courtside. We could hear it in the first row of the press seats, so it must have sounded even louder to McEnroe's highly sensitive ear. This was a man who could be distracted by someone sneez-

ing in row twenty, so it was hardly sur-
prising that he reacted. But the extent
to which he reacted, however, was both
absurd and fatal. He completely lost his
concentration and allowed Lendl, who
had never won a Grand Slam title at
that stage of his career, some precious
moments to steady his ship. McEnroe,
meanwhile, was complaining about the
noise and just starting to feel the heat—
not the heat from his opponent's racket,
but the actual heat of a sunny summer's
day in Paris. Ridiculous as it may seem,
his decision to do away with the head-
band that had become his trademark
during the early years of his career may
have proved a fatal mistake. Because his
forehead was turning red and, later, it
became apparent that he suffered some
mild form of sunstroke. The following
afternoon, when we had both travelled
to London and met in the lounge at the
Queen's Club, he said, "Feel it—feel my
forehead. It's on fire."

And it was. That was why, for the
rest of his career, McEnroe protected
his fair, freckly Irish skin with head-
scarves whenever he played outdoors.
But the damage had been done. The
nerves, the complaining, the effort, and
the tension contrived to combine with
the heat of the sun and sap his energy.
As the third set progressed and Lendl
measured his back-court drives with
ever-increasing care and determination,
McEnroe started to lose a fraction of
his pace.

"He's getting tired," whispered the
former French number one Pierre Bar-
thès to a companion in his courtside
box. As a serve-and-volley player him-
self, so rare for a Frenchman, Barthès
knew what it took to play that style of
tennis on clay and his early detection of
McEnroe's problem was a harbinger of
things to come.

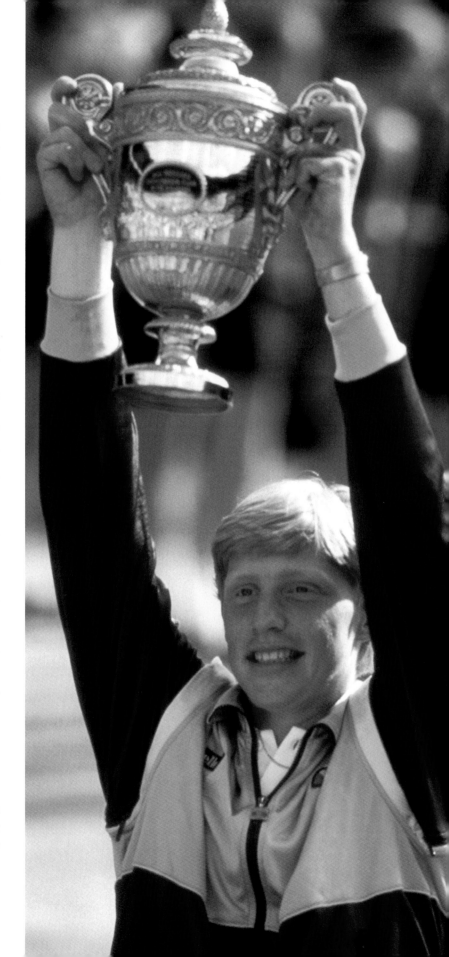

Just two games after his screaming fit with the cameraman, McEnroe had Lendl 0–40 down and then, falling flat trying to reach a blistering Czech forehand, he let another break point slip in that fifth game of the third set. They were mistakes that he could no longer afford. Suddenly, Lendl broke only to be broken back immediately. The Czech knew the match was changing and ripped a magnificent backhand service return down the line as he attacked an American serve that was beginning to lose its bite. A point later, he clinched the set 6–4, but even in the fourth, McEnroe had his chances, coming out ahead after three consecutive breaks of serve. But Lendl, however, had got his teeth into the match and would not let go. Grabbing the set 7–5 with some more powerful returns, Lendl benefited from McEnroe's forehand errors when he had chances in the fifth. The Czech was eventually rewarded for his strength of mind and body when, for the first time in the match, he went ahead at 6–5, 15–40 on the McEnroe serve. One match point was saved but not the second and so, from the depths of a two-set deficit, Ivan Lendl had followed in the footsteps of his compatriots Jaroslav Drobný and Jan Kodeš to become Champion of France.

The victory set Lendl on the path to many more triumphs, but McEnroe never got over the loss and never will. It was not just the fact that he let a Grand Slam title slip from his grasp, but the *French* title—the one that he always knew would be hardest for him to win, the one that could have established him among the greatest champions who had proved themselves capable of winning on all surfaces.

John McEnroe would never win a singles title on European clay—not in Paris nor at any level on the ATP Tour. The fact that Jimmy Connors never did either was of small consolation. He had blown it, and he knew perfectly well whom to blame.

It was ironic and seemingly unfair that two high-profile setbacks clouded a year that otherwise was flooded with sunshine and brilliance. Seemingly back to his invincible best at Wimbledon and the US Open, McEnroe was still riding the wave until America's Davis Cup team travelled to Gothenberg for the final and hit an iceberg. McEnroe felt the scar for months to come.

McEnroe played poorly but behaved well during his defeat to the clever, powerful Henrik Sundström, but Arthur Ashe's team was already holed amidships, statistically and emotionally. In stark contrast to McEnroe, Jimmy Connors, who never grasped the concept of being a team player, had left a nasty note for practice partner Jimmy Arias soon after the team arrived in Gothenberg, accusing him of being late (which he wasn't), and then found himself totally outplayed on the indoor clay court by Mats Wilander.

Connors had been complaining about line calls throughout the match and, at one stage, shook the umpire's chair in rage. At the end, Connors shook hands with Wilander but no one else, storming off court in a fury.

In a belated attempt to mend America's reputation, McEnroe made a point of shaking hands with everyone in sight after his loss, but more than good behavior was required in the doubles rubber, which he and Peter Fleming had to win but didn't. Suffering their first-ever defeat as a Davis Cup pair, the Americans went down 7–5, 5–7, 6–2, 7–5 to Anders Järryd and a nineteen-year-old youngster named Stefan Edberg.

The drama rumbled on long after Sweden's victory, and the ice lodged between members of the US team and the United States Tennis Association (USTA) officials took a very long time to thaw. Ashe, who was due to hand over the captaincy to Tom Gorman in 1985, pleaded on McEnroe's behalf when voices back home built up a chorus of criticism but the fact that it had been Connors who brought the team's reputation in disrepute fell on deaf ears.

The incoming USTA president, Randy Gregson, a more politically ambitious man than his popular predecessor, Hunter Delatour, was listening to his constituents in small town America to whom McEnroe, a brash, loud-mouthed New Yorker, was simply beyond the pale. Many of them, oblivious to the obscene asides that Connors constantly muttered under his breath to ball kids and officials, admired the midwesterner's fighting spirit and tended to blame him less than McEnroe. But Gregson, urged on by worried sponsors, found a way round that by demanding all future Davis Cup team members sign a good conduct pledge. McEnroe refused.

"I just can't face it," he told me the following year. "I still have a very nasty taste in my mouth about the whole thing. After all I have tried to do for the team, it hurts to be treated this way."

Make that all he had tried to do for the Davis Cup. The entire competition was under threat of becoming an irrelevance when leading players like Connors, Vitas Gerulaitis, and even, on a rare occasion, Ashe himself had opted not to play in the late seventies. Borg was also ambivalent on occasion, and that sort of attitude can become contagious. McEnroe, however, wouldn't have it. Even as a teenager, he stepped up and stated flatly, "My parents taught

me the there is no greater honor than to represent your country, and I will always be available to play Davis Cup for the United States."

And he had been, trekking off to face the wild, intimidating crowds in South America on clay courts, which required hours of toil. Ever since his debut in the 1978 final against Great Britain at the Mission Hills Country Club near Palm Springs, California, McEnroe had made himself available for the Da-

he decided to take a sabbatical from the game. There were a lot of things creating havoc in his mind, but I suspect the Davis Cup affair was the beginning of his disillusionment with tennis.

Even so, he answered Gorman's call in 1987 to head off down to Argentina and haul the United States back into the World Group, which he did by beating the obdurate clay court expert Guillermo Pérez-Roldán in five long sets, with Andre Agassi clinching promotion with a win over Martín Jaite. McEnroe's sense of patriotism was still strong, but the magic had waned, and a great talent was allowed to drift away. After 1984, he was never the same player again.

One of the great truisms and joys of sport is the fact that there has to be something new and unexpected around the corner. The 1982 French Open was always going to be different because, instead of turning up to claim the title he had won for four straight years and six times in all, Bjorn Borg had hired a boat and was sailing the Aegean Sea.

The smart money was on Guillermo Vilas, who was the 1977 champion and, after Borg, the best clay court player of his era. When the Argentine left-hander reached his fourth Roland Garros final, the die seemed cast. But something strange had been happening on the other side of the draw. A seventeen-year-old Swede named Mats Wilander from the small city of Växjö had been following up a semi-final appearance in Rome with more eye-catching victories. He had outlasted Ivan Lendl in the fourth round, Vitas Gerulaitis in the quarters, and the other top Argentine, José Luis Clerc, in the semi-final. However, not before this quiet young man with a sharp mind had insisted on having match

vis Cup and it would not be too much of a stretch to say that his commitment saved it. But now he was being asked to sign a piece of paper to say he promised to be a good boy by people he did not respect. He wasn't having it.

Obviously, his overall reputation played a huge role in the whole problem, but the fact remained that he was not to blame for what happened in Gothenberg. Gregson, however, didn't care and, even after the good conduct pledge fell by the wayside, Tom Gorman was told that he could not pick McEnroe for his team in 1985 or 1986.

With his private life starting to unravel, McEnroe hit bottom when he lost to Brad Gilbert at the ATP Masters at Madison Square Garden in 1986 and

point replayed. Clerc's shot had been called out but, in an amazing act of sportsmanship, Wilander told umpire Jacques Dorfman that the ball had been good. "I didn't want to win that way," Wilander explained coolly afterward. Clerc netted the replayed point, and Roland Garros had another Swede in the final.

But Wilander was not finished. He had learned about handling big occasions from watching Borg and had also, from a young age, become used to playing against adults at his local club. So the physical size of the heavily muscled Vilas did not scare him. In fact, it was the other way around. "I think he started to get nervous when I won the tie break in the second set," said Wilander, who became the youngest male ever to win a Grand Slam singles title, until Michael Chang usurped him in 1989.

On a scorching hot day in Paris, the score was 1–6, 7–6, 6–0, 6–4. Tennis had a new star. Wilander explained his triumph in Borgian terms. "I noticed how Bjorn never missed, never got tired, and never showed emotion," said Wilander. "He was easy to copy."

The innocence of youth. No one else ever got so close to copying Borg. Wilander continued to leave his mark on the eighties, winning three Australian titles, two more at Roland Garros, and then the US Open in a turgid baseline struggle 6–4 in the fifth against Lendl in 1988. By then, Wilander, who was small, swift, and relentless off both flanks, had added a new weapon—a one-handed backhand—to use as an alternative to his sound double-hander. It made him such a formidable opponent that he claimed three of the four Grand Slam titles in 1988, only "failing" at Wimbledon, where he reached the last eight. It was a remark-able achievement that remained unmatched until the Federer–Nadal era.

Wilander was unable to retain his French Open title in 1983 because a force of nature arrived out of Africa. Yannick Noah had been discovered by Arthur Ashe in Yaoundé in the Cameroons at the age of eleven and, on Ashe's advice, Noah went to live with his French mother in Nice, where he attended the first French Federation training school outside of Paris. At the age of seventeen, he had been good enough to partner Ashe in the doubles at Wimbledon. By 1983, Noah obliterated the opposition at Roland Garros, dismissing Lendl 6–0 in the fourth set of the quarter finals; fellow Frenchman Christophe Roger-Vasselin 6–3, 6–0, 6–0 in the semis; and Wilander 6–2, 7–5, 7–6 in the final.

When this tall, engaging young man with the Afro haircut and huge gap-toothed smile won match point, the Stadium Court went into delirium and Noah's father, who had played soccer for Cameroun, virtually fell out of the stands as he rushed to embrace his son. Noah had become the first Frenchman to win his native title since Marcel Bernard in 1946 and joined Ashe as the only black male to win a Grand Slam title.

(opposite, top) *He wears a coat and tie now as tournament director of Roland Garros, but back in 1993, Guy Forget enjoyed the Perth sunshine during the Hopman Cup. The tall left-hander had led France to victory in the Davis Cup Final in Lyon two years before and later captained the team.*

(opposite, bottom) *Snapped in a quieter mood in the corner of the locker room at the West Side Tennis Club at Forest Hills, Vitas Gerulaitis could party all night and play all day.*

(above) *Eventually, Andre Agassi decided his hair was becoming a time-wasting distraction and cut it off. (Photo by Art Seitz)*

Noah went on to enjoy a fine career, winning a total of twenty-three ATP titles, including the prestigious clay court events in Hamburg and Rome but, given the fact that many experts regarded him as the finest athlete ever to play the game, he probably underachieved. That, however, is relative because he went to become a hugely successful French Davis Cup captain, leading his nation to victory over the United States at Lyon in 1991, before setting out on a completely different career as a singer of Afro-reggae music—much of which, he composed himself. His popularity was such that the younger generation knew little of his tennis career, and he attracted eighty-four thousand people to concert at the Stade de France in Paris in 2010. His son, Joakim Noah, has been a star with the Chicago Bulls and New York Knicks basketball teams.

The game did not have to wait long to unearth another superstar. It had been impossible not to notice the tall, red-headed youngster who emerged on the circuit in 1984 but any chance Boris Becker had of making a real impact on Wimbledon as a sixteen-year-old was cut short when he fell and badly damaged his ankle ligaments after taking a set off Bill Scanlon. After weeks of intensive treatment, Becker returned to the circuit in 1985 and continued to throw himself about court in a style that quickly attracted fans around the world.

At Wimbledon, the seventeen-year-old German became embroiled in a tough

duel with Tim Mayotte, the elegant former Wimbledon semi-finalist whose serve-and-volley game was perfectly suited to grass courts. But so was Becker's. He had proved it by winning the prestigious Queen's Club title the week before and had just survived a rain-interrupted marathon against Sweden's Joakim Nyström in the third round. But the grass was slippery and, in the twelfth game of the fourth set with Mayotte leading two sets to one, Becker fell yet again. Feeling pain in the same ankle, the youngster panicked and thought he had damaged it as badly as he had the year before. So, signaling to Mayotte at the far end of the court that he was ready to quit, he began walking toward the net to shake hands.

Luckily for him, Mayotte was behind his baseline and before the pair could meet, Becker's manager, Ion Țiriac, and his coach, Günther Bosch, both yelled out, "Wait! Get the trainer!"

So Becker went to his chair, and the umpire called the locker room and Bill Norris, the legendary ATP trainer who was to spend over thirty years tending to players on the tour, began his journey out to Court 14. "It took me a while," Norris admitted later. "Court 14 is a distance from the Centre Court locker room, and the walkways were seething with people."

When he finally reached the stricken German, Norris had to make a quick decision. How bad was the injury? And would it be damaged further if Becker played on? Luckily, Norris had treated Becker the year before, so he was well-prepped on the situation. In his book *Pain, Set and Match*, Norris described what happened as he made an evaluation that changed the course of tennis history.

"There was only minimal soft tissue swelling, which was a good sign, so I

started maneuvering the ankle lateral-ly and then up and down by pushing up from underneath the toes—all the while looking straight into Becker's glacial blue eyes to gauge his reaction. He had full range of motion on the an-kle and my immediate thought was that he was not feeling any great pain and that he could continue."

So Norris strapped up the ankle with his usual expertise and sent him back on court. The whole interrup-tion had lasted almost half an hour, but Mayotte—one of the game's gen-tlemen—never complained, not then and not after he had seen his daredev-il young opponent throw himself back into the fray and, after grabbing the fourth set on the tie-break, close out an extraordinary victory 6–2 in the fifth.

After more intensive work from Norris the next day, Becker was able to beat Frenchman Henri Leconte in the quarters; another Swede Anders Jarryd in the semis and, finally the tall, big serving South African Kevin Curren in the final 6–3, 6–7, 7–6, 6–4.

Wimbledon was stunned. Seem-ingly, the entire nation of Germany, where Becker became a sporting god, went into hysteria and the perception of what was required to win the world's premier championships was torn to shreds. A giant of a seventeen-year-old

(opposite, top) *Brian Gottfried, a tireless worker and US Davis Cup stalwart, reached the final at Roland Garros in 1977 and won fifty-one ATP tour singles as well as fifty-four in doubles. With his Mexican doubles partner Raúl Ramirez, Gottfried won Wimble-don in 1976, and the French Open in 1975 and 1977.*

(opposite, bottom) *Pat Cash, the 1987 Wimbledon champion and Australian Davis Cup star, and his checkered headband.*

(right) *For a time, backgammon was all the rage on the ATP tour. By the pool at the Sheraton Hotel in Kingston, Jamaica, Clark Graebner watches Vitas Gerulaitis try to concentrate, while something seems to have caught Ilie Năstase's eye.*

(following spread) *A trend-set-ting moment at Wimbledon as Pat Cash, having beaten Ivan Lendl in the 1987 final, clambers up through the courtside seats to embrace his father and his inspiration in the players' box.*

Wood to Graphite

For those interested in the evolution of the tennis racket, it should be noted that Kevin Curren, using a Jack Kramer Wilson Pro Staff, was the last player to reach the Wimbledon semi-final using a wood racket when, in 1983, he lost to Chris Lewis, the New Zealander ranked ninety-first in the world at the time. Curren was also the last to reach a Grand Slam final with a wood frame when Mats Wilander beat him at the Australian Open in 1984. By the time he played Wimbledon in 1985, Curren's new graphite frame gave his serve even more power. McEnroe last used a wood racket—a Dunlop Maxply—at Wimbledon in 1982, the year he lost to Connors in the final. He won the title the following year with a new Dunlop graphite.

with body strength and mental maturity way beyond his years had blasted his way through the field to take the title. Even more impressive, in the eyes of many seasoned observers, was the way in which Becker returned the following year to defend his crown with a straight-set victory over Ivan Lendl in the final.

"I knew what I was doing then," Becker laughed some years later. "The first time was a bit of a blur, but I felt the pressure of being Wimbledon champion when I had to defend my title."

Before moving on, one should not overlook Kevin Curren's performance in 1985. Displaying unerring skill on the volley as he came leaping into the net behind his huge first serve, Curren destroyed three past or future Wimbledon champions on his way to the final, beating a still young Stefan Edberg in straight sets in the fourth round; John McEnroe 6–2, 6–2, 6–4 in the quarters; and Jimmy Connors 6–2, 6–2, 6–1 in the semis. The South African, who would take American citizenship that year, had every reason to believe he could become champion. Becker, however, had other ideas.

The next Swede on the bloc turned out to be one of the best. Stefan Edberg burst onto the scene with his beautifully streamlined serve-and-volley game by winning the Australian Open on grass at Kooyong just two years after he had won the junior title there. Utilizing the advantage of a fast court, Edberg defeated Wilander in straight sets.

Edberg returned in 1987 (the Australian Open was not held in the inter-

(opposite) *Pat Cash powering another forehand on Wimbledon's Centre Court.*

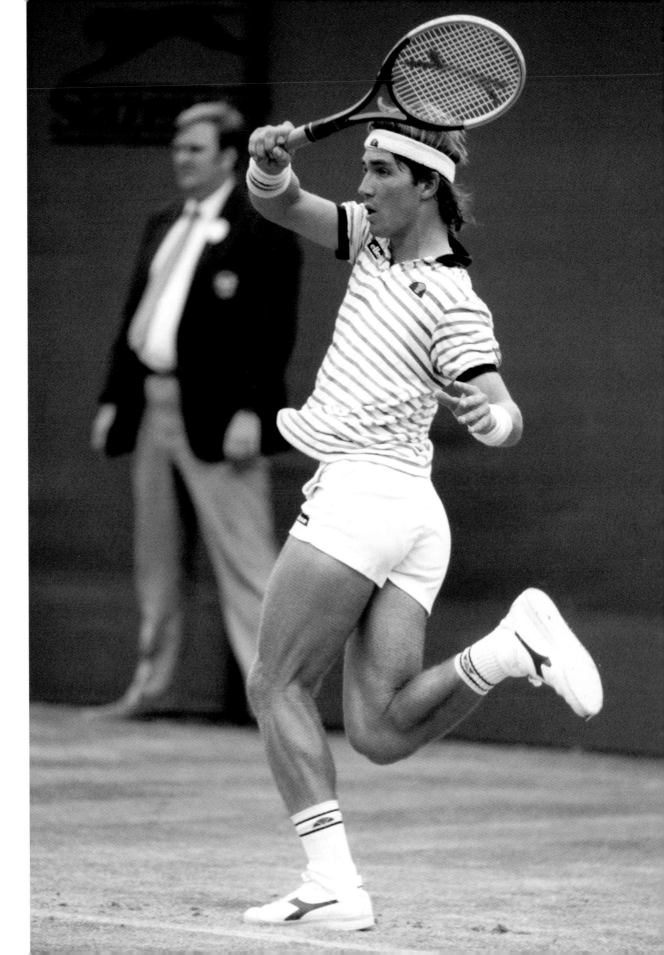

Bjorn Borg unleashes another first serve—an underrated shot that brought him innumerable free points on grass at Wimbledon.

Park before the name was changed to Melbourne Park. With more land acquired a few years later, the Australian Open was rescued from the suburbs, literally and figuratively, and placed on the center stage of Australian sport. Today, the complex, which sits just across the tracks from the ninety-three thousand-capacity Melbourne Cricket Ground, enjoys unmatched facilities with no less than three stadiums with sliding roofs.

There was a link between Edberg and Bjorn Borg, and it was significant. Both had been coached by Percy Rosberg in Sweden during their early teenage years. And it could be said Rosberg, who rarely travelled and stayed out of the limelight, made two of the best technical decisions we have seen in the modern game. He told Borg to retain his double-handed backhand but insisted Edberg get rid of his. As Borg's two-hander and Edberg's one-hander turned out to be two of the most effective shots on the tour, Rosberg probably deserved more acclaim than he has received.

Edberg soon became locked into a career-long rivalry with Boris Becker and although the German finished with the better head-to-head record of 25–10, Edberg kept pegging Becker back by beating him in big matches, such as two out of three Wimbledon finals and the 1989 Masters final at Madison Square Garden. Edberg also finished number one in the world in 1990 and 1991—strangely, something that Becker never achieved.

Before we leave the eighties, the brief but eye-catching career of Pat

vening year so that the dates could be switched from December to January) and disappointed Australian fans by beating the local hope, Pat Cash, in five. It proved to be the last Australian Open played at Kooyong. For the previous two years, Brian Tobin, Tennis Australian president, working in tandem with the Victorian Premier of the time, John Cain, had been planning the construction of a magnificent stadium little more than a ten-minute walk from the center of Melbourne, by clearing land alongside the railway tracks. The stadium, later named after Rod Laver, was originally called Flinders

Cash requires attention. A stocky, muscular Australian, Cash made his mark by reaching the semi-finals of both Wimbledon and the US Open in 1984. The latter defeat came on the famous Super Saturday at Flushing Meadows that saw McEnroe beat Connors in five sets, Martina Navratilova defeat Chris Evert in a three sets women's final, and Lendl get past Cash in the fifth set tie break of their protracted semi-final.

Injuries started to affect Cash's career all too soon and it was not until 1987, following his appearance in the Australian Open final, that his moment came. A second-round victory over his close friend Paul McNamee set him on his way at Wimbledon and, after crushing serve-and-volley victories over the French left-hander Guy Forget, Mats Wilander, and Jimmy Connors, he found himself facing Ivan Lendl in the Wimbledon final.

Lendl, ironically, had been undergoing intensive coaching from another great Australian, Tony Roche, but as hard as he tried, he could never make the Czech secure enough on the volley to seize the one Grand Slam title that always eluded him.

Cash's volleying offered a master class in how to deal with fierce, dipping service returns. With his powerful thigh muscles, he was able to volley below the height of the net with bent knees—a physical exercise that only the best athletes can sustain over a long period. So Cash was thankful that he was able to wrap up his victory in three hard-fought sets 7–6, 6–2, 7–5.

After winning match point, Cash, sporting his trademark checkered black-and-white headband, set a precedent by climbing up into the players' box to embrace his family. More than some winners, Cash—a brash, outspoken but popular Aussie—caught the public imagination, but it was a shame that his body could not back up his talent. He was able to reach just one more Grand Slam final, losing for the second straight year in the final of the Australian Open—this time to the other Swede, Wilander, 8–6 in the fifth.

The final personality to emerge on the men's tour in the eighties was Michael Chang, a short but solidly built Chinese American, who astounded the tennis world, not simply by becoming the youngest ever Grand Slam winner at seventeen years and four months,

(clockwise from left) *All smiles for a departed friend. The author is surrounded by Guillermo Vilas, Chris Evert, and Andrea Jaeger at the Vitas Gerulaitis Memorial Dinner at the Plaza Hotel in New York, masterminded by Karen Happer. (Photo by Art Seitz)*

John McEnroe never won a singles title at any level on red European clay, but he was shrewd enough to ask his Douglaston, New York, neighbor to partner him in the mixed at Roland Garros, and they won! Mary Carillo has been talking with wit and wisdom on television ever since.

Hot and sweaty, Stefan Edberg after playing for Sweden against France in Cannes under a burning Mediterranean sun.

(above) *Michael Chang will always be remembered for the underhand serve that helped him beat Ivan Lendl in 1989 at Roland Garros. More importantly, he went on to upset Stefan Edberg in five sets to become the youngest-ever French Open champion at seventeen.*

(opposite) *Brazil's Gustavo Kuerten knew how to celebrate—especially at Roland Garros, where he was champion three times.*

but by the manner in which he did it. Ironically his 6–1, 3–6, 4–6, 6–4, 6–2 victory over Stefan Edberg in the French Open final was not what his totally unexpected triumph will be remembered for.

In the fourth round, it was the point Chang played against Ivan Lendl while serving at 4-3 and 15-30 in the fourth set that stamped itself on tennis history. Feeling cramps in his thighs and wanting to find a way to finish the point quickly, Chang served underhand. There was a gasp from the packed crowd. Lendl reacted speedily enough to push a forehand back in court, but Chang quickly won the point. Amazingly, never again in a long career that saw him rise to number two in the world, did Chang ever contemplate

using the shot again. "It just never entered my mind," he said after he retired.

If the victory over Lendl, which Chang finished off 6–2 in the fifth with no more interference from his cramping thigh muscles, had been a surprise, the manner in which the American managed to upset Stefan Edberg 6–1, 3–6, 4–6, 6–4, 6–2 in the final to win what was to prove to be the only Grand Slam title of his career was a major shock.

Edberg had already won Wimbledon and two Australian Open titles and would go on to win three more Grand Slams, but clay was not his primary surface and he never came closer than a quarter-final showing at Roland Garros again. Chang simply outsteadied the elegant Swede from the back court, serving well and passing when Edberg tried to press. For a seventeen-year-old, it was an amazing achievement and Edberg, never a man to reveal his feelings too readily, was still shaking his head in disbelief as he checked in at Charles de Gaulle Airport the next day for the flight to London. "I have no idea how I lost that match," he muttered.

10 *Women in the Eighties*

The Chris Evert and Martina Navratilova show rolled on into the eighties, with this pair of super stars collecting a total of twenty-five Grand Slam titles between them during a decade of consistently amazing success.

But, increasingly, they found themselves having to share the stage with a younger generation who would steal leading roles, often in unexpected fashion. Tracy Austin was the first when, in 1979, she emerged from Southern California as a tiny teenager with braces and pigtails and wearing check pinafores. Harmless? Soon, no one was fooled. By the time she had ended Evert's 125-match winning streak on clay by beating her in the

(right) *Two great champions, two great friends. For fourteen years, Chris Evert and Martina Navratilova battled each other at the highest levels of the game. This time it was Navratilova's turn to win at Wimbledon.*

(opposite) *Steffi Graf could volley.*

semi-final of the Italian Open, opponents were becoming wary of this steely-eyed and hugely ambitious youngster. Her talent was no longer in dispute by the time she became the youngest-ever winner of the US Open at the age of sixteen years and nine months, having defeated Navratilova en route to the final, where she overcame Evert again 6–4, 6–3.

In 1980, Austin won the year-end Virginia Slims Championships with another victory over Navratilova, having created a little piece of history earlier in the year by winning the Wimbledon mixed doubles with her brother, John Austin. They were the first brother-sister partnership to win a Grand Slam title.

Tracy Austin was so dominant in the summer of 1981 that she reeled off twenty-six consecutive victories, encompassing titles at San Diego and the Canadian Open before completing the run in triumph at the US Open with a 1–6, 7–6, 7–6 win over Navratilova in the final.

It was a great match that, as Austin admitted later, could have gone either way. But it will probably be remembered more for what happened at the awards ceremony. When Navratilova's name was mentioned, a twenty-three thousand crowd roared its approval—only a matter of weeks before the woman from Czechoslovakia had become an American citizen. A newspaper report had also outed her as gay. It had been a long and often lonely road. But now,

suddenly, spontaneously, a tough New York crowd was showing what they thought of her.

"What I felt was acceptance, approval, and love," Navratilova told a Tennis Channel audience decades later. As Tracy Austin pointed out, the image of the tough athlete dissolved. Navratilova, a deeply emotional person, broke down and cried. On the same program, Jimmy Arias said, "I always thought Martina was crying because she lost the match. Now I understand that it was so much more than that."

Indeed, it was.

During a period in 1980 to 1981, Austin collected twenty titles on the WTA tour. But a series of back prob-lems, resulting in serious injuries, start-ed to affect her career and, by the time she turned twenty-one, her career was essentially over.

Her life could have been over too, when, in New Jersey in August 1989, a truck hit the car that she was driving at 65 mph, leaving her with a mass of in-juries to her spleen, back, and knee. She had just started a comeback from her tennis injuries by playing some matches in World Team Tennis, and a subse-quent attempt at yet another comeback in the 1990s proved frustrating. Even-tually, the pin in her right knee side-lined her for good and Austin has since become an expert analyst on Tennis Channel and other networks.

Steffi Graf was waiting in the wings but, in the meantime, a Czech player who probably did not receive the accolades that she deserved maintained a drumbeat of success throughout the decade. In 1980, Hana Mandlíková, a slim, lithe young athlete from Prague, emerged as the shock Australian Open champion at the age of seventeen by defeating the local favorite, Wendy Turnbull, in the final 6–0, 7–5. Quickly proving that was no fluke, Mandlíková used her aggressive net rushing game, augmented by a penetrating backhand, to overcome Chris Evert at the semi-final stage of the French Open in 1981 before defeating the German Sylvia Hanika in the final.

A few weeks later, she reached the final at Wimbledon, where Evert beat her 6–2, 6–2. Some injuries interfered with her progress, but in 1985, she was back in the Grand Slam winner's circle when she cemented her status as a top-level champion by defeating Evert in the semi-final and Navratilova 7–6, 1–6, 7–6 in the final at the US Open. No one had beaten both those icons in one tournament since Tracy Austin.

Navratilova gained some measure of revenge in the Wimbledon final the following year, but Mandlíková added a fourth Grand Slam title at the Australian Open in 1986, beating Navratilova in the final. The pair of Czechs were never close, but they did team up

(opposite, left) *Czechoslovakia's Hana Mandlíková celebrates one of the four Grand Slam titles that she won during a generally underrated career.*

(opposite, right) *Despite injuries from a bad car crash that cut her career cruelly short, teenage sensation Tracy Austin managed to win two US Opens among a total of thirty career titles, including three WTA Championships.*

(above) *Another Wimbledon triumph for Martina Navratilova— this time over a young Steffi Graf.*

(page 202) *Steffi Graf*

(page 203) *Martina Navratilova*

Steffi Graf was brought up, on court and off, by Peter Graf, her dictatorial father who was an aspiring coach. He had her practicing on court four hours a day and allowed her virtually no social life. Eventually, he agreed to bring in a professional coach—the former Czech Davis Cup player Pavel Složil—and, suddenly, tennis had a new star when the long-legged teenager with the flowing blonde hair scored a stunning victory over Navratilova in the final of the 1987 French Open by 6–4, 4–6, 8–6.

Switching seamlessly to grass, Graf used her big first serve and more-than-adequate volleys to reach the Wimbledon final four weeks later, with victories over Gabriela Sabatini in the quarters and Pam Shriver in the semis before falling to Navratilova 7–5, 6–3. And she was still seventeen.

Turning eighteen the week after Wimbledon, Graf continued to scythe her way through tournaments with her terrifying "off" forehand with which she was able to kill rallies by getting herself into perfect positions with her speed of foot. It was not long before she was being called "Fräulein Forehand." Like most things she did in life, Graf played quickly, giving off an air of impatience as she waited to serve, and opponents simply couldn't keep up with her.

She went down to the evergreen Navratilova again in the US Open final 7–6, 6–1, but it was the last time she lost in a Grand Slam until Roland Garros two years later. Graf ensured that the year of 1988 would go down in history. She not only won the Grand Slam of all four major championships—the first player to do so in a calendar year since Margaret Court—but she also added an Olympic gold medal in Seoul to emphasize her total dominance of the sport.

She defended her Australian title in 1989, and then suffered a very rare set-

to win the US Open doubles together in 1989.

By then, Mandlíková, whose father Vilém Mandlik was an Olympic two hundred meter medalist in 1956, had enjoyed a long career with the Czechoslovakian Fed Cup team, leading them to victory three consecutive years between 1983 and 1985.

Mandlíková rounded off a long and remarkable career in the game by coaching another Czech, Jana Novotná, to the Wimbledon title in 1998.

Less than two years after the birth of Boris Becker in Leimen in 1967, Steffi Graf had been born in Brühl, a town to the south west of Stuttgart and just ninety-one kilometers from Becker's birthplace. Germany had been searching for a true champion tennis player ever since the days of the elegant Baron Gottfried von Cramm in the 1930s, and suddenly, by chance, two appeared in the same corner of the country at virtually the same time.

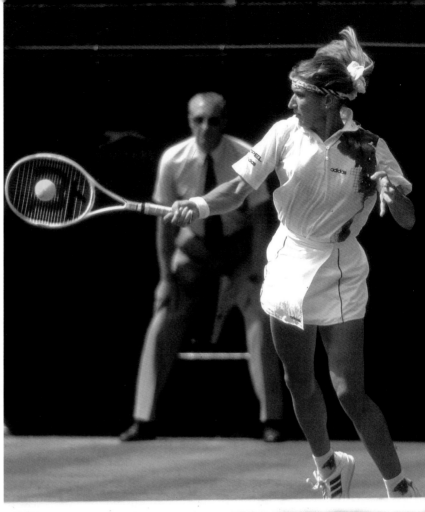

back in Paris when, after she had beaten the newest prodigy, Monica Seles, in the semi-final, she was worn down by the little Spanish baseliner Arantxa Sánchez Vicario 7–6, 3–6, 7–5.

Normal service was resumed at Wimbledon, where Evert and Navratilova were her victims in the last two rounds, and also at Flushing Meadows, where Graf defeated Sabatini in the semi-final before getting the better of Navratilova yet again in the final 3–6, 7–5, 6–1.

By the end of the decade, Steffi Graf was clearly the best player in the world. Chris Evert called it a day after losing in the quarter-final of the US Open in 1989 and, although Navratilova still had another Wimbledon title in her, the nineties would be all about Graf and Monica Seles—complete with tales of triumph and tragedy.

(opposite, top) *Her height and long reach made Gabriela Sabatini a threat on all surfaces—not least grass, on which she reached three Wimbledon semi-finals and the final in 1991, the year after she had won the US Open.*

(opposite, bottom) *Martina Navratilova and Pam Shriver congratulate each other on another win.*

(above, left) *Monica Seles, pictured here at the US Open, always had two bodyguards in close proximity after she was stabbed by an obsessed fan in Hamburg in 1993.*

(above, right) *A example of how to hit the ball in the middle of the racket. They used to call Steffi Graf "Fräulein Forehand." (Photo by camerawork USA)*

Monte Carlo Country Club

Roquebrune–Cap-Martin, France

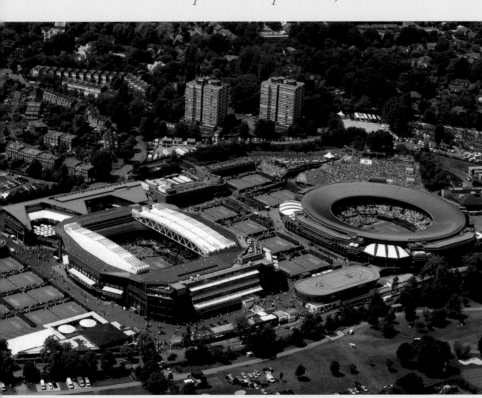

Wimbeldon Tennis Club

London, UK

STADIUMS

After obtaining $14 million in the early 1970s to restore and expand Stade Roland Garros, Philippe Chatrier, president of the French Federation, said, "A great game must have great infrastructure."

The tennis world listened—no more so than two players with wide visions, Butch Buchholz and Charlie Pasarell, as well as Brian Tobin, when he became president of Tennis Australia. Tobin, with the backing of John Cain, Prime Minister of Victoria, moved the Australian Open from Kooyong and built the vast complex that is now Melbourne Park. Rod Laver's name was put on the main stadium, and Craig Tiley's energetic leadership has seen the facility grow. Melbourne Park now has three stadiums with roofs. Buchholz, turning a rubbish dump into a splendid tennis center on Key Biscayne, gave the world its fifth biggest tournament, and Pasarell, after stops along the way, created the Indian Wells Tennis Garden.

Wimbledon built No. 1 Court, the USTA built a twenty-three-thousand-seat arena and called it the Arthur Ashe Stadium, and smaller stadiums sprung up all over the globe, especial in Asia. Some are old, some new, and at least one is surrounded by ancient Romans statues. Tennis has great infrastructure.

Am Rothenbaum

Hamburg, Germany

Foro Italico

Rome, Italy

Rod Laver Arena

Melbourne, Australia

11 The Nineties: Men

By the end of the eighties, another major political upheaval was brewing, and it would manifest itself by way of a radical change in how the men's professional game was run. Goodbye Men's International Professional Tennis Council, hello ATP Tour!

In a nutshell, the men's game, in the form of the Association of Tennis Professionals, ditched the Pro Council along with the International Tennis Federation (ITF) and went into direct partnership with the tournament directors who had formed the other third of the Pro Council.

It all happened because Raymond Moore, now president of the Indian Wells Tennis Garden, came to the conclusion that the game was stagnating under the jurisdiction of the Pro Council and that the men's tennis needed to strike out on its own. As Moore was chairman of the Pro Council at the time, it was clear that a major blow out was in the offing.

Moore had an ally in Harold Solomon, the former French Open finalist who had become more and more involved in the game's politics after his retirement. By 1987, Moore and Solomon were drawing up plans for what a new tour would look like. They realized that the first order of business would be to find an experienced CEO who could deal with the explosive nature of what was about to happen and keep the players' association intact while the breakaway was achieved.

Moore went to New York to start interviewing candidates and settled on three contenders, one of whom agreed to travel to Pilot Pen Classic, the tournament that Moore and Charlie Pasarell owned at the Hyatt Grand Champions resort in Indian Wells, even though he hadn't been able to meet with Moore in New York. It turned out that this was none other than Hamilton Jordan, who had been President Jimmy Carter's White House chief of staff.

Moore got the impression that Jordan, a seemingly unlikely contender, was keen on the job after he arrived with an elaborately prepared presentation complete with graphs and statistics. He gave every indication of being very serious about what he was being asked to do. Because Jordan would obviously not be afraid to ruffle the feathers of a few tennis officials after playing hardball with several world leaders on behalf of President Carter, he impressed Moore.

After consulting Solomon, who agreed that there could be no one better suited to the job, Moore got Jordan to sign on the dotted line. Meanwhile, Moore had informed the Pro Council of his intentions and the reaction to his announcement was predictable. The former chairman and then president of the ITF, Philippe Chatrier, who had never lost a vote in his life before Moore unseated him on the Council, was both livid and sad. Chatrier had always wanted to be considered a friend of the players and was hurt by the idea that they no longer valued his counsel.

(above) *Harold Solomon, who became an influential voice on the Pro Council later in his career, was a Roland Garros finalist in 1976, losing in four sets to Adriano Panatta.*

(opposite) *Andre Agassi—the long haired DayGlo look didn't last, but the two-handed backhand remained the same, bringing him eight Grand Slam titles.*

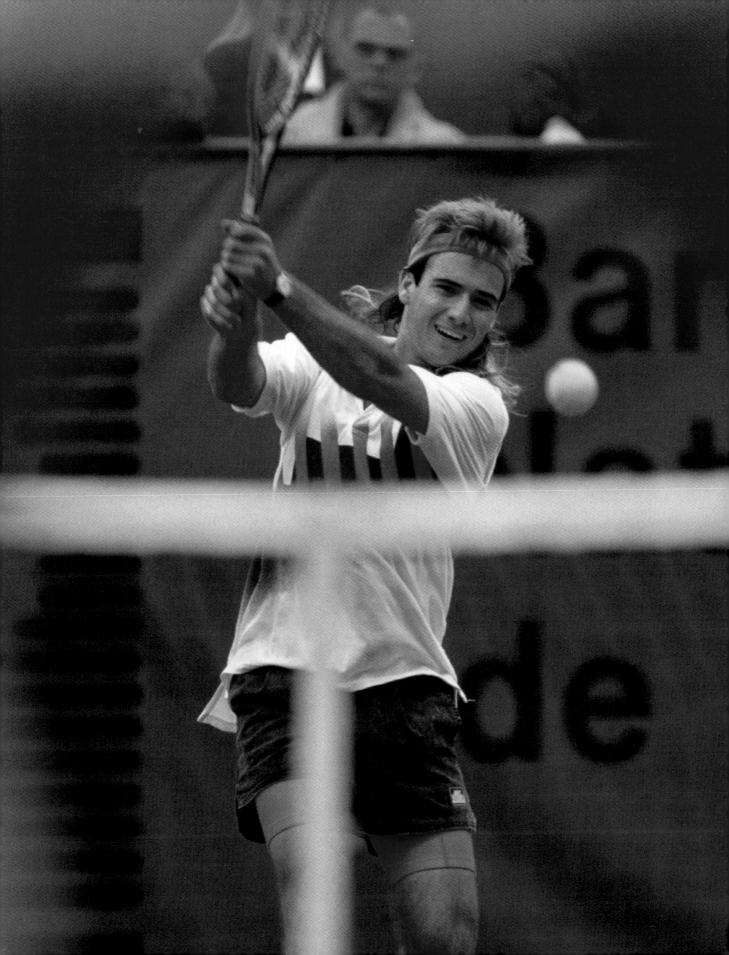

(top) *Cliff Buchholz, left, helped his brother Butch, right, create the world's fifth largest tournament, originally known as the Lipton, on Key Biscayne. Between them stands Gardnar Mulloy, Mr. Tennis in Miami, who won Wimbledon with Budge Patty in 1957, and played tennis through his nineties before his death at age 103. (Photo by Art Seitz)*

(bottom) *Raymond Moore was a Davis Cup stalwart for South Africa before moving to the United States, where he teamed up with Charlie Pasarell to mastermind the growth of the tournament in the Coachella Valley, which eventually moved and settled at the Indian Wells Tennis Garden as the BNP Paribas Open. A former president of the Pro Council, Moore hired Hamilton Jordan, President Carter's chief of staff, as CEO of the new ATP Tour in 1990.*

When the whole idea was explained to them, two of the tournament director reps, Franco Bartoni, the Italian representing Europe, and Graham Lovett, an Australian representing Asia, saw the benefit of no longer having to deal with tradition-bound ITF. Ironically, Pasarell, Moore's own partner, who was the North American representative, voted against the concept. But, even so, Moore's motion carried five to four, and the Pro Council had effectively signed its own death warrant.

Moore still had to explain the whole idea to the business people with whom the ATP dealt on a weekly basis, like J. Wayne Richmond of adidas; tournament directors like Jim Westhall; and, in particular, Butch Buchholz and his brother Cliff, who had created what was then the fifth biggest tournament in the world on Key Biscayne in Miami. A meeting was called in New York during the 1987 US Open, and the plan was unveiled. None of them liked it. "Basically," Moore recalls, "I think they thought we were crazy."

Even when Moore was left alone with the ATP staff, he found it difficult to garner support. "Only Jim McManus, the former player who had been working with the ATP since its inception, and our chief road manager, Weller Evans, were with me. I obviously had a lot of persuading to do," said Moore.

The arrival of Hamilton Jordan showed everyone that Moore meant business. The public eventually got to hear of this revolution within the game at what turned into the notorious Parking Lot Press Conference, which was held outside the gates of the Billie Jean King National Tennis Center at Flushing Meadows during the US Open in 1988.

The fact that the press conference received so much worldwide attention was basically the fault of the USTA. Hamilton Jordan had formally asked for a meeting room on site at Flushing Meadows. Jordan realized the USTA, which worked closely with the ITF, was not going to like the announcement that he was due to make. Nevertheless, he expected that they would allow the ATP to use a conference room for half an hour. However, without thinking through the consequences, they refused. Hamilton Jordan's PR instincts were a little savvier than that.

Seizing the opportunity that had been handed him on a plate, Jordan had a lectern driven into the parking lot, put a huge ATP sign in front of it, and positioned it right outside the gates. Clearly visible over Jordan's shoulder as he spoke was another sign. It read, "US Open." Although there was no question of the players not competing that year, the establishment had closed the gates to the ATP's leaders. The headlines were huge.

The new ATP CEO, who was a well-known figure in his own right, gathered a group of players around him, including Tim Mayotte and, most importantly, Mats Wilander, who was ranked number one in the world at the time.

"The ITF had been taken off guard," said Mayotte later. "They never believed our breakaway tour would happen. The impact of the press conference showed everyone we were really serious, especially as Mats was there."

Moore's first concern was to get the top players to commit to the new tour, which was set to begin in 1990. "We were afraid that some would get cold feet after the initial excitement had worn off," Moore said. "Initially, we had eighty-five of the top one hundred signing a letter of intent, but

something more binding was needed if we were to convince sponsors to commit to our cause. So we managed to get twenty-four highly ranked players, including eight of the top ten, to sign contracts. We could work with that."

And they did. Once they had the benefits of becoming partners with the players explained to them, the vast majority of existing tournaments agreed to join the new tour. Fifty-eight of the

seventy-eight who signed up were especially excited by the new direction men's tennis was taking because they were given license to legally offer guarantees to top players. The practice had been going on under the table for some years, but now Jordan and Moore wanted greater transparency.

The top nine events, known today as the ATP 1000 Masters Series, would be offering so much prize money—a minimum of $1 million—that guarantees would not be necessary for the simple reason that all players would have to sign a pledge to play in all of them. But for tournaments of a lesser category that were always struggling to attract ticket-selling names, the ability to offer a guarantee in addition to prize money was a very attractive proposition.

Some other rule changes were also put in place. The computer ranking, by which the players lived or died, was modified. Until then, points were allocated on an average system, with total

(top) *When the ATP broke away from the Pro Council, the USTA turned down CEO Hamilton Jordan's request to use a room for the announcement, so he moved it outside the gates at Flushing Meadows and created extra publicity with his Parking Lot Press Conference.*

(bottom) *Charlie Pasarell, like Butch Buchholz, one of the game's great movers and shakers, unfolds yet another idea at the Saturday morning breakfast press meetings that he used to hold at Indian Wells.*

points being divided by the number of tournaments played. That was changed to a system that awarded points only to a player's best fourteen results, which meant that a player could play extra tournaments without the fear of having what he earned being divided by a greater number.

Under pressure from the ATP, the tournaments were persuaded to come up with considerably more prize money. In the early years that rose from a total of $47 million to $85 million. Structurally, the running of the men's game changed, too. A new ATP headquarters was established at Ponte Vedra, just south of Jacksonville in northern Florida and, with some assistance from Prince Albert, a real tennis fan, a European office was opened in Monaco.

Probably feeling that he had achieved what he was hired to do, Hamilton Jordan, who was not in the best of health, resigned after a year and was succeeded by Mark Miles, a smart and savvy sports executive from Indianapolis who had run the 1987 Pan American Games. Miles proved himself to be a clever politician, which he needed to be. He found himself chairing an ATP board that consisted of three player representatives and three tournament directors. The very concept of creating a tour made up of two entities whose interests would, inevitably, diverge was bold to say the least.

A group of us, including Vijay Amritraj, the then ATP president, Marty Davis, Bob Green, and two Europeans who would have much to do with building the Monaco office—former British number one Colin Dowdeswell and Željko Franulović, the 1970 French Open finalist—had long, animated discussions as to whether the whole idea would work. To be fair, it probably wouldn't have over the first decade had it not been for Mark Miles's diplomatic skills. Amazingly, Miles never allowed himself to be left with the deciding vote when any contentious decisions came up. He always managed to persuade someone on one side or the other to create a majority by voting with the other side.

Offering full disclosure regarding my role in the proceedings, I was invited by Miles to become the public relations director for Europe working contentiously, as it turned out, under the former French number one Pierre Darmon, who was appointed European director, a role I had filled for three years in the 1970s.

While all this was going on, action on the court continued to attract an ever-growing public, especially in America where, by the end of the decade, three players had established themselves as world stars. Pete Sampras, Andre Agassi, and Jim Courier became consistent Grand Slam winners through the nineties, with Sampras claiming twelve of his fourteen Slams in that ten year period; Agassi five of his eight, and Courier all four of the major titles that he won.

But 1990 offered up an interesting mix of something old and something new. Ivan Lendl, whose fitness and consistency had made him part of the furniture on Grand Slam finals days in the 1980s, retained his Australian Open crown by winning the eighth and last of his Grand Slam titles in Melbourne. At Roland Garros, the big Ec-

uadorian left-hander, Andrés Gómez, one of the most popular players on the tour, brought a smile to people's faces when he won his first and only Slam at the age of thirty.

After defeating another left-hander and future world number one, Thomas Muster, in the semi-final, Gómez used his big serve and the volleying skills that earned him thirty-three doubles titles to outwit Agassi, who was ten years his junior, in four sets.

Agassi, with his peroxide blonde hair, lime-colored shirts, and denim shorts worn over pink compression pants, had hardly gone unnoticed, but the cognoscenti were not distracted by the young man's appearance. They knew that this son of an Iranian Olympic boxer who had been brought up in Las Vegas before being sent to the Nick Bollettieri Academy in Florida was not only different but also hugely talented. And so it proved.

If Agassi had offered a hint of what was to come, Pete Sampras laid it on the line at the 1990 US Open by beating Agassi in the final 6–4, 6–3, 6–2. A contemporary had been dealt with in the final, but Sampras, who had been ranked eighty-ninth in the world a year before, had already taken care of the old guard in in the previous rounds, outlasting Lendl in five sets in the quarter-final and McEnroe in four in the semi. Sampras was only nineteen years and one month old—the youngest ever winner of the US Open.

Agassi was not alone in being shocked. "I felt like I would beat him," he said. "But it was just an old-fashioned street mugging out there."

Starting two years later, Sampras set about doing a lot more mugging, going on to win Wimbledon seven times in eight years. Much closer to Stefan Edberg, who had beaten Becker in the Wimbledon final that year, than the red-headed German in temperament, Sampras also proved to be the antithesis of Agassi, his career-long rival, in style of play as well as personality. Sampras was shy, focused, and genial and if ever it could be said that a champion let his racket do the talking, Sampras was that man.

Edberg was only marginally more outgoing, but the handsome blonde Swede carried a presence with him on court that had much to do with Tony Pickard's tutelage in body language. When Pickard became his coach, Edberg was eighteen, but despite his beautifully fluent serve-and-volley game, he had a hang-dog air about him, which suggested lack of confidence. Pickard, who possessed the swagger of a man who had won Wimbledon when, in reality, he had only played a few Davis Cup matches for Britain, went to work on Edberg's posture. The results were startling.

"Get your chin up!" was Pickard's first order. "Get your shoulders back! Walk as if you know you're going to win!"

As we have seen, the transformation helped Edberg win the Australian Open and Wimbledon in the eighties, during which time he also reached the semi-finals of the US Open in 1986 and 1987. Edberg, however, struggled in New York.

(above) *Prince Albert likes nothing better than a game of tennis, and if he can find a player like Bjorn Borg to hit with at the Monte Carlo Country Club, all the better! Prince Albert's generosity enabled the new ATP Tour to establish its European headquarters in the principality in 1990.*

(following spread) *Patrick Rafter vs. Goran Ivanišević in the memorable 2001 Wimbledon final, which Ivanišević won in five sets.*

(above) *Former French Open final-ist Željko Franulović was heavily involved with the creation of the new ATP Tour in 1990. He eventually ran the Monte Carlo office before taking over as tournament director of the famous Monte Carlo Open just across the street.*

(below) *A Wimbledon doubles final-ist with Australia's Allan Stone in 1975, Colin Dowdeswell established his banking credentials with Merrill Lynch after his retirement, and was influential in setting up the ATP Tour's Monte Carlo office in 1990. He has also served on the ATP Player Council.*

The flashy, raucous atmosphere of Flushing Meadows, as well as the pace of the city itself, grated on the quiet Swede, and he never felt comfortable there.

So Pickard went to work on him psychologically. Despite a considerable difference in age and temperament, the pair had become close friends, and Edberg listened when Pickard told him to block out everything except the tennis. Pickard found his man a quiet place to stay on Long Island, and only allowed him on site for the time required to practice and play his matches. The result was that Edberg was able to let his game flow and for two years, he dominated the US Open, beating Jim Courier 6–2, 6–4, 6–0 in the 1991 final, and Sampras 6–2 in the fourth the following year. It was a great example of mind over matter and having the benefit of someone you trust to help you focus on a specific goal.

After reaching a third Grand Slam final and his second consecutively at Roland Garros in 1991, the Agassi saga raged on through the decade and beyond. It hit its most dramatic moment yet when the new tennis outlaw stormed the game's most traditional citadel and, wearing all white as the All England Club rules demanded, became Wimbledon champion in 1992. He had needed to beat Becker in the quarter-finals after the German had appeared in six of the previous seven Wimbledon finals, and then denied McEnroe a last hurrah by outhitting the old renegade in straight sets. McEnroe was thirty-three, and the kid from Las Vegas simply spun the wheel too fast.

Agassi was expecting to meet Sampras in the final, but Sampras had fallen to the rangy left-handed Croat, Goran Ivanišević, in the semi-final and Agassi didn't know whether that was a good thing or not. He had been blasted off court by the Croat's lethal southpaw serve on the only two occasions they had met, and the serve did not appear any easier to handle on Wimbledon's fast grass.

Agassi lost the first set on the tie-break, never having been given a sniff at breaking a serve that was hurtling toward him at 138 mph; however, the volatile Croat couldn't maintain the momentum and errors allowed Agassi to pounce with his returns. Suddenly, he was leading by two sets to one. But Ivanišević, stung by the reverse, began cracking a few returns himself and roared through the fourth set 6–1.

In his revealing autobiography, titled *Open*, Agassi lets us know that thoughts of the next day's headlines started filtering into his head. He knew what they would say if he lost in a Grand Slam final for the fourth straight time, so he ran on the spot at the changeover to keep the blood flowing and told himself how much he wanted this title. He thought he hadn't craved the trophy enough in his other finals. This time, he told himself, he was going to "let everyone in this joint KNOW you want it."

The "joint" was Wimbledon's august Centre Court, with the crowd warming to him and, despite searching desperately for a first serve, Agassi didn't allow Ivanišević a look at a break point. The score reached 4–5 in the fifth, with Ivanišević needing to hold to stay in the match. But he double-faulted twice, recovered to level at 30–all, and eventually got passed as Agassi swept away a winner off his half volley. Match point. Agassi's conversation with himself, inaudible against the roar of the crowd, was severe: "Don't hope he double faults. Don't hope he misses. YOU control what YOU can control. Return this serve with all your strength."

And he did. Leaping in the air and swinging at his backhand return, Agassi forced an error on his opponent's volley, which plopped into the net. Agassi fell to the ground and couldn't believe the emotion that poured out of him. In his box, his coach Nick Bollettieri, his brother Phil, and his childhood sweetheart, Wendi Stewart, hugged each other. Agassi's trainer and close friend Gil Reyes had tears in his eyes back in Las Vegas. Reyes, more than anyone, knew what it had taken to get Agassi into the shape required to win a Grand Slam. These were the people who had got him to the point where he was clasping the golden trophy out there on Centre Court, but the cast would change more than once in the coming years as the evolution of this unusual player continued.

As a result of his father's relentless demands, Agassi grew up seeing a tennis court as his cage and, to general disbelief, he insisted in his autobiography that he hated the game. That was one reason why his reaction to becoming Wimbledon champion was more complicated than one might have expected. In *Open*, he described it this way: "I'm unnerved at how giddy I feel. It shouldn't matter this much. It shouldn't feel this good. Waves of emotion continue to wash over me, relief and elation and even a kind of hysterical serenity, because I've finally earned a brief respite from the critics, especially the internal ones."

Few people understood the pressure that Agassi was always putting on himself—the driven desire to prove worthy to those he loved. He was to change dramatically in the coming years, more so, I think, than anyone I have ever known. To anyone outside his immediate circle, he often appeared to be a surly, suspicious brat who would not even want to share a locker room with fellow players. For a couple of years at Roland Garros, he changed in a trailer that Nike provided for him, which was parked just outside the gates.

Within a few years, Agassi had grown into a fascinating and admirable human being. It is quite possible that he will end up being remembered as much for what he has done for education in Nevada with his Andre Agassi Prep charter school and the standards it has set as his tennis. Agassi morphed into a different person.

Late in his career, when he had settled into a lasting and wonderfully harmonious marriage with Steffi Graf, I asked him if he recognized the punk he had been in early years. "No," he smiled. "Who was he?"

It would be impossible to think of Agassi now without his Stefanie, as she likes to be called, by his side, but I believe the transformation started during his first marriage to the actress Brooke Shields. The Ivy League graduate not only had a tennis pedigree (her grandfather was Frank Shields, the 1931

(above) *Guga! The dashing Brazilian was virtually unknown when he burst onto the scene unseeded to win the French Open in 1997. Gustavo Kuerten proceeded to establish himself as one of the greatest clay courters of the modern era by winning Roland Garros twice more in 2000 and 2001. He also won the ATP Finals indoors in Lisbon in 2000. His career was cut short with hip problems.*

(below) *Jim Courier—after winning four Grand Slams, the Floridian ran the Legends Tour in America and became the US Davis Cup captain. He also established himself as an insightful television analyst in Australia and works regularly for Tennis Channel in America.*

Wimbledon finalist) but, as a performer herself, she understood the demands of his profession. More importantly, I think that she taught Agassi about some of the finer things of life—speaking her fluent French as she showed him Paris and, almost literally, teaching him which fork to pick up at dinner.

Agassi had married Shields a year or so after Wendi Stewart had told him that she needed to find her own way in life and couldn't trail around in the wake of a tennis star, no matter how much she loved him. He was devastated and soon, another major figure in Agassi's life would call it quits. Just a few days after Agassi had lost his Wimbledon crown to Sampras in five

sets in the 1993 quarter-final, a FedEx envelope arrived at his home in Las Vegas confirming what he had just read in *USA Today*. Nick Bollettieri was telling him that he wanted to spend more time with his family and no longer wanted to be his coach. Agassi said he felt numb but retained his sense of humor. "My entourage is thinning faster than my hair," he wrote.

Hair, believe it or not, had gotten inside Agassi's brain during the early part of his career. He had fretted and had nightmares about it and went to extraordinary lengths to hide one terrifying fact: it was falling out. Going bald at an early age can be traumatic for any man in his early twenties, but Agassi

had built a public image on his flowing blond locks. His solution was to wear a hairpiece. Naturally, he didn't want anyone to know about it, and panic set in on the eve of his first Grand Slam final at Roland Garros in 1990, when the thing came apart in the shower the night before he was due to play Gómez. Bobby pins were required to keep it in place, and Andre's sister Rita came up with some. But Agassi entered the court with his mind more on his hair than Gómez.

In *Open*, Agassi described his state of mind: "Whether or not it's slipping, I imagine it's slipping. With every lunge, every leap, I picture it landing on the clay, like a hawk my father shot from the sky."

This subplot to what was happening on the Centre Court at the French Open would have been hilarious, had it been known, to everyone but the man himself. This was real trauma and, to a lesser degree, it was a problem that plagued him for the next two years until, on their third date, Agassi plucked up courage to tell Shields. She said it didn't make her love him any less. After their marriage and after he had won the US Open in 1994, she persuaded him to have it cut off. He thought of Samson and Delilah but succumbed and allowed it to happen.

"It seems so trivial—hair," Agassi recalled. "But hair had been the crux of my public image, and my self-image, and it's been a sham. Now the sham was lying on Brooke's floor in tiny haystacks. I felt well rid of it. I felt true. I felt free."

So free that he traveled down to Australia for the very first time in January 1995 and won the Australian Open, beating Sampras, no less, in four sets in the final. He wondered what had taken him so long to venture Down Under. He

said he would remember it as his first bald Slam.

It was, in fact, his third in total because, the previous September he had won the US Open by beating Michael Stich 6–1, 7–6, 7–5 in the final. The victory was significant in many ways, not least because it was his first big success with his new coach, Brad Gilbert, the former world number four, who had started working with him at the beginning of the year. Agassi's new manager and ex-school friend Perry Rogers had read Gilbert's acclaimed book *Winning Ugly: Mental Warfare in Tennis* and had recommended him to Agassi. Over a dinner at Fisher Island in Miami, Gilbert had fearlessly dissected the good and the bad in Agassi's game and was hired on the spot.

(opposite) Ivan Lendl had a mighty first serve to go with his power-driven groundstrokes—assets that helped the naturalized American reach eight consecutive US Open finals.

(right) Gogo! The popular Andrés Gómez, one of many fine Ecuadorian players to emerge from Guayaquil, grabbed his chance for glory late in his career by winning his only Grand Slam title at Roland Garros at the age of thirty in 1990.

Agassi felt as if he was back in school. Gilbert told him that he had to be consistent, like gravity. But as the spring unfolded, Agassi was losing—to Sampras in Osaka, to Yevgeny Kafelnikov in the first round in Monte Carlo, and to the rugged Austrian left-hander, Thomas Muster, in the French Open.

He was working hard, believing in Gilbert's philosophy, but the breakthrough wouldn't come. Fighting back from two sets down against Todd Martin in the fourth round at Wimbledon, he lost the fifth 6–1. Gilbert insisted good things were about to happen. "Trust me," he told Agassi.

At the Canadian Open in Toronto, good things did happen. Agassi won the tournament and headed for New York with a spring in step. After beating Guy Forget and Wayne Ferreira, two classy players, and another dangerous foe in Michael Chang, Agassi was lunching with Gil Reyes at the famous Manhattan watering hole, P. J. Clarke's, when he read a column by Mike Lupica in the *New York Daily News*. Lupica said Agassi simply wasn't a champion. Agassi turned white and then remembered Gilbert's words: "Control what you can control."

In the next round, Agassi gained revenge on Todd Martin before facing Stich in the final. The second set could have gone either way, but Agassi took it on the tiebreak and then broke at five all in the third set. Serving for the match, he remembered Gilbert's instructions: "When in doubt, go for the forehand. The forehand." He did and became the first unseeded player since Fred Stolle in 1966 to win the US title. Who was the first man who ever won it unseeded? Frank Shields, whose granddaughter was in the stands alongside Brad Gilbert, Perry Rogers, Gil Reyes, and brother Phil. "At

last," Agassi wrote in *Open*, "the team is firmly, irrevocably in place."

But it wasn't. By the time Agassi's career ended, only Gil and his brother would be there.

Agassi's opponent in that US Open final, Michael Stich, must rate as one of the most misunderstood and underachieving players of his era. Considering he beat Boris Becker, his adored countryman, in the 1991 Wimbledon final 7–4, 6–4, 7–6, Stich's "underachieving" tag may seem unfair. But that would be ignoring the extent of Stich's talent, which was considerable.

A latecomer to the game who really didn't start playing seriously at the professional level until he was nineteen, Stich was a tall, lanky player with a big serve, which he augmented with a delicate touch at the net. None of his contemporaries were as comfortable on all surfaces as the German who won eight of his eighteen titles in his native country. In fact, there was nothing that Stich did not win in Germany, at a time when a great deal of top tennis was played there.

The list of his achievements was very impressive. Immediately after his Wimbledon triumph, Stich returned home to win the ATP outdoor event in Stuttgart on clay and then, in 1992, he won the Grand Slam Cup indoors in Munich. This was a maverick event, offering huge prize money, which the ITF had created to offset the threat of the ATP Masters Finals, which had also been moved to Germany from New York one year before. Tennis politics was still alive and well.

In 1993, Stich cleaned up in spectacular fashion, winning Ion Ţiriac's ATP indoor tournament in Stuttgart, the long-established German Open on clay in Hamburg, and, at the end of the year, the ATP World Championships,

(opposite) *Smooth as silk—the beginning of Stefan Edberg's serve-and-volley action.*

(above) *Ion Ţiriac played ice hockey for Romania in the Olympics before establishing a formidable Davis Cup record. Coach to Guillermo Vilas and Boris Becker, chairman of the Madrid Open, founder of Ţiriac Air (he flies his planes himself), Ţiriac likes nothing more than a good meal, which he found here at the lovely home of Pierre and Carolyn Barthès outside Paris. Tony Roche and Fred Stolle enjoyed it too.*

which was being held at the lovely Festhalle in Frankfurt. Stich beat Sampras in the final after advancing through the round robin unbeaten—something no one else did in the nineties.

In 1994, Stich won the ATP clay court event in Munich and gave yet another demonstration of his versatility by winning the newly created pre-Wimbledon grass court tournament in Halle. Stich was no less successful when wearing German team colors. He helped Germany win the Hopman Cup in Perth, Australia, and the World Team Cup in Dusseldorf and, most importantly, he was a member of the Davis Cup winning team in 1993 that defeated Australia in Dusseldorf.

Stich and Becker were never close, but they put their egos aside for their nation's sake at the Barcelona Olympics in 1992 and won a gold medal playing together in doubles. As far as Germany was concerned, there was absolutely nothing Stich did not win either in, or for, his country apart from the Olympic singles gold. His was a record unique in German sport.

The fourth American to make headlines in the early nineties was Jim Cou-

rier, a powerful back-court hitter whose hair matched the color of the oranges for which his hometown of Dade City, Florida was famous. Courier flirted with the idea of becoming a baseball player (he has often thought how different his life would have been). Instead, he went to the Nick Bollettieri Academy, roomed with Andre Agassi, and had Pete Sampras round to dinner at his parents' house. So there were no surprises when he found himself playing Agassi in the 1991 French Open final, having bludgeoned Edberg and Stich along the way.

Courier fought back from two sets to one down to beat Agassi 6–4 in the fifth at Roland Garros, but it was the two stars he had beaten who interrupted his progress later in the year. At Wimbledon, he lost to Stich in the quarter-finals, and at the US Open Edberg's smooth serve-and-volley game was too much for the twenty-one-year-old. He won only six games.

Courier quickly put that defeat behind him and collected his second Grand Slam in Melbourne at the start of 1992, throwing himself into the Yarra River in celebration after he

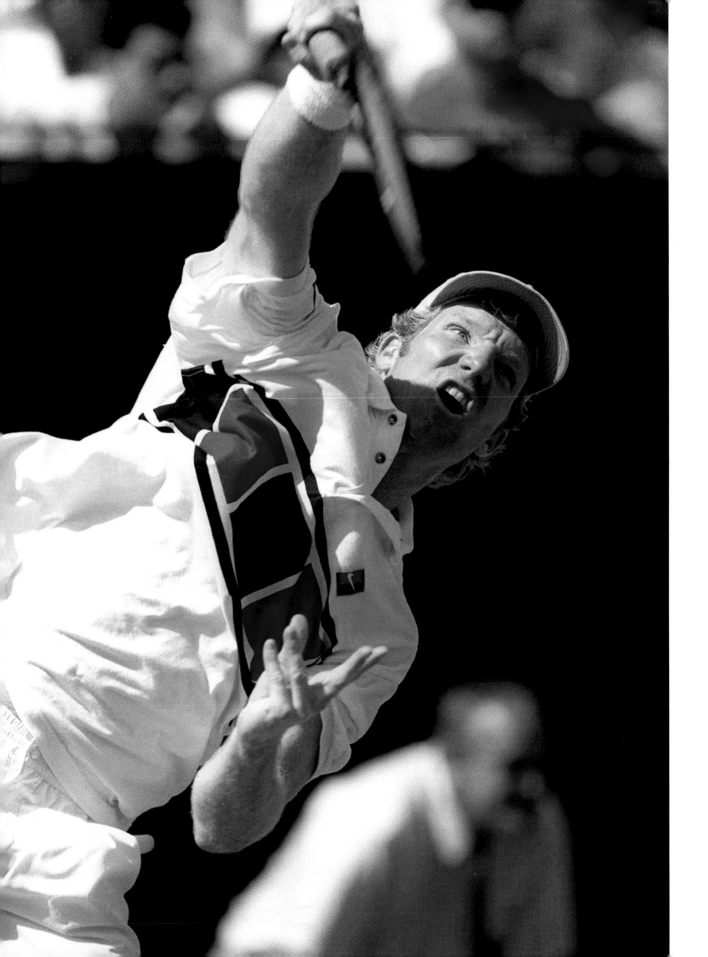

had beaten Edberg in four sets in the final. Courier was a quick learner, and it showed as he upped his passing game against the attacking Swede.

Defending a big title is often more difficult than winning it in the first place for a young player, but the American did not fail when he returned to Roland Garros and overcame Thomas Muster, Ivanišević, Agassi, and, in the final, the left-handed Czech Petr Korda.

Suddenly, Courier was a major star and won the hearts of the Parisian crowd by making his acceptance speech in French. Unlike some of his colleagues, Courier had embraced Europe in every sense, polishing his French by listening to his *petite amie*.

By the time he retained his Australian Open crown in 1993, beating Edberg once again in the final, Courier was hitting the ball as hard as anyone on the tour, and with his fitness honed by an incredible work ethic, he had, to the surprise of many, become the man to beat.

Had he managed to win two more matches that summer—in the finals of the French Open and Wimbledon—Courier would have ensured himself of an even higher place in the pantheon of Grand Slam winners. But Sergi Bruguera, a tall Spaniard who became very difficult to beat on clay, shocked Courier by defeating the American 6–3 in the fifth set of the Roland Garros final. Courier might have turned it around when, on his second break point at 3–5, he had the winner in his sights, but he went for a huge forehand off a midcourt ball and slammed it into the net.

Losing the crown that he had held for two years was a big blow for Courier but, once again, he put the loss behind him and adapted very quickly to grass, his least favorite surface. At Wimbledon, he beat Wayne Ferreira, Todd Martin, and

Stefan Edberg, a player he had come to dominate, on his way to the final.

His old pal Sampras was waiting for him on a blistering hot day that saw temperatures soar to a 103 degrees Fahrenheit on the Centre Court. Princess Diana, looking as cool and elegant as anyone in the front row of the royal box, was there to witness a fine duel as Courier forced Sampras to battle through two tiebreaks in the first two sets and then fight back to win the third. Only a couple of points here and there divided them, which made the eventual 7–6, 7–6, 3–6, 6–3 loss all the more devastating for Courier because no one needed to tell him that this was probably going to be the best chance he would ever have of becoming Wimbledon champion.

"It was obvious Pete was just going to get better," said Courier. "And my chances of reaching a grass-court final again were not that great."

And so it proved. Courier reached three more Grand Slam semi-finals, but none of them were at Wimbledon. As the stresses and strains of his ruggedly muscular game began to take their toll, this wholehearted champion had to be content with his back-to-back triumphs in Melbourne and Paris.

With Pat Cash's career destroyed by numerous injuries, Australia was due for another big star, and one arrived in the form of Patrick Rafter, a handsome, engaging, super-fit Queenslander who had learned how to fight for what was his among a family that included eight siblings.

Rafter first came to notice by winning the traditional Northern Championships on grass in Manchester just before Wimbledon in 1994. In true Aussie style, Rafter was a net rusher, and his volleys stung. All the more surprising

(opposite) *Fast action: the Jim Courier serve.*

(above) *Having lost in two Wimbledon finals, Goran Ivanišević, the tempestuous Croat, who admitted there was a Good Goran and a Bad Goran depending on his mood, found the right one in 2001 and beat Patrick Rafter to win the title. He then flew home and took some friends on a tour of the islands off the coast of Split in his Princess yacht.*

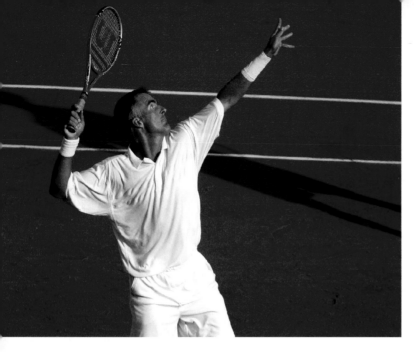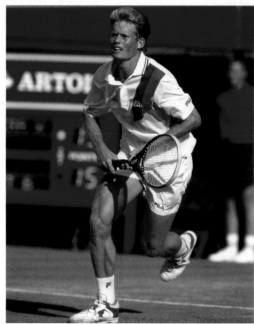

then that his first real success at Grand Slam level came on clay at Roland Garros, where he reached the semi-final of the French Open in 1997.

He was not afraid to attack on clay, although it was far from easy when he met the big Dutchman Richard Krajicek on a Suzanne Lenglen court that was being turned into a dust bowl by the wind. "The clay was flying everywhere," Rafter recalled. "There was dust in your eyes, and it was tough to hit through the ball." But the robust Queenslander managed it in four sets to advance to the semi-final, where Bruguera awaited him. Rafter did not disgrace himself against one of the best clay-court players of the era, but lost a drawn out struggle 6–7, 6–1, 7–5, 7–6.

It was at the US Open later in the year that Rafter surprised most observers by blowing away Andre Agassi and Michael Chang on his way to the final, which he won in four sets against Britain's left-handed Greg Rusedski. Suddenly, the affable Aussie had joined the magnificent pantheon of Australian Grand Slam champions.

In the suffocating summer of 1998, Rafter excelled as a player and athlete. Rafter, playing in clothes saturated in

sweat, won the Canadian Open, Cincinnati Masters, and the Hamlet Cup back to back and somehow retained enough fuel in his body to retain his crown at Flushing Meadows.

Doing that was no easy task. Rafter was taken to five sets in his opening match by the talented Moroccan, Hicham Arazi, and then needed to get past Goran Ivanišević and Jonas Björkman before running into Sampras in the semi-final. The American had won his fifth Wimbledon title just two months before and was favorite to claim what would have been his fifth US Open crown. Rafter was doubly determined to beat him after Sampras had made some unusually cutting remarks about players' needing to prove they were not "One Slam Wonders."

The score of 6–7, 6–4, 2–6, 6–4, 6–3 tells the tale. Rafter did incredibly well to fight back from two sets to one down in front of a raucous New York crowd and showed his opponent just what he was made of. It was a thrilling contest with two serve-and-volley players going at it hammer and tongs and, on the day, the Australian had more left in the tank at the end.

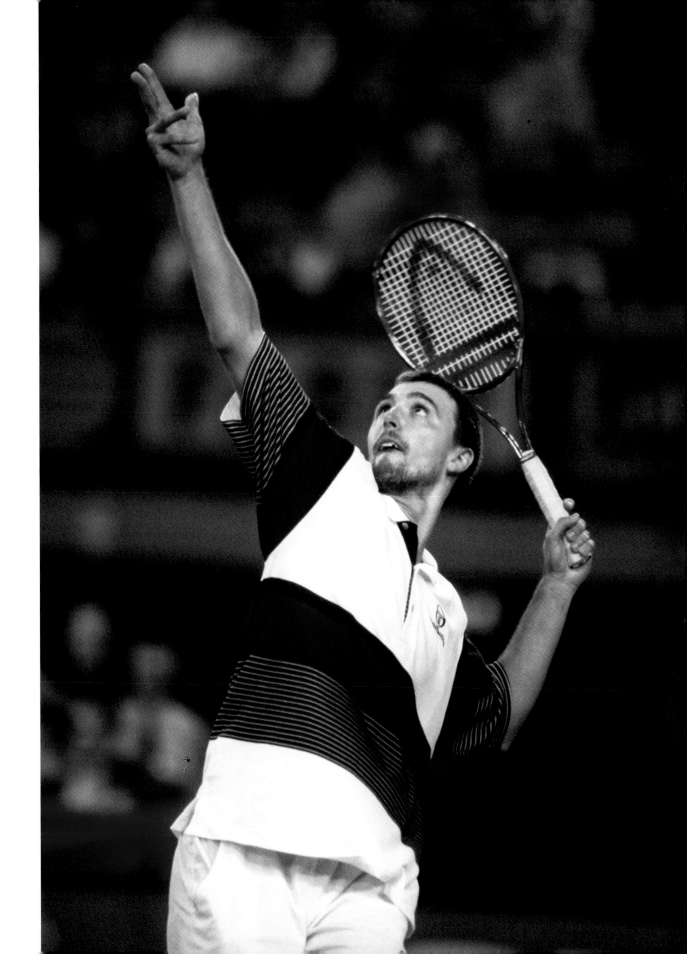

Another Australian, Mark Philippoussis, was waiting for Rafter in the final, making it the first time two Aussies had reached the men's singles final at the US Open since Ken Rosewall beat Tony Roche in 1970. The fact that there were seven all-Australian finals between 1960 and 1970 reflects Australia's dominance in that era.

Philippoussis, a six feet and six inch giant with a massive serve, who was to win one of his eleven ATP titles at Indian Wells in 1999, had blasted Britain's Tim Henman, Sweden's Thomas Johansson and Spain's Carlos Moyá out of his path on the way to his first Grand Slam final, with Johansson giving him most trouble—the fifth set finally being decided 12–10 in the tiebreak.

Despite his exhausting summer, Rafter was too quick at the net and decisive on the volley in the final as he came charging in behind his big serve and overwhelmed his compatriot in the end, winning the fourth set 6– 0.

With his Greek-Italian background, Philippoussis struggled to come to terms with the "mateship" ethic of an Australian Davis Cup team and fell out with Rafter a couple of years later over his seeming ambivalence to the cause. There had been no doubting his commitment in the 1999 Davis Cup final against France, which was played at an indoor arena in Nice where the acoustics were such that a screaming crowd of nine thousand damaged one's ear drums.

Australian won the Cup due largely to the superb performance Philippoussis produced in beating the talented Cédric Pioline 6–3, 5–7, 6–1, 6–2. Asked afterward how he managed to block out the noise, Philippoussis suddenly came up with one of the more poetic quotes that we have heard in tennis press conferences when he answered, "All I heard was the

Founders Raymond Moore and Charlie Pasarell put the first spades into the sand on Miles Avenue at Indian Wells and out of the desert sprang the spectacular Indian Wells Tennis Garden (opposite).

The complex, which stages the BNP Paribas Open, is now owned by Larry Ellison with Moore still involved as CEO.

beating of my heart." In tennis parlance, Philippoussis was "in the zone."

Rafter would go on to reach two Wimbledon finals and enjoy just one week as world number one, but a chronic shoulder injury prevented this hugely popular player from reaching his full potential.

Not many players have risen from the game's backwaters to the spotlight of a Grand Slam final faster than an extraordinarily engaging character from Brazil called Gustavo Kuerten. Few outside South American had heard of this loose-limbed, gangling, grinning twenty-year-old who was ranked six-

ty-sixth in the world when he arrived at Roland Garros in 1997.

All Kuerten's success had come at challenger or satellite level, and he warmed up for his assault on the French Open by winning a satellite title at Curitiba, Brazil. Soon, Parisian crowds were saying a lot more than "Ooh la, la" as they watched Kuerten outhit Thomas Muster in five sets to reach the semi-final, and then Yevgeny Kafelnikov in another five-set tussle to reach the final. Muster, who defied his stevedore-on-court image by painting landscapes on silk in his hotel bedrooms, had won the French Open in 1996, and Kafelnikov was the defending champion. Kuerten seemed oblivious and rounded out an extraordinary fortnight by crushing Bruguera, the winner in 1994 and 1995, in straight sets in the final. Three champions had been swept away by Kuerten's 125 mph serves, pounding topspin forehands,

and scything one-handed backhands. He could volley too, and he covered the court like a gazelle.

Guga, as everyone quickly learned to call him, did it while clad in a bright blue and yellow striped shirt with a broad yellow headband that half-covered his curly brown hair and left everyone agape. After winning match point, he climbed the podium to receive the trophy. Finding Bjorn Borg standing there to present it to him, the young man bowed low to his childhood idol. Then, in the absence of the "Girl from Ipanema," whom one had half-expected to appear at his side, he danced the samba with his mother, Alice, and grandmother, Olga. Suddenly, a corner of Paris was turned into a Brazilian festival as a large group of his supporters danced the conga all the way round the stadium. Tennis had found a new star.

Kuerten would have more success at Roland Garros in the following decade

before his open stance forehand created hip problems that ultimately ended his career. Marcelo Ríos, another talented South American who lost to Petr Korda in the 1998 Australian Open final, had a similar style, and he too, was having hip surgery in his mid-twenties.

Even in pre-Nadal days, Spain was producing a plethora of top-class players. There was evidence of that in the 1998 French Open final when Carlos Moyá, who would enjoy a brief spell as world number one, earned his only Grand Slam title by beating his compatriot Àlex Corretja 6–3, 7–5, 6–3

(left) *Yevgeny Kafelnikov, a naturally gifted Russian who won Roland Garros in 1996 and, while coached by the Californian Larry Stefanki, the Australian Open in 1999, when he rose to number one in the world.*

(right) *Thomas Muster became world number one in February 1996, the year after he beat Michael Chang to win at Roland Garros. A tough, rugged character on court, Muster surprised many people by painting landscapes on silk from his hotel window.*

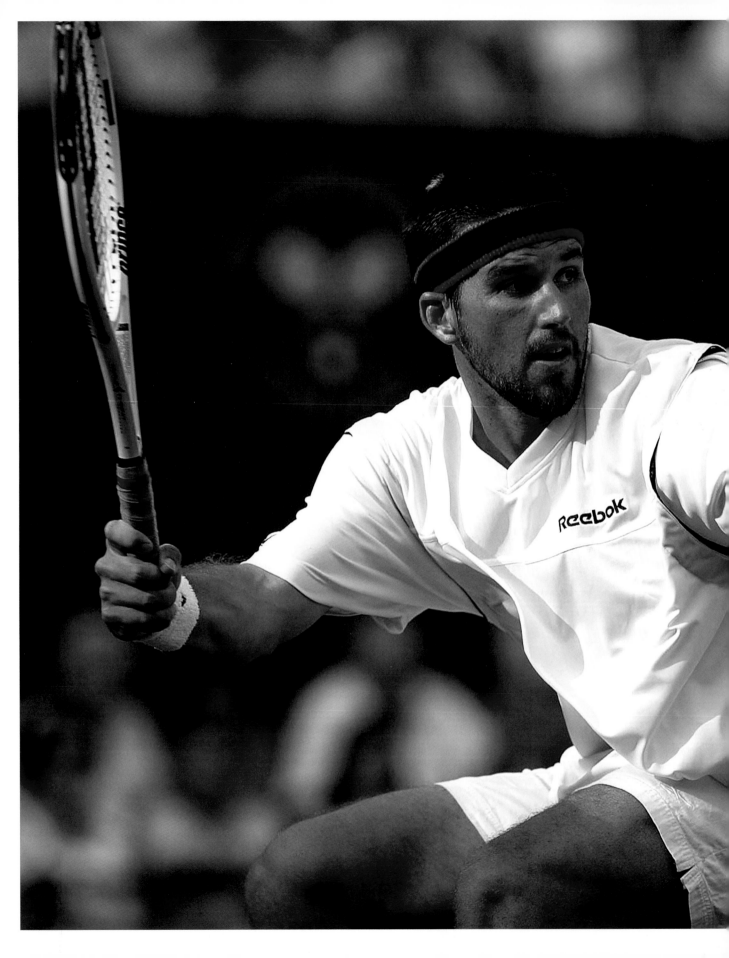

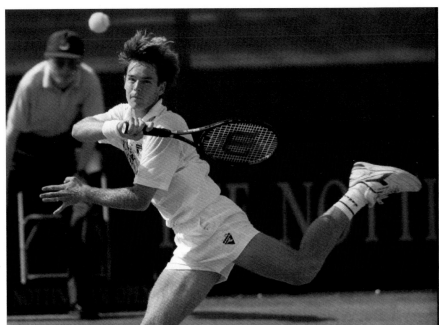

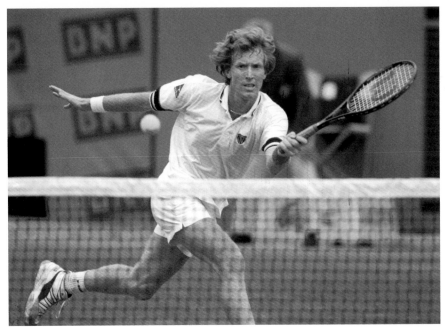

on finals day. Proving they were not just clay-court specialists, the pair met again indoors at the ATP World Championships, which had been moved from Frankfurt to Hannover. Moyá seemed to be on the brink of another straight-set victory when he took the first two sets 6–3, 6–3, but there were a few more determined fighters on the tour in that era than Corretja and he battled back to grab the big-

(opposite) *Queenslander Patrick Rafter. (Photo by camerawork USA)*

(above, top) *Todd Woodbridge, the right-handed member of the famous Woodies, partnered with Mark Woodforde to eleven Grand Slam titles out of sixty-one overall. When Woodforde retired, he and his Swedish partner Jonas Björkman claimed five Grand Slams in four years. After seventeen years on tour, Woodbridge retired with eighty-three doubles titles and carved out a new career as a television commentator and on-court announcer.*

(above, bottom) *Mark Woodforde who, with Todd Woodbridge, formed the Woodies, one of the most successful doubles combinations of the Open era. The red-headed left-hander lives with his family at Rancho Mirage, California.*

(above left) *Petr Korda, a talented Czch left-hander, was a Roland Garros finalist in 1992, and then won the Australian Open in 1998, beating Chile's Marcelo Ríos, briefly a world number one, in straight sets.*

(above right) *Sergi Bruguera, a tall Spaniard with a terrific two-handed backhand who was coached by his father Luis, dominated Roland Garros in 1993 and 1994, and then appeared in a third final in Paris in in 1997, losing to Gustavo Kuerten.*

(opposite) *Princess Diana was a tennis player and fan, frequently attending the Queen's Club tournament. Here, she lights up the royal box at Wimbledon.*

gest victory of his career by winning the last three sets 7–5, 6–3, 7–5. It said much for the enthusiasm of the Hannover tennis fans that almost no one left their seats as two Spaniards fought a war of attrition for almost five hours.

The decade could hardly end without yet more heroics from Andre Agassi. As he said at the start of the 1999 French Open, there were probably as many as six players on people's list as potential champions, and he wasn't one of them. After hitting rock bottom in November 1997, when his ranking plummeted to 141 in the world, Agassi had rebuilt his career with Brad Gilbert's help, but the process had been long and tortuous. Fourth-round showings at Melbourne and New York were the best that he had to offer at Grand Slam level in 1998, but

he had started winning a few matches by the time he arrived in Paris the following year and was seeded thirteenth.

Following Gilbert's instructions, Agassi took an aggressive attitude with him onto the slow clay of Roland Garros and caused the first big upset when he outplayed the defending champion, Carlos Moyá, in four sets in the fourth round. The tireless Slovak, Dominik Hrbatý, who was enjoying his best Grand Slam showing, was taken care of in the semi-final also in four sets. Suddenly, Agassi found himself in the French Open final for the third time—eight years after losing to Courier in 1991.

His opponent was unexpected, to say the least. Andrei Medvedev, a droll, quick-witted Ukrainian, was ranked one hundred in the world at the time,

although that was a hardly a fair reflection of his ability. Medvedev had already won eleven ATP titles, including three German Opens on the heavy clay courts of the Rothenbaum Club in Hamburg. But injuries had struck and his ranking had suffered. He put all that behind him in the second round as he gave Pete Sampras, the number two seed, a clay-court lesson, winning in four sets. He then overpowered Kuerten, champion two years previously, in straight sets. Medvedev was full of confidence by the time he walked on court for his first—and only—Grand Slam

final on a day of low, glowering clouds at Roland Garros.

It was just the kind of weather that suited Medvedev's hard-hitting, backcourt game. He showed why by running through a nerve-racked Agassi 6–1 in the first set. At 1–0 in the second, the rain started. Agassi sought the refuge of the locker room, only to be confronted by a combustible Brad Gilbert. The coach was not in the habit of raising his voice, but he did now.

According to Agassi's autobiography, Gilbert screamed at him, "What do you want me to say? You tell me

(above) *Andrei Medvedev, a droll Ukrainian who came close to beating Andre Agassi in the 1999 Roland Garros final.*

(opposite) *Àlex Corretja earned the biggest title of his career at the 1998 ATP Finals in Dortmund, Germany, when he battled back from two sets down to beat Carlos Moyá, the fellow Spaniard who had beaten him in the French Open final that year. To get there, Corretja had needed to beat Hernán Gumy in a five-and-half-hour marathon, the longest in Roland Garros history. On retirement, Corretja became a television commentator and coached Andy Murray from 2008 to 2011.*

he's too good. How the fuck would you know? You can't judge how he's playing! You're so confused out there, so blind with panic, I'm surprised you can even see him! Too good? You're MAKING him look good!"

Chastened, Agassi returned to the court, but he still found Medvedev too good and lost the second set 6–2. Agassi was being pushed behind his baseline by the power of the Ukrainian groundstrokes. Playing defense was not Agassi's game, and he surprised himself when he managed to break serve for 4–2 in the third. It was a shaft of sunlight in more ways than one because the clouds rolled away from southwest Paris, the sun appeared, and the clay reacted, drying fast. Vitally, the conditions had swung in the American's favor.

Not that he could capitalize immediately, Medvedev broke straight back. At 4–4, he reached break point when Agassi came up with consecutive double faults for 30–40. Agassi didn't need to be told Medvedev was five points away from the title. Walking in circles, squeezing his eyes, on the verge of tears, he missed his first serve. That was five straight serves that he had failed to get in court. "I'm falling apart," he told himself. But then Gilbert's words echoed in his head. Agassi knew that Medvedev would be expecting a safe second serve. There was still enough of the innate champion in Agassi to bluff him, so he put in a hard serve to the backhand, which Medvedev could only shovel back. A quick rally ensued that saw Agassi have to dig out an awkward forehand volley that landed on the line and then win the point with an easy volleyed winner. Two points later, Agassi has held serve, broken to love, and taken the third set 6–4.

The match had changed. With the court drying, Medvedev stared mournfully at the sun shining in his eyes, knowing his chance had gone. Agassi, moving inside the court and hitting harder with every shot, took charge and made history by winning this memorable battle 1–6, 2–6, 6–4, 6–3, 6–4. Only Fred Perry, Don Budge, Rod Laver, and Roy Emerson had won all four Grand Slam titles (although Federer, Nadal, and Djokovic would do so later) and Agassi's predecessors only had to achieve the feat on two surfaces: clay and grass. Agassi had won the US Open and the Australian on two different hard courts, emphasizing his versatility and all-round skills. By the time they retired, it was what separated him from Sampras, who had a 20–14 winning record over him but had never even reached a Roland Garros final. Agassi had the ability to win everywhere, on anything. Sampras tended to dominate when they met in Slams and had the bigger, more spectacular game. Who was better? The arguments will rage for as long as the game is discussed.

Henman Hill
London, UK

When the huge TV screen
was erected in front of the
hill next to Wimbledon's
new No 1 Court, it became a
popular picnic area and was
soon dubbed Henman Hill to
acknowledge the popularity
of Tim Henman, the four
time Wimbledon semi-fi-
nalist. After Andy Murray's
titles winning triumphs,
Murray Mount was suggest-
ed. Both names seem to fit.

12 The Nineties: Women

For women's tennis, the nineties was the decade of Steffi Graf, Monica Seles, and Martina Hingis with a notable contribution from Arantxa Sánchez Vicario, the little Spaniard from a major tennis family who followed her 1989 victory at Roland Garros with three more Grand Slam titles—winning the French Open in 1994 and 1998, and the US Open in 1994.

However, after Martina Navratilova had taken her final bow in singles by winning her eighteenth Grand Slam title with a straight set win over Zina Garrison at Wimbledon in 1990 (she was a losing finalist at Wimbledon to Conchita Martínez in 1994), the headlines from the women's game were largely focused on the extraordinary—and, in a certain way, tragic—rivalry between Graf and Seles.

Graf was the established champion, having taken control of her sport to a degree that even Evert and Navratilova had not managed by winning eight of the eleven Grand Slams that she played from Wimbledon in 1987 to the US Open in 1989. In the remaining three, she reached the final.

When the slender German with the devastating forehand beat Mary Joe Fernández 6–3, 6–4 to win her third consecutive Australian Open title in January 1990, she appeared to be unstoppable and unbeatable. However, Graf knew there was a threat looming on the horizon because she had been confronted by it in the semi-final of the 1989 French Open. An extraordinary

fifteen-year-old of Hungarian origin from Serbia named Monica Seles had taken her to three sets before Graf was able to win 6¬–3, 3–6, 6–3. The talent of her young foe was unmistakable.

Nick Bollettieri, the coach with an eye for the exceptional, had seen Seles play in the Orange Bowl in Miami at the age of eleven. In his book *Bollettieri: Changing the Game*, he describes his first impression of Seles as being a "toothpick on two spindly legs." He went on to say that it was her aggressive intent on every shot that impressed him most. "She had no need for the twenty-one feet behind the baseline. I thought her motto must be to hit the ball hard, hit it early, and never back up. Her determination and total focus on each strike of the ball was remarkable. She was pure, relentless, controlled aggression!"

Bollettieri signed Seles up immediately and offered her and her family free accommodation at his academy in Bradenton, Florida. With Serbia starting to become embroiled in the Balkan War, Karolj Seles, a cartoonist who had worked for several Serbian newspapers, grabbed the opportunity to take his family to a safer environment, even though it meant leaving behind Monica's first coach, Jelena Genčić, who went on to teach a very young Novak Djokovic.

Even Bollettieri, who was accused of running a boot camp so fierce was his work ethic, was astounded by Seles's inexhaustible desire to improve. Often, she kept him on court until 9:00 PM

(above) *Arantxa Sánchez Vicario was the star of the show one year at the Trophée de la Femme, an exhibition promoted by Pierre and Caroline Barthès at their huge twenty-six-court facility at Cap d'Agde in the south of France.*

(opposite) *It's impossible to know what Monica Seles might have achieved had she not been stabbed in the back while sitting in her chair at a changeover in Hamburg in 1993. Even so, her record is amazing: nine Grand Slam singles titles, missing only Wimbledon, where she was a finalist in 1992.*

at night, hitting with one practice partner after the next. She turned pro when she reached her fifteenth birthday and won the second pro tournament she ever played, beating Chris Evert in Houston.

Although she missed the 1990 Australian Open, Seles was in full flow soon afterward at what was then called the Lipton Championships (later, the Miami Open) on Key Biscayne. She took the place by storm, demolishing opponents with the incredible power of her two-handed groundstrokes—all hit with a squawk that became her least-appealing trademark. Racing about court on skinny legs that still did not look strong enough to carry her body weight, Seles played at an even faster pace than Graf, marching around between points with the urgency of a girl who felt there was no time to lose. Sadly, she was right about that.

Creating a major surprise, Seles won the Lipton and promptly embarked on a thirty-six match winning streak that took her all the way to her first Grand Slam title in Paris, culminating in a 7–6, 6–4 triumph over Graf in the final, after staving off four set points in the tiebreak, which she eventually won 8–6.

The unbeaten run came to an end when she lost to Zina Garrison in the quarter-final at Wimbledon, and she went down in the third round at the US Open. During 1991 and 1992, Seles simply took the game away from Graf, despite losing to the German in the 1992 Wimbledon final 6–2, 6–1. That blemish apart, Seles proved herself too strong for everyone, winning six of the seven Grand Slams in which she competed. In 1991, her record was astonishing; reaching the final in all sixteen tournaments in which she played and won ten of them, including three Grand Slams. (Injury kept her out of Wimbledon that year.)

Apart from grass, where a serve-and-volley player of Graf's class could cut through her defenses, it did not matter on which surface Seles played. She was just as effective indoors, as a run of three straight wins in the WTA Finals at Madison Square Garden proved. Playing over the best of five sets, Seles defeated Gabriela Sabatini 6–4, 5–7, 3–6, 6–4, 6–2 in 1990 before getting the better of Martina Navratilova in 1991 by 6–4, 3–6, 7–5, 6–0, and beating Navratilova again the following year 7¬–5, 6–3, 6–1.

Considering Steffi Graf was at the height of her powers, the winning record Seles set from January 1991 to February 1993 is barely credible. She won twenty-two titles and only once, in thirty-four tournaments, did she fail to reach the final. Inevitably, she replaced Graf as world number one and was held in awe throughout the sporting world.

Seles continued on her winning way when she beat Navratilova in the final of the Virginia Slims event in Chicago and then travelled to Hamburg for the German Open at the Rothenbaum Club. She was playing Bulgaria's Magdalena Maleeva in the quarter-final and sitting in her chair at the changeover without a care in the world when a man emerged from the crowd and stabbed her in the back with a nine-inch knife.

The thrust penetrated her back by 0.59 inches. The physical wound healed quite quickly; however, the psychological impact was something else. Seles was traumatized by the experience, which sent shockwaves through the tennis community.

It took Seles more than two years to feel confident enough to return the WTA Tour, and she certainly proved herself ready to compete in the summer of 1995, by becoming the first woman to win the Canadian Open in Toronto without dropping a set. A couple of weeks later, Seles seemed to be putting all her doubts behind her as she steamrollered her way to the final of the US Open with straight set wins over number four seed Jana Novotná and number three seed Conchíta Martinez. However, Graf was waiting for her in the final, and the German won a roller-coaster contest by the strange score of 7–6, 0–6, 6–3. Considering how little she had played, it was a fine effort by Seles. She seemed to be back on track when she showed how much she loved Melbourne Park by winning her fourth Australian Open title there in January 1996.

However, as the year unfolded, it became clear that Seles was not quite the same player. She lost in the quarter-final at Roland Garros to Jana Novotná, a future Wimbledon Champion but a player she should have beaten on clay. A year later, she went one round better in Paris but lost to seventeen-year-old Martina Hingis 6–7, 7–5, 6–4. Seles, however, was not giving up and in 1998, she battled her way into the Roland Garros final, crushing Hingis 6–3, 6–2 in the semi-final before losing to Arantxa Sánchez Vicario.

But by then, Seles's life had been scarred by tragedy once again. A year

earlier, her father had been diagnosed with stomach cancer, and he died the week before the French Open began. It had become a foregone conclusion that this vibrant man, who continued to coach his daughter by phone while receiving treatment, did not have long to live.

On the eve of her final against Sánchez Vicario in 1998, Seles told Barry McKay in a television interview that she was thinking of her father's instructions as she played the match against Hingis—always focus on the ball, just the ball. She spoke of the trouble that she had been having with focus generally ever since the stabbing and all through her father's illness, but she insisted that she drew comfort from her mother's presence in Paris and the memory of what her father had done for her.

It is not difficult to read a struggle with concentration into the score of the final that year. Sánchez Vicario, a player who could run forever and never gave anything away, won 7–6, 0–6, 6–2. When Seles zeroed in and threw caution to the wind, she overwhelmed

(opposite) *Here comes a sliced Monica Seles backhand!*

(above) *They called the incredible Steffi Graf "Fräulein Forehand" and here's why: that shot and her terrific speed and agility earned the German no less than twenty-two Grand Slam singles titles and Olympic Gold in Seoul, South Kore,a in 1988—the year she also achieved the Grand Slam of winning all four major titles in one calendar year.*

(above) *By reaching the Wimbledon final in 1990, where she lost to Martina Navratilova, Houston's Zina Garrison became the first African American woman to reach the top of the game since Althea Gibson five decades earlier.*

(opposite, top) *Wimbledon took Jana Novotná to their hearts when she broke down in tears as she received the runner-up medal on Centre Court after losing to Steffi Graf in 1993. Triumph and tragedy were to follow. After losing in another final in 1997, the Czech returned the next year to prove her coach, Hana Mandlíková, right when Mandlíková assured her that it would be third time lucky. And it was! Tears of joy flowed when she beat Nathalie Tauziat and received the trophy from an equally emotional Duchess of Kent. Fate, however, had not finished with this delightful champion. She died of cancer at the age of forty-nine.*

the little Spaniard in the second set but appeared unable to maintain that intensity as she tried to reclaim a crown that she had worn for the three consecutive years before fate struck her down.

It was her last Grand Slam final. Seles made the semi-final at the Australian Open and again in Paris the following year. Even as late as 2002, she got as far as the semis in Melbourne. Some sort of consistency was there because she made the quarters of all the three remaining Slams that year, but

the spark was gone. It had probably died with her father.

"He always made tennis fun. He never pushed me," Seles observed frequently when asked about the man who, according to Robin Finn in *The New York Times*, "was an oasis of congeniality on the tennis tour, garrulous but never bombastic."

Karolj Seles's aim for his daughter was to create "not only the perfect sportswoman but someone who could see beyond fame and money, one who can find her own way in life once she gets too old for tennis."

Although she played her last professional match at the French Open in 2003, losing in the first round, Seles, apparently loath to let go, did not announce her retirement until 2008. It had been a stellar career shrouded in regret.

The stabbing incident was a tragedy for both Seles and Graf in very different ways. The worst of it was that the perpetrator of the attack, who was diagnosed as being psychologically disturbed and who never served jail time for his crime, was a Graf supporter who was jealous of Seles. Tragically, he achieved exactly what he set out to do.

Graf reclaimed her dominance over the women's game without ever having the chance to show that she could have challenged Seles for the number one spot—if, indeed, she could have. Given her talent and champion's determination to fight through adversity, Graf might have worked out a method of dealing with the Serbian whirlwind, but the question mark will remain forever.

Although she has never spoken ill of him, Graf had a very different father,

The WTA had decided to switch to a best of five set format in the final match of their Finals in 1984 when Navratilova beat Evert 6-3, 7-5, 6-1 but reverted to best of three in 1999 when Lindsay Davenport beat Martina Hingis 6-4, 6-2.

who treated her in a very different way. Peter Graf, who was a car salesman when his daughter was born in Brühl, near Heidelberg in Germany, had played professional soccer and began hitting balls with Steffi across the living room sofa when she was three. He was determined that she would become a top player and drove her relentlessly.

Peter Graf took total charge of his daughter's career and paid for it when he served twenty-five months in jail for tax evasion in 1997. Steffi had to undergo hours of grilling by the judge, but she was exonerated on the grounds that she knew little of how her father looked after her business affairs. She did, however, agree to pay 1.3 million Deutsche Marks to a charity.

There were more lurid headlines in Germany when Peter Graf was blackmailed over an affair that he had with a *Playboy* model. Against this backdrop, it was amazing that Steffi was able to concentrate on her tennis. Although the personal storms were brewing in the background and health problems—bone spurs, back spasms, and clogged sinuses—began dogging her at every turn, this exceptional athlete managed to maintain the incredibly high standards that she had set herself and went on winning.

From 1992 until she retired in 1999, Graf had Heinz Günthardt at her side as coach. A fine singles player and exceptional doubles champion, he and his long-time partner Balázs Taróczy of Hungary won Wimbledon and the French Open together. The Swiss was not as fierce in his coaching methods as her father had been, but nor was he intimidated by this super star who no longer needed to be told how to play the game. Günthardt drove her hard when necessary and fine-tuned some aspects of her game without ever being able to

convince her to use her perfectly serviceable topspin backhand. She used it in practice, but once she was on the match court, it was slice, slice, slice. She was obviously most comfortable using it as a method of setting up the rally so that she could finish it with her lethal forehand.

Injuries became a real problem. After winning the Lipton title at Key Biscayne in 1996, she joked that she had suffered so many health problems that required searching for so many doctors in cities all over the world that she was thinking of writing a guide book.

Despite a second foot operation, she won three Grand Slam titles in 1993, after losing to Seles in the final of the Australian. Then, after a mediocre year in 1994, which included just one Slam (the Australian) and a very rare first-

(above) *Nick Bolletieri. Pete Sampras, Andre Agassi, and Jim Courier all spent part of their tennis youth living at Bolletieri's Bradenton Academy in Florida. He was instrumental in the enabling Monica Seles to settle in America.*

(above) *Chicagoan Katrina Adams broke records by becoming the youngest president of the USTA, as well as the first African American and former WTA tour player to hold that position, which she did with distinction from 2015 to 2018. Adams worked assiduously to embrace black tennis across America, especially with her work at the Harlem Foundation. On tour, she won twenty-two doubles titles, frequently partnering her African American colleagues Zina Garrison and Lori McNeil. Adams is pictured here with one of the US Open's great supporters, New York City Mayor David Dinkins. (Photo by camerawork USA)*

(opposite) *If you can coach your child to be the number one player in the world at the age of sixteen, you need to be doing something right. Martina Hingis's mother, Melanie Molitor, deserves so much credit for guiding her to the top so swiftly.*

round loss (to the American Lori Mc-Neil at Wimbledon), Graf reasserted her dominance over the next two years, winning every one of the six of the Grand Slams that she played, missing the Australian on both occasions.

In 1995 and 1996, Graf found herself facing Arantxa Sánchez Vicario in all four of the finals that she played at Roland Garros and Wimbledon. The Spaniard, whose brothers Emilio and Javier were both doing well on the ATP tour at the time, was known as a clay court specialist, but the fact that she was able to fight her way through two Wimbledon finals on grass revealed the extent of her determination and versatility. In 1995, Sánchez Vicario was appearing in her sixth Grand Slam final out of seven, having won both the French and US titles in 1994—the latter with a stunning 1–6, 7–6, 6–4 upset triumph over Graf. This exceptional consistency had established her as a solid number two player in the world, and even Graf could not prevent her from reaching the top spot for a brief period at the start of 1995.

By the time she defeated Seles in the final of the US Open in 1996, Graf's physical condition was becoming a serious concern quite apart from the trauma of her father's pending imprisonment. She managed to win the WTA Finals at Madison Square Garden for the second straight year with an extraordinarily uneven five-set victory over Martina Hingis by a score of 6–3, 4–6, 6–0, 4–6, 6–0. It was the last major title that she would win until she met Hingis once again in the final at Roland Garros in 1999. The story of that emotional match deserves paragraphs of its own. First, though, we should introduce Hingis—a far from typical Swiss Miss who achieved the quite ex-

traordinary feat of becoming number one in the world at the age of sixteen.

Born in Košice, Slovakia, the little girl who had been named after her mother's idol, Martina Navratilova, was skiing and hitting tennis balls at the age of two. By four, she was entering tournaments. Her mother moved to Switzerland in 1988, and ten years later, Hingis was leading Switzerland to its first Fed Cup final, where she won both singles but could not prevent Spain from winning the trophy 3–2.

By then, the teenage prodigy had made her professional debut at a WTA event in Zurich in October 1994, two weeks after her fourteenth birthday. She did not seem the slightest bit overawed by the occasion. A year and a half later, she was holding up the Wimbledon doubles trophy with Helena Suková, having become the youngest Wimbledon doubles titleholder at the age of fifteen years and nine months.

Two months later, Hingis was a semi-finalist at the US Open in singles. Then, in 1997, she really came into her own, winning the first of three consecutive Australian Open titles, reaching the final at Roland Garros, and winning Wimbledon and the US Open—all at the age of sixteen. Hingis had already ascended to the number one ranking in the world when she defeated Seles 6–2, 6–1 at the Lipton International Players Championships at Key Biscayne, making her the youngest ever number one at sixteen years six months.

By then, the experts were scratching their heads. They could see why Venus Williams was starting to make inroads on the pro tour at the age of eighteen (in 1998, Williams reached one Grand Slam semi-final and four quarter-finals) because she was tall and strong and hit a powerful ball. Hingis was five feet and

seven inches and was not going to over-power anyone. She was winning because she had this sixth sense of how to play the game. Obviously, her mother, Melanie Molitor, was a superb coach, but her daughter had an instinct about tennis—a natural talent that allows a young player to analyze a game or a point as it is happening. Like a champion chess player, Hingis was usually two or three shots ahead in her thinking as a rally developed, knowing which move and which placement would enable her to open up the court. She was a natural and simply far too clever for most of her opponents. Asked to pick out her best attributes, Chris Evert mentioned her balance and unpredictability. "She may not be a great volleyer, but she gets in when you least expect it and is always perfectly balanced to play her shots," Evert said.

Hingis held the number one ranking for 209 weeks. To have risen to the number one spot at sixteen was an achievement that must rank as one of the greatest that the game has ever seen.

Hingis started her dream year of 1997 by winning in Sydney before beginning her three-year domination of the Australian Open in Melbourne with a 6¬-2, 6-2 victory in the final over the former champion Mary Pierce. Flying up to Tokyo, she won the prestigious Pan Pacific title and then, with barely time to catch her breath or discover which time zone she was in, she flew on to Europe. It was the same story

at the Paris Indoors, traditionally held at the little Stade Pierre de Coubertin arena at the Porte de Saint-Cloud station, which is walking distance from Roland Garros.

It was difficult to believe Hingis was still sweet sixteen as she exuded all the vivacious, carefree attitude of a teenager having the time of her life. There was a flirtatious innocence about how she dealt with people, including the media. I remember how she eyed a sideboard of French patisserie in the press room at Coubertin and, turning away with a big grin on her face, she joked, "Mmm, can't have any of those or I will put too much on this!" With that she slapped her bottom in a provocative way and returned to the locker room.

Titles in Miami and Hilton Head, South Carolina, followed. By the time she reached the Roland Garros final, sweeping aside Sánchez Vicario, who was already a two-time French Open champion, in the quarters 6-2, 6-2 and surviving a tough 6-7, 7-5, 6-4 victory over Seles in the semi-final, Hingis was hot favorite to continue her thirty-seven match-winning streak over the ninth seeded Croatian, Iva Majoli.

It was not to be. Playing the match of her life in the tournament of her life, the nineteen-year-old Majoli, who would never get as far as a semi-final in any Grand Slam again in her career, outplayed Hingis to win 6-4, 6-2. "She served better than me and made me run," Hingis told Bud Collins after she and Majoli had embraced each other warmly at the end. Hingis, managing a big smile, took her defeat well, which is in stark contrast to what would transpire when she played Graf in the French Open final two years later.

Given the sporting way in which Hingis had accepted defeat against Ma-

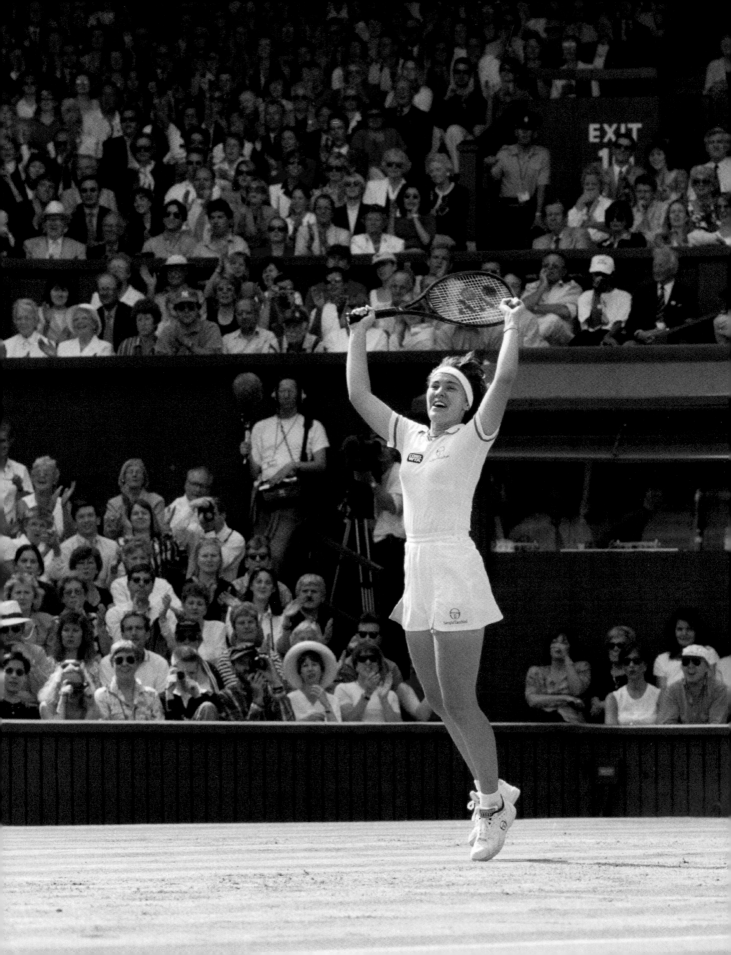

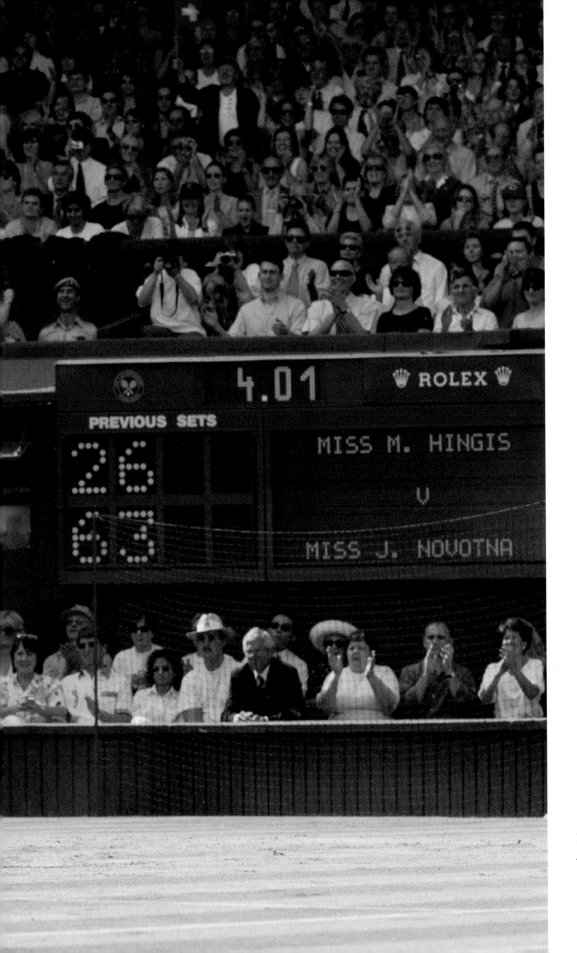

4.01 ♔ ROLEX ♔

PREVIOUS SETS

26
63

MISS M. HINGIS

V

MISS J. NOVOTNA

A jump for joy as Martina Hingis wins Wimbledon in 1997, beating Jana Novotná 6–4 in the third.

joli, it was a little surprising the Roland Garros crowd should give her such a hard time in 1999. Understandably, their sympathies lay with Hingis's opponent, the hugely popular Steffi Graf, who was playing the French Open for the sixteenth time, having reached the final eight times and winning five of them.

On this occasion, the two players arrived at finals day with very different expectations. Hingis had returned to her best after slipping back a touch the previous year when she lost to Seles in the semi-final at Roland Garros, to Jana Novotná in the semi-final at Wimbledon, and to the rising star from California, Lindsay Davenport, 6–3, 7–5 in the final of the US Open, where she was defending champion. Davenport, in fact, used her height and power to usurp Hingis's position as number one in the world by the end of 1998, before the Swiss regained it early in the new year.

But the smile was back on Hingis's face as she moved easily through the draw in Paris beating Sánchez Vicario, who was the defending champion, 6–3, 6–2 in the semi-final with some surprisingly aggressive play. Hingis, still three months short of her nineteenth birthday, had already won five Grand Slams, and the French Open was the only one missing from her personal honors board. It was what she wanted most because it would complete her Grand Slam set and because she felt she deserved it. She knew in her heart that she was good enough to win it. Few would have disagreed with her. Anticipation turned to anxiety, and she was wound up tighter than a Swiss clock when she walked on court to face a player who had beaten her six times in eight meetings.

Graf, on the other hand, was just happy to find herself in the final. As a result of another foot operation and various other ailments, the German had not been in a Grand Slam final since winning the US Open in 1996. She had lost 7–5, 6–1 to Seles in the quarter-final of the Australian Open and, in contrast to Hingis, her expectations were low.

They were not improved when Hingis broke her serve in the first game of the match and, despite breaking back quickly, she could not bring her forehand to bear on the Swiss defenses with sufficient effect to prevent Hingis from taking the first set 6–4. The prize that Hingis craved was creeping closer.

It became closer still when she broke to lead 2–0 in the second set. Then, this incredibly shrewd and successful eighteen-year-old allowed the moment to overwhelm her. Maybe it was the crowd who were yelling their support for Graf and reacting to Swiss winners with no more than a ripple of applause. Maybe it was an uncontrolled teenage impulse to demand what she felt was hers. Maybe the desire simply became too much. Whatever it was, Hingis's reaction to a dubious line call on the first point of the third game changed the match.

Her forehand service return was called out, and when Hingis queried it, umpire Anne Lasserre got down from her chair to consult the line judge and inspect the mark. She confirmed the call as out. Hingis was having none of it. Striding forward, she marched around the side of the net into her opponent's territory, which is against both the spirit and rules of the game.

If the crowd had been vociferous on Graf's behalf, their fury at Hingis's behavior now reached the point of hysteria. Boos and catcalls rang out around the old stadium, which had rarely heard anything like it. Still refusing to accept

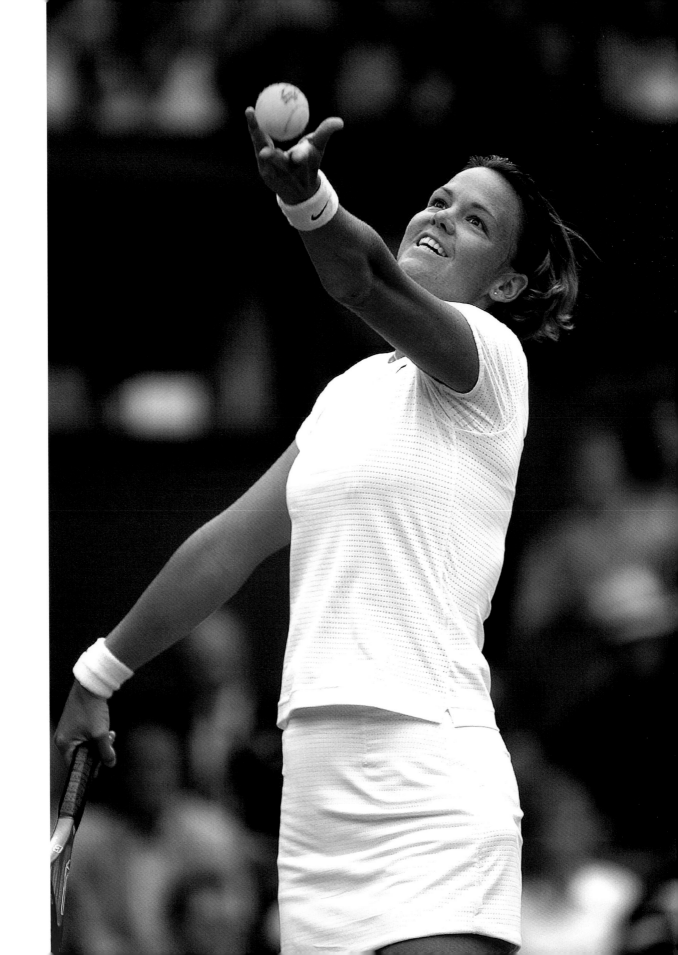

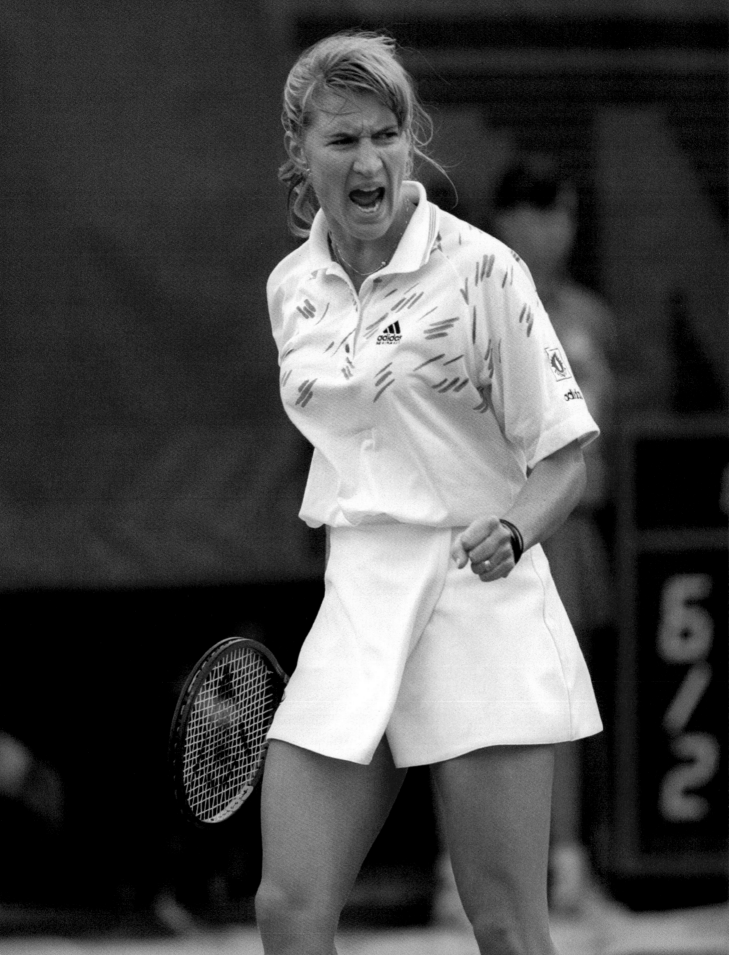

the umpire's judgement, Hingis sat down and waited for the long-serving WTA supervisor Georgina Clark to come on court. After a brief verification of the umpire's decision, Clark told Hingis that she must continue and allowed the umpire to do the correct thing, which was to penalize Hingis a point, which made the score 30–0 to Graf. The penalty point was awarded because Hingis had already been warned for racket abuse.

The match resumed amid an atmosphere of high tension but, although Graf held for 1–2, Hingis kept herself under sufficient control to extend her lead to 3–1. Just three more games needed. Graf found herself being carried along on the wave of popular emotion, and she drew on it, breaking back after a long exchange of cross-court forehands to level at 3–3. At 4–4, Hingis showed no sign of being overwhelmed by the hostility being showered on her and broke again with a typical backhand winner into space she had created. She was serving for the title 5–4.

The mind does strange things in moments of crisis. After Graf had earned herself break back point in the tenth game with one of her explosive forehand winners, Hingis allowed herself to do something stupid—a rarity for this canny player. She tried a drop shot off the backhand from behind her own baseline. And it fell into the net.

People sipping their coffee on the terraces of the cafés at the Porte d'Auteuil almost a mile away must have heard the roar. Graf had leveled at 5–5 and was inspired. She took eight of the next nine points to win the set 7–5. Shocked and hurt, Hingis was spent. Nevertheless, she had one more trick up her sleeve. Match point down at 2–5, 30–40, Hingis suddenly produced a backspun underhand serve, which caught Graf totally by surprise. Lunging forward to reach the ball, Graf could only shovel it over the net and got passed. The crowd hissed, but Graf would not join in the criticism afterward. "I thought it was a hell of a serve," Graf said. "For her to do it for the first time at match point down was very good. I had the feeling the crowd thought it was an insult. But it was a good decision from her point of view."

No matter what the crowd thought, Hingis was not going to give up. After missing a game point, she tried another underhand serve when she faced her second match point. This time, it missed and, after a conventional second serve, she netted a return, and Graf had won her sixth French Open crown by 4–6, 7–5, 6–2.

Distraught, Hingis fled to the locker room in floods of tears and only returned at the insistence of her mother, who led her back into the arena by the arm. Only when the eighteen-year-old recovered her composure to give a generous speech in French did she receive a warm round of applause. As Steve Flink wrote in his acclaimed book *The Greatest Tennis Matches of the Twentieth Century*, Hingis had made many miscalculations. "Her actions were inflammatory, inviting the crowd to treat her with increasing disapproval," Flink wrote. "Nevertheless, the audience were willing to tolerate Graf's excessive questioning of line calls."

That was true, and it reflected the fact that, even in Paris where the crowds can be harsh, I have never seen a young player subjected to such sustained venom.

The aftermath of this extraordinary duel could never have been predicted. Neither player would win another

(top) *Shy as a player with limited English, Argentina's Gabriela Sabatini blossomed into a self-assured, multilingual businesswoman with her own brand of perfume after she retired from the game.*

(bottom) *It took Jennifer Capriati a while to win her first Grand Slam title, but not so for the young lady she happened to have a photo taken with in Florida. By the time Sofia Kenin was twenty-one in 2020, both could call themselves Australian Open champions. (Photo by Art Seitz)*

Grand Slam title in singles. That was, perhaps, less shocking as far as Graf was concerned, because she was fighting injuries at the end of a long and magnificent career. Few, though, would have thought that Hingis would fall short. However, injuries began to affect her too. After losing to Serena Williams 6–3, 7–6 in the final of the US Open that year, she came close to adding to her total of five Slams in singles only in Australia, where she lost three consecutive finals between 2000 and 2002. Doubles, as we shall see, was a very different story, when Hingis made a surprise return to the game more than a decade later.

Graf, of course, would revel in her retirement after she started dating Andre Agassi in 1999 and marrying him two years later. Occasionally, she can be persuaded to join him at a charity mixed doubles event, but she prefers her life as a housewife in a Las Vegas suburb, looking after the couple's two children.

All the drama surrounding the rivalries between Graf and Seles and Graf and Hingis should not preclude mention of another of the decade's most popular performers: Gabriela Sabatini. Stealing the words of a song written about a neighboring country, the tall, tanned, young, and lovely girl from Argentina caught the eye for her looks as much as for her ability with a racket.

This innately shy young woman was not looking for fame and public adoration. In fact, she recoiled from it. Years after Sabatini retired in 1996 amid emotional scenes at the WTA Finals at Madison Square Garden, she admitted, "I was very introverted. I loved playing tennis from the first moment I grabbed a racket, and I was very competitive. But I think my fame and my public profile had something to do with the fact

that I did not become world number one. To be so famous would have been a problem for me."

She was two points away from facing that problem in the 1991 Wimbledon final when she led her friend and great rival Steffi Graf in the third set before the German snatched it away from her 6–4, 3–6, 8–6. A victory would have made her number one, following her triumph at the US Open nine months earlier when she had beaten Graf in the final 6–2, 7–6 after coming through a huge battle with Mary Joe Fernández in the previous round 7–5, 5–7, 6–3.

Sabatini had burst onto the WTA tour with her powerful and aggressive back-court game at the age of fourteen. By the time she had grown to five feet and eight inches, she had the ability to dominate opponents with her superb athleticism and surprise them with the ferocity of her one-handed backhand. She was only three weeks past her fifteenth birthday when she reached the semi-final at Roland Garros in 1987. The following year, she improved her Grand Slam record by reaching the final of the US Open, where Graf beat her 6–3, 3–6, 6–1.

Before the year was out, Sabatini won her first big title by defeating Pam Shriver in the final match of the WTA Finals in New York 7–5, 6–2, 6–2. The medium-paced carpet at Madison Square Garden obviously suited her game because Sabatini appeared in four finals there, winning for the second time in 1994 over Lindsay Davenport 6–3, 6–2, 6–4.

By the mid-nineties, her English had improved, but she still hated interviews and the ceaseless travel was beginning to wear her down. Managing to lose 1–6, 7–6, 10–8 to Fernández at Roland Garros in a three-hour-and

thirty-six-minutes marathon after she had led the American 6–1, 5–1 said as much about her scattered mental state as it did the strength of Fernández's. The future US Fed Cup winner and captain should be credited with one of the most remarkable comebacks in Grand Slam history.

Three years later, Sabatini retired at the age of twenty-six and her legion of fans worldwide prayed that she would return, but she never did. Now, Sabatini presents a very different image to the world when she appears at charity events or promotes one of her perfume products. Poised, elegant, and speaking perfect English, she is obviously living life on her own terms and is all the happier for it.

The startling emergence of the Williams sisters (more on them in the next chapter) was preceded by Lindsay Davenport's rise to prominence as one of America's most-admired women players. There was never much doubt that the Californian teenager who grew to six feet and two inches would play some sort of sport at a high level, and the odds were on volleyball. Her father, Wink, had been on the US volleyball team at the Mexico City Olympics in 1968, and both her sisters played the game. Young Lindsay, however, picked up a racket and liked it, and was given full family support. She took a while to establish herself, but once the power of a huge ground game started to find consistency, she became a threat to everyone.

After some guidance from the hard-driving coach Robert Lansdorp, a former tour player named Robert Van't Hof took over as her coach. He was at Davenport's side in 1998 when she pounded Hingis to defeat 6–3, 7–5 to win the US Open. The moment she won match point, Davenport started crying.

"It was just mind blowing," she said. "I felt the crowd wanted me to win, and when it happened, I felt I had done something that made everyone there happy."

Her supporters were happier still at Wimbledon the following summer, when Davenport caught Graf at the end of her career (her last final at the last Grand Slam that she would ever play) and beat the great champion 6–4, 7–5. Six months later, she proved too strong for Hingis again—this time, in the final at Melbourne—and added the Australian Open to her list of Grand Slam singles titles.

(above) *Twice a finalist at the Australian Open and once at Roland Garros, Mary Joe Fernández's long career includes winning the 1991 Australian Open doubles with Patty Fendick, and Roland Garros in 1996 with Lindsay Davenport. Captain of the US Fed Cup team for eight years, Fernández married Tony Godsick, Roger Federer's manager in 2000. They have two children.*

had been number one in the world on eight different occasions for a total of ninety-five weeks—a monumental effort considering the level of opposition that she had to face throughout her career.

Mary Pierce, born in Canada of an American father and French mother, was another player who left her mark on the nineties and on into the next decade. Tall and strong with a double-handed backhand, Pierce elected to play for France. In 1995, she presented that nation with a rare Grand Slam title by beating Sánchez Vicario in straight sets to win the Australian Open.

By then, Pierce had already given the French public something to cheer at Roland Garros the previous year, when she overpowered Graf 6–2, 6–2 in the semi-final before losing to Sánchez Vicario 6–4, 6–4 in the final.

Unhappily, Pierce was another female player who was suffering from father problems at the time. In 1993, Jim Pierce was banned from attending any WTA tournaments for his frequently abusive behavior, both to his daughter and other members of the tennis community. Nick Bollettieri and Mary's brother, David, took over her coaching from a passionate but hopelessly undisciplined father and rose to number three in the world, following her triumph in Melbourne. Later, Pierce's game was refined by one of the game's most respected coaches, Sven Groeneveld.

Pierce's greatest triumph came in 2000, when she beat Conchita Martínez to become the first French woman since Françoise Dürr in 1967 to win at Roland Garros. It was quite an achievement as Pierce had to fight her way past Seles in three sets in the quarter-finals and past Hingis 6–4, 5–7, 6–2 in the semi-finals. Needless to say, Pierce became the toast of Paris.

Davenport was also a prodigious performer on the doubles court, winning three Slams, including Wimbledon with Corina Morariu the same year that she won the singles, and appearing in no less than ten other finals.

It was only when she married Jon Leach, whose brother Rick had coached her for a time after Van't Hof left, and started having babies that Davenport ceased to be a constant presence at the sharp end of major tournaments. By the time that she had her fourth child in January 2014, Davenport had established herself as a respected and fluent summarizer for Tennis Channel. She

13

The 2000s Men & The Big Four

(below) *A Canadian by birth, Greg Rusedski's switch to Great Britain caused controversy at the time, but the big left-hander soon established himself as a dedicated performer for Britain in the Davis Cup. He reached the final of the US Open in 1997, and later became a successful captain of the Junior Davis Cup team.*

(opposite) *US Open champion in 2003, Andy Roddick was appearing in his fourth Wimbledon final in 2009, when he came so close to beating Roger Federer in a memorable duel. The humorous Texas resident with a fast lip and faster serve also racked up ten straight years in the world's top ten, always keeping American tennis in the conversation.*

The twentieth century had begun with Dwight Davis launching his new idea for an international team competition, with Reggie and Laurie Doherty making the men's game a family affair by winning everything worthwhile, and with Blanche Bingley Hillyard winning Wimbledon in corsets.

If there was to be a link to that scenario a hundred years later, then it was the imminent rise of another family who would be destined to dominate the game—the women's game rather than the men's, starting out poor rather than rich, black instead of white, and certainly not wearing corsets. The Dohertys and the Williams sisters may not have been cut from the same cloth, but in their eras, they were all pretty adept at stitching together wins on a tennis court.

More on Venus and Serena Williams later but, as far as the men were concerned, the new millennium dawned with their game in transition.

Pete Sampras would find Grand Slam titles more difficult to come by. The Californian with the long arms and mighty serve won his seventh record-breaking Wimbledon title over Patrick Rafter in the 2000 final, but he was stunned at the US Open when a tall, languid Russian named Marat Safin blasted him off court in the final 6–4, 6–3, 6–3.

Safin was blessed with so much talent that he hardly knew how to harvest it and, sadly, he left a lot of it rotting in the barn as his uneven career unfolded. But on that day in New York, his multiple skills were a sight to behold as, in a very different and not very helpful sense, there were the bevy of beauties who occupied his box when Safin lost to Sweden's Thomas Johansson in the 2002 Australian Open final. The big handsome Russian enjoyed the good life. With his coach—Mats Wilander at the time—ab-

sent, Safin explained his Melbourne ticket distribution this way: "Well, I had to find support from somewhere."

A couple of years later, with Peter Lundgren installed as coach, he was back on track. With focus and proper training, Safin appeared in another Australian Open final in 2004, losing to the emerging Roger Federer, and then won his second Slam the following year in Melbourne by beating local favorite Lleyton Hewitt in four sets. Safin, an interesting, enigmatic character, was always full of surprises and produced another on retirement by getting himself elected to the Russian parliament.

Sampras, however, was not going to drift away quietly. He had a last hurrah in him and produced it in typical and appropriate style by beating his old foe, Andre Agassi, in the final of the 2002 US Open 6–3, 6–4, 5–7, 6–4. It was the last time that they played each other—the last time in a career-long matchup that had started back in the 1990 US Open, when Sampras had won the final in straight sets. Now, in their thirty-third meeting with Sampras leading the series 19–14, Agassi was supposed to come out the winner. Under the tutelage of a new coach, the shrewd Australian Darren Cahill, Agassi's career was on the upswing again. He knew that Sampras had reached his pinnacle and was starting, almost imperceptibly, to slide down that slippery slope. But he was wary. Too many defeats had taken its toll on Agassi's confidence. After Sampras had gained a two set to one lead, Agassi was clinging to the idea that he would have an edge in a fifth set, but he couldn't get there. On the second of two break points on Sampras's serve at 3–4 in the fourth, Agassi blasted a service return straight at his rival's feet. He was sure that it was a winner. But Sampras, reaching for the ball as it almost got past him (reaching back to his halcyon days of brilliance), flipped back a half volley

that cleared the net and landed dead in Agassi's court. Sampras allowed himself a tiny smile of satisfaction. Agassi had seen it all too often before, and it drove him mad.

Agassi led Sampras 3–2 on clay, but all the other stats favored Sampras. It had been a strange and often awkward relationship off court and always an intense one in the heat of battle. In their very different ways, both will go down as two of the great American tennis players of all time.

Agassi, of course, was still very much a factor at the top of the game, winning the Australian Open three times in four years between 2000 and 2003, and making the final of the US Open once again in 2005, when he lost to a youthful Roger Federer.

As the decade got under way, several talented players were busy building on their achievements in the 1990s. Patrick Rafter, the two-time US Open champion from Queensland, reached consecutive Wimbledon finals in 2000 and 2001, losing to Sampras and then Goran Ivanišević, while Gustavo Kuerten cemented his position as one of the greatest clay-court performers that the modern game had seen by winning two more French Opens, beating Sweden's

Magnus Norman in 2000 and Spain's Àlex Corretja in the 2001 final. Sadly, both Kuerten and Norman had their careers cut short by the need for hip surgery in their twenties, the result, the experts said, of an open stance forehand. The immensely talented Chilean left-hander Marcelo Ríos, whose style put similar pressure on his hips, suffered the same fate.

The story of Wimbledon 2001 was a saga in itself. After a decade on the tour, Ivanišević, the tall Croat with the massive left-handed serve, had won twenty-two ATP titles in places like Stockholm, Stuttgart, Vienna, and Milan—mostly, on quick, indoor surfaces—but had only broken through to a Grand Slam final three times, all of them at Wimbledon and all of them ending in defeat. In 1992, Ivanišević lost to Agassi in five sets. In 1994, Sampras handled him in three, and in 1998, it was Sampras again—this time 6–2 in the fifth.

In 2001, Ivanišević found himself due to face the local hero, Tim Henman, in the semi-final of a Wimbledon already troubled by frequent rain. Henman, a clean-cut Englishman with a stylish serve-and-volley game, who rose to number four in the world, was given every chance of beating the errat-

(opposite, top) *Tim Henman came so close to reaching a Grand Slam final—four times in the last four at Wimbledon. Strangely, he may have come closest at Roland Garros when he beat one Argentine clay-court expert, Juan Ignacio Chela, in straight sets and outplayed another, Guillermo Coria, 6–3 in the first set of semi-final, eventually losing it 7–5 in the fourth.*

(opposite, bottom) *When the Madrid Open was still played indoors during the winter, Germany's Nicolas Kiefer (left) who was ranked world number four in 2000 and Magnus Norman, who reached the Roland Garros final the same year, traveled out to Real Madrid's old training ground to meet Roberto Carlos and watch a training session. In 2011, Norman, whose career was cut short by injury, partnered with two other Swedish players, Mikael Tillström and Nicklas Kulti to create the Good to Great Academy outside Stockholm. Norman coached Stan Wawrinka for many years.*

(above) *Elation for the exciting and excitable Goran Ivanišević, who finally gets his hands on the cup at Wimbledon in 2001, after beating Patrick Rafter.*

ic Croat by most experts, but the scheduling did him no favors. The weather had been bad all week, and the forecast for the Friday called for rain later in the afternoon. With no roof in those days, this would make it virtually impossible for the second semi-final to get finished. But the scheduling committee—possibly with NBC television and it's "Breakfast at Wimbledon" program and BBC commitments—opted to put Agassi's match against Rafter on first.

So the inevitable happened. Henman and Ivanišević managed to get through three sets and three games, and then it rained. By then, it was late, and the match was called for the night. There was no question as to which player had the momentum. Ivanišević had taken the first 7–5 before Henman upped his return game and won a tight tiebreak in the

second 8–6. Then the lean Englishman from Oxfordshire took over. In a blur of terrific serve-and-volley aggression, Henman won five games in twelve minutes before closing it out 6–0. Ivanišević, whose service rhythm had deserted him, did manage to hold in the gathering gloom at the top of the fourth, but if the match had continued, all the momentum would have been with Henman.

The media were all over the story, of course, because there had not a British man in the Wimbledon final since Bunny Austin had lost to Don Budge in 1938. The pressure on Henman was immense, and it got worse. When the match resumed on Saturday, the weather allowed only fifty-one minutes play. During that time, Ivanišević had held his nerve in the tiebreak and evened it up at two sets each. Obviously, there

would be no Sunday final. And the winner of this second semi-final would have to face Rafter on Monday with an unrested body and a frazzled mind. It was not difficult to imagine which mind had been battered most. Certainly, there was pressure and expectation on Ivanišević, but Henman was carrying a nation on his shoulders, up close and personal. Twice, he had been forced to go to bed, trying not to replay every point that had been played and trying not to dream dreams that seemed tantalizingly close.

In the end, it proved too much. When they returned to the Centre Court on that Sunday afternoon, Henman managed to hold serve for 3–3, but all the dash and panache that had been so evident in his game during that dazzling third set had vanished. His first serve carried no sting. He tried to level for 4–4, crushing Ivanišević's returns off weak second deliveries, but a double fault handed Ivanišević the ultimate initiative. Keeping hold of his own nerve-shredded temperament, Ivanišević served it out for a 7–5, 6–7, 0–6, 7–6, 6–3 victory. It was the only Wimbledon semi-final in history that had taken three days to complete.

Somehow, on the Monday afternoon, Ivanišević managed to survive an uninterrupted epic against Rafter, who had won a thrilling fiver setter against Agassi back on Friday. The score in the first four sets—6–3, 3–6, 6–3, 2–6—reflected an even contest with each man having periods of dominance on serve, interspersed with some inspired returns. The fifth, however, became deadlocked. At Wimbledon, there was no tiebreak in the fifth set, so it continued 6–6, 7–7. Rafter, who was seeking to join a pantheon of Australians who had conquered Wimbledon, finally

cracked on his serve to leave the Croat standing on the threshold at 8–7.

If ever one needs to examine what pressure and nerves can do to a player's tennis, the sixteenth game of this fifth set provided it. Ivanišević began by hitting a ball that he should have left alone out of court on a high volley. Missing his first serve again, he leveled at fifteen all before double faulting. Then, he compensated for another miss on his first serve by hitting an ace on his second. The ever-amiable Rafter shook his head and grinned. Then came an ace and the first match point. Ivanišević demanded

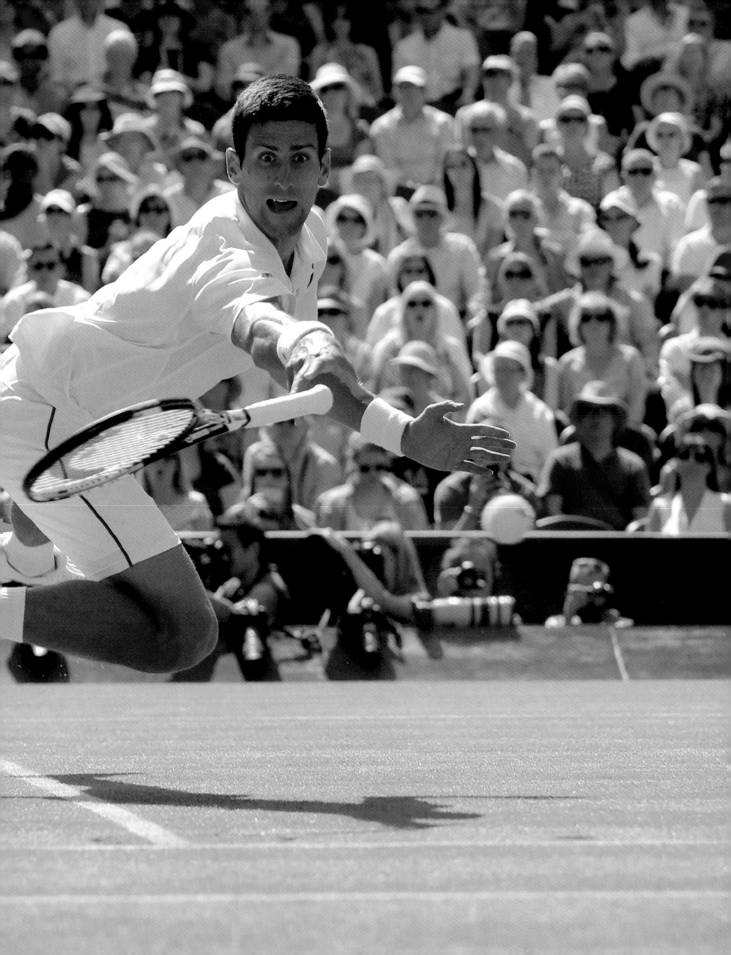

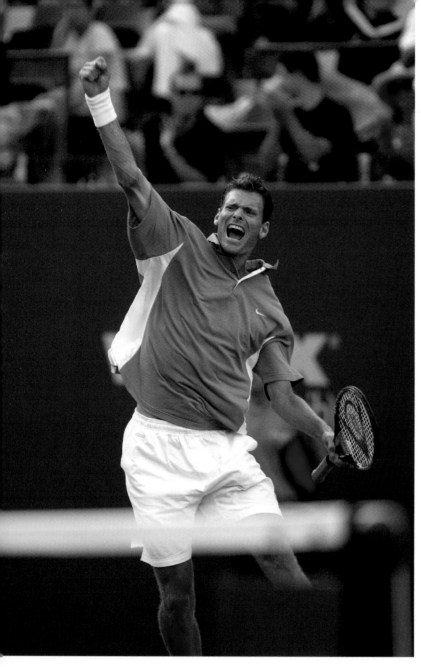

Sjeng Schalken, a tall, powerful Dutchman, reached the semi-finals of the US Open in 2002. He won twelve ATP tour titles and came closest to a major breakthrough when he twice had a break in the fifth set against Lleyton Hewitt in the 2002 Wimbledon quarter-final, the year Hewitt became champion. (Photo by camerawork USA)

the same ball. Superstition was rife, and Croats in the crowd were crossing themselves and appealing to the heavens.

Trying to slow down and control his nerves, Ivanišević literally pulled up his socks, but his serve collapsed again—a second serve missing the service line by at least three feet. It was possibly the worst second serve that Ivanišević had ever produced. Then, at last, a first serve. Match point number two. Another double fault. Deuce.

Rafter then hit a backhand up the line that missed by an inch. Ivanišević went down on his knees in prayer. You had to admire the Australian. Pushed wide on his backhand side, Rafter then put up the perfect backhand lob to save the third match point.

Rafter then netted a backhand and, on match point number four, he couldn't control a backhand that flew into the net. Ivanišević collapsed full-length on the scarred turf, sobbing his heart out. Rafter, who should have been the one crying, greeted his adversary with a smile as large as the Out Back, showing why he was and remains one of the most popular people in the game.

Right at the beginning of the new century, a scrawny kid from Adelaide in South Australia was just about to make his mark. Lleyton Hewitt had already signaled his intent by winning his hometown ATP event at Memorial Drive in 1998 at the age of sixteen. In the final, he had beaten Jason Stoltenberg, a much-respected Australian who, later in Hewitt's career, would have a spell as his coach. Michael Chang and Aaron Krickstein actually won an ATP title at a slightly younger age, but the kid's attitude was what impressed observers most. He fought for each and every ball. He was a scrapper, runner, and fighter, the like of which few people had seen. He was quickly dubbed "Little Lleyton," which was a bit strange because Hewitt ended up just a smidgen off six feet tall. With his blond, baby-face looks and shortish legs for a man of that size, he looked little, and the image stuck.

He grew in reputation, though, grabbing opportunities that came his way right and left. He made his first impression at Grand Slam level by reaching the

semi-final at the US Open in 2000. He returned the following year to win the title—but not just win it. After sweeping past the likes of James Blake, Andy Roddick and, in the semi-final, Yevgeny Kafelnikov, the twenty-year-old with a growing reputation for a demonstrative personality on court (too many "Come Ons" for some people's liking) found himself facing Pete Sampras in the final. Having been upset in such shocking fashion by Marat Safin in the previous year's final, Sampras wanted his title back—the title he had won on four previous occasions. And he looked well set to do it.

After surviving yet another classic with Agassi in the quarter-finals, which saw him emerge with a 6–7, 7–6, 7–6, 7–6 victory, Sampras came into the final having not dropped serve in no less than eighty-seven service games. So what does the precocious young Aussie do when he wins the toss? Hewitt elects to receive and promptly breaks the Sampras serve. Even though the American broke back immediately, Hewitt had established his credentials and went on to win the first set tiebreak before totally taking over the match to finish a 7–6, 6–1, 6–1 winner.

It was a stunning performance, made all the more remarkable by the fact that Hewitt kept his emotions under complete control. Even at the end, while his father Glynn, a former Aussie Rules footballer who had transferred much of his own competitive spirit to his son, and Lleyton's mother Cherilyn, another feisty athlete, embraced in the stands and shook hands with his coach, Darren Cahill, the new champion looked almost unaffected as he

acknowledged the cheers of a shocked but appreciative New York crowd. They love a fighter and, almost in the Jimmy Connors mold, they had found a new one.

During the previous twelve months, certain changes had been taking place at Wimbledon that would prove very beneficial for Hewitt, who had proved he could win on grass by taking the Queen's Club title. Concerned by the mounting discontent over the lack of rallies when big servers like Sampras and Ivanišević took to the Centre Court, the All England Club ground staff set about scarifying the grass. Scarifying is technical term used to describe raking under grass to pull out soft moss. The result makes the court harder, especially in dry weather, and so the ball bounces higher. No longer having to bend and dig for low-bouncing first serves skidding through at them, the returner has a much better chance of putting the man racing to the net under pressure. So much so, that serve-and-volley tactics no longer become automatic.

The Wimbledon authorities have always been shy about revealing the full extent of what they did to their famous grass courts, but it is no good pretending that it was inconsequential. Just look at photographs of the Centre Court during second week of any championship prior to 2002 and since. All is revealed. In the old days, a grassless furrow leading to the net down the center of the court would be clear for all to see. Since the scarification, that path to the net is barely visible, while acres behind the baseline are scarred and grassless. Of course, other factors came

(top and middle) *Two photos, pre-2000 and post-2000, offer evidence of how harder courts, coupled with the effect of Luxilon strings, have changed the way the game is played at Wimbledon. The worn furrow to the net is gone and, with it, serve and volley. The action now is mostly on the baseline.*

(bottom) *Grigor Dimitrov, the popular Bulgarian, finally did justice to his talent by winning the ATP Finals at London's 02 Arena in 2017, by beating David Goffin in the final.*

Paradorn Srichaphan, the best player ever to emerge from Thailand, rose to number nine in the world in May 2003. He showed his versatility by winning singles titles on grass at Nottingham, and indoors at the Stockholm Open, before retiring to take up golf. It took him five years to make the grade on the pro tour, but he decided to concentrate on his tennis academy in Pattaya, Thailand, in 2020.

into play as well. The larger framed rackets with Luxilon strings, which offered much greater spin with resulting control on big shots, had also played into the hands of the returner, making charging the net behind anything but the biggest serve a suicide mission.

All this played into the hands of the man who had soared to number one in the world at the age of twenty. The ball was suddenly bouncing straight into Hewitt's wheelhouse. Only one of the players Hewitt met on his way to beating the talented Argentine David Nalbandian in the final had realized what one needed to do to worry the super-confident Aussie. Make him bend. And that was what the tall Dutchman, Sjeng Schalken, started to do after losing the first two sets 6–2, 6–2.

Sitting right behind the receiver in the BBC Radio commentary box on Court One, I had a close view of what Schalken's change in tactics achieved. Suddenly, Hewitt was having to bend and lunge as Schalken started slicing his forehand, cutting it with underspin so that it skidded low off the grass just like all the balls used to if players were silly enough to stay back. Schalken's savvy change of tactics enabled him to claw his way back into the match by winning the third set tiebreak and then start to dominate it as he rushed Hewitt into mistakes, winning the fourth 6–1. Twice in the fifth, the Dutchman seemed to have the match within his grasp as he broke serve, but he couldn't hold his own. Hewitt's returns were simply too good, and Schalken couldn't get enough first serves in court to keep him at bay. So Hewitt grabbed the decider 7–5 and went on to beat Henman 7–5, 6–1, 7–5 in the semi-final.

Looking back, it is incongruous to say the least that Henman, one of the finest grass-court players of his era, was never able to reach a Wimbledon final. He was a semi-finalist four times and a quarter-finalist four times, but always there were rain delays and Ivanišević or Hewitt or Sampras standing in his path. The year 2002 would have provided him with a golden opportunity had the draw been different, because it was a catastrophic year for top players and Ivanišević wasn't even there to defend his title, injury having struck once again.

Pete Sampras deserved better than to end his illustrious Wimbledon career with a second-round loss to an unknown Swiss named George Bastl, and Andre Agassi fared no better, losing to the best player Thailand has ever produced, Paradorn Srichaphan. The stage was set for Richard Krajicek too. The 1996 champion came through a big serving marathon with another giant, Mark Philippoussis, 6–7, 7–6, 7–6, 7–6, 6–4 in the fourth round. The Dutch star, however, was returning to the tour after a long injury layoff and was short of match fitness. It showed when he lost to Belgium's skillful Xavier Malisse 9–7 in the fifth.

That win put Malisse through to the second Grand Slam semi-final of his career, but he was struck with nerves early on and ATP trainer Bill Norris had to rush on court to treat him for heart palpitations. Luckily, there was a rain interruption and Malisse recovered to play well in the third and fourth sets before losing 6-2 in the fifth. Out of nowhere, the sturdy twenty-eighth seeded Argentine had just beaten a twenty-seventh seeded Belgian to find himself in a Wimbledon final. Speaking little English at the time, Nalbandian looked a little bewildered in the media glare that suddenly surrounded him. The state of shock seemed to ham-

per him in the final, which he lost 6–1, 6–3, 6–2.

Lleyton Hewitt had the world at his feet, but fate and the next generation were closing in on him faster than he could have expected. When injuries started to affect his all-action game, his form fell away in 2003, but this hugely competitive young man was not about to give up. Battling on, he continued to throw himself into his sport with unbending passion and twice helped Australian win the Davis Cup in 1999 and 2003. He did not retire until 2016. Australia loved him.

Through much of the decade and beyond, Andy Roddick was trying to do the same thing for American tennis, and no one could suggest that he didn't put his heart and soul into the task. Roddick managed only one Grand Slam title, beating Juan Carlos Ferrero of Spain in

the final of the US Open in 2003. Federer will attest to Roddick's prowess on grass, having found himself facing the muscular American in three Wimbledon finals in 2004, 2005, and 2009.

It is the third meeting that will stay in the memory. Roddick, serving up a storm and hitting the ball with great force off the ground, won the first set 7–5 and led by six points to two in the second set tiebreak—four set points for a two-set-to-love lead against a champion who was trying not to remember how Rafael Nadal had snatched his title from him in the previous year's epic final. Federer saved the first three and then watched helplessly as Roddick stormed into the net and shaped to make a high backhand volley with the open court at his mercy. He hit it wide. It was a mistake that will haunt him forever. Within two points, Feder-

(above, left) *The tall Croat Ivan Ljubičić rose to number three in the world. In 2005, Ljubičić played a stunning Davis Cup against the United States in Los Angeles, winning all three rubbers, which included defeats of Andre Agassi and Andy Roddick. Ljubiči won Indian Wells in 2010, and then joined his own coach, Ricardo Piatti, in coaching Milos Raonic before Ljubiči moved into Roger Federer's camp. The only active player to have served on the ATP board of directors.*

(above, right) *Richard Krajicek worked on his backhand service return. It was the key to the big Dutchman beating Roger Federer and then MaliVai Washington in the final to win Wimbledon in 1996. He is now the director of the ABN AMRO World Tennis Tournament in Rotterdam. (Both photos by camerawork USA)*

(top left) *A couple of giant strides takes the Aussie Mark Philippoussis inside the service line for a high forehand volley. (Photo by camerawork USA)*

(top right) *This kind of two-fisted backhand helped Russia's Marat Safin announce himself on the world stage with a stunning straight-set victory over five-time winner Pete Sampras in the 2000 US Open final. (Photo by camerawork USA)*

(below) *An Irish sense of humor helped Patrick McEnroe handle being John's younger brother. On becoming a shock semi-finalist at the 1991 Australian Open, Patrick opened his press conference by saying, "There you are, just as expected: Edberg, Lendl, McEnroe, and Becker." Apart from running the USTA development program for six years, Patrick was America's longest-serving Davis Cup captain, winning the cup in 2007. He won the 1989 French Open doubles with Jim Grabb.*

er had taken the breaker 8–6. There was no question Roddick was playing well enough to win the match, as he demonstrated time and again in the last three sets with the tension mounting. This contrasting pair of athletes thrilled the crowd with as fine an exhibition of lawn tennis as you could wish to see.

Federer took a two-set-to-one lead by winning another tiebreak, but Roddick was not done. He battered the Swiss into temporary submission by taking the fourth 6–3. The fifth, of course, had to go the distance—and it was *some* distance. At 14–15 and deuce, Roddick hit a forehand long. Match point Federer. He missed a first serve that he badly needed, and after one routine forehand, Roddick hit his next forehand off the top of his racket frame.

As the ball flew up into the air and out, Federer climbed almost as high, leaping off the ground in glee as the crowd, sunburned and hoarse, cheered his sixth Wimbledon title—a herculean effort that had taken him four hours and sixteen minutes to complete.

Roddick was distraught. He had played the match of his life—the match for which he will always be remembered on the game's greatest stage against an opponent many consider to be the greatest of all time. Losing was no disgrace, but it hurt. It was still hurting as he sat, tears in his eyes and head in his hands, in the corner of the locker room as Federer and his entourage came in. Years later, when Roddick had switched professions and was interviewing Federer for American televi-

sion, he thanked his old rival for what happened next. Apparently, Federer had hushed his group and limited the celebrations to silent fist bumps. "That was impressive to me," said Roddick. "I want to thank you."

"It was a matter of respect," Federer replied. "I know how hard you had tried."

Throughout the decade, a lot of great players tried very hard in all manner of ways and on all manner of surfaces to beat Roger Federer and, mostly, they found it an impossible task. As Federer glided his way into the history books with one great achievement piled upon another, those three rivals were achieving great things of their own, beginning with Rafa Nadal, who took control of Roland Garros to such an astonishing degree that he won the French Open no less than thirteen times in fifteen years from 2005 to 2019. Injuries played a part in the defeats that he suffered in 2015 and 2016. In 2009, we witnessed one of the greatest shocks of the modern era when Sweden's unheralded Robin Söderling, known primarily as a fast indoor player until

then, produced a stunning display of hard-hitting clay-court tennis to beat Nadal in the fourth round. Gaining an air of confidence that he had rarely shown before, the silent Swede went on to reach the final, where Federer was waiting for him.

For the previous three years, the Swiss player had proved his own clay-court pedigree by reaching the final at Roland Garros. But each time, Nadal was waiting for him, and the result was almost a foregone conclusion. Now, suddenly, Federer found an unfamiliar face across the net, and the maestro did not fluff his lines, beating Söderling 7–6, 6–1, 6–4 to complete the much-prized achievement of winning all four Grand Slam titles.

In Davis Cup, nations relied heavily on the top four players to bring them success. Rafael Nadal led Spain to four victories; Novak Djokovic made tennis Serbia's favorite sport by helping his nation win the Cup in 2010; and Roger Federer, linking up with Stan Wawrinka, brought Switzerland its first ever Davis Cup triumph in 2014; and then Andy Murray ended Britain's sixty-nine-year wait for

(top left) *When in Shanghai … Andre Agassi, Marat Safin, Lleyton Hewitt, and Roger Federer.*

(top right) *Spain's Feliciano López continued his long-playing career even though he became tournament director of the Madrid Open in 2019. A dashing left-hander with a great one-handed backhand, López is a rare serve-and-volleyer. Four of his seven titles have come on grass—two at Eastbourne and two at the Queen's Club. In 2019, he helped get Andy Murray back on track after hip surgery by partnering with him for the Queen's Club title.*

(below) *Belgium's Xavier Malisse reached the Wimbledon semi-final in 2002, where he lost to David Nalbandian. He won two of his three ATP singles titles at Delray Beach, Florida, and won the French Open doubles with compatriot Olivier Rochus in 2004.*

glory by leading his Scottish dominated team (Captain Leon Smith and doubles partner Jamie Murray) to victory over Belgium in Ghent in 2015.

So who were this quality quartet who lifted the profile of the game to ever greater heights? Let's take a look in greater detail.

Roger Federer was the first to make his mark, but it took a while. Like John McEnroe before him, Federer had loved playing soccer as a youngster and did nothing exceptional in junior tennis—nothing, that is, to suggest that he would turn into the champion that he has become. He also had something in common with one of his idols, Bjorn Borg. Despite emerging onto the ATP tour as shy, controlled players, they had both had needed to learn how to handle the temper tantrums that afflicted their early teenage years.

Like Borg, Federer came from a solid family background, although, unlike the Swede, it was multinational. His father, Robert Federer, had left Basel, where he worked as a laboratory assistant for the pharmaceutical giant Ciba-Geigy, to try something different in South Africa. He ended up working for Ciba's plant in an industrial area of Johannesburg, and it was there that he fell in love with one of the company's eighteen-year-old secre-

taries, Lynette Durand. Not long after, the couple returned to Basel, where first their daughter, Diana, was born, followed by Roger, who arrived on August 8, 1981. The newly married couple both enjoyed sport and joined the Ciba club, primarily to play tennis although Lynette, the more naturally gifted athlete, had excelled at track and field hockey in South Africa.

Roger Federer's first coach was one of the very few people to recognize something special about him at the age of eight. He was Seppli Kacovski, an exiled Czech whom Chris Bowers quotes in his biography of Federer, titled *Roger Federer: Spirit of a Champion*, as saying, "After one or two days, I knew this was a massive talent."

Kacovski obviously knew what he was talking about, but the path ahead was not easy. With much foreboding, Federer tore himself away from the family home at the age of fourteen to live at the Swiss National Training Center at Écublens near Lausanne on Lake Geneva. It was in the French-speaking part of Switzerland, and Federer had been brought up speaking Swiss German and English. He struggled with the language and struggled to get out of bed in the mornings for 8:00 AM training, and fled home at weekends to his parents and to see his childhood friend and fellow tennis player, Marco Chiudinelli.

Slowly, things improved at Écublens, especially when Federer shared a flat with another player who would become a good friend on the tour, Yves Allegro. Apart from being older, Allegro was also a French speaker, so Federer's education included another language and the necessity to do the washing up occasionally. His destiny lay far from the kitchen sink. When Peter Carter, a

young Australian coach, came into his life, he started to learn how to focus on the things that mattered.

Focus had never been a problem with another star of the future, Lleyton Hewitt, and there was connection. Carter was a South Australian contemporary of Darren Cahill, who took charge of Hewitt's early career. Ironically, when Federer was chosen to play for a politically divided Swiss Davis Cup team in 1999, it was against Australia. The tie was played indoor in Geneva. Hewitt beat Federer in the fourth rubber, with Mark Philippoussis clinching the tie for the visitors by defeating George Bastl in the decider. Politics had seen the removal from the team of Marc Rosset, Switzerland's best player at the time, and

Federer was not in favor of that. In a few short years, he wouldn't have to worry about such things. Whenever he decided to play, everything would be just the way Federer wanted.

But that kind of influence was still some way off. Carter was working on the temperament and was soon joined by an amiable Swede named Peter Lundgren, who had reached number twenty-five on the ATP ranking. Federer seemed to like working with both men but always considered Carter his first adult coach. Yet in 2000, when it came time for Federer to travel extensively on the tour and choose which coach to go with him, he surprised many people in Swiss tennis by opting for Lundgren. The Swede was the most easy-going of the two, and maybe

Roger felt that would work better on the road. He never explained the decision publicly, but he and Carter remained good friends.

So Federer was devastated when Lundgren had to tell him, just after he came off court at the Canadian Open in Toronto, that Carter had been killed in an automobile accident in South Africa. Carter had recently married Sylvia, a Swiss who had just been given the all-clear after suffering from a brain tumor. They had gone to see Kruger National Park as a way of celebrating the good news. For some reason, they were traveling in separate vehicles when Peter's driver swerved to avoid a minibus and overturned.

Federer decided to fulfill his commitment to play in Cincinnati the following week but lost to Ivan Ljubičić in the first round. He immediately flew to Basel for the funeral. Later, he told René Stauffer, the leading Swiss tennis writer, "He was a very important man in my tennis career, if not the most important. I had been with him from the age of ten to fourteen and then again from sixteen until twenty, so I knew him very well. He gave me a lot in terms of his personality, in terms of technique and on the court. It was a hard loss."

In the worst possible way, Carter's sudden death helped Federer grow up. He would turn twenty years old eight days after the crash. Suddenly, he had to deal with losing someone really close to him for the first time. He had become established as a young player to look out for on the tour in the previous eighteen months, having won his first ATP title at the Milan Indoors in 2001. I met him there for the first time and chatted to him and Lundgren, a friend of mine, over breakfast at the Diana

Hotel. He was quiet and respectful and came across as an intelligent and serious young man despite his reputation for throwing rackets around. He beat the big Frenchman Julien Boutter in the Milan for the title but, more impressively, had outplayed Goran Ivanišević and Yevgeny Kafelnikov in earlier rounds. The talent was there, but when would it blossom?

Evidence that full flowering was imminent seemed to be confirmed when he shocked Pete Sampras at Wimbledon in 2001 with a 7–6, 5–7, 6–4, 6–7, 7–5 victory, completing the upset in three hours and forty-one minutes with a forehand service return winner that left the champion standing and stunned. The fourth-round encounter was a quick-fire duel with few rallies but some brilliant volleying from both men. There was no question that Federer had proved himself in the most demanding of circumstances. But the effort had taken a lot out of the nineteen-year-old, and Tim Henman, who was quick and commanding at the net, took him out in the quarter-finals. There was more consistency to Federer's play in 2002, when he claimed his first Masters 1000 title on the heavy clay of

(opposite, above) *Roger Federer celebrates a victory.*

(opposite, bottom) *Roger Federer emerges from the smoke at the O2 Arena in London, which held the Nitto ATP Finals for twelve years before its move to Turin, Italy.*

(above) *Not recommended for the knees. Like Federer, Rafael Nadal find an extravagant way to celebrate after one of his victories.*

(below) *José Higueras won sixteen ATP titles during his time as number one in Spain before marrying the mayor's daughter in Palm Springs and settling in California. Having established his tennis academy, Higueras spent time on the tour, coaching Michael Chang, Jim Courier, Todd Martin, Roger Federer, and Carlo Moyá among others. The highly respected coach joined the USTA coaching staff during Patrick McEnroe's tenure.*

(clockwise from top left) *Serena Williams and Roger Federer. Champions like selfies too!*

Lynette and Robert Federer were always supportive and never pushy—sort of number one tennis parents.

Roger and Mirka Federer are parents of two sets of twins. Is that a Grand Slam in parenting?

Hamburg in the German Open. Two others—indoors in Vienna and outdoors in Sydney—followed. By year's end, his ranking had risen to number six in the world.

However, the Grand Slam breakthrough did not come immediately in 2003. He lost in the fourth round of the Australian Open and the first round at Roland Garros, shocking himself and everyone else by losing 7–6, 6–2, 7–6 to the little-known Peruvian Luis Horna. Doubts started to surface. Was he just a graceful talent without the tenacity to win big? He had failed to live up to the expectations created by that victory over Sampras when he lost in the first round the following year to Mario Ančić of Croatia 6–3, 7–6, 6–3. The pressure was mounting as he began his 2003 challenge for the Wimbledon crown—the one he had always shouted about winning as a kid while he played against that garage wall. He had a scare against Feliciano López when his

back started hurting, but he recovered in time to beat Sjeng Schalken in the quarter-finals and Andy Roddick, the man whom he would be seeing a lot of at the All England Club in future years in the semi-final. Going into his first major final, the young Swiss had all the momentum. Despite facing an opponent with a massive serve, he was always in control against the giant Australian Mark Philippoussis and won 7–6, 6–2, 7–6.

Despite an unshaven look with his long hair tied in a bun behind his head, Federer's tennis was pure Savile Row, cut and tailored to perfection, the epit-

ome of class and style. He allowed the Australian just one look at a break point and never appeared troubled until he won match point and burst into tears.

"I was always joking around, saying I was going to win this—and look!" he said to Sue Barker on court afterward, as he lifted the golden cup to the heavens. Then, the tears started rolling down his cheeks again. It would be hard to believe some of them were not for Peter Carter.

And so it began. The breakthrough had been made, and Roger Federer was off on a run of success the like of which sport has rarely seen. As the years went by and the titles accumulated at an astonishing rate, Federer began revealing himself as a man of style and substance off the court as well. The fact that, after the Sydney Olympics in 2000, he had a woman in his life probably helped. Mirka Vavrinec was a Czech-born player who had been taken to Switzerland at a very young age and, encouraged by Martina Navratilova, she had started playing seriously. She and Federer had said hello casually when she joined the newly opened Swiss Tennis Center at Biel, but it was not until they were both chosen to represent Switzerland at the Olympics that they became more than acquaintances. Vavrinec was a little nonplussed at first: "He kept following me around and then, on the last day in Sydney, he kissed me."

The kiss led to marriage in 2009, after many years traveling together on the tour during which time Vavrinec took charge of his PR and other secretarial duties. More, importantly, she produced twin girls and, a few years later, twin boys. There were mutterings in the locker room. "He even does that perfectly," some guys joked admiringly.

The hair got cut short, and the Basel vowels started to disappear when Federer spoke English. He proffered an air of sophistication that enabled his agent Tony Godsick to make him a fortune in endorsements. Whether it was selling a watch or promoting a bank, Roger Federer tended to be the first face you saw plastered against the wall of arrivals halls at Heathrow and JFK. Like Serena Williams, Maria Sharapova, and Rafael Nadal, he had transcended his sport and become an international celebrity.

Rafael Nadal had made his first appearance at Wimbledon that year of 2003, losing in the third round to Thailand's Paradorn Srichaphan. Following the example of the great Manuel Santana, it would take the teenager less time than some people imagined to adjust his game to grass. On clay, of course, he was ready from the womb. The first of those thirteen French Open titles came in 2005, and the manner of his dominance at Roland Garros had left no one in any doubt that he was turning into the greatest clay player of all time.

Nadal had grown up in the town of Manacor on the island of Mallorca in a family that was already vested in sport. One of his uncles, Miguel Ángel Nadal, was a commanding center back for FC Barcelona and represented Spain in three world cups. His other uncle, Toni, would become his career-long companion and coach. Toni Nadal had tried playing on the ATP tour without much success and decided to take a coaching course in Barcelona. On returning home, he took a look at his four-year-old nephew and had a hunch that it might be worth his while trying to teach him how to play. The boy's endless energy and strength at such a young age, and the glint in his eye, suggested that there would be plenty to work with.

Toni was a strict and demanding taskmaster. When six-year-old Rafa broke his racket in frustration at missing a shot, Toni looked him in the eye and said, "You do that once more, and I will no longer be your coach. There are millions of kids in the world who would give anything for that racket you have just broken." No one has ever seen Rafa abuse his racket again.

It is obvious, if you study him on court, that Nadal is usually in complete control of his emotions and actions. He is a person of ritual and not, he insists, of superstition. The fact that he lines up water and power drink bottles in an exact line on either side of his chair, taking one sip out of each at every changeover, cannot be superstition, he argues convincingly, because he wouldn't go on doing it while he is losing. His prematch ritual starts with a cold shower then having his fingers taped, and then some explosive physical movement like sprinting up and down inside a locker room despite severe space limitation. And the ticks, like picking at the rear of his shorts and flicking sweat off his forehead before each point? He is totally unaware of them. He is as intense and focused on court as any player I have seen. He wants to win every point, and he will run himself into the ground to achieve it.

Off court, the fierceness of his on-court persona ebbs away and the charm, enhanced by that brilliant smile, presents the off-duty Rafa to the world. But there were some interesting revelations when John Carlin, the British sportswriter who ghosted his autobiography, spoke to his long-time girlfriend, Maria Francisca Perelló. She only traveled with him occasionally on tour because she had a regular job with an insurance company in Mallorca before they were married in 2019.

"Rafa is super-sensitive deep down, being full of fears and insecurities that people who don't know him could scarcely imagine," she said. "He doesn't like the dark, preferring to sleep with the lights or the TV on. He doesn't like thunder or lightening and won't let me go outside to fetch something if there's a storm. He's a very prudent driver and is constantly telling me to drive slowly and carefully."

Given his sensitivity, it is hardly surprising that the breakup of his parents' marriage came as a devastating blow. His father first told him of trouble at home as they boarded the flight back to Mallorca after he had won the Australian Open in 2009. In shock, he didn't speak to his father for the rest of the flight.

"My parents were the pillar of my life, and that pillar had crumbled," he

(opposite) *It's the follow-through and the extension on the forehand that sends Rafael Nadal's forehand whirring back across the net with more rotation on the ball than any other player has been able to create. (Photo by camerawork USA)*

(top left) *Maria Francisca Perelló was Rafael Nadal's girlfriend before they married in October 2019.*

(top right) *Manuel Santana, who kick-started the tennis explosion in Spain, acclaims Rafael Nadal, his successor as Wimbledon Champion in a royal box full of stars. David Beckham is seated behind Santana, and the 1958 Wimbledon champ, Ashley Cooper, stands next to John McEnroe.*

(above) *Rafael Nadal spends time taping every finger before his matches. You can see why.*

wrote in the most moving passages of the book. "My family had been the holy, untouchable core of my life, my center of stability and a living album of my wonderful childhood. Suddenly, utterly without warning, the happy family portrait had cracked. I suffered on behalf of my father, my mother and my sister who were all having a terrible time."

At a more mundane level, Nadal had been suffering from tendonitis in his knees for many years, the result of a heavily muscled frame pounding around a tennis court, putting extreme pressure on his joints. The knees had been worrying him more than usual toward the end of 2008, and now there was the emotional blow to deal with. His physical trainer, Joan Forcades, told him that there was a holistic cause-and-effect connection between emotional stress and physical collapse. Nadal says he believes that to be true, and with less sleep and what he called his "paradise lost" at home without his father around the dinner table, it slowly started to affect his game.

However, the problem was not just emotional. Despite his continued dominance at Roland Garros and a second US Open title over Novak Djokovic in 2013, keen observers felt that, by the following year, Nadal was missing something technically. He still managed to keep Djokovic from completing his Grand Slam set of all four major championships by beating the Serb in the 2014 French Open final, but injuries—not just with the knees—were starting to mount. It was a wrist problem that forced him to miss the US Open that year. By the start of 2015, it was clear Nadal was not the player of old.

The severity of his 6–2, 6–0, 7–6 defeat at the hands of the consistent Czech, Tomáš Berdych, in the quar-

ter-final of the Australian Open spoke volumes for the state of his game, not to say his mind. When he arrived in Paris not having been able to win any of his favorite clay-court tournaments in Monte Carlo, Barcelona, Madrid, and Rome, the alarm bells were ringing.

Pierre Barthès, the former French number one who had run Europe's largest tennis camp at Cap d'Agde near Marseille for many years, sat on a deserted Philippe Chatrier Court before the French Open started that year watching Nadal practice and identified the problem. When the practice was over, Barthès chatted with Toni Nadal: "It's the forehand, isn't it? The extra extension at the moment of impact has gone." Uncle Toni's reply verified Barthès's expert observation. "Yes, we're working on it," he said.

But as the year wore on, doubts rose as to whether it was fixable. By the time he had failed to reach the quarter-finals at either Wimbledon or the US Open, it seemed that the Spanish hero, who had gathered a huge and passionate following all over the world during his remarkable career, was in a serious decline. He still managed to finish the year ranked number six, but it was the first time he had been out of the top four since 2004. It seemed that his best years were gone. Wrong. Regaining his fitness, he beat Kevin Anderson to win the US Open in 2017, and then claimed a fourth US crown by defeating the surging young Russian Daniil Medvedev two years later. All the while, Roland Garros was his—thirteen titles and counting. The spirit had not died, and the legs had not run their course.

Tennis players spring from unlikely places in unlikely circumstances and Novak Djokovic fits that description perfectly. His parents, who ran a piz-

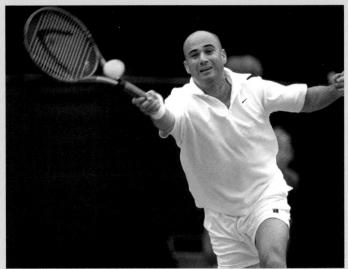

Rafter & Agassi: A Contrast in Styles

At Wimbledon, the twentieth century had begun with a classic example of why matchups count for so much in deciding to what extent aesthetic pleasure can be derived from a tennis match. If one word defines it, it is contrast. And no two players of that era provided a better *contrast* in style than Andre Agassi and Patrick Rafter. They had met in the 1999 Wimbledon semi-final, which was dominated by the brilliance of Agassi's return game, a factor that enabled him to win 7–5, 7–6, 6–2. A year later, they were at it again, also at the semi-final stage. The 2000 duel took the rivalry to a new level. The master returner and the big server were both at the top of their game. For the tennis connoisseur, the match was a feast of ever-changing delights. First, the Australian's serve held sway, enabling him to take the first set 7–5, but Agassi's pinpoint returns began cutting deep into Rafter's defenses, and the American took the second 6–4. The duel was riveting. The Centre Court crowd fully engaged with support for both men. I remember turning to Peter McNamara, my summarizer in the BBC Radio commentary box that day, and saying on air, "Macca, I am enjoying this so much, I wish it could go on forever." The great doubles champion, himself a Wimbledon singles semi-finalist, grinned. "Me, too, mate," he replied. With the grass surface obviously aiding the net rusher, Rafter was able to emerge the winner of this dynamic battle with a score 7–5,

4–6, 7–5, 4–6, 6–3, but it was always a matter of a point here or there. "Against Andre, I felt I had to do something extra, put more pressure on him by going over on my backhand, whereas normally I preferred to chip the return," Rafter recalled when we spoke recently. "But I think we provided the crowd with their money's worth!" It was interesting to hear a champion being so conscious of the crowd's pleasure. Rafter fully recognized that certain matchups did not always offer maximum entertainment. "When I played Pete [Sampras] I felt for them," he said. "Our styles were so similar that points were over in a flash, but with Andre, the contrast offered so much more scope to display the game at its best. With Andre's returning ability, a split-second decision was needed on whether to go in, and if you hesitated, you would find yourself having to play a lower volley and so give him the chance to pass." Rafter lost to Sampras in the final that year and was denied the ultimate again in 2001, when Goran Ivanišević beat him. Along with Andy Roddick, Rafter was as deserving of a Wimbledon title as anyone in the modern era, but fate decreed otherwise.

left: Patrick Rafter at the Australian Open in 2001. right: Andre Agassi at Wimbledon in 2000.

za parlor in Kopaonik, a mountainous region of Serbia, during the summer knew nothing of tennis, a sport that attracted little attention at the end of the last century, despite the old Yugoslavia having produced some fine players like Niki Pilić and Željko Franulović, both finalists at Roland Garros. They were both Croats, a distinction that became acute after the dictator Tito died, and the Serbs stuck to soccer and basketball.

Not so for a five-year-old who started watching Stefan Edberg and Pete Sampras winning Wimbledon on the family television. Fascinated by the sport, little Novak said he wanted to try and play himself. Money

was tight, but his parents bought him a racket and shoes. Without asking for permission, the five-year-old set off for the tennis courts, which were right across the street from the pizzeria. As Chris Bowers describes in his brilliantly researched biography of Djokovic, titled *The Sporting Statesman: Novak Djokovic and the Rise of Serbia*, the courts were being run by a remarkable televison producer and part-time coach named Jelena Genčić, a woman in her fifties who had helped Monica Seles and Goran Ivanišević when they were very young.

While coaching on that fateful day in the summer of 1992, Genčić noticed a little chap staring through the

(opposite) *Lean and hungry, Novak Djokovic has the perfect athletic build for tennis.*

(clockwise from left) *Serbian flags fly at all Novak Djokovic's big matches. Djokovic was a national hero even before leading Serbia to a Davis Cup triumph over France in Belgrade in 2010.*

As the future tournament director Željko Franulović points out, the legendary event at the Monte Carlo Country Club was designated an ATP Masters 1000 event when the tour was reconfigured in 1990.

Novak Djokovic is out for the evening with wife Jelena, mother Dijana, and father Srdjan.

Ion Ţiriac, whose impact on the game has been beyond measure, and Marshall Happer, the North Carolina lawyer who headed the Pro Council during the stormy political years of the 1980s.

Ana Ivanović, who practiced with Novak Djokovic in an empty swimming pool in Belgrade as a kid, rose to number one in the world after winning the French Open at the age of twenty in 2008. (Photo by camerawork USA)

In particular watch his eyes. He came alone, without parents, without anyone. That is very interesting."

It is an interesting fact that after working with Novak for no more than two days, Jelena Genčić asked to meet his parents. So they walked over to the pizzeria and while the boy nestled up against his mother, Genčić told his parents, "You have a golden child. In the eight years since I have stopped working with Monica Seles, I've never found as great a talent as your son. By the time he's seventeen, he'll be in the top five in the world."

Genčić admits Novak's parents were shocked. But, after enquiring into Genčić's background and verifying her credentials, they agreed to do everything they could to let her continue working with their boy. The problem was money. Genčić worked for free so there was no immediate problem, but she knew there would be major financial requirements in the years ahead for equipment, travel, and all the expenses needed to launch a player onto the circuit. She told his father that he would need to find money, which he did, often having to borrow it and getting himself into trouble trying to pay it back. Novak's father, with his irascible temperament, did not make himself popular. His parents, however, saw the rapid improvement Novak was making and believed in the dream.

Djokovic has called Genčić his tennis mother; she was all of that, if not more. She saw the intelligence and nurtured it. She insisted that he learned English and taught him about the world—art, poetry, and classical music. He wanted to listen to hard rock, but she insisted on his listening to Chopin, Debussy, and Greig to calm him down. On one occasion, feeling a little de-

wire netting by her court. When she moved to a different court an hour later, he followed. She noticed that he had a racket and asked him how old he was and if he would like to join in. "Five," he answered. "I've been waiting for you to ask me to join you."

The coach was startled at the little boy's boldness and was impressed when, having told him he could come back at 2:00 PM, she noticed from her balcony overlooking the courts that he was there at 1:30 PM. There was something about the five-year-old that connected with Genčić from the very first moment they spoke. Before going to lunch, she told the other coaches, "Watch this boy.

pressed, she wanted something stronger and put on Tchaikovsky's 1812 Overture with its full, pounding orchestra. Soon, Djokovic sat up and said, "Jeca, I've got goose bumps."

Genčić took that sudden realization of what music can do for the emotions and taught him to use it in match situations. She told him that, if he was a few points away from winning a match, he should stay calm and close it out, but if he was on the verge on losing to remember this music, the orchestral crescendo, and the feeling it gave him. "The adrenalin will start to kick in, and you may well win," she told him.

Genčić also used the concept of visualization to help Djokovic with his tennis. She told him about the man whose name adorns Belgrade Airport: Nikola Tesla, a scientist who is credited with discovering AC/DC, the alternating current. One day, Genčić found an article recounting how Tesla talked of visualizing an idea and then putting it down on paper. She explained that for tennis, visualization is very important for working out tactics. She played Smetana's symphonic poem *Vltava* to Djokovic. When it finished, she asked him what he had visualized and shared with him what she had been visualizing. To put it mildly, this was not everyday tennis coaching. It helped because Djokovic was bright enough to absorb what he was being taught.

Genčić told Bowers that Djokovic only asked one question about visualization: "Do you think you will see into the future what will happen?" He was just seven years old.

The loving partnership continued until Djokovic was twelve and eventually, he went to Munich to spend time at Niki Pilić's academy. Once her protégé became a traveling pro,

Genčić didn't see much of him, but she was always in his mind. He frequently made references to classical music in his interviews.

At the end of the 2011 season, Djokovic went to visit her, carrying the replica Wimbledon trophy he had won that summer. "This is what we were working for, wasn't it?" he asked as they gave each other a big hug. They saw each other again occasionally, but in 2013, Genčić contracted liver cancer. She was still teaching on court a week before she died on the middle Saturday of the French Open. Learning the news after he had beaten Grigor Dimitrov, Djokovic was in tears and was excused the mandatory post-match press conference.

There was a service of Thanksgiving for the life of Jelena Genčić in Belgrade on the second Monday of Roland Garros so, of course, Djokovic could not go. But he sent a letter to be read out, and it concluded with these words: "You were an angel. Both when you coached me and afterward, I felt your support wherever I went. Sincere. Strong. Unconditional. You left an indelible mark on Serbian tennis. Everyone who holds a racket in his or her hands today is indebted to you. I promise I will speak your name to future generations and that you spirit will live on, on our tennis courts."

Djokovic had already learned that life could be tough and cruel. Serbia was the target of NATO bombing during the Balkan War in the nineties, and he was eleven when the bombardment began. He spent seventy-six nights in a cellar, sleepless and afraid, like so much of Belgrade. A young Ana Ivanović was also living in the city, and sometimes the pair practiced together in a dry swimming pool that had been turned into a court with no run-back— an incentive to take the ball early!

A shovel shot from the talented Frenchman Fabrice Santoro, whose unorthodox two-handed game confused opponents and delighted crowds. (Photo by camerawork USA)

The young players tried to make the most of it, enjoying time off from school when the bombing was too heavy, but Djokovic remembers it for what it was. "It is a very powerful memory from my childhood that really shaped my character," he told Chris Bowers. "It was a devastating and helpless time for my country, those three months of not knowing who and what is next, and you have nowhere to hide for real. Many innocent people died."

Novak Djokovic and Andy Murray were born seven days apart in May 1987. Both having taken to tennis, it was inevitable that they would become boyhood rivals and, in the early years, quite close friends. In a very different manner, they also suffered the shock of violence at a young age.

The Dunblane school shooting massacre is among the top three worst in British history—one that brought about radical changes in gun laws. It is now illegal for a private citizen to own a gun in Britain. Dunblane is a town near Stirling, Scotland, where the Murray brothers, Jamie and his younger sibling Andy, grew up. Both went to Dunblane Primary School. On the morning of March 13, 1996, both were in school. Jamie was in a flimsily built out building that served as a classroom, while Andy was walking toward the gymnasium, where his class was due to take the second scheduled spot for gym that morning.

At approximately 9:30 AM, a forty-three-year-old man who had been a youth club leader that had been let go for allegedly behaving inappropriately with boys, walked into the gym and began firing, killing sixteen children and one teacher and wounding several others.

Downtown, Judy Murray was working in the family's toy shop when she heard there had been a shooting at the school and tried to drive there. The traffic was clogged for the last half mile, and she got out and ran. "And there we were at the school gates, hundreds of us parents, queuing up to find out had happened, not knowing if our children were alive or not."

Judy had to explain to Jamie and Andy what had happened in the car going home. She was relieved that they were too young to grasp the full enormity of the horror. Once he was on the tour, Andy batted away questions about it but, finally in 2013, after he had steeled himself to do some research, he spoke about the tragedy for the first time when interviewed by Sue Barker for a BBC documentary about Britain's new Wimbledon champion.

In between breaking down in tears and clutching at one of his dogs for sup-

port, Murray said, "At the time, you have no idea how tough something like that is, something that all my family and all the people of Dunblane went through. I started to do some research. Before I really didn't want to know. But, as you get older, you start to realize that the whole town has recovered from it so well. It is nice that I have been able to do something that the town is proud of."

Murray feels very strongly that his triumphs of winning an Olympic Gold medal in singles for Britain in 2012 and retaining it four years later, as well as his two triumphs at Wimbledon has enabled Dunblane to be remembered for something other than the massacre. His commitment to the place in unswerving. He married his long-time girlfriend Kim Sears at Dunblane Cathedral, and his family have renovated and upgraded a small hotel that has already won tourism awards in Scotland.

It says much for Judy Murray, who coached both her boys, that she knew when to let go and allow Andy to attend the Sánchez-Casal Tennis Academy in Barcelona—an experience that enabled him to grow up as a person and a player.

Murray did not appear on the tour at Grand Slam level until 2005 but, like Djokovic, his rise to the top was swift. The Serb had secured the number three world ranking by the end of 2007. Murray was at number four a year later, having appeared in his first Slam final at the US Open where he lost to Roger Federer. For all the top four, much followed until everything came to a halt in March 2020.

(opposite, clockwise from top left) *Brothers and world number ones, Jamie and Andy Murray led Britain to a Davis Cup success in 2015.*

Andy Murray and Kim Sears's wedding. Her father Nigel is a top coach in the women's game at Dunblane.

Boyhood rivals and friends, and career-long opponents, Andy Murray and Novak Djokovic have helped shape men's tennis in the twenty-first century.

Judy Murray always has rackets at the ready. No one has worked more tirelessly or successfully for the cause of British tennis.

(above) *Andy Murray, one of Britain's greatest athletes and the only player to win consecutive singles titles at the Olympic Games, was never afraid to throw himself about court.*

The Tennis Center at Crandon Park

Key Biscayne, Florida

Caja Mágica

Madrid, Spain

Qi Zhong

Shanghai, China

Roland Garros

Paris, France

Arthur Ashe Stadium

New York City

Kooyong Lawn Tennis Club

Melbourne, Australia

14 A Spotlight on Doubles

During the years before Open Tennis arrived in 1968—and for a short time after that—playing doubles was automatic. It didn't matter if you were Ken Rosewall or a teenage qualifier, you found a partner and played doubles.

Then, slowly, it began to change. The demands of top singles players became more onerous. The money poured into the singles draws, and coaching staff advised their players to preserve their energies for what mattered. But doubles mattered too—or they should have. It is the form of the game most often played at club level. When spectators are offered it at pro tournaments, they lap it up more often than not.

While it is true the game's evolving athleticism has put greater strain on the body, players of a few decades ago still smile at the workload that they took on while seeming to survive. Vijay Amritraj, who became ATP president at the time of the formation of the new tour in 1990, told stories of how he and his brother Anand used to play a two- or three-hour best of five singles and then go straight back on court for doubles, day after day, in any tournament that they played.

"We never gave it another thought," said Vijay. "We were tennis players and wanted to play tennis." The Amritrajs came from a remarkable Madras family that included a third brother,

Ashok, who became the third cog in a wheel that kept the Amritraj name on Indian Junior Trophy for nine straight years. Anand and Vijay used their doubles prowess to take India to two Davis Cup finals, as far apart as 1974 and 1987.

Inevitably, it was the Australians who dominated that last era when singles champions were expected to win doubles titles as well. Frank Sedgman and Ken McGregor became a pair of names that rolled off the tongue together after World War Two, as they won the Grand Slam of all four doubles titles in 1951 and only missed out on the US title the following year. They had taken over from the remarkable pair of John Bromwich and Adrian Quist, who won the last three Australian titles before the war and picked up seamlessly in 1946 to win another five.

When Sedgman and McGregor turned pro with Jack Kramer, the teenage wonders Lew Hoad and Ken Rosewall stepped up to claim six Grand Slams before Roy Emerson began his run with Neale Fraser, winning seven Slams with the future long-serving Davis Cup captain from Victoria, and four with Fred Stolle. In all, Emerson won sixteen Slam titles in doubles to go along with his twelve in singles. He remains the only man to have won all four major championships in both singles and doubles.

It used to be said that the best doubles team in the world was "John

McEnroe and anyone," which was exceedingly unfair on Peter Fleming, whose powerfully accurate service returns formed a crucial part of that famous partnership. Undoubtedly, McEnroe was one of the greatest doubles performers of all time, but Emerson might be the best ever. It seems as if he could win anywhere with anyone.

Beginning in 1960, Roy Emerson won six consecutive Roland Garros titles with five different partners—Fraser (with whom he won in 1960 and 1963), Rod Laver, Manuel Santana, Ken Fletcher, and Fred Stolle. Emmo, as he was known, did not just try his best at Grand Slams. The Godo Cup at Barcelona offered just one example. At the lovely Real Club, Emerson won the doubles title seven times with five different partners, including much the same cast of characters, but adding the Indian with the magical hands, Ramanathan Krishnan.

Recently, I asked Emerson the secret of becoming a great doubles player. "Look after your partner," said the man who had learned his tennis in Outback Queensland. "That's why the art of good doubles

(top) *Four Australians who produced some of the great doubles duels of all time: Fred Stolle and Ken Rosewall, left, shake on it with John Newcombe and Tony Roche.* (bottom left) *The legendary pair of Frank Sedgman and Ken McGregor, near court, won Wimbledon in 1951 and 1952, before turning pro with Jack Kramer.* (bottom right) *America's Bob and Mike Bryan, the all-conquering twins and their trademark chest bump.*

(left) *Fred Stolle and Roy Emerson take a moment to relax at their New York hotel. The Aussies won the US Open together in 1965 and 1966, and the French title in 1965.*

(right) *Anand and Vijay Amritraj enjoy a laugh with the talented New Jersey photographer Mel DiGiacomo at Forest Hills.*

(opposite left) *US Davis Cup stalwarts Stan Smith and Bob Lutz won three US Open titles and the Australian Open in 1970.*

(opposite right) *The long-time New Jersey resident Colin Dibley has 1976 US Open champions Marty Riessen and Tom Okker on his right, and Stan Smith and John Newcombe to his left. The popular Aussie won seventeen ATP doubles titles with a variety of partners including Chris Kachel and Ray Ruffels. He also partnered both the talented Mayer brothers—Sandy with whom he won Palm Springs in 1976, and the doubled-handed Gene at Metz, France in 1980.*

play is not to miss or mess up your return of serve—ever. If your partner is at the net, you must never put him in trouble with a sloppy return. And you have to get your serves in deep and know how to lob."

With his exceptional speed and athleticism, Emerson was able to take care of his partner better than most and, while playing with the left-handed Fraser—or Laver, as he did successfully on numerous occasions—he was able to make extra use of having a southpaw partner. "The great advantage of playing with a lefty is that you never have to serve directly into the sun if you organize your rotation properly," Emmo pointed out.

The left-right factor played a big part in one of the game's most successful doubles partnerships: John Newcombe and the lefty Tony Roche. The pair from New South Wales started on their winning ways in the late 1960s and ended up with twelve Grand Slams as a team, while Newk, with his deadly forehand volley, also won the Wimbledon title in 1966 with Fletcher; the US Open in 1971 and 1973 with Roger Taylor and

Owen Davidson, respectively; and Roland Garros with "The Flying Dutchman," Tom Okker, in 1973.

Despite the dominance of Emerson and Newcombe, other teams did manage to get a look in during the period that saw the arrival of Open Tennis. Many fine partnerships were formed on Lamar Hunt's WCT tour like that between Okker and Northwestern's Marty Riessen. A long career saw Riessen win fifty-three doubles titles, mostly with Okker, but included seven with the Texan Sherwood Stewart. He also helped Arthur Ashe win his only title of any kind on European clay by winning Roland Garros in 1971. In addition, Riessen won seven mixed titles—six of them with Margaret Smith Court.

The Australian-born Bob Hewitt quickly found an excellent partner when he moved to South Africa in Frew McMillan, who played two-handed on both sides and was, according to Emerson, one of the best returners of serve in the game. They won five Slam titles together, including three Wimbledons.

Fred Stolle, the long-legged Sydney-sider, was a frequent and very successful partner of Hewitt but also of Rosewall, Emerson, and Newcombe—all of whom helped Stolle to an impressive tally of ten Slam titles.

By the time Donald Dell had taken over the US Davis Cup captaincy in 1968, he found himself with a ready-made doubles team in Stan Smith and Bob Lutz, who had won consecutive NCAA titles in USC colors in 1967 and 1968. They became the lynchpin of Dell's winning teams and were soon part of his fledgling management company, Pro Serv. Smith and Lutz, both big volleyers behind powerful serves, went on to become one of the great combos of their era, winning thirty-seven titles together, including four at the US Open, one at the Australian, and the WCT title in Dallas in 1973.

As an example of how far hard work can take you, few offered a better example than Brian

Gottfried, one of the best liked players on the tour who reached the singles final at Roland Garros in 1977, losing to Guillermo Vilas. By then, Gottfried had reached across the border to find a doubles partner in Raúl Ramírez, with whom he would form a career-long partnership. The pair won Roland Garros in 1975 and 1977, and, in 1976, they won Wimbledon in one of the most exciting doubles finals seen in years. Their opponents were two neat and swift Queenslanders, Ross Case and Geoff Masters, who pushed them all the way to 7–5 in the fifth.

Case and Masters made up for it the following year in another thriller to snatch the Wimbledon crown from John Alexander and Phil Dent, the 1975 Australian Open champions, 6–4 in the fifth. Case went on to make a bit of history in 1980, when he won the first pro event held in China at Canton in partnership with Jaime Fillol, the Chilean who had become the fourth president of the ATP a short while earlier.

Gottfried ended up with fifty-four career doubles titles and Ramírez with sixty (as well as nineteen in singles). Gottfried was ranked as the number one doubles player in the world for sixty-one weeks starting in 1976. The vast majority of Ramírez's titles were won with Gottfried, but there was one odd exception. At the 1975 American Airlines Tennis Games in Tucson, Ar-

izona, the ATP decided to try something different and threw everyone's name into a hat and simply drew doubles pairs. Life is all about grabbing your chances, and a tall Californian named Bill Brown certainly grabbed his. Brown drew Ramírez as a partner. They won the title, beating Ray Moore and Dennis Ralston 2–6, 7–6, 6–4. The experiment was never repeated, so Ramírez and Brown go down in history as a unique pair of champions.

In 1978, Peter Fleming, a lanky giant just out of UCLA, found himself without a partner at the Monte Carlo Open. So a friend suggested that he might find Tomáš Šmíd, the tenacious and tireless Czech, to be a good fit, and they proceeded to win the title. By the time the grass-court season arrived, Fleming had found a very different partner who was even younger than himself. He called him Junior—not a name many other people have dared called John McEnroe. Their first major outing together took them to the Wimbledon final, where they lost to Bob Hewitt and Frew McMillan but McEnroe and Fleming did not waste time making their mark. With McEnroe's swinging lefty

serve pushing the returner way out of court and Fleming's punishing service returns forcing opponents on the defensive, this aggressive pair were back in the Wimbledon final the following year—this time winning the title over Gottfried and Ramírez. Two months later, they upset Smith and Lutz, whom they would succeed as America's Davis Cup pair, to win the US Open. A year later, though, they could not prevent the USC duo from seizing their crown 6–3 in the fifth.

McEnroe and Fleming did not have it all their own way at Wimbledon because the 1980s saw the emergence of the Maccas, two chirpy guys from Melbourne called Paul McNamee and Peter McNamara, who won Wimbledon in 1980 and then again in 1982, beating McEnroe and Fleming in the final. With McNamara's powerful serves and thudding volleys and McNamee's acrobatics at the net, they were a formidable pair who also found individual success in singles. McNamara was a Wimbledon semi-finalist and winner of the tough clay-court title in Hamburg, while McNamee, having made the dramatic technical switch to a two-handed back-

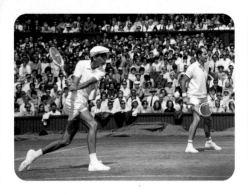
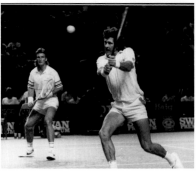

hand, made it work well enough to beat McEnroe at Roland Garros.

McNamee also won the Australian Open with the muscular Mark Edmondson in 1983 and then produced an extraordinary display of volleying in partnership with Pat Cash to help Australia win a Davis Cup doubles against Sweden at Kooyong.

Neither Wimbledon, where they won four times, nor the US Open where they claimed three titles, turned out to be McEnroe and Fleming's favorite hunting ground. By a distance, that was Madison Square Garden, where the ATP Finals was held through the eighties. For seven straight years beginning in 1978, McEnroe and Fleming so dominated doubles at the Garden that they did not even lose a set in any of the finals in which they played. Teams found that they had no answer to the dynamic American duo on a medium-paced indoor carpet, which allowed Fleming to wreak havoc with his pinpoint returns, not to mention McEnroe's exquisite touch volleys. Fred Stolle described them as the best that he has ever seen. "All us Aussies knew how to hit a volley and, using some follow through, we generally hit them harder than most Americans in my day," Stolle told me. "But for touch on the volley, McEnroe was on his own. He had more feel than anyone."

By the beginning of the nineties, two players from opposite ends of the world had established themselves as exceptional doubles players whose achievements tended to get overlooked because they took on numerous partners before arriving on the same side of the net. John Fitzgerald was a South Australian who went on to captain his country in Davis Cup, and Anders Järryd was an agile, speedy Swede who had to live under the glow of Stefan Edberg's star-splashed career. However, their achievements were considerable.

Fitzgerald began his Grand Slam winning ways in partnership with John Alexander at the Australian Open in 1982, when it was still played on grass at Kooyong. Fitzy, as everyone called this typically outgoing Aussie, then teamed up with the lean, fast-talking Czech Tomáš Šmíd—first, to beat Edberg and Järryd in the 1984 US Open final, and then to partner Šmíd to victory at Roland Garros in 1986. The next year, Järryd stepped forward to win no less than three Slam titles, the Australian and US Opens with Edberg, and Roland Garros with the tall American Robert Seguso, who achieved most of his doubles success, which included consecutive Wimbledon titles, with Ken Flach.

Not content with one triple in a year, Järryd repeated the performance in 1991 with Fitzgerald, winning Roland Garros, Wimbledon, and the US Open. Järryd ended up with eight Slam doubles

titles, and Fitzgerald seven. Both men played Davis Cup singles for their country. Järryd proved his versatility by scoring a shock win over Boris Becker in the WCT Dallas Finals of 1986.

By 1989, Peter Fleming had retired, and McEnroe was looking around for a partner at the US Open. He settled on an untried redhead from Adelaide named Mark Woodforde, who was also a left-hander. Keeping his nerves under control, Woodforde helped McEnroe take the title by beating the Americans Ken Flach and Robert Seguso in the final.

McEnroe and anyone? Well, Woodforde did not turn out to be just anyone. Teaming with a lightly built but very skillful Melburnian, Todd Woodbridge, in 1992, the pair quickly established themselves as "the Woodies" by beating the Americans Kelly Jones and Rick Leach in the final at Melbourne Park. Neither man was particularly big or powerful, but both possessed sharp volleys and the doubles player's greatest asset: a great return of serve.

The following year, the Woodies began a five-year run of dominance at Wimbledon by beating Grant Connell of Canada and Patrick Galbraith, who would eventually become president of the USTA. It was the same final with the same result in 1994, and the Woodies remained unbeaten for three more years. In all, they finished with eleven Grand Slam titles as a pair

before Woodbridge went on to enjoy considerable success with Sweden's Jonas Björkman.

Quick and aggressive, Björkman proved the perfect foil for Woodbridge who, like him, had also reached the Wimbledon semi-final in singles. But in doubles, they did considerably better, winning three straight Wimbledon titles from 2002 to 2004, as well as the US title in 2003. Björkman proved himself as versatile a player as any in his era by winning a total of nine Slam doubles, including two Australian with Jacco Eltingh of Holland and Aussie icon Patrick Rafter in 1998 and 1999, and then, after his run with Woodbridge, finished off a stellar career by winning consecutive Roland Garros titles with the big Belarussian Max Mirnyi.

There was a familiar name popping up in doubles finals around this time called Stolle, but it wasn't Fred. Sandon Stolle, even taller than his father, became one of the very few sons to even come close to emulating dad when he and the gifted Czech Cyril Suk defeated Mark Knowles and Daniel Nestor to win the US Open in 1998. By then, Stolle had teamed with Paul Haarhuis, Eltingh's normal partner, to reach the final of Roland Garros in 1995 and the Wimbledon final of 1999, as well being runner-up at Flushing Meadows in 1995 with the American Alex O'Brien.

The tennis world had seen the Bryans coming. It would have been hard not to. Mike and Bob Bryan, a pair of identical twins out of California, has collected more than one hundred junior titles before they won the first of a staggering 119 titles at senior level by beating Mark Knowles and Daniel Nestor to win the Canadian Open in 2002. A year later, they won the first of sixteen Grand Slam titles

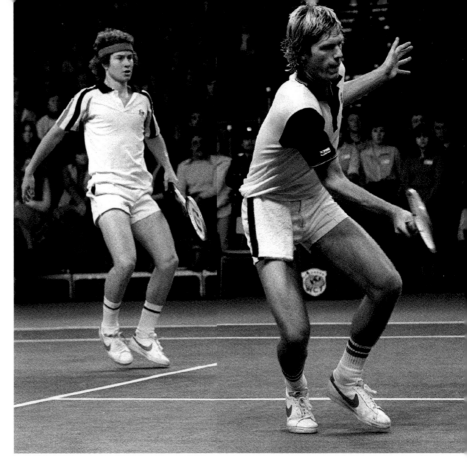

by beating the scratch team of Paul Haarhuis and Yevgeny Kafelnikov at Roland Garros. Later that year, they were successful on clay again at the Houston Racket Club when they won a thriller in the final of the ATP Finals doubles 6–4 in the fifth over the French pair of Michaël Llodra and the double-handed magician Fabrice Santoro.

And so it continued—Mike, the right-hander, Bob, the lefty, were a perfect partnership which, as they often joked, had started in the womb. Carefully raised by Wayne and Kathy Bryan, a couple of tennis-playing parents, the twins went on to become not only the most successful doubles partnership of all time but also great global ambassadors for their sport, spending much more time abroad than most American players.

Known for their match-winning chest bump, Bob and Mike were heading for retirement in

2020, having won just about everything there was to win. They helped the United States beat Russia in the Davis Cup final in Portland in 2007, won Olympic gold in in London in 2012 and bronze in Beijing four years earlier, and four ATP Finals titles. When Bob got injured, Mike won Wimbledon and the US Open in 2018 with Jack Sock. They raised the profile of doubles and gathered a huge fan club. It is probably safe to say tennis will not see their like again.

Another world number one doubles player did not have the luxury of a twin to play with, but Leander Paes, a little dynamo of a competitor from Calcutta, found enough great partners to help him win fifty-five titles on the tour, including eight Grand Slams and ten mixed. During the early part of his career, he was paired with Mahesh Bhupathi, and they began by winning Roland Garros in 1999.

(clockwise from lower left) *John Alexander, who went on to be a senator in the Australian Parliament, also won the Australian with John Fitzgerald in 1982. Tomáš Šmíd and Pavel Složil played in the Czechoslovakian Davis Cup team that beat Italy in Prague in 1980, and reached the final at Roland Garros in 1984. Šmíd also won the US Open with John Fitzgerald that year, as well as the French Open with the Aussie in 1986. John Alexander and Phil Dent, the last great players to emerge from Harry Hopman's reign as Australia's Davis Cup coach, won the Australian Open over Bob Carmichael and Allan Stone in 1975, and were three times runners-up in Melbourne. They also lost to Ross Case and Geoff Masters in the 1977 Wimbledon final. Jamie Murray embellished an outstanding doubles record by winning his second mixed title with Martina Hingis on her return from retirement in 2017.*

Switching surfaces with ease, they won Wimbledon a month later. Martin Damm, Lukáš Dlouhý, and Radek Štěpánek were others who helped Paes finish with a record of having won all four Slams. Often in partnership with the talented Bhupathi, Paes enjoyed a terrific Davis Cup career that saw him overtake Nicola Pietrangeli with the most Davis Cup doubles wins in history.

I watched a lot of great tennis in 2015, but the match that burned in memory, even though I only saw it on television, was the Davis Cup doubles in Glasgow when Britain, captained by a Scot, Leon Smith, played Australia's Wally Masur in the semi-final. The tie stood at 1–1 on the Saturday when the Murray brothers, Andy and

Jaime, took on Lleyton Hewitt and Sam Groth. Obviously, there were two world-class singles players on either side of the net but, when mixed with Jaime's innate doubles skills and Groth's massive serving, the brew produced a recipe fit for the gods. BBC Radio's Russell Fuller described the contest as spellbinding and so it was.

From two sets to one down— and match point down in the fourth set breaker—the Murrays came through 4–6, 6–3, 3–6, 6–7 (6–8), 6–4 after three hours and fifty-six minutes of athleticism and skill that had the packed arena roaring its approval. I have never seen so many defensive volleys played from beneath the height of the net, so many lunges for impossible winners, so much

big serving in the crunch, and so much evidence of the reflexive skills demanded of great doubles players. At thirty-four, Hewitt played like a man possessed and lifted Groth to hitherto unseen heights. And for the Murrays, it was their finest moment as a pair of brothers. It took them all the way to the final in Belgium, where Britain was to win the Cup for the first time since 1936.

In partnership with John Peers of Australia, Jamie Murray had already been enjoying a great doubles season, reaching the final of both Wimbledon and the US Open. The wins, coupled with good results on the ATP Tour, enabled him to become the world's top ranked doubles player in March 2016, after winning the Australian Open with a new

partner, the Brazilian Bruno Soares. Fittingly, as the elder brother, he had beaten his sibling to a position of world number one, but Andy Murray did not take long to catch up, becoming the top singles player in November that year. Naturally, there was no prouder mother in Britain than Judy Murray, who had coached them both from infancy.

More success followed when he and Soares beat the Spaniards Pablo Correño Busta and Guillermo García López to win the US Open that year before Jamie started a run that added significantly to the mixed doubles title that he had won with Serbia's Jelena Janković back in 2007. In 2017, he made the most of the return of Martina Hingis to the women's tour by helping the Swiss win Wimbledon and the US Open. Switching to the flamboyant American Bethanie Mattek-Sands as a partner, Murray then completed a run of three straight US Open titles by winning at Flushing Meadows in 2018 and 2019.

With more doubles specialists making a career for themselves as the prize money improved, it became more difficult for anyone to dominate as the Bryans influence faded. Daniel Nestor had managed

to win consecutive French titles with the ever-reliable Max Mirnyi in 2011 and 2012, but the French pair of Pierre-Hugues Herbert and Nicolas Mahut proved themselves to be the most successful team in the latter half of the decade by winning all four Grand Slams, beginning with the US Open in 2015 and completing the quartet of victories at the Australian in 2019.

A Colombian pair had finished the decade as impressively as anyone. Juan Sebastian Cabal and Robert Farah climbed to joint number one in the world by the time they added the US Open title to the Wimbledon crown that

they had won two months earlier. By the end of the year, they had become national heroes in Colombia and were verging on $4 million each in career prize money. So doubles, which some would say is the game's most difficult art, was finally offering its champions a decent living.

(above) *In a brilliantly played and raucously supported Davis Cup doubles in Glasgow, Jamie and Andy Murray, left-hand court, out fought the Australian pair of Lleyton Hewitt and Sam Groth to help Britain reach the final in Ghent, where they beat Belgium in 2015.*

(below) *Leander Paes and Mahesh Bhuphati did not always play together, but when they did, the results were startling—twenty-three titles in all, including three Grand Slams.*

15 The Williams Sisters

(above) *Venus and Serena in the beginning.*

(opposite) *A sisters pose. (Photo by camerawork USA)*

Richard Williams is a genius. No, not the Richard Williams who played the Davis Cup for the United States and survived the sinking of the *Titanic*. Nor the fine sportswriter at *The Guardian*. Nor the million other people with that name. We are talking here of a rough, gruff sharecropper from Louisiana with a forbidding countenance who, aided to a considerable degree by his wife Oracene, raised two daughters who did exactly what he expected of them. Exactly.

When Venus was ten and Serena nine, Williams called in a couple of local reporters to the gang-ridden ghetto of Compton, California, and told them, "Now, see here. This is Venus, and this is Serena. They are both going to win Wimbledon, and both going to be number one in the world."

Trying to keep a straight face, the reporters said, "Sure thing, Mr. Williams. Check back with us. Let us know how you get on." They wandered off, shaking their heads. What Richard Williams had just told them was impossible. Just impossible. One daughter to achieve one of those things might have been conceivable if you believed in miracles. But both? Ridiculous.

Yet Venus and Serena, of course, achieved exactly what Daddy had said they would. And they did it in a way that strained credulity still further. Mr. and Mrs. Williams defied every norm and, according to current wisdom of

the time, did everything wrong. For a start, they took them out of all junior competition. "I just didn't like the atmosphere at junior tournaments," Oracene told me many years later. "It wasn't a race thing. Just the way people were acting. I didn't want the girls involved in that."

With occasional help on the phone from Jack Kramer, Richard Williams had been teaching daughters out of a book until Venus was ten. When they both started to show exceptional promise, he asked the respected coach Rick Macci to fly across country from Florida and start working with them.

Macci was dubious but decided to accept Williams's invitation. He was picked up in the family van, piled high with dirty clothes and old balls. "Richard wouldn't let the girls use new balls because he wanted them to learn how to bend off a low bounce," Macci said, already impressed by the father's reasoning.

Having survived a bumpy ride to the courts and a spring that literally burst out of the passenger seat and harpooned him in the bottom, Macci couldn't believe his eyes when Venus and Serena got on the court, such as it was, and started hitting. "They were off-balance—arms, legs, hair, and beads flying everywhere," he recalled when we talked many years later. "I wondered why I had come. Then I got them to play points, and everything changed. They got serious, structured strokes ap-

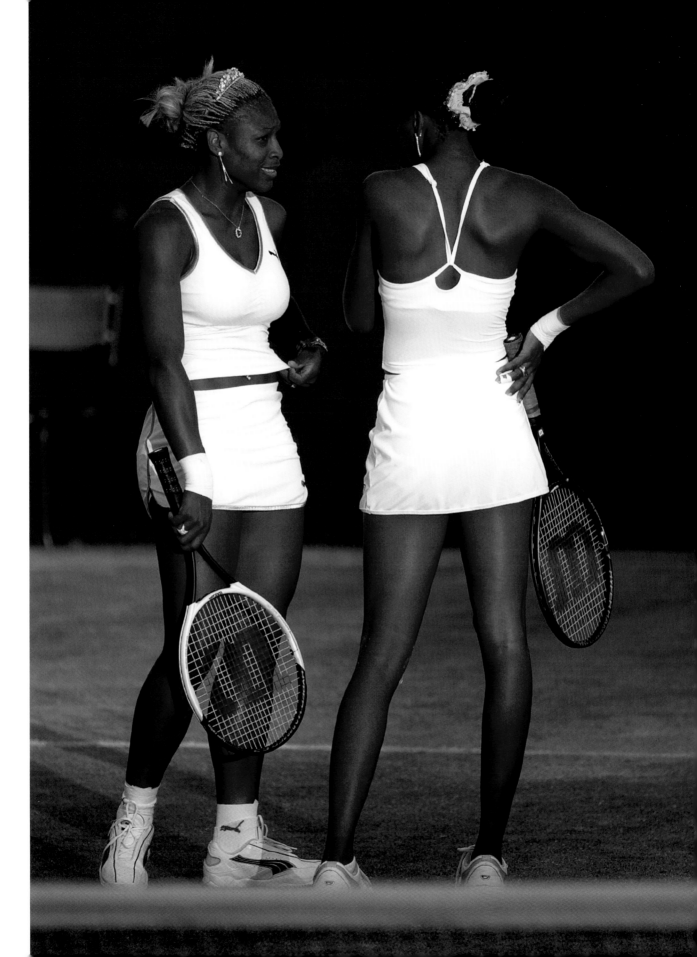

peared, and they chased everything—everything, never gave up on a ball."

The clincher came when Venus pranced off to the bathroom, first with long strides, then suddenly walking on her hands before doing a backward cartwheel.

"I thought with that kind of athleticism, I could get her to do anything," said Macci, who found himself being interrogated that evening by Richard. "Not just about tennis, he wanted to know everything about me and my views on a whole range of subjects. I was impressed." So much so that he found a way to get them settled in Florida and selected a series of male hitting partners for them. "They never played girls, so they got very used to power," Macci explained.

When Venus reached 14, it was decided to ask for a wild card into the WTA event at Oakland, California. Such had been the hype on the grapevine, some of us flew out to see her play her first pro match—and first of any kind in three years—against Shaun Stafford of South Africa, then ranked fifty-seventh in the world. Venus won. You are not supposed to be able to do that—not an any age.

Macci was not worried. He relied on Venus's inbred thirst for competition and her ability to absorb advice. "We told her that she was bigger, stronger, and faster—and that Stafford had an awful forehand," Macci recalled. "She lapped it up. She was wired for these moments. She had so much fortitude and fiber."

Coaches will tell you that three years without any tournament competition would make it impossible for any player to walk into a top tournament and win,

but Venus did. In the next round, she led the three-time French Open champion Arantxa Sánchez Vicario by a set and 3–1 as well. Unsettled, the Spaniard went off for a bathroom break, and Venus, who was unaware that the rules allowed an opponent to do this, lost concentration and went down easily in the third. But the point had been made.

With Richard Williams calling out "That's one for the ghetto!" at his daughter's press conference, we wondered what tennis was in for. Most expected Venus to be pushed out onto the tour on a regular basis with Serena following behind. Wrong again. They were sent back to school. "Education first" was their parents' edict. It made the sisters hungry to play and, choosing their tournaments carefully, their path to the top became an inevitability.

In 1997, Venus made it to the final of the US Open, where she was outmatched by the wily Martina Hingis, but three years later, she won Wimbledon and the US title. Completing her father's instructions, she became number one in the world on February 25, 2002.

Even back in Oakland, when we took a stroll down Main Street so that Richard could smoke a cigarette, which was not allowed in the hotel, he told me that Serena was the more talented of the pair. "Mark my words. Serena is going to be better," Richard told me. Right again.

However, it took Serena a while before she was able to prove it. Throughout her life, Serena has looked up to her older sister and still does. They adore each other, but both knew the time would come when they would have to face each other as professional tennis players. When it happened in the sec-

ond round of the Australian Open in 1998, Serena wasn't ready emotionally. The sixteen-year-old girl walked into Rod Laver Arena playing the sister whom she loved instead of the ball. Venus won 7–6, 6–1.

The second meeting, and their first in a WTA final, came, appropriately enough, at the Lipton Championships (later the Miami Open) on Key Biscayne, a two-hour drive from their home in Palm Beach Gardens. It was a better contest, but Venus still prevailed 6–1, 4–6, 6–4.

Later that year, at the 1999 US Open, Serena proved that she was ready for the big time by defeating Lindsay Davenport in the semi-finals at Flushing Meadows and then gaining revenge for Venus by overpowering Hingis 6–3, 7–6 in the final. Ignoring the family pecking order, Serena had won a Grand Slam title before her sister. But in 2001, the inevitable happened. The sisters found themselves facing each other at the US Open in their first Grand Slam final. Richard disappeared and went for a walk, as he always did when his daughters had to play each other. By the time he had returned to the Louis Armstrong Stadium, Venus had retained the title that she had won the previous year over Lindsay Davenport with a clear cut 6–2, 6–4 victory.

Conspiracy theorists were quickly coming up with the idea that their head-to-head matches would be fixed with their father deciding who should win. There was never any evidence of that although, when questioned, neither denounced the notion with much vehemence. "People think what they want to think," Venus said. Neither suggested that they relished playing each oth-

er, but they had been taught to be professionals and went out and did their job. However, an incident occurred at Indian Wells in 2001 that turned into something of a disaster. The sisters were due to play in the semi-final but, no more than ten minutes before they were due on court, Venus scratched. The reason she gave was tendonitis, but players always give tournaments a minimum of thirty minutes warning, and usually much longer, if injury is going to prevent them from playing.

Even the cochairman, Charlie Pasarell, was unaware until he heard the announcement on court. It was an evening match with a capacity fifteen thousand crowd eagerly awaiting a much-hyped contest. Unsurprisingly, boos rang out. Less anticipated was the reception Richard Williams and Venus received as they made their way to their seats for Serena's final against Kim Clijsters the next day. To say the least, it was hostile. Richard said it was racist. Certainly, it was extremely unpleasant, and it continued through the match with Serena being insulted by a small minority who were not interested as to who was to blame. To her credit, Serena kept her concentration and won the title, but even then, the boos didn't stop. Pasarell denounced the crowd's behavior, but it wasn't enough to assuage the hurt that the Williams family felt. They didn't play at Indian Wells for fourteen years.

Even before 2002, when the rivalry took a sea change on court, it was becoming clear that Richard's prediction was correct. Serena, despite a different body build, had just as much athletic ability as Venus, and she had just as much power. She also had more touch and flexibility. When they met again in

(opposite, top to bottom) *Beads were the look in the early days for Venus and Serena.*

Rick Macci, who stepped into fine-tune Richard's early coaching and helped the family move to Florida from Compton, California. (Photo by camerawork USA)

Early acclaim for Venus from Martina Navratilova.

I discovered Richard Williams's little secret in the corner of a sponsor's suite at the Lipton on Key Biscayne in 1995. When he needed embellishment for his How to Play Tennis *book, he used to phone up the expert, Jack Kramer. "Jack's my man!" Richard admitted. None better!*

(above) *Mother Oracene.*

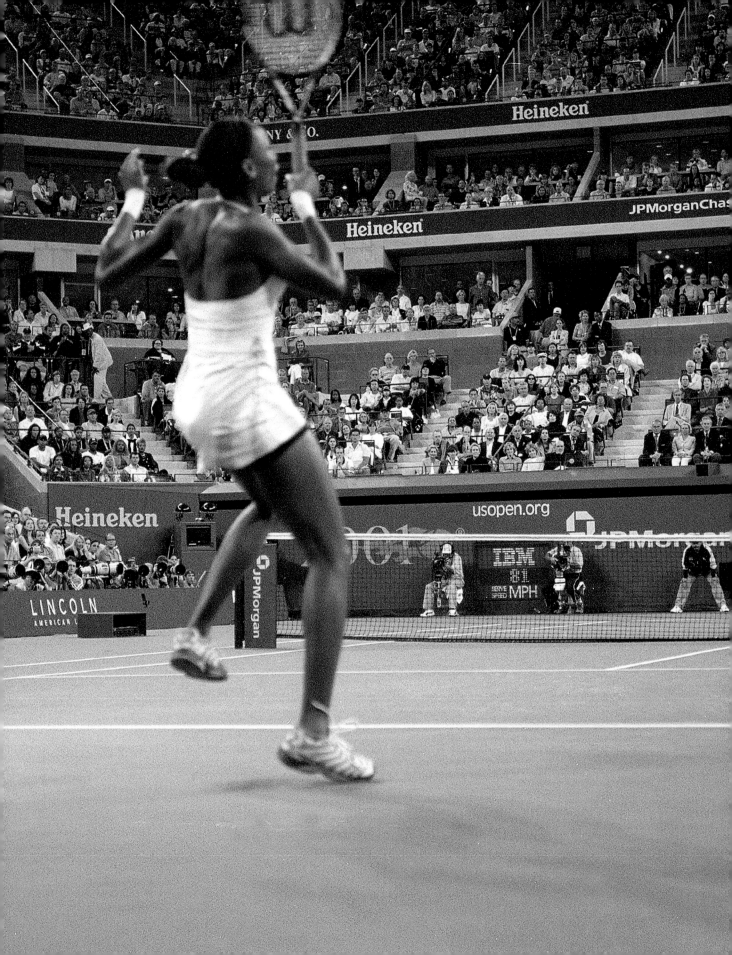

the US Open final, Serena reversed the previous year's score, winning 6–4, 6–3.

Fred Stolle, title holder at Roland Garros and Forest Hills in his day, watched the Williams sisters emerge and grow from his seat alongside Cliff Drysdale in the ESPN commentary booth. He soon realized that Serena was simply the more naturally gifted of the two. "When Richard first put rackets in their hands, I suspect Venus needed more coaching than Serena," Stolle told me. "For Serena, striking a tennis ball was just more natural. She also had a better serve—probably the best the women's game has ever seen—whereas Venus's second serve was always her weak spot. Their athleticism was comparable despite different body builds, but I think Serena struck the ball about ten percent harder."

Finally, mature enough to put personal feelings aside, Serena began 2002 by beating Venus in the semi-final at Key Biscayne and then simply took over the women's game. The warning signs emerged at the Foro Italico in Rome, where red European clay proved no barrier to the overwhelming power Serena brought to the court. She beat Jennifer Capriati in the semi-final and Justine Henin, who was on the brink of becoming one of the best clay-court players of her era, in the final to become the Italian champion.

That was the antipasto. The full feast was about to begin. At Roland Garros, Serena steamrollered her way through the draw to the reach the final where, for the first of four consecutive Grand Slams, she found Venus waiting for her. The score was 7–5, 6–3. A month later at Wimbledon, it was 7–6, 6–3. A loss to another African American play-

The world great stages became their playground. Venus and Serena play another final at Arthur Ashe Stadium at the US Open. In all, they met in nine Grand Slam finals.

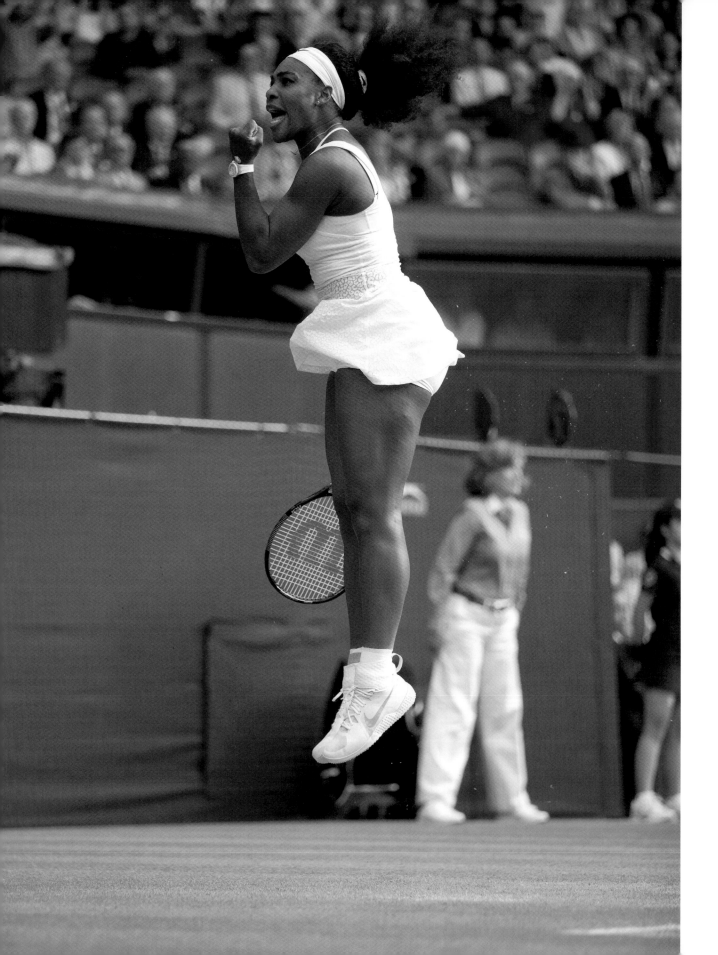

er, Chanda Rubin, in the WTA event in Los Angeles ended a twenty-one match-winning streak before the Serena-Venus Show took center stage again at Flushing Meadows. This time it was 6–4, 6–3, and the title-winning triumph lifted Serena to number two in the world. The number one? Take a bow Richard Williams. It was Venus.

In the fall, an eighteen match-winning streak was interrupted when Serena lost the WTA Championship Final at the Staples Center in Los Angeles to Kim Clijsters. Melbourne beckoned in the New Year, and it was the same old story. Serena won the Australian Open, beating Venus in one of their best matches 7–6, 3–6, 6–4. Winning four consecutive Grand Slam singles titles, albeit not in one calendar year, gave the youngest Williams what became known as the Serena Slam. It would not be the last.

There was also the Serena Saga, which encompassed far too many triumphs and tears to chronicle in detail here. After the emotional eruption that blew up over a disputed line call during her semi-final against Kim Clijsters in the 2009 US Open—which resulted in a $82,000 fine for abusing a lineswomen among other things—Serena finally apologized, admitting that she was a "prideful, intense, and emotional" per-

sonality. No disputing that. Nor was there any disputing the fact that Serena could win much as she pleased as long as she was fit—a physical state that became increasingly difficult to maintain.

Nevertheless, the Grand Slam titles kept coming: the Australian over Justine Henin in 2010, followed by another Wimbledon, where she beat the surprise Russian finalist Vera Zvonareva, until health problems began to intrude. 2011 proved to be a barren year, culminating in the shock 6–2, 6–3 loss to an inspired Samantha Stosur of Australia in the final of the US Open. She failed to retain her crown in Melbourne in January 2012, and then at Roland Garros, Serena experienced a very fateful Parisian spring.

For the first time ever, she lost in the first round of a Grand Slam, going down fighting, but going down nonetheless to a tall, powerful French player named Virginie Razzano, who refused to buckle when Serena battled back from 0–5 to 3–5 in the third set.

Returning to the apartment that she had maintained for several years in the city, Serena shut herself away for a while and then phoned Patrick Mouratoglou, who was starting to make a name for himself as a coach. Having started with Marcos Baghdatis at his original academy, Mouratoglou had just begun working with Grigor Dimitrov at his new place not far from Roland Garros. Serena wanted to know if she could come and practice. Cutting a very long story short, Mouratoglou found the words that Serena needed to hear. Almost instantly, they developed a relationship that reached beyond the tennis court. Romance dimmed after a while, but such was the mutual respect that Mouratoglou remained her coach.

(opposite) *The Wimbledon jump. If Serena had jumped that high at the Olympics, she might have won gold. (Photo by camerawork USA)*

(above left) *Kim Clijsters returns to title-winning ways. (Photo by camerawork USA)*

(above right) *Lindsay Davenport's big two-handed backhand. (Photo by camerawork USA)*

(above) *Fashion-conscious Serena Williams. Perfect in pink and a lot of other colors too.*

Serena, lavishly gowned for the 2019 Met Gala in New York.

They were still in a professional relationship eight years later, Serena having won ten of the first seventeen Grand Slams that she had played with Mouratoglou at her side, as well as two losing finals. For three consecutive years, beginning in 2012, she also won the WTA Year End Championships.

In 2015, Serena hit her peak, winning the year's first three Grand Slams and appearing invincible until she suffered one of the most unexpected defeats of her career in the semi-final of the US Open, when Italy's Roberta Vinci, who had covered every inch of the Arthur Ashe Stadium, produced the most delicate of short forehand cross-court winners to complete a stunning 2–6, 6–4, 6–4 victory. "She just played out of her mind," said Serena. It was true, and there was not much else to say.

When Serena lost to Germany's Angelique Kerber in the final of the Australian Open four months later and then went down 7–6, 6–4 to the tall and elegant Spaniard Garbiñe Muguruza 7–6, 6–4 in the final at Roland Garros in June, it was clear that the cloak of invincibility that had clung to ger shoulders twelve months earlier had slipped away. She was thirty-four years old and feeling life's aches and pains. She was far from done, but the consistency was gone. After gaining revenge on Kerber by winning Wimbledon for the seventh time a month later, she had only one more Grand Slam in her before the new decade dawned, winning in Melbourne—also for the seventh time—against Venus.

The biggest change that came over Serena's life was her marriage to Alexis Ohanian, the founder of Reddit, and the arrival in September 2017 of her daughter Olympia, who could claim at least part of her mother's Australian Open title as she had been on court throughout in utero. Serena returned to the tour in time to reach the 2018 Wimbledon final, where she lost to Angelique Kerber.

Anyone who thought that motherhood might have doused Serena's competitive fire was disabused of any such notion at the US Open that year, when all hell broke loose during her final against one of the game's great new talents, Naomi Osaka, a powerful twenty-year-old with a Haitian father and a Japanese mother. Osaka began brilliantly, peppering the Arthur Ashe Stadium with stinging winners that Serena couldn't handle to take the first set 6–2.

The problems started when Patrick Mouratoglou gave Williams some coaching advice, which is illegal in Grand Slams, although not totally so on the WTA Tour. Serena protested loudly when the experienced umpire Carlos Ramos hit her with a code of conduct warning. She blew up again at 3–2 up in the second, smashing her racket and getting a second warning after losing a serve. Worse followed as she continued to harangue Ramos, who docked her a game penalty to put Osaka 5–3 up.

Serena has thrown some fits in her time, but none as pained and explosive as this. Calling for referee Brian Early, she disrupted the match for several minutes, railing about sexism and calling Ramos a thief. The New York crowd, uninterested or unaware of the fact that Naomi had gone to school about half an hour away when the family moved to New York from Japan, yelled support for Serena throughout, virtually all twenty-three thousand of them. It was to Osaka's im-

mense credit that she was able to maintain her concentration and serve out for a thoroughly deserved victory.

But there were tears all over the place. Naomi had every reason to cry because her moment of glory had been smothered by the behavior of an opponent sixteen years her senior—an opponent who had been her childhood idol. It was probably Serena's least glorious moment but, eventually, she apologized. Too late. As Kevin Mitchell wrote in *The Guardian*, "What might have been a moment of greatness had curdled into seething controversy." Shame.

In some ways, Venus has enjoyed an even more extraordinary career than Serena. The elder sister not only had to get to grips with the fact that she was not the more naturally gifted of the two but, from 2011 onward, she had to battle Sjogren's syndrome, which leaves sufferers with a constantly dry mouth and eyes, aching joints, and tiredness. For most people, it is not the tennis court that beckons but the couch.

Venus's reaction to her illness was to change her diet, search for appropriate medication, and get back to work. The result? By 2020, she had won forty-nine WTA titles and appeared in sixteen Grand Slam finals, winning seven. Only two players, apart from Serena, have ever beaten Venus in a Slam final: Martina Hingis at the US Open in 1997, when she was seventeen years old, and Garbiñe Muguruza at Wimbledon in 2017, when she was thirty-seven years old. Most players don't get to Slam finals at seventeen, and hardly any at thirty-seven, but none suffering from a debilitating disease. Just like winning that first pro match at Oakland, none of it should have been possible, but she is a member of a family that does the impossible as a matter of routine.

A twenty-year span in reaching Grand Slam finals is a record in women's tennis, shared with Serena. Venus has sprinkled a little more stardust on her game by winning five Olympic medals (four gold and one silver), thus equaling the record set by Kitty McKane Godfree in the 1920 Olympics. In Fed Cup, Venus played thirty rubbers for the United States, two of them in the 4–1 victory over Russia in 1999.

In 2015, Venus won her penultimate title on the Stanley Street courts at Auckland, New Zealand. A finalist there the year before, victory was finally secured over her sister's great friend, Caroline Wozniacki. But Auckland had not seen the last of the Williams family. In 2020, Serena defeated Jessica Pegula, daughter of the Buffalo Bills owner, in the final to win her first title as a mother.

By the time Venus became the only player to reach two Grand Slam finals in 2017, as well as losing to Wozniaki in the final of the WTA Championships at the age of thirty-seven, people were beginning to wonder if Venus really did play among the stars. If he had still been around, Frank Sinatra would have sung about it. Superlatives were becoming superfluous.

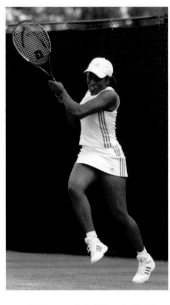

The accomplished Chanda Rubin, daughter of a Louisiana judge, won the Australian doubles title with Arantxa Sánchez Vicario in 1996 and went on to obtain an economics degree at Harvard before becoming a commentator for Tennis Channel. She also managed the very rare feat of recovering from 0–5, 0–40 in the third set against Jana Novotná in the third round of the French Open in 1995, winning it 8–6.

Serena—Excuse me?

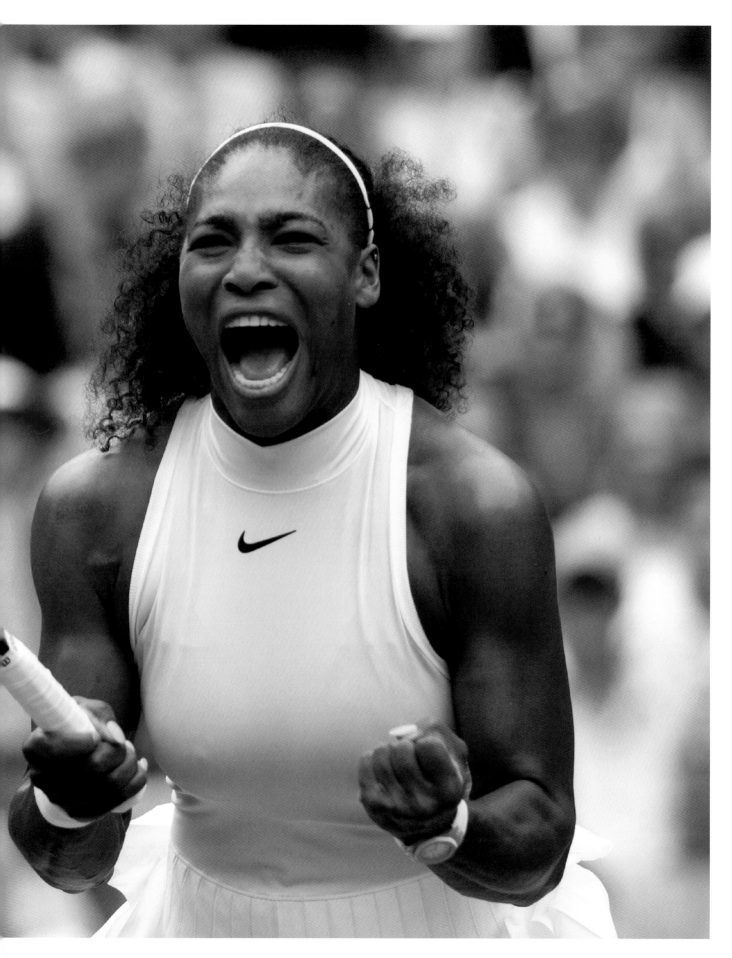

16 The Olympics

Tennis might never have returned to the Olympic Games as a medal sport had it not been for the determination of two far-sighted officials—Philippe Chatrier, president of the International Tennis Federation, and David Gray, the general secretary of the organization.

Chatrier, who was largely responsible for the modernization and enlargement of Stade Roland Garros during his time as president of the French Federation, and Gray, who had spent most of his career writing elegantly for *The Guardian*, both viewed the game's absence from the Olympics with dismay and became determined to do something about it.

Tennis had been one of the nine founding sports of the modern Olympics, which were reborn from the days of ancient Greece when Baron Pierre de Coubertin, a small man with a big moustache and an even bigger idea, fulfilled his life's ambition by setting in motion a new version of the Olympic Games in Athens in 1896.

John Pius Boland, an Irishman who later became a prominent politician, happened to be visiting Greece that year and found himself entered into the draw for the tennis event by the friend whom he had come to see. Boland not only won the gold medal in singles by beating the Greek Dimitrios Kasdaglis in the final but also won gold in doubles alongside a German partner, Friedrich Traun. There is no record of whether he played tennis seriously again.

In 1900 in Paris, Laurie Doherty became Britain's first gold medalist in singles, while his brother Reggie also won gold by winning the mixed with another English player, Charlotte Cooper, who took splendid advantage of women being allowed to play for the first time by winning the singles event. Reggie Doherty added to his medal tally by getting a bronze in singles.

When the Olympic Games returned to Paris in 1924—the year of Eric Liddell, Harold Abrahams, and Coach Sam Mussabini immortalized in *Chariots of Fire*—there was little hint of trouble. But, possibly stoked by Abrahams's decision to break from the norm and hire Mussabini as a professional coach, a row soon broke out between the Olympic committee and the International Lawn Tennis Federation over the rules regarding amateurism. Absurdly, the officials of the day could not reach an agreement and tennis was dropped.

It was not until Chatrier started to exert considerable influence on international sport in the early 1980s that pressure to get tennis reinstated at the Olympics began to ramp up. Meeting with International Olympics Committee (IOC) officials, Chatrier and Gray started to lobby for readmission, and they had a strong case. By any evaluation, tennis was the second most internationally played sport in the world. But there was still some persuading to do.

"We feel as if we are cousins left out in the cold," said Gray before the IOC finally agreed to allowing an Under 21 competition to be included in the Olympic schedule at Los Angeles in 1984 as a non-medal sport. "And there are serious financial considerations. If tennis were an Olympic sport, sports federations across the world who

The joy of winning together. Zina Garrison and Pam Shriver in Seoul in 1988 with their doubles gold medals.

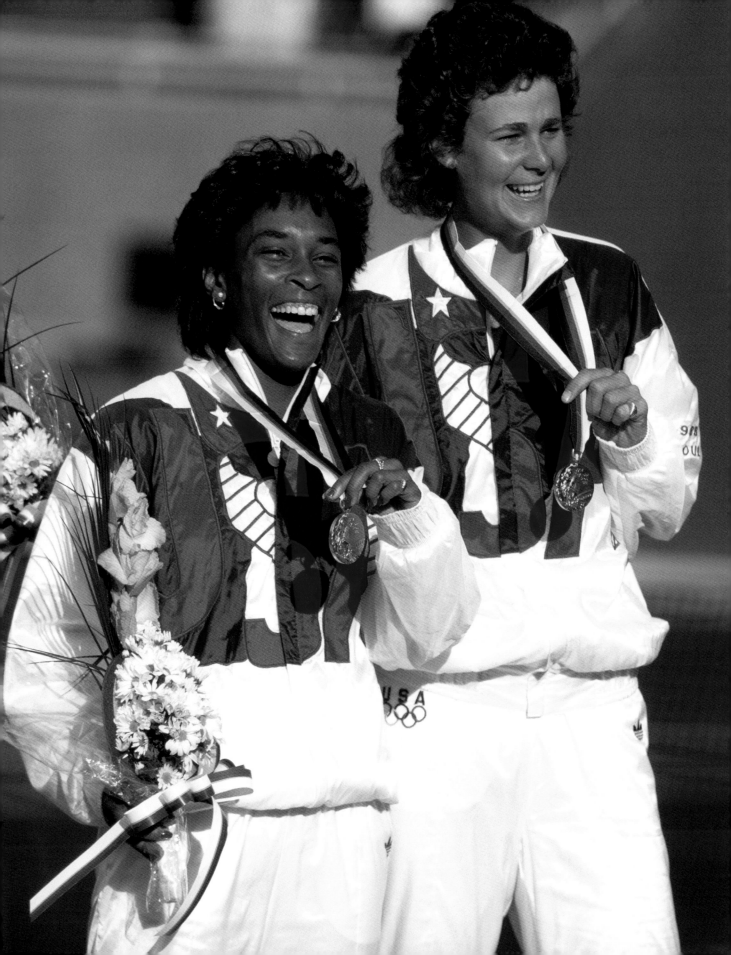

are now cut off from Olympic funding would receive desperately needed cash for courts and training programs."

With people like Jean Borotra getting in the ear of Dr. Juan Samaranch, then the IOC supremo, Chatrier's pleas finally bore fruit. At Seoul in 1988, tennis once again became a fully fledged Olympic sport. With some exceptions, the players were overjoyed. Many stayed in the Olympic Village and loved mixing with world-class runners, jumpers, and weight lifters. Although most of the Olympic sports are individual in nature, everyone always feels that they are representing their country, and team spirit flourishes.

I discovered an example when I went in search of an outside court to watch Britain's Sara Gomer play her match. Gomer was a good player but not exactly a super star. But there was somebody who definitely qualified as such standing at courtside for a full two hours on a hot and humid Korean afternoon. Decathlon gold medalist Daley Thompson was supporting Sara quite vocally all the way.

The return of tennis to the Olympics proved an immediate success in Seoul. By the time the hugely talented Slovak Miloslav Mečíř had won gold in the men's singles by beating the American Tim Mayotte in the final, and Steffi Graf had won the women's competition over Gabriela Sabatini, a total of 111,000 tickets had been sold at the tennis stadium and worldwide television had provided two thousand hours of coverage. Tragically, David Gray lived to see none of it, having succumbed to cancer in 1983.

As the Olympics became part of tennis life every four years, it was interesting to observe how some unexpected names stepped forward to grab medals under the noses of more established rivals. The outstanding example came in 2016 in Rio de Janeiro when Monica Puig, never ranked higher than twenty-seventh at the time, fought her way past Garbiñe Muguruza, Laura Siegemund, Petra Kvitová, and then Angelique Kerber in the final to win Puerto Rico's first Olympic Gold medal in any sport.

As a player who, until that moment, had never fulfilled her promise, critics wondered how Puig had managed to lift her level so dramatically through a whole week of intense Olympic competition. Afterward, she gave a hint of why. "I do it for my country," she said. "The Olympics is not about me. It is about Puerto Rico. I know how badly they want this. This island is full of bad news every time there is a Games [the hurricane had just hit], and then someone wins a medal and everything stops and I know how happy they get."

Motivation is an amazing thing. Sadly, Puig could not maintain it. Back on the tour, playing for herself, her ranking quickly dropped below fifty.

In Barcelona in 1992, the giant Swiss Marc Rosset, who was not known for his consistency or durability on the ATP Tour, ploughed his way through the draw and an enervating final match that lasted more than five hours in Catalan heat against the little Spaniard Jordi Arrese to win gold. It was easily the greatest achievement of Rosset's career.

At Atlanta in 1996, Andre Agassi, who was already a Grand Slam winner, gave the fans plenty to shout about by beating Spain's Sergi Bruguera for gold, while in Sydney four years later, the talented Russian Yevgeny Kafelnikov, who had won the Australian Open title the previous year, added to his success Down Under by beating Germany's Tommy Haas in the final.

Athens in 2004 produced another unlikely gold medalist in Chile's Nicolás Massú. Briefly ranked number nine in the world, Massú wrote himself into his nation's history books by becoming the first Chilean ever to earn an Olympic gold medal when he teamed with Fernando González to win the doubles. Putting that excitement aside, Massú went one better the next day by beating the American Mardy Fish to add another gold in singles. Amazingly, the tennis event in Greece was played on hard courts, whereas virtually all of Massú's previous success had come on clay. For the talented Fish, the silver medal became a consolation for a career ruined a short while later by health issues.

González, a powerful athlete who had one of the biggest forehands in the game, added to his notable Olympic achievements by reaching the singles final in Beijing in 2008, but he needed more than a forehand to stop Rafael Nadal from adding gold to his sparkling career resume.

When London staged the 2012 Olympics and Wimbledon became the tennis venue, the stage was set for Andy Murray. As a nation's hopes rode with him, he showed his strength of character by wiping away the tears that had flowed on Centre Court only three weeks earlier after he had lost to Roger Federer in the Wimbledon final and gained mighty revenge—crushing Federer 6–2, 6–1, 6–4. Back in Scotland, his hometown of Dunblane was so happy that they painted a red letter box in the center of town all gold.

Perhaps another one should have been painted silver because Murray, taking the eighteen-year-old Laura Robson as his partner, reached the mixed doubles final, losing a thrilling encounter against the Belarussian pair

of Victória Azárenka and Max Mirnyi 2–6, 6–3, 10–8. For Robson, who was to suffer a debilitating wrist injury, it was the highlight of a career that promised so much more.

Further Olympic glory awaited Andy Murray when the Games opened in Rio di Janeiro in 2016. Sailing through the early rounds, he only dropped sets to Fabio Fognini and Steve Johnson. There seemed little chance of the Scot being unable to defend his title until he came up against Juan Martín del Potro in the final. The tall Argentine, who enjoyed plenty of support from across the border, had survived a grueling semi-final against Nadal after upsetting Novak Djokovic in the first round and was using his new one-handed slice on the backhand, a

stroke forced on him because he had been unable to continue with his devastating two-hander as a result of numerous operations on his left wrist.

It is impossible to know what kind of a handicap that proved to be for del Potro, for it was an encounter of such mood swings and unfathomable highs and lows from both players that serious analysis became redundant. Perhaps the fact that there were no fewer than fifteen breaks of serve between two big servers says enough. What is certain is that the four hours and two minute duel that went to Murray by 7–5, 4–6, 6–2, 7–5 left both players totally exhausted. At the end, they clung to each other at the net. In *The Guardian*, Kevin Mitchell wrote, "del Potro looked as

if he might fall over if he let Murray go. But they smiled the smile of champions who had given their all."

The victory gave Murray a special place in Olympic tennis history. He became the first player to successfully defend a gold medal in singles. A similar triumph was achieved by an unrelated pair bonded by name—Mary Joe Fernández and Gigi Fernández. The Spanish-speaking American duo teamed up to win gold in Barcelona in 1992, beating the talented pair of Arantxa Sánchez Vicario and Conchita Martínez in the final, and they did it again at Atlanta four years later with a win over Jana Novotná and Helena Suková. The Czechs had also been silver medalists in 1988 in Seoul, where Pam Shriver proved that she could win without Martina Navratilova at her side by teaming up with Houston's Zina Garrison to win gold. Garrison, a Wimbledon singles finalist two years later, thus became the first African American tennis player, male or female, to win Olympic gold.

In men's doubles, going back to the beginning, Reggie Doherty won gold in 1900 with his brother Laurie and again with George Hillyard, who was actually All England Club secretary at the time when the Games were played in London in 1908. Although the latter success was achieved on grass at Worple Road, some of the matches had actually taken place indoors at the venerable Queen's Club on courts that still exist today.

Moving on to the modern era, that long-serving pair of Americans Robert Seguso and Ken Flach took gold in Seoul, and then Boris Becker and Michael Stich, never the best of friends, buttoned up their egos in Germany's cause and beat South Africa's Wayne Ferreira and Piet Norval in the Barcelona final.

It was only fitting that the Woodies should claim gold in Atlanta because Mark Woodforde and Todd Woodbridge had emerged as one of the most popular and successful teams of their era, winning all four Grand Slam titles, including no fewer than six Wimbledon crowns. In Atlanta, they beat the British pair of Tim Henman and Neil Broad in the final.

Lack of Olympic gold in singles will remain a very rare missing link in Roger Federer's golden chain of success, but in Beijing in 2008, partnering his friend Stan Wawrinka, he was able to get a medal of the right color in his trophy cabinet by winning the doubles with a hard-fought four-set victory over the Swedes, Thomas Johansson and Simon Aspelin. Never the most outwardly demonstrative of players, Federer revealed how much the victory meant to him by leaping into the air, hugging the man whom he calls Stanley and rolling around on the ground with him. "It made me very happy," Federer said, superfluously. "It was a once in a lifetime thing."

If Wawrinka had been Federer's obvious partner, not so for Marc López, who was given the opportunity to partner Rafael Nadal in Rio in 2016 because the two had been life-long friends. Obviously, López's talent made him worthy of the opportunity, but being given a chance and taking it are two different things, and in no way did López let his friend down. Playing some thrilling tennis, the Spanish pair defeated two Romanians, Florin Mergea and Horia Tecău, who had been the world's number two ranked doubles player the previous year, enabling Nadal to win his only Olympic gold up to that time.

Looking back, the reintroduction of tennis into the Olympics has added luster to the game and the Games alike.

(opposite) *Two Chileans— Nicolás Massú with gold and Fernando González with bronze—were among the surprise medalists at Athens in 2004. America's Mardy Fish won silver.*

(above) *Once ranked number two in the world, an Olympic silver medalist in Sydney in 2000, a player who is still active on the Legends tour, and now tournament director of the BNP Paribas Open at Indian Wells, Tommy Haas has contributed much to the game.*

(top) *When Andy Murray won gold at Wimbledon in 2012 and doubled up a silver in the mixed doubles alongside Laura Robson, his hometown of Dunblane in Scotland decided to paint one of its red letter boxes gold. It probably needed another coat when Murray added a second singles Olympic gold in Rio in 2016.* (bottom) *Mary Joe Fernández, right, who was the US Fed Cup captain for many years, and Puerto Rico's Gigi Fernández are not related but will be forever linked as doubles gold medalists at the Barcelona Olympics in 1992.* (opposite) *Ferocious on court and charming off it, Indian icon Leander Paes has enjoyed one of the longest careers on the tour, reaching into his forties. He has fifty-five doubles titles, including eight Grand Slams to show for it, playing with no fewer than 131 partners. He was most successful with his Indian Davis Cup colleague Mahesh Bhupathi and later Lukáš Dlouhý and Raven Klaasen. Winning a bronze medal at the Atlanta Olympics was one of his proudest moments.*

Philippe Chatrier and David Gray, his able lieutenant, would be proud of how the players have responded and the great duels that they have fought.

For many, it is not even about the winning. It is about being part of something bigger than themselves and their sport. If there is one player who epitomizes that spirit and that attitude, it is Leander Paes, the small, feisty, and apparently ageless Indian who has not played his best tennis at the Olympics—certainly nothing to compare with his Grand Slam record of eight titles in doubles and ten in mixed—but he has taken part. Paes has taken part so consistently and with such unerring passion that he played in his seventh consecutive Olympics Games in Rio at the age of forty-three. *That* is an Olympian effort.

17 Women in the Twenty-first Century

As the new century dawned, the Williams sisters, already in their stride, continued to be the dominant force. Even as Venus, fired by her indomitable spirit, struggled through illness, Serena won twenty-two of her twenty-three Grand Slam titles after the turn of the century. Yet there were far too many aspiring champions in the making to allow them a free reign.

The list, in fact, was surprisingly long and diverse and offered some strange statistics—none more so than that of Caroline Wozniacki, who claimed the number one WTA ranking through 2010 to 2011 for a total of sixty-seven weeks without winning a Grand Slam title. When the blonde Dane with the ever-ready smile finally did so, beating Simona Halep in the final of the Australian Open in 2018, it enabled her to regain the number one ranking, albeit briefly, for the first time in six years—the longest gap ever recorded since the WTA rankings were created in 1975.

Wozniacki was not alone in reaching the top spot without winning a Grand Slam title. Dinara Safina, Marat Safin's brother, did so off the back of three Slam finals as did Serbia's Jelena Janković, who managed to win the mixed at Wimbledon with Jamie Murray in 2007 but could only reach a singles final once—at the US Open the following year. Neither Safina nor Janković could achieve what most players would feel was the more satisfying goal: that of winning a Grand Slam title. Not so for Kim Clijsters and Amelie Maures-

mo, who went on to claim Grand Slam crowns after being ranked number one.

It was no coincidence that this anomaly recurred during the first decade of the century because the disruptive influence, if one may put it that way, was Serena's inconsistency. When fit and focused, Serena could waltz into any Slam and collect a huge number of ranking points. But frequently, she would then disappear from the regular WTA tour for a variety of reasons, leaving more consistent performers to stack up points. Wozniacki, a runner and a retriever of relentless determination, was a classic example of that because she played often and never lost easily.

But right at the beginning of the decade, it was Jennifer Capriati who stole most of the headlines. Hers was a story of teenage triumph, near tragedy, and ultimate fulfillment after long periods of anguish. The strongly built Floridian with an Italian-born father of—to put it kindly—aggressive ambition burst on to the scene by winning the Virginia Slims of Florida at the age of thirteen years and eleven months. Capriati added the Puerto Rico title that year as she rose to the world's top ten. Just shy of fifteen years old, Capriati became the youngest top tenner in open tennis history.

Using her big, flat-hit forehand and making up for a weakness on the second serve by pounding aggressive service returns, Capriati became a golden girl in a literal sense when she won the gold medal in singles at the 1992 Barcelona Olympics by beating Arantxa Sán-

(above) *Serbia's Jelena Janković and Scotland's Jamie Murray won Wimbledon's mixed doubles title in 2007. The next year, Janković was rewarded for consistency and grueling work made on the tour by rising to number one in the world; however, a Grand Slam singles title eluded the 2008 US Open finalist.*

(opposite) *Jennifer Capriati is triumphant. (Photo by camerawork USA)*

(top) *Instinctive understanding of how to play the game enabled Martina Hingis to become world number one at the age of sixteen, an astonishing achievement.*

(bottom) *Another win for one of the game's finest clay-court players, Belgium's Justine Henin.*

chez Vicario in front of the Spaniard's own crowds in the semi-final and Steffi Graf 3–6, 6–3, 6–3 in the medal match.

Adulation followed her success, and Capriati was too immature and too brow beaten by her demanding father to handle it. She was arrested for stealing a fifteen-dollar bracelet and fell into drug addiction. She dropped off the tour in 1994 and did not play at all the following year. The valley into which she had fallen was deep and dark but, summoning a champion's resolve, she climbed out of it with astounding success.

By 2001, she was able to pound her way through a tough Australian Open field—one that included wins against Lindsay Davenport and Monica Seles before winning the title with a 6–4, 6–3 victory over Martina Hingis. When she clinched match point with a deadly ac-

curate backhand service return winner, the twenty-five-year-old once-upon-a-time child prodigy rolled back the years and skipped around Melbourne Park's Centre Court like a kangaroo. She then rushed over and reached up to a beaming Stefano, the father to whom she owed everything, despite troubling moments.

In June, Capriati pulled off the rare feat of winning Roland Garros back to back with the Australian. She did it in the most dramatic fashion, winning a nail-biter against Belgium's Kim Clijsters in Paris 1–6, 6–4, 12–10. Despite a quarter-final loss to Venus Williams at the US Open, Capriati rose to number one in the world in October and proved that she could wear the mantle with pride by retaining her crown at Melbourne Park in January 2002 with 4–6, 7–6, 6–2 win over Martina Hingis, which was the

(top left) *When fifteen-year-old Martina Hingis played her first WTA tournament in Zurich in 1994, she got to meet the person who really mattered: Georgina Clark, the English umpire, referee, and WTA European director.* (center) *Petra Kvitová had already won Wimbledon twice by the time she was attacked by a knife-wielding intruder in her kitchen in Prague in 2016, but she recovered from hand surgery faster than expected and quickly became a consistent force on the tour again—reaching the year end WTA finals for the seventh time in 2019.* (right) *Coach Darren Cahill probably didn't have to tell Simona Halep to keep here eye on the ball. That intense focus was always part of her game. (Photo by camerawork USA)*

Swiss player's sixth straight appearance in the Australian Open final, having won the first three.

Capriati continued to be a force in the game, appearing in two semi-finals at Roland Garros and two at the US Open, but at the end of 2004, she called it quits on one of the most unlikely careers in the history of women's tennis.

By 2003, the spotlight had turned to Belgium, where two players of vastly different character and background emerged to give their linguistically split nation huge success on the international stage. Justine Henin, a petite French speaker from Liege with one of the finest backhands ever seen, won seven Grand Slam titles, including four at Roland Garros. Only Wimbledon eluded her, but she still reached the final there in 2001 and 2006.

Kim Clijsters, born one year after Henin, was a taller, more powerful player, who was a Flemish speaker from Blizen. Clijster's career followed a very different path. Outgoing and smiling in contrast to the more introvert Henin, Clijsters insisted on being a mother and homemaker as well as a tennis star. Her career of uneven success reflects that.

In 2003, she was clearly the most consistent performer on the tour, as a period of several weeks as world number one showed. Clijsters was a finalist at Roland Garros and the US Open, and a semi-finalist in the other two Slams. To back that up, she won nine WTA titles at places like Sydney, Indian Wells, Rome, and Luxembourg, while retaining the WTA Championship title that she had won the year before. A Grand Slam title seemed a

(above) *Denmark's Caroline Wozniacki rose to world number one in 2010, having reached her first Grand Slam final at the US Open the year before. Not until eight years later, was she able get her hands on a Grand Slam title, beating Simona Halep to win the Australian Open—a triumph no more than this dedicated player deserved. (Photo by camerawork USA)*

Using the great athleticism given to her by a father who played soccer for Belgium and a gymnast mother, Clijsters became a force in the game over the next three years, retaining her US title and winning the Australian in 2011. Those successes lifted her number of career singles titles to forty-one (as well as eleven doubles, mostly earned with Japan's Ai Sugiyama). She retired for a second time to have two more children, both boys. She was poised for yet another come back at Indian Wells when coronavirus closed down, not just tennis, but the world in the spring of 2020.

Like her game, Justine Henin's career was more compact. She sprung to prominence in 2001, by reaching the French Open semi-final and then defeating Capriati to reach the Wimbledon final, where she lost to Venus Williams. Finding ways to add some more power to her slender five-feet-and-five-inch frame, Henin geared herself up for the best year of her career in 2003, when she rose to number one in the world as a result of winning Roland Garros and the US Open and reaching the final of the other two Slams. Her ability to dominate on all surfaces had much to do with the precision of her service return, especially off that majestic backhand. In the end, only a Wimbledon title eluded her, but a record of two finals and three semi-finals in seven appearances at the All England Club proved her prowess on grass.

Roland Garros, of course, became Henin's playground. In 2003, she defeated Clijsters in a disappointingly one-sided final 6–0, 6–4, when half of Belgium seemed to have descended on Paris to watch their nation's two sporting heroines. She was even more severe on Mary Pierce in the 2005 final, winning 6–1, 6–1 and Svetlana Kuznetsova

foregone conclusion, but injury interfered, and it was not until the US Open of 2005, when she beat Mary Pierce in straight sets, that she finally achieved one of her goals.

By 2007, Clijsters was not only married to former American basketball coach Brian Lynch but also pregnant. The following year, Clijsters gave birth to daughter Jada, who played a memorable part in the on-court celebrations that broke out on Arthur Ashe Stadium when her mother, having decided to come out of retirement, beat Caroline Wozniacki to win her second US Open title. Obviously relishing the bright lights and cheering crowds, little Jada proved herself a scene stealer as Clijsters paraded with the cup.

only made life marginally more difficult for Henin, who retained her crown with a 6–4, 6–4 win. A third straight title was achieved when she beat the future champion, Anna Ivanović 6–1, 6–2.

Indoors, Henin had her moments too. When the WTA Championships were moved from Los Angeles to Madrid in 2006, Henin grabbed the title with a 6–4, 6–3 win over Amélie Mauresmo and then played a final the following year that stays in the mind—a classic confrontation between the short and the tall, the aggressor against the counter attacker. Maria Sharapova did her best to stay on the front foot, moving inside her baseline whenever possible and volleying brilliantly at times, but Henin came up with winners from impossible positions and retained her title with a terrific 5–7, 7–5, 6–3 win. The rallies, the athleticism, the skill—it was impossible not to marvel at the level women's tennis had reached heading into the new century.

Maria Sharapova epitomized much of what was happening in the women's game, not least with an ambition and work ethic only a select few had been able to surpass in the previous decades. To describe her story as rags to riches is too simplistic. Very few eight year olds have found themselves on the curb at Miami Airport at 1:00 AM, clutching their father's hand—a father who had just left her mother in Moscow to arrive in this strange land with no English, one contact who didn't show, and $700 in his pocket. Her book *Unstoppable* is well-titled and worth a read. Like Richard Williams, Yuri Sharapov was a chancer and a doer and just a little mad. Somehow, he got his daughter to Nick Bollettieri's camp on Florida's gulf coast and, after fifteen minutes watching Maria hit and, more importantly, noticing the look in her eyes, Bollettieri took her in. Until the talent blossomed, Yuri worked menial jobs. His faith paid off.

Growing to a statuesque six feet and two inches, Sharapova used her height and strength and razored concentration to overcome lack of mobility and surge through junior tennis to emerge on the WTA tour unranked at the age fourteen after being given a wild card at Indian Wells. A year later in 2003, she won her first title at the Japan Open. Eight months later, after recovering from a set and 3–1 down in the semi-final against Lindsay Davenport, she won Wimbledon by crushing Serena Williams 6–1, 6–4 in the final. She was seventeen years old, and the tennis world was in shock. It seemed inevitable that she would win Wimbledon again, but she never did—although she did make the final in 2011. What she did manage was to win the US Open in 2006 and the Australian in 2008, although by the end of that year, a shoulder problem that plagued her for the rest of her career forced her to withdraw from the US Open.

With three in the bag, Sharapova set her eyes on the Grand Slam no one ever thought she could win—an opinion fueled, in part, by Sharapova's typically self-deprecating assessment of her performances on clay as resembling "a cow on ice." A hint of what her new coach, Thomas Hogstedt, had been able to add to her game—primarily footwork and mobility—came in 2011, when she won the Italian Open in Rome, which is generally considered the world's second most prestigious clay-court tournament. Further belief was instilled the following year, when she retained her title at the Foro Italico with a typical display of defiance, saving match point against China's Li Na in a two hour and

(opposite) *Belgium's Kim Clijsters keeps her eye on the ball. (Photo by camerawork USA)*

(top) *Dinara Safina was able to join her brother Marat Safin as world number one, but despite winning WTA singles titles all over the world in places like Palermo, Paris, Prague, and Rome, this powerful player could never land a Grand Slam. (Photo by camerawork USA)*

(bottom) *Jada Clijsters was a scene stealer when her mother won the US Open. (Photo by Art Seitz)*

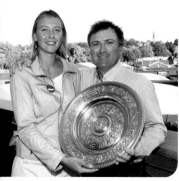

(top) *Maria Sharapova lines up another forehand.*

(bottom) *Maria Sharapova said her book* Unstoppable *was really the story of a father who had the courage to leave Russia for Florida with $700, one contact, and an eight-year-old child. Sharapova ensured his courage paid off.*

(opposite) *Maris Sharapova gives the fans. There have always been plenty of them for one of the game's most luminous stars. (Photo by camerawork USA)*

fifty-two minute struggle. Roland Garros beckoned. Was she ready?

Sharapova answered that question in emphatic style. Beating Petra Kvitová along the way, she defeated the little Italian clay-court expert Sara Errani 6–2, 6–4 to achieve an improbable goal that had seemed so far out of her reach just a couple of years before. The triumph in Paris also enabled Sharapova to join a very select group of champions—those who had won all four Grand Slam titles. Margaret Court, Chris Evert, Martina Navratilova, Steffi Graf, and Serena Williams were in good company. And, amazingly, it was not a flash of inspiration in a Parisian spring. A year later, she seemed quite at ease again on clay, beating the competitive Belarussian

Victória Azárenka on her way to a second Roland Garros final before losing to Serena Williams.

With Hogstedt deciding that he needed to spend more time with his family, Sharapova turned to Sven Groeneveld at the beginning of 2014. The partnership clicked. Having worked with numerous other top players, including Mary Pierce when she won the Australian Open, the technically astute Dutchman was regarded as one of the world's best coaches. He quickly built on Sharapova's clay-court confidence. She needed to marry it with her innate fighting spirit through a fortnight of exhausting endeavor in Paris. A set down in successive matches against Samantha Stosur, Garbiñe Muguruza, and Eugenie Bouchard, Sharapova emerged with enough strength to resist the challenge of the rising Romanian star Simona Halep in a memorable final that turned into another exhausting struggle. It lasted three hours and two minutes and included sixteen breaks of serve before

the scurrying little Romanian was forced to surrender to the sheer will power of her opponent.

Apart from amazing herself, Sharapova had proved all the critics wrong by becoming one of the most successful clay-court players of her era with two Italian titles and two French, including that run of three consecutive finals at Roland Garros defying all reasonable analysis. Perhaps the key to it can be found in this statistic: she had won twenty straight clay-court matches during that period while requiring three sets to do so in every one. Always fighting. Always refusing to surrender.

Her unlikely triumphs earned her the respect of her peers but not their friendship. She had always remained aloof in the locker room, insisting it was her place of work. Groeneveld recounted how she did not allow any casual conversation while driving to the courts for a match. "The focus was total," Groeneveld said. "Getting her to concentrate was something I never had to worry about."

Suffering throughout her life from a poor immune system, Sharapova was always susceptible to picking up the odd cold and virus. There were physical problems too with her shoulder, which was operated on in 2008. But she began 2015 by reaching the Australian Open final for the fourth time before losing to Serena Williams, and then made the semi-final at Wimbledon where Williams beat her yet again.

In the end, Williams did not turn out to be her biggest problem. It was her own stupidity and the carelessness of those around her. In 2015, the World Anti-Doping Agency (WADA), the body in charge of drug abuse in sports, announced it was investigating Meldonium, a supplement freely available in

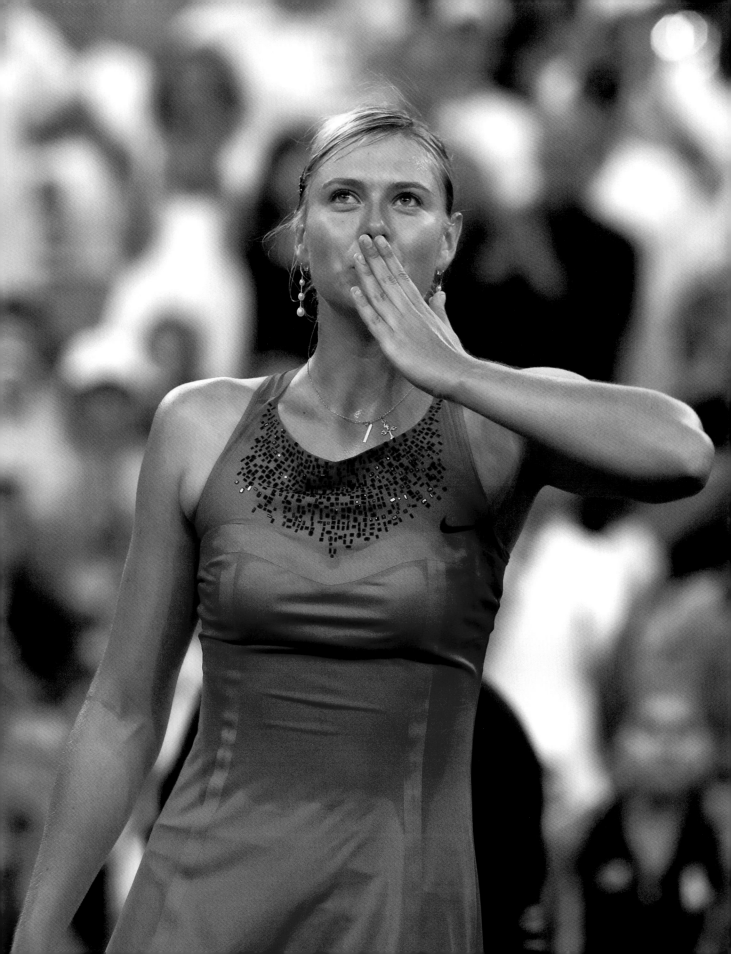

(left) *No one has done more to popularize tennis in China than the witty and talented Li Na, who won the French Open in 2011 and the Australian Open in 2014, rising to number two in the world. (Photo by camerawork USA)*

(right) *Along with Flavia Pennetta, who won the US Open title over Roberta Vinci in the unlikely final of 2015, Sara Errani kicked off the resurgence of women's tennis in Italy by reaching the French Open final three years earlier. (Photo by camerawork USA)*

(opposite) *Accuracy rather than power was the essence of Justine Henin's serve. She will always be remembered for the beauty of her one-handed backhand.*

pharmacies across Eastern Europe and Russia. Sharapova had been advised to take the equivalent by a family doctor when she was eighteen because a test found a minor fault with her heart. At eighteen, one usually does what fathers and doctors tell you.

WADA started getting interested when it learned hundreds of East European athletes were using it because it was supposed to be performance-enhancing. Without scientific evidence, they decided to make January 1, 2016 the date when Meldonium would be put on the banned list. The news did make the newspapers, mostly in small print, and the WTA send out an email about the ban. Apparently, none of Sharapova's team noticed.

So, as she had been doing for almost ten years, she took her normal dose a week before the Australian Open and was tested positive. Originally, she was banned for two years with the sentence

being reduced to fifteen months in October. In March, WADA had admitted that it had no idea how long Meldonium stayed in the human body, so it had to listen to pleas from numerous athletes saying they had taken the supplement prior to January 1.

At the end of an interview that I had with Sharapova in California just before her comeback in April 2017, I suggested, almost flippantly, that she could have saved herself a lot of trouble by saying she took it before the deadline. I got a quick, indignant retort. "No, I would never do that. That's not me. I made a big mistake and I paid for it," she said.

People like Groeneveld, who knew her well, were not surprised. "She is one of the most honest people I know," he said. The problem was that very few people in tennis knew her personally, and she was suffered a barrage of condemnation from fellow players.

The whole thing turned into a huge saga, but I just want to make two points. The possible explanation—although not good enough—that Sharapova did not notice the announcement of Meldonium being banned was the fact that she had always bought it under a different name, Mildronite. Secondly, critics who insist she took it deliberately after January 1 must also accept the fact that, if true, she clearly would have been committing professional suicide because she *knew* all players were tested at the quarter-final stage of the Australian Open if not before.

The Court of Arbitration for Sport (CAS) obviously accepted this, because it stated that there had been "no significant fault" on her part and that she was not to be regarded as a drug cheat. The problem was many did.

In 1999, Amélie Mauresmo, an attractive French player with a beautiful one-handed backhand, burst to prominence by reaching the final of the Australian Open, where she lost to Martina Hingis. The talent and athleticism were there for all to see, but it took Mauresmo another seven years to get it all under control. Nerves is the simplistic explanation. A string of early-round losses in front of expectant crowds at Roland Garros told the tale as Mauresmo struggled to come to terms with Billie Jean King's dictum that pressure should be a privilege. For Mauresmo, it was clearly agony, but her ability was such that on stages that were one step down from Grand Slam level, she was soon collecting WTA titles, even in front of demanding French crowds at the Paris Indoors and Nice. She won Rome too in 2004, and the five titles that she won that year sent her to the top of the rankings. She was the first French player to reach number one in the open era. Retention of her Italian title the follow-

(opposite) *After giving birth to her son Leo, Victória Azárenka, already a two-time winner of the Australian Open, considered giving up tennis when she became embroiled in a distressing custody battle. But her love of the game was too strong, and she burst back onto the tour in 2020, winning the Cincinnati title when it was played at Flushing Meadow, and reaching the final of the US Open two weeks later.*

(above) *Born in Plantation, Florida, and a product of the Chris Evert and Nick Saviano academies, Sloane Stephens finally did justice to her talent by winning the US Open in 2017 with a win over her good friend Madison Keys. The following year, Stephens reached the final at Roland Garros. (Both photos by camerawork USA)*

ing year built on her success. She was
primed and ready for the Australian Open
in 2006. Despite having Lady Luck at
her side—Clijsters with an injury in the
semi-final and Henin through illness in
the final both failed to finish their match-
es against her—Mauresmo had been play-
ing title-winning tennis throughout and
removed any doubts as to her authenticity
as a Grand Slam champion by winning
Wimbledon six months later. Her power
proved too much for Henin as Mauresmo,
freed of nerves, fought back to win 2–6,
6–3, 6–4 in a duel that displayed two of
the world's finest one-handed backhands
in all their glory.

Unusual for a female player, Maures-
mo built a new career for herself as a
coach when she retired in 2009. Suc-

cess came quickly too as she guided her
compatriot Marion Bartoli to one of the
least-expected Wimbledon triumphs of
recent years in 2013. That led to another
surprise: an invitation from Andy Mur-
ray to be his coach. The Scot met the
inevitable raised eyebrows by pointing
out that being coached by a woman was
nothing new to him as his mother had
been his first coach and praised Maures-
mo for her playing achievements, knowl-
edge, and work ethic.

Murray reached another Australian
Open final with Mauresmo in his coach-
ing box. She evidently helped him with
his clay-court game as he won Munich
and Madrid back to back in the spring of
2015, notably scoring his only clay-court
success over Rafael Nadal in the Span-

ish capital. After the partnership ended amicably, Mauresmo went on to captain the French Fed Cup team.

If Murray, a self-announced feminist, struck a blow for women by working with a female coach, Li Na attacked the subject differently– by attacking her husband! She did it in the nicest way, of course, using Jiang Shan as the butt of her sharp humor in numerous on-court speeches as she began to hike interest in her sport in China to an amazing degree. After she had used her tactically clever baseline game to beat Petra Kvitová, Victória Azárenka, and Sharapova at Roland Garros in 2011, a staggering total of 330 million people tuned in to watch her win the French Open title with 6–4, 7–6 win over reigning champion Francesca Schiavone.

It was not just that Li Na was breaking records as an Asian athlete—winning at Roland Garros made her the first Chinese person to win a Grand Slam singles title—but the manner in which her amusing, self-deprecating personality was making headlines. After firing her husband as coach and hiring the experienced Carlos Rodríguez, she said, "Husband and coach, no good." Later, after finally winning the Australian Open in 2014, having lost twice in the final in the previous three years, she joked while glancing at her husband, "You're a nice guy. You lucky to find me."

The ever-present smile was disarming. People loved her. Apparently on the instructions of her mother, she stopped playing tennis at the end of 2014 to have children. Luckily for Asian tennis, she continued to promote the game and, in 2019, she became the first Asian to be inducted into the International Tennis Hall of Fame.

Li Na was one of those players who lit up the women's game during the first two decades of the century without coming

close to the length of dominance enjoyed by the top four in the men's game or the Williams sisters. All had great talent, but with at least five of them, the desires and needs of motherhood either interfered or came calling. We have noted some examples, but Victória Azárenka was another. The tall Belarussian with a powerful double-handed backhand imposed herself on the tour in a dramatic and sometimes emotional fashion during 2012 and 2013, a period that saw her rise to number one off the back of two Australian Open titles and consecutive appearances in the final of the US Open. She was also a semi-finalist at Roland Garros and Wimbledon and, in 2012, won two medals at the London Olympics.

Then, injuries started to take their toll. In 2016, she curtailed her season, giving birth to a son, Leo, late in the

(opposite) *Style, athleticism, and charm—Amélie Mauresmo won the Australian and Wimbledon titles in 2006. (Photo by camerawork USA)*

(above) *The unusual combination of Japan and Haiti produced a beguiling new star for tennis when Naomi Osaka powered her way to the BNP Paribas title at Indian Wells in March 2018, and then made everyone sit up by holding steady in the face of much chaos on the other side of the net to win the US Open over Serena Williams. Just to emphasize her capabilities, Osaka justified her number one ranking by beating Petra Kvitová over three tough sets at the Australian Open four months later.*

(above) *Elena Dementieva's long career was inextricably linked to fellow Russians. Anastasia Myskina beat her in the 2004 French Open final. Later that year, it was Svetlana Kuznetsova who defeated her in the final of the US Open. Her greatest triumph came against Dinara Safina, when she won the Olympic gold medal in Beijing in 2008. A weakness on the serve, which numerous coaches including Fred Stolle tried to fix, was key to a career that flirted with greatness. Dementieva was a semi-finalist at all four Grand Slams, reaching that stage seven times in all. (Photo by camerawork USA)*

(opposite) *This mighty serve helped Garbiñe Muguruza, the Spaniard with a Venezuelan mother, defeat Venus Williams to win the Wimbledon crown in 2017.*

year. Unhappily, a battle for custody of the child ensued and, for legal reasons, she was unable to leave California, which complicated her comeback plans. She did, however, manage to reach the semi-final at the Miami Open in 2018, and played even better on the game's resumption in the fall of 2020 when she reached the US Open final.

Petra Kvitová, the imposing six feet tall left-hander from the Czech Republic was another player who faced unusual challenges, and hers were very different from Azarenka's. Kvitová had established herself with a terrific year in 2011, becoming an unexpected Wimbledon champion with a straight-set win over Sharapova in the final. Qualifying for the WTA Championships for the first time, Kvitová won the title in Istanbul with a 6–3 in the third win over Azarenka and also helped the Czech Republic to win the Fed Cup.

Illness and injury interfered with her progress in the next few years, but she remained a solid top ten player. She stepped up a notch by winning Wimbledon a second time in 2014, using her exceptional power to crush Eugenie Bouchard 6–3, 6–0 in the final—a defeat that ended the young Canadian's fleeting flirtation with stardom after she had reached the semi-finals at both the Australian and French Opens that year.

Just before Christmas 2016, Kvitová became the second female tennis player to suffer from a knife attack—not one like Monica Seles experienced on court but one that happened while working in her kitchen at home in Prague. A man, having gained entry to inspect the boiler, grabbed her from behind and stabbed her left hand. It does not seem to have been established whether that was deliberate, Kvitová being left-handed. It took three years before

DNA tests helped to find the culprit. He was jailed for eight years.

Happily, Kvitová recovered faster than that after initially being told that she might never be able to play again because the tendons of her hand were so badly damaged. But she was back on court in five months and quickly regained her top-ten ranking, winning five WTA titles in 2018 and reaching the final of the 2019 Australian Open, where she lost to Naomi Osaka.

Garbiñe Muguruza, a tall, elegant Spaniard born in Caracas of a Venezuelan mother, was the next modern power player to impose herself on the women's game, when she defeated Serena Williams in the final of at Roland Garros in 2016. Then, having fought her way through a trough that saw her lose in the second round at Wimbledon and the US Open, Muguruza reemerged to leave another mark on the Williams family by beating Venus in the Wimbledon final of 2017. The score was 7–5, 6–0, but the outcome could have been different for Venus had she been able to win either of the two set points she reached at 5–4 in the first set.

The fact that Venus was playing her second Grand Slam final of the year at thirty-seven was remarkable enough, but her ability to match Muguruza stroke for stroke in numerous power-packed rallies on the worn grass was astonishing. With rain threatening, the entire match was played under Wimbledon's translucent roof, creating an unusual echo as each shot was hit. And they were hit hard. Some winners that sped off both players rackets neared eighty miles per hour. Muguruza blasting her free-flowing forehand, and Venus crunching backhands two-handed from knee height off the low bounce. The first of the two set points lasted twenty-one shots before

Venus netted. That proved the decisive moment of the match.

Muguruza's smile lit up the Centre Court during her chat with Sue Barker, who asked her if she had a message for her long-time coach Sam Sumyk, who had stayed at home for family reasons. "This is it," Muguruza replied, pointing to the big, gleaming rosewater dish, first presented in 1886 to Blanche Bingley on winning the third ever Wimbledon. Long before the name became so meaningful, the dish had been christened "Venus." The former Wimbledon champion Conchita Martínez had been sitting in for Sumyk. Some critics felt her calmer approach to coaching had helped restore Muguruza's confidence. The pair were obviously a good fit. Martínez took over from the Frenchman permanently in 2019.

Svetlana Kuznetsova, a Russian brought up on Spanish clay, beat fellow compatriot Elena Dementieva in the final of the US Open in 2004 and was still battling away in 2009, when she beat another Russian, Dinara Safina, in the final of Roland Garros. Apparently, Kuznetsova was a hoot in the locker room with her pals; however, opponents did not find her relentless counter-punching game that funny on court. Kuznetsova was still plying her trade after nineteen years on the tour, having added the Citi Open in Washington, DC to her list of eighteen singles titles as late as 2018.

Simona Halep was another of those players like Arantaxa Sánchez Vicario and Justine Henin who flourished at the higher echelons of the game despite lack of inches. Standing just five feet and six inches, Halep joined that group of women who made it to number one on the WTA ranking before winning a Grand Slam. An appearance for the second time in a Roland Garros final

Getting to wear the iconic Ralph Lauren outfits at Wimbledon as a ball kid is not easy. Weeks of rigorous training about rules and etiquette (no talking on court) go into the selection of some 250 applicants from South London schools. They receive no pay, but they do get fed.

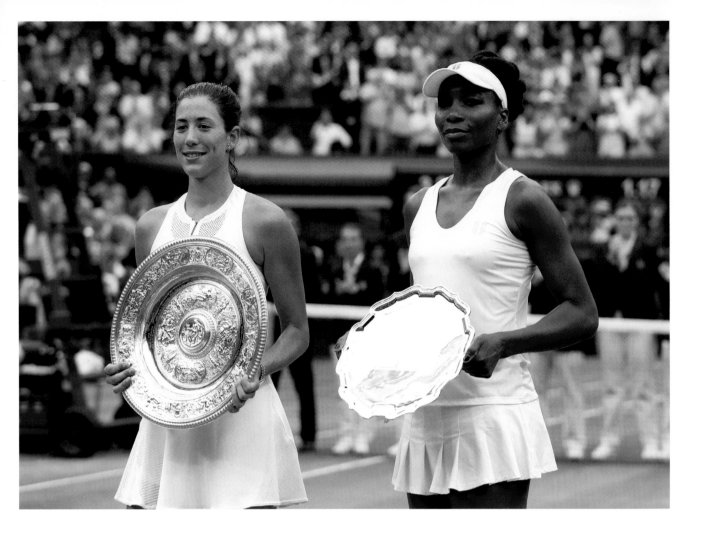

(above) *Revealing her remarkable longevity and courage, Venus Williams was appearing in her ninth Wimbledon final—and second Grand Slam final of the year—when she was beaten by Spanish newcomer Garbiñe Muguruza in 2017.*

(opposite top) *A fighter to the last, Simona Halep, was coached by Darren Cahill, managed by former French Open champion Virginia Ruzici, and mentored on occasion by Ion Țiriac. Romania's most celebrated star of recent years appeared in two Grand Slam finals before winning the French Open at Roland Garros in 2018, and Wimbledon the following year. (Photo by camerawork USA)*

in 2017 helped her get there. She was even more secure at the top of the tree when she finally seized a Grand Slam title in Paris in 2018, beating Sloane Stephens 3–6, 6–4, 6–1 in the French Open final. Having been her coach for the better part of four years, the Australian Darren Cahill, who had guided Andre Agassi in his prime, decided to spend time with his family and so was not at her side when Halep, adding a little oomph to her amazing defensive qualities for Wimbledon's grass, became the first Romanian to win a singles title at the All England Club with a stunningly decisive 6–2, 6–2 victory over Serena Williams in the 2019 final. She had hired a Romanian coach, Daniel Dobre, to help her achieve her life's

ambition, but Cahill was back at her side by the end of the year.

Trying to make sense of what was happening in the women's game around this time was not easy. Angelique Kerber epitomized the reasons for a certain amount of confusion. The German left-hander with an excellent two-handed backhand was on the tour for eight years before cracking the top fifty. Then, revealing a liking for grass, she reached the semi-final at Wimbledon in 2012, before showing remarkable all-round skills in 2015, winning titles on green clay, red clay, grass, and hard courts at Charleston, Stuttgart, Edgbaston, and Stanford. By then, Kerber was in the top ten and poised for an extraordinary year in 2016 that saw her win the Aus-

tralian Open and US Open and get to the final of Wimbledon. Roland Garros? She lost in the first round.

Even as she rose to number one at the age of twenty-eight—the oldest to reach the pinnacle since Capriati—it was clear nothing came easily to this determined counterpuncher whose strengths lay in her ability to grind opponents into whatever surface on which she found herself playing. Fame, however, did not sit easily with this charming but shy competitor. The flash bulbs blinded and distracted her and 2017 was a disaster for her; her ranking plunged to twenty-one.

Showing all the stoicism that had enabled her to claw her way to the top, Kerber hired Wim Fissette as her coach at the start of 2018. Straight off, she reached the semi-final in Melbourne and the quarter-final in Paris, and crowned it all by simply outplaying Serena Williams 6–3, 6–3 in the Wimbledon final. A thirty-year-old baseliner winning Wimbledon over Williams in straight sets? That's the glory of sport. Nothing is impossible.

Sloane Stephens would concur with that. After eleven months off the tour with a foot injury, this African American whose father had played in the NFL and mother who swam for Boston University returned in 2017, losing in the first round at Wimbledon, playing well in Canada but arriving at Flushing Meadows unseeded with modest hopes—the kind of hopes one has when your ranking had stood at 957 just a few weeks before. Stephens had found form quickly winning fifteen of seventeen matches and battled through to the semi-final of the US Open where she beat Venus Williams. And it was there that history and coincidence combined. Sloane's opponent in her first Grand Slam final turned out to be another black American, Madison Keys. The last time two Americans had

reached the final at Flushing was fifteen years earlier, and they were both black too—Venus and Serena.

Unhappily, this final was hopelessly one-sided with Stephens winning 6–3, 6–0 against a player who got off to a nervous start and never recovered. Though she did get a sympathetic arm over her shoulders when Sloane went over and sat next to Keys on court afterward. "Maddy is my best friend, and for us to be here is a special moment. I wish it could have been a draw."

In the space of two years, women's tennis saw two young talents flower amid the cacti of the Californian desert at Indian Wells. First, Naomi Osaka won the BNP Paribas title in 2018 by beating Russia's Daria Kasatkina in the final. The following year, Bianca Andreescu, a sturdy Canadian power hitter of Romanian origin, showed her gratitude for being given a wild card by beating Angelique Kerber to win her first ever title on the WTA tour.

(above) *Until the sudden emergence of Roland Garros 2020 champion Iga Świątek, Agnieszka Radwańska was Poland's most successful player, and ranked in the top ten for six straight years, winning twenty titles on the WTA tour and reaching the Wimbledon final in 2012, losing to Serena Williams 6–2 in the third.*

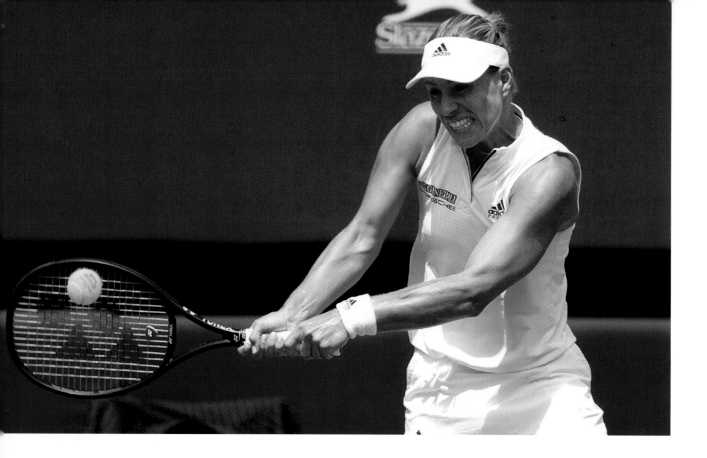

(above) *If you can win WTA titles on green clay, red clay, grass, and hard courts, as Germany's Angelique Kerber did in 2015, it is obvious that you are quite good at playing tennis. But until then, Kerber had only one Wimbledon semi-final in 2011 to show for success at a higher level. Then, something clicked and an amazing 2016 brought her Grand Slam titles in Melbourne and New York with a Wimbledon final to back them up. By September, she was number one in the world at the age of twenty-eight. Her charming smile just grew bigger when she defeated Serena Williams 6–3, 6–3 to win Wimbledon in 2018. (Photo by camerawork USA)*

(opposite left) *Caroline Wozniacki wouldn't give up. After reaching number one in the world in 2010 as a result of her consistency on the WTA tour (she won thirty-nine titles overall), the popular Dane finally nailed a Grand Slam title eight years later, when she beat Simona Halep in the final of the Australian Open.*

(opposite right) *Having slipped from her position of number one in the world, Naomi Osaka regrouped and won her third Grand Slam over Victória Azárenka on the deserted Arthur Ashe Stadium in 2020, while emerging as an activist for Black Lives Matter.*

As we have seen, Osaka emerged teary-eyed but victorious from the drama of winning the US Open the following September and then proved her pedigree in Melbourne by winning the 2019 Australian Open with a fine victory over Kvitová.

By then, it had become clear that Osaka, with her multicultural background, was a multidimensional thinker who was not afraid to let thoughts spill into her post-match press conferences. Happy to query herself in public ("Did I mean to say that?") Osaka revealed an interesting nugget after beating Kvitová, a two-time Wimbledon champion, in a rugged battle 7–6, 5–7, 6–4. She had left the court for a bathroom break after the second set, a twenty-one-year-old struggling to keep a grip on her emotions in the heat of a Grand Slam final. "So I sat myself down and thought, 'You are not entitled to win this match. She's a great player.

You are not entitled. Just go back out there and fight.'"

Armed with this mature piece of self-advice, Osaka went back on Rod Laver and did just that, unleashing more of her heavy hitting off both flanks to win her second straight Grand Slam title.

It was difficult to assess the extent of Andreescu's potential by the time the coronavirus crisis brought everything to a halt because the nineteen-year-old was being afflicted to an alarming extent by shoulder and knee problems. Nothing had prevented her from making a stunning impact in New York, where, in just her fourth Grand Slam, she beat Serena Williams in straight sets in the final of the US Open. It was the second time Andreescu had beaten Williams that summer, having done so in the final at Toronto, where Canadian fans, already blessed with so much young talent coming through in the men's game, blinked

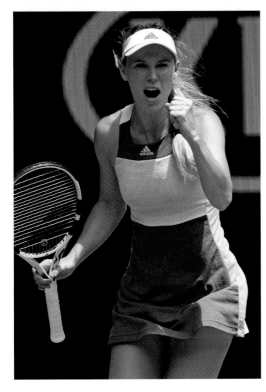

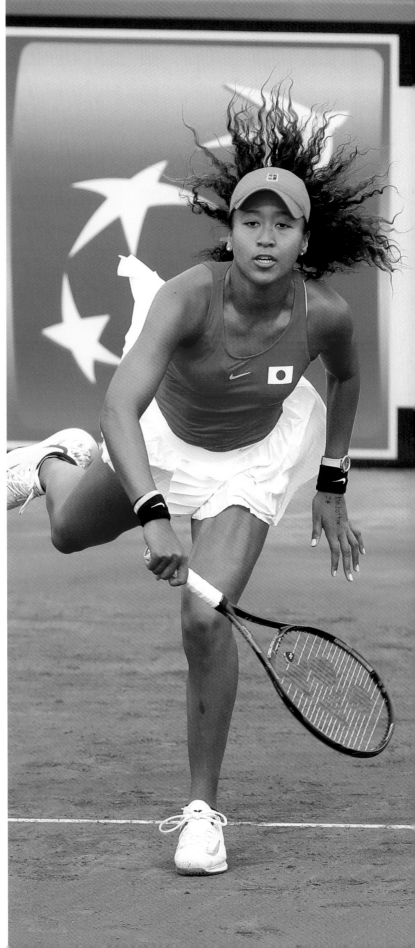

in amazement at the power and ra-
zor-edged purpose of Andreescu's game.

By then, of course, another young star
had been born. Ashleigh Barty, a little
Australian who had taken a year away
from the game in 2014 to play cricket for
Queensland, suddenly revealed her true
abilities by winning the Miami Open,
before fighting her way through the
French Open field to become yet anoth-
er new Grand Slam winner with a 6–1,
6–3 demolition of the unseeded Czech
Markéta Vondroušová.

The decade ended with no fewer than
twelve women players still active on the
tour holding at least two Grand Slam
titles—an unprecedented spread of rich-
es in an era of evenly matched talents.
And another one emerged when Sophia
Kenin, a resident of Delray Beach, Flor-
ida, but yet another player with Russian
roots, sprung out of nowhere to beat
Muguruza in the final of the 2020 Aus-
tralian Open just before the shutdown.

18 Men in the Twenty-first Century

By the time the coronavirus drew a curtain across the world tennis stage in March 2020, the men's game had seen fifteen years of dominance by a quartet of players the like of which is unlikely ever to be seen again.

There are many ways in which one can illustrate statistically the manner in which Roger Federer, Rafael Nadal, Novak Djokovic, and Andy Murray took over the sport between 2005 and 2020, but I would offer this as the clearest example: A total of sixty-nine Grand Slam Championships were played during that period, and only *two* did not feature one of the Big Four—Marat Safin beating Lleyton Hewitt in the Australian Open in 2005, and Marin Čilić defeating Kei Nishikori at the US Open in 2014.

Dropping down a level to the Masters 1000 tournaments on the ATP, the virtual shut out was almost as complete. The Big Four won more than eighty percent of those events, which are, in some respects, as tough or tougher to win than a Grand Slam. With smaller draws, the winner rarely got the chance to play someone ranked below sixty, and all his six matches need to be played over six or seven days, as opposed to seven matches over fourteen.

The stats at 1000's level were revealing too. Federer won twenty-eight titles and appeared in twenty-one other finals. For Nadal, it was 35–13, Djokovic 34–16, and Murray 14–7.

There will be question marks raised against Murray's inclusion, which statistically seem obvious. My reason for doing so is based on many factors, the first being that it is difficult to exclude from the equation a man who appeared in eleven Grand Slam finals and twenty-one Masters 1000 finals during that period. Not only was Murray always in the mix, rarely losing to anyone other than his three rivals, but injury forced him to miss thirteen Grand Slams as opposed to six for Nadal, four for Federer, and one for Djokovic.

Despite respiratory problems early in his career and arm problems later, it was Djokovic's ability to remain fit enough to play that enabled him to climb up the statistical ladder and challenge Federer and Nadal in 2019 and 2020. When Djokovic won the Australian for the seventh time in 2020, he closed the gap on Federer. It was the Serb's seventeenth Slam singles title. Federer led with twenty with Nadal at nineteen.

Murray was not so fortunate. He actually won his first Wimbledon title in 2013, after pulling out of the French Open because he couldn't get his arm up high enough to deal with a kicker second serve to his backhand on clay. The problem, emanating from his hip, was certainly not cured by the time he triumphed at Wimbledon crown, and it continued to plague him. Not enough, however, to stop him doing something unique in Olympic tennis—winning a gold medal in singles at Wimbledon in 2012 and defending the title four years later in Rio. Nadal, with gold in Beijing in 2008, is the only other member of

(below) *Argentine hero Juan Martín del Potro deserved more moments like this in a career that was ruined by a lingering wrist injury. Saving three match points on his way to upsetting Roger Federer in the 2009 US Open final, Del Potro seemed poised to become a major force in the game, but he had to wait until the US Open of 2018 before reaching another Grand Slam final after numerous surgeries.*

(opposite) *An appearance in the 2018 Roland Garros final where he lost to Rafael Nadal was the first stepping stone for Austria's Dominic Thiem, who went on to win his first Grand Slam title amid the eerie silence of the 2020 US Open. (Photo by camerawork USA)*

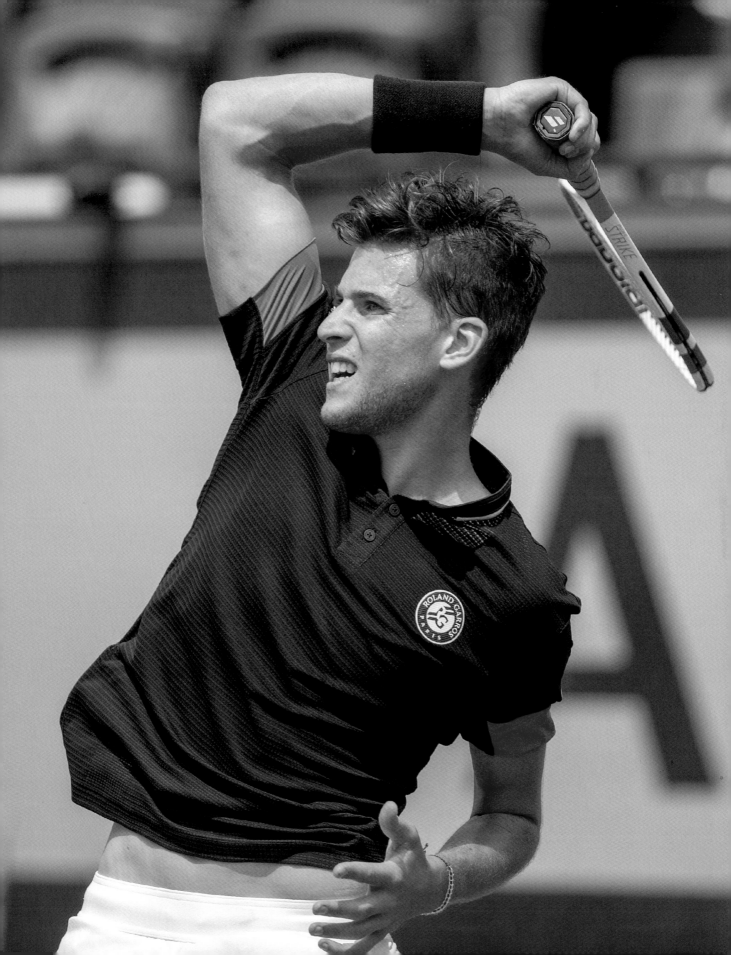

the Big Four to have won Olympic gold in singles.

Stan Wawrinka, owner of one of the game's most glorious one-handed backhand, could claim to be included in this assessment because he won three Grand Slam titles, the same number as Murray. But there is very little back up. He appeared in four Slam finals as opposed to Murray's eleven. Wawrinka's record at the 1000 level is shockingly poor for a player of such stature: just one title and only three finals.

So much for the statistics, but as one reviews the great matches of the era now, it is the quality of the tennis played by the Big Four that still leaves one gasping. The pace of their shots, the athleticism matching their mental strength, the ability to pull off impossible winners under extreme pressure, their tactical intuition—what a feast of sporting entertainment they provided for their spellbound fans!

All had different qualities, but they also shared many: a refusal to give in, an ability to play at the highest level of which they were capable virtually every time they walked on court, and a sense of pride and purpose unsurpassed in the annals of the sport. For a decade or more, Federer, Nadal, Djokovic and Murray formed a club that had a notice on the door: "No Admittance." Those who managed to push it open had to do something very special indeed.

The difficulty factor can also be illuminating. During those fifteen years, covering seventy-one Slams (if one adds the 2020 Australian Open), only four players outside the Big Four managed to reach a Slam final as many as three times: Wawrinka, who won all three of his appearances; Marin Čilić, with one victory and two finals; and Dominic Thiem, with three losing finals and his first title

"Will he make it?" Roger Federer watches intently on Wimbledon's Centre Court as Rafael Nadal stretches for a high backhand volley.

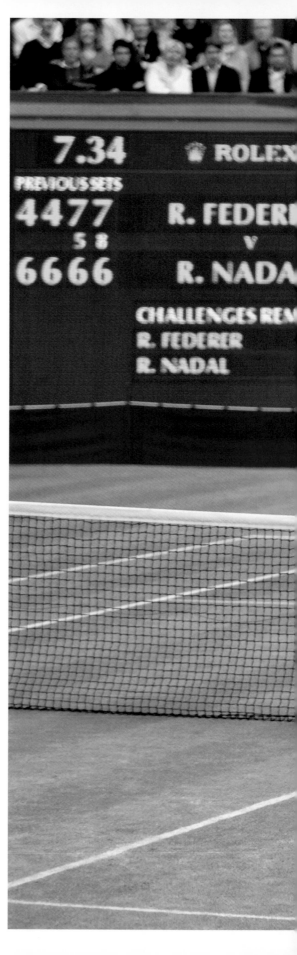

342

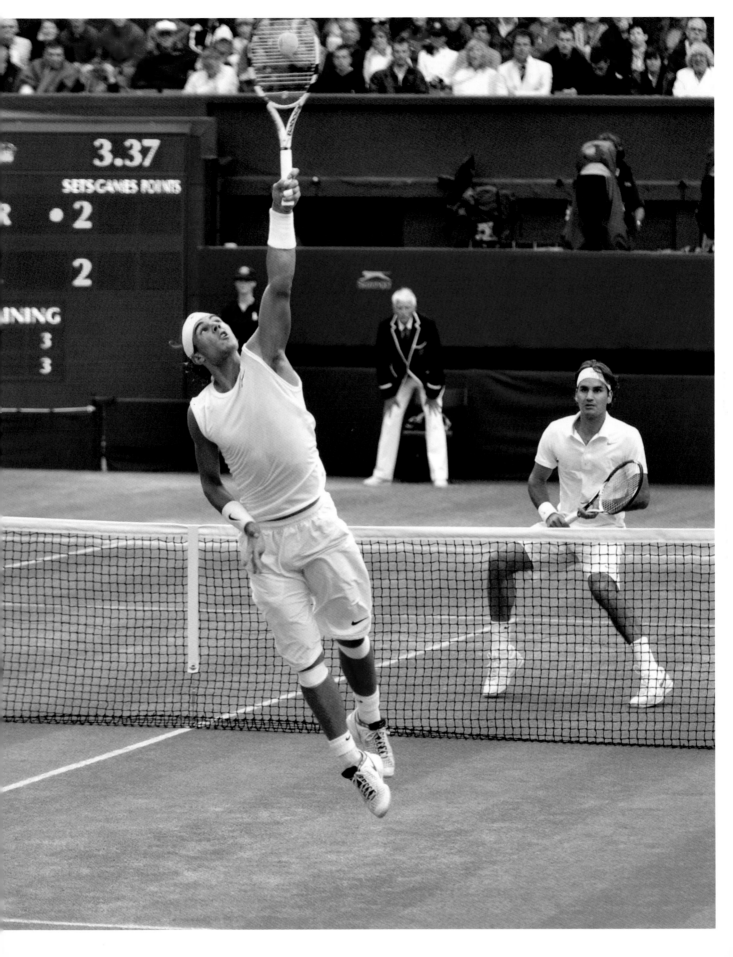

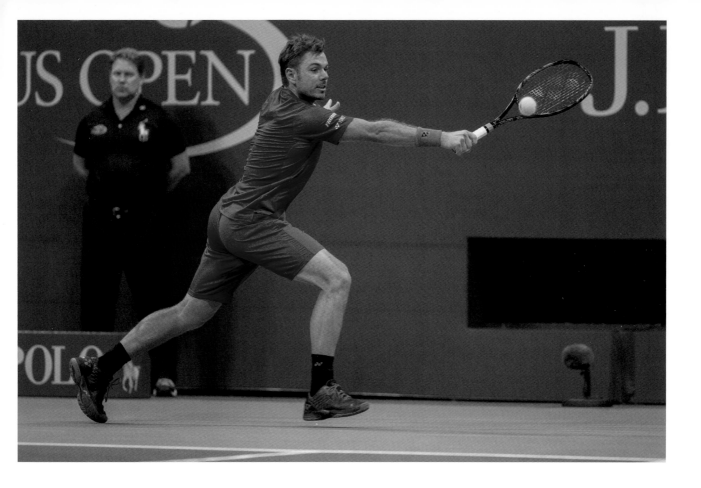

winning performance at the 2020 US Open. Andy Roddick straddled the divide. Having won the US Open in 2003 and reached the final there the next year, Roddick went on to reach another final at Flushing Meadows in 2006, and two finals at Wimbledon in 2005 and 2009. Roddick, it should be noted, was by far the most consistent outlier during this period, maintaining his top ten ranking for ten years—a remarkable display of consistency considering the opposition he had to face. David Ferrer, the Spanish road runner who must have covered thousands of miles on court, was the next best along the power hitting Czech, Tomáš Berdych. Both maintained a top ten ranking for six years between 2010 and 2015.

The matches that unfolded during this golden era of men's tennis have woven such a rich tapestry for the game

that it would take volumes to do justice to every thread. Inevitably, one is left with the task of picking strands that cry out for special attention or just remain imprinted on the brain. Packed crowds in the game's greatest arenas have come away hoarse, often sunburned, and frequently exhausted after participating in some of the greatest dramas that sport has ever produced.

The duels demanded heroics from the winners because the men whom they had to beat in search of ultimate glory were so brilliant themselves and so capable of winning, but for a blazing forehand that caught the line or an "error" that missed by a centimeter.

Two of the most extraordinary encounters were not even finals. Both were semi-finals, played in consecutive years—2010 and 2011—at the US Open, and both involved Djokovic and Feder-

er. Both also saw Federer, the man who had won the title at Flushing Meadows for five straight years between 2004 and 2008, unable to convert match points because Djokovic challenged fate and went for outrageous winners.

In 2010, Federer reached his fourth match point at 5–3 in the fifth set. Serving, he opted to go to the Serb's forehand. He was still rooted to the baseline as the ball flashed cross court for a winner that clipped the line. "I just closed my eyes and hit my forehand as hard as I could," Djokovic explained with a little smile. He had gone on to win the match 5–7, 6–1, 5–7, 6–2, 7–5.

In 2011—same time, same place—Federer won the first two sets 7–6, 6–4 but lost the next two 6–3, 6–2. Once again, he was serving for a place in the final at 5–3. Incredibly, the first match point at 40–15 became an exact repli-

ca of what had occurred twelve months earlier. Federer served to the forehand, and Djokovic ripped it back cross court for a winner that hit the line. With Federer netting on his forehand (as he had done the year before) on the second match point, Djokovic went on to win 7–5 in the fifth. You will never need a clearer or more precise example of how history can repeat itself.

These two defeats came after the first crack had appeared in Federer's sheen of seeming invincibility at the 2009 US Open. The far-fetched result still stands as one of the most unlikely upsets in Grand Slam history. Federer not only went into the final seeking to tie Bill Tilden's record by winning a sixth consecutive US title, but he also was facing Juan Martín del Potro, a twenty-year-old from Argentina who had managed just one Slam semi-final in thirteen attempts. And Federer, who had served for the second set before losing it on the tiebreak, had regained control and led by two sets to one. Save for the band of Argentines leaping and chanting in the country's blue and white striped soccer shirts, few people on Arthur Ashe stadium envisaged anything but a routine Federer victory.

There had been warning signs. The six-foot-and-six-inch giant with a measured, languid gait had reached the final of the Canadian Open in August. More significantly, he had hammered Rafael Nadal 6–2, 6–2, 6–2 in the semi-final just two days before. It was Del Potro's mighty forehand that had done the damage against Nadal, and now it started to emerge as a threat to Swiss progress as Federer found himself being pushed further and further back off his baseline. Suddenly, the atmosphere changed as arguments over line calls erupted. Harking back to early teenage

ing Federer in such stunning fashion, that he had the mental capacity as well as the physical ability to become a huge force in the game. However, even in his moment of triumph, there had been warning signs that his left wrist, which was helping to generate the power on his deadly accurate two-handed backhand, was beginning to feel the strain. Del Potro managed to reach the final of the first ATP Finals to be staged at the 02 in London's Docklands that year—losing to Russia's clinically brilliant Nikolay Davydenko in straight sets—but the wrist became so bad that he required surgery after losing the fourth round of the Australian Open and did not play again in 2010.

Reappearing in February 2011, the man they call the Tower of Tandil won the title at Delray Beach, and the following year seemed to be back on track, taking titles at Marseille, Vienna, and Basel on indoor hard courts and Estoril on clay. By early 2014, Del Potro's wrist was hurting again, and he underwent surgery in March. After that, the problem became a nightmare with two more surgeries required in 2015, followed by an operation on his right knee in 2019.

Stoically, this mild-mannered man had proved that, even with a modified backhand, he could still be a threat on the tour by winning the BNP Paribas at Indian Wells in March 2018 and climbing back to number five in the world. For Del Potro, it was a story of what might have been.

In a different context, one could say the same for Federer. Great as his record is, how much better could it have been had a couple of shots here and there had different outcomes? We had seen two examples with Djokovic chancing his arm at the US Open but, as early as 2008, Federer had revealed a surprising

days, a rattled Federer used profanity while telling umpire Jake Garner what he thought of his officiating.

The fourth set went to Del Potro on the tiebreak and, after breaking early, the Argentine, having shed his nerves, simply took charge behind a big serve and that destructive forehand. Incredibly, Federer had no answer and lost the fifth set 6–2.

The shock was considerable, but, in retrospect, it might have seemed less so had Del Potro's destiny not been torn apart by injury. It was clear, after beat-

inability to grab every chance he carved out for himself, even on his favorite grass court at Wimbledon.

Putting any negative connotation on Federer's loss to Nadal in the 2008 Wimbledon final would be making a mockery of the brilliance that unfolded on that fabled Centre Court as the sun settled over London SW19. Many will say it produced the great tennis match ever seen. As Andy Bull wrote in a brilliant retrospective for *The Observer* ten years later, "There is no ready measure of greatness, no simple standard or scale." So one turns to the people who know. John McEnroe said, "It's the greatest match I have ever seen." Bjorn Borg concurred. "You cannot see a better tennis match." Borg and McEnroe know.

The facts state that, having won the title for five straight years, Federer lost his crown 6–4, 6–4, 6–7, 6–7, 9–7 in a duel that lasted four hours and forty-eight minutes and ended in light so bad that Hawk-Eye could not pick up the ball. For drama at dusk, it reminded me of Pancho Gonzalez's raging against the light at two sets down to Charlie Pasarell in 1967. Play was suspended on that occasion, but this time referee Andrew Jarrett told the umpire that, with the fifth set standing at 7–7, only two more games would be played. Two was all Nadal needed.

But let us backtrack to put the moment in context. Six months earlier, Federer had contracted glandular fever. The illness may have contributed to his loss to Djokovic in the semi-final of the Australian Open in January and, as he struggled on, certainly affected his play as he went down to Andy Murray in Dubai, Mardy Fish at Indian Wells, and Andy Roddick in Miami. The illness was out of his body by the time he fought his way through to a third

straight Roland Garros final in June. As expected, Nadal beat him there. Now it would be the Spaniard's turn to concede surface advantage to his rival on Wimbledon's grass.

Just as Federer had proved that he was pretty darn good on clay, so Nadal had shown that he refused to be intimidated by grass. In the previous two years, he had reached the Wimbledon final, leaving his Spanish contemporaries to their blushes after several had opted not to play championships. Nadal would not countenance such surrender and, like Manuel Santana decades before him, had worked hard to make up for any grass-court deficiencies. Under

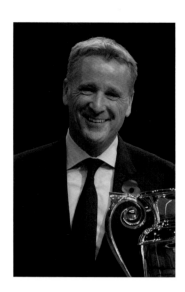

Toni Nadal's guidance, he added the serve-and-volleying skills to his game that he would need to conquer the faster surface. Most impressive was the improvement in his serve into which he injected a great deal more power. If he was never going to volley as naturally as Federer, he had his quick eye, which made him a threat at the net.

Nadal had arrived in London with a burning desire to put his 6–1, 6–3, 6–0 loss to Federer in the previous year's final behind him. For him, it was a matter of pride. The manner of the defeat had left him, as he admitted in his autobiography, "utterly destroyed." He said he felt that he had let himself down. "And I had hated the feeling. I had flagged mentally," revealed Nadal. Distraught, he had wept for thirty minutes in the locker room after the match.

Meanwhile, Nadal had established himself as the greatest clay-court performer in history. The heavily muscled young man from Mallorca had announced himself as something special by winning the fabled Monte Carlo title as the European spring dawned in April 2005. After beginning his run of dominance at the Real Club de Barcelona, Nadal went on to claim the Italian title in Rome before beating the Argentine, Mariano Puerta in the final at Roland Garros. In the following three years, Federer, proving his clay court prowess, fought his way to the draw to meet Nadal in the final, but he never came close to dethroning the new King of Clay.

So the two men of the moment—the two men firmly sitting atop the rankings as number one and number two in the world—walked onto the Centre Court on a cloudy July afternoon in 2008 to begin a duel that was destined to exceed the hype. Bristling with an even greater sense of determination than usual in his desire to eradicate memories of the previous year's final, Nadal was aggressive from the start. Going after Federer's service with pounding returns that fizzed with top spin, Nadal broke in both the first sets and led 6–4, 6–4.

An eighty-minute rain delay seemed to give Federer a new life. Nadal found himself having to raise his game to even greater heights as the third set unfolded, with a mesmerized crowd feasting off a series of rallies that demanded the utmost in athletic skill. However, a shocking straight-set victory for the Spanish left-hander still seemed on the cards as the pair battled toward the tiebreak. The champion was not disappearing that easily and won it 7–5.

There was so little in it that the fourth set mirrored the third, and another tiebreak seemed inevitable—as inevitable, in fact, as a Spanish victory—when Nadal went ahead 4–1 and then 5–2 in the breaker. Now, surely, the crown would be his. But he doubled faulted. 5–3. Compounding the error, Nadal contrived to stick a backhand into the net and suddenly his two service points were gone. 5–4. Gasps emanating from the stands turned into a mighty roar on the next point as Federer produced a majestic backhand crosscourt winner. 5–5.

Then, out of nowhere, it was set point to the Swiss at 6–5 as Federer unleashed one of his big first serves to Nadal's forehand and forced the error. But then, it was Federer's turn to err after a long rally and it was 6–6. Nadal served, Federer returned long, and it was match point. There was no question that Nadal deserved to be the winner of what had already become a wonderful encounter. But, for more times than one could count, Federer did what he had done so often on that famous patch

of grass: with his back to the wall, he came up with a stinging first serve that caught the line. 7–7.

For speed, accuracy, and sheer audacity, the next two points surpassed anything we had seen before. Federer pulled Nadal wide to his forehand side and raced toward the net. He barely got there, and it didn't matter. Nadal, running at full tilt to his left, had unleased the most incredible forehand that shot up the line like a bullet and landed inches in. Match point again. Federer's response told us all that we needed to know about what kind of champion he was. Reacting to Nadal's acutely angled approach, which pulled the Swiss wide on his backhand side, Federer matched the quality and daring of the point that we had just witnessed with a pin-point winner down the line. 8–8.

A forehand cross-court winner gave Federer another set point. When Nadal put his backhand long off a second serve, the place went crazy. Nadal had plenty of support, but this was Federer's Centre Court—one that he had owned ever since his shock loss to Croatia's Mario Ančić six years before. The fans had been with him all the way as he climbed back to the mountain top to look Nadal in the eye at two sets all.

The unforgettable tiebreak had been the heart of the matter—the proof that there was nothing these two incredible athletes could not achieve when pitting their dramatic skills against each other. Through the elongated fifth set, the tennis continued to amaze. Federer teetered on the brink at 5–5 and 15–40, but he was serving first and, after a lovely forehand winner, Federer got to deuce with another ace.

The hour of 9:00 PM had passed, and some members of the audience looked more distressed and bedraggled than the players whom they were supporting with such fervor. The lights from the electronic scoreboard gleamed in the gloom, and the faintest hint of a smile played around Bjorn Borg's mouth as he sat elegantly attired in the first row of the royal box. If anyone knew what was going on through the minds of the two men in front of him, it was he.

To his immense credit, Nadal had, if anything, become stronger as the set progressed, refusing to allow the memory of match points in the fourth set to deflect his focus. At seven games all, Federer needed another ace to help him out of 15–40, and then, facing another break point, a winning first serve. The Mallorcan, however, was relentless. When Federer erred twice on his forehand, the breakthrough was made. Holed amidships, Federer was floundering. Nadal, in knee-length pirate pants and sleeveless shirt, was poised to seize the bullion. And he did so with all the elan of Errol Flynn, whose yacht I had seen decades before, riding at anchor in a Mallorcan harbor. For the first time in the match, after four hours and fifteen minutes of thrust and counter thrust, Nadal, at 0–15 down, decided to serve and volley. He made no mistake. Federer saved one more match point, but the next was beyond him and a tired forehand settled into the net.

Nadal fell back onto the turf in relief. Following in the footsteps of Pat Cash twenty-one years earlier, Nadal clambered up into the players box to embrace his parents and ever-present Uncle Toni before walking perilously across the roof of the NBC commentary box to clasp hands with the heir to the Spanish throne in the royal box. For everyone involved, it had been a royal occasion.

If many will say this was the greatest of the great duels that threw star-

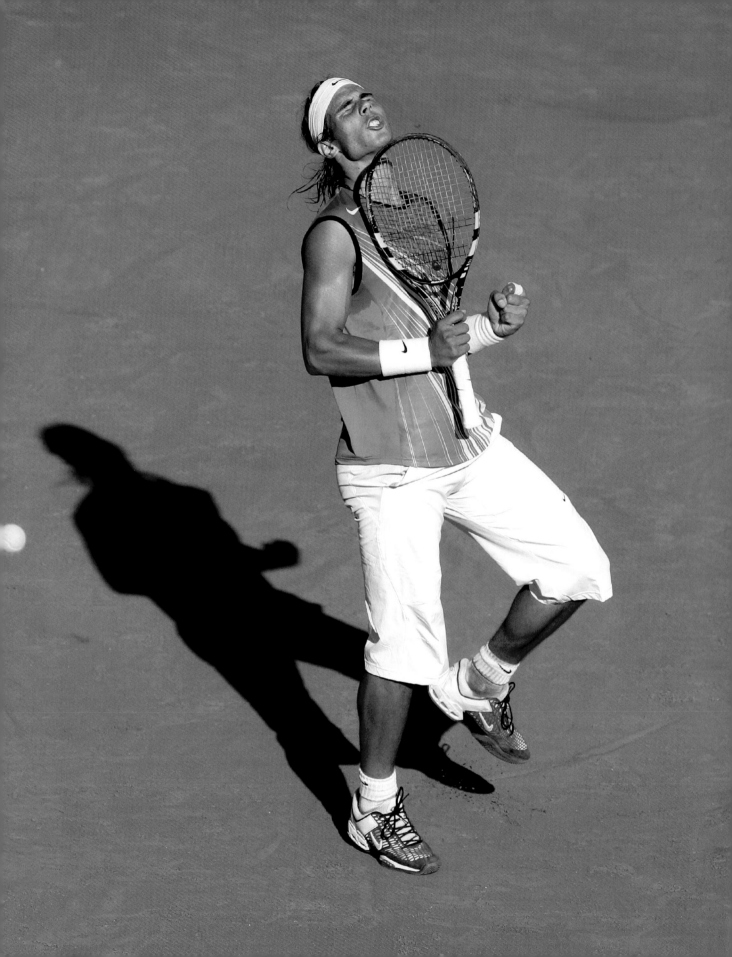

dust across the tennis stage in the first two decades of the twenty-first century, there are plenty of others that lifted interest in the game to new heights. Every year, attendances and television viewing figures across the globe were on the rise—not just at the Grand Slams but especially at the big combined ATP/WTA events at Indian Wells, Miami, and Madrid. The spectacle was too seductive, and the brand of varied athletic skills too tempting for anyone interested in sport to turn away. Even more than in the old days, when Jean-Paul Belmondo at Roland Garros and Peter Ustinov at Wimbledon had been fixtures, a new generation of celebrities ranging from Robert Redford, whose idol growing up had been Pancho Gonzalez, and Barbara Streisand, who became good friends with Andre Agassi, also became avid followers. So too did stars from other sports like Wilt Chamberlain, Wayne Gretsky, David Beckham, Thierry Henry, and Cesc Fàbregas.

It was global, it was exciting, and the money poured in—at least at the top. For smaller tournaments and those players who struggled to make the world's top hundred, it was a great deal harder. Federer, Nadal, and the Williams sisters would have been able to sustain it for a while, but the surge in interest needed extra stimulus. Djokovic, Murray, and a host of attractive female stars provided it.

Djokovic and Murray, born a week apart in May 1987, stepped forward together and would have kept battling for titles in tandem had not the Scotsman's hip injury derailed his career—not that the Serb was so robust in the early years. Respiratory problems left Djokovic gasping for breath one year at the Australian Open. It was only when a change of diet helped him eliminate the problem that he could use his perfectly constructed body to full effect.

Djokovic beat Murray to a Grand Slam final, losing to Federer at the US Open in 2007, whereas Murray's first final came a year later, also a Federer victim in New York. By then, Djokovic had beaten the giant Frenchman from Le Mans, Jo-Wilfried Tsonga, in January of 2008 at the Australian Open. By 2011, he was fully in his stride, grabbing three Slam titles out of four, with victories over Murray in Melbourne and Nadal at Wimbledon and the US Open. By then, there was no questioning Djokovic's stature in the game. He simply emphasized it by retaining his Australian title the following year, by beating Nadal yet again.

Roland Garros, however, was another matter. Even though Djokovic shocked Federer by defeating the Swiss in straight sets in the semi-final, he could not prevent the King of Clay from gaining some measure of revenge for past defeats on other surfaces by retaining his crown with a four-set victory.

Throughout this period, Murray had been also been establishing himself as a top player, gaining respect in the locker room as a man no one relished facing. Win or lose, players knew that they had been in a match against the tall, powerful Scot whose body had been honed into a well-muscled machine by his British fitness coach, Jez Green. Testimony to his rise lay in the eight ATP Masters 1000 titles that he won between 2006 and 2011, including back-to-back wins at the Canadian Open and Shanghai, along with the beginning of string of frustrating appearances in the Australian Open final. By 2016, he had lost in five of them.

When victories over Marin Čilić, David Ferrer, and Tsonga carried him

to the final at Wimbledon in 2012, Britain caught tennis fever. In the post-war years, Mike Sangster had got as far as the semi-finals at Wimbledon in 1961; Roger Taylor had followed him with three appearances in the last four; and Tim Henman teased his huge fan club with four similarly close attempts in 1998, 1999, 2001, and 2002. Now this taciturn Scot had become the first British player since Bunny Austin in 1938 to make it to the final. Could he emulate Fred Perry by becoming the first home-grown champion since 1936? A nation hoped, but there was a problem called Roger Federer.

If Murray was carrying the weight of a nation on his shoulders, it did not show early on. Hitting blistering service returns, he broke immediately and was always in charge of the first set, winning it 6–4. There were chances in the second, as two break points came. Murray carved out chances but couldn't take them. Federer pounced, using his wide variety of skills to close out the set 7–5 and surge toward the title 6–3, 6–4.

Murray was far from disgraced, but for Federer, who had not won a Grand Slam title since the Australian Open two years before, it was a reaffirmation that he was still capable of producing exceptional tennis. As Simon Cambers noted in *The Guardian*, the critics had been quick to note his "failure" to win a slam during a relatively lean moment in his career. "The feeling was that, with the advancement of age, he was now a little vulnerable over five sets," wrote Cambers.

Federer was thirty years old at the time. Perhaps, with just a little greater ring of truth, the same could have been written seven years later, when the Swiss maestro was appearing in his twelfth Wimbledon final.

For Murray, it was hard to absorb his fourth straight loss in a Grand Slam final, but he had hired Ivan Lendl at the start of the year to help him get through these things. No one knew how to do it better than the tough-talking Czech-born American who had made it to eight consecutive US Open finals, winning just three. Lendl was just the right man for Murray to have in his box as the next big challenge arrived only three weeks later—again, at the All England Club, but this time under the cloak of the Olympic Games.

Considering how emotional he had been after losing to Federer, it was remarkable that Murray was able to get his mind back in order in so short a space of time. Wimbledon might have been several miles away from the heart of the Games at the Olympic Stadium in London's Docklands, but the spirit of the moment pervaded the All England Club, offering a very different feel to the championship fortnight. For a start, players were allowed to wear colored clothing, and the crowds reflected a greater sense of nationalism. On court, matches were best of three sets, not five.

The Scot proceeded through the draw untroubled—even staying on top of Djokovic with a 7–5, 7–5 semi-final victory—but not so for Federer. It took him four hours and twenty-six minutes to get the better of Juan Martín del Potro in the semis. Federer's 3–6, 7–6, 19–17 victory was the longest in Olympic history. It was hardly surprising the Wimbledon champion was feeling the strain somewhat when he met Murray in the medal match, but even so, the way the Scot strolled to victory 6–2, 6–1, 6–4 left British fans incredulous as well as elated.

Emotionally and physically, it had been an exhausting two months for Murray on the British grass, and that was reflected by early-round losses at

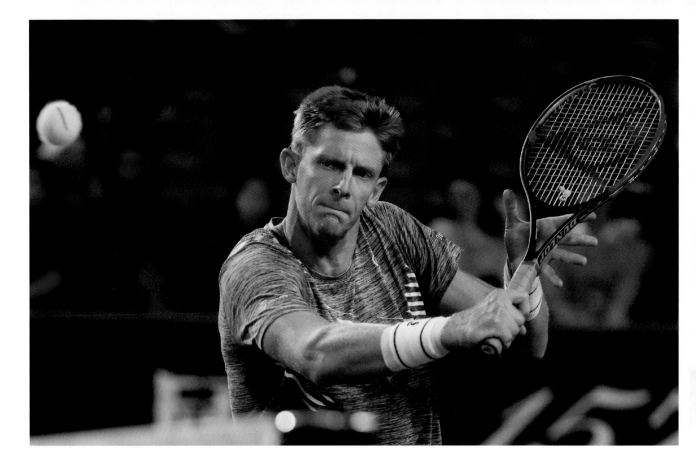

the Canadian Open and Cincinnati. His eyes were set on the US Open, and he was hitting the ball well enough in the early rounds at Flushing Meadow as he proved by beating the future champion Marin Čilić and then, in the semi-final, Tomáš Berdych, who had taken out Federer.

It was windy at 4:00 PM, when Murray set off chasing destiny once again in the great bowl of Arthur Ashe Stadium against Novak Djokovic. It was clear from the outset that neither man was going to give an inch. The first set lasted eighty-seven minutes before Murray, on his sixth set point, grabbed the tie-break 12–10. The second set was barely less attritional. Watching the way the Scot kept Djokovic on the move during lung-busting rallies (there was one of fifty-four strokes), I remained convinced that it was here that he won the match.

It was no surprise that Djokovic came back at him, forcing rare errors with aggressive hitting and taking the next two sets 6–2, 6–3, but Murray had a big enough foundation of fitness in the fifth to take charge again, exploiting the fact that the Serb was half a step slower as his legs felt the effect of earlier demands.

Murray looked almost bewildered when he completed a life's ambition and closed out the fifth 6–2. Afterward, his brother Jamie said it best: "He got the result his talent, dedication, and perseverance deserved. I'm so proud of him." So was Britain's sporting public. He had become the first British man to win a Grand Slam singles title since Fred Perry took the US title over at Forest Hills in 1936.

The greatest prize was still not his. With the first signs of pain in his lower back beginning to restrict his movement, Murray pulled out of the 2013 French Open. "I'll never be able to handle high kickers to my backhand off the clay," he told me, wincing as he tried to

Born in South Africa and educated in Illinois, the six-feet-and-eight-inches Kevin Anderson was on the tour for seven years before serving his way into the US Open final in 2017, where he lost to Rafael Nadal. The following year, he made it to the Wimbledon final, losing to Novak Djokovic. Numerous injuries then impeded his momentum. With wife Kelsey, Anderson is a strong anti-plastic advocate and raises money for the animal charity PAWS.

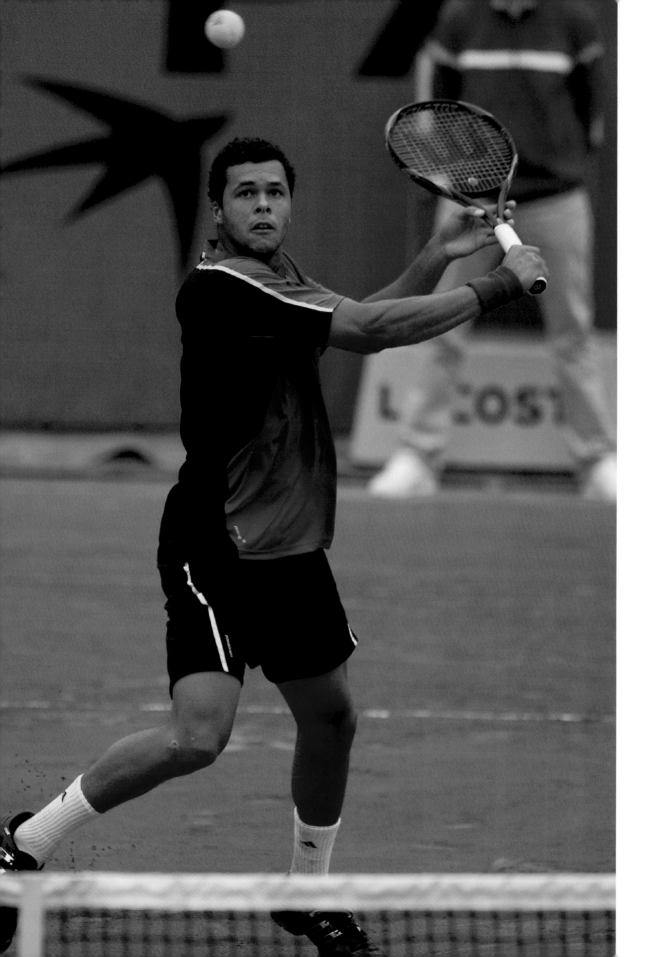

raise his left arm. It turned out to be one of the wisest decisions of his career.

Few players are free of some niggle or other, but Murray was match fit by the time the championships rolled around, and he was pleased to get through the first four rounds without dropping a set. The tenacious Spanish left-hander Fernando Verdasco gave him his severest test in the quarter-final, but he scrambled out of it 7–5 in the fifth. He then needed four sets to beat the tall Pole, Jerzy Janowicz. That put him back where he felt he belonged: in another Wimbledon final.

However, there was no Federer to greet him across the net. Nor Nadal. Both had suffered bewildering early round losses—Federer to Sergiy Stakhovsky, an erratic talent from the Ukraine and Nadal to the Belgian Steve Darcis. It was Djokovic who came through to play in his second Wimbledon final after winning in 2011; however, it had not been easy for the Serb who needed five tough sets to get past Del Potro in the semi-final.

With Djokovic having won his fourth Australian title over the Scot in January, he and Murray were meeting for the third time in the previous four Grand Slam finals and for the second time in eleven months on Wimbledon's Centre Court, following Murray's win there in the Olympic semi-final.

Murray knew that he was on the cusp of greatness. The British media would not let him forget it. Not always cutting the most lovable figure on court—far too much muttering and snarling at his box—his fans had allowed him into their hearts because they had begun to understand him, especially after the tears that had flowed following his loss to Federer the year before. They knew then how hard he tried and how much he cared.

The Centre Court and a packed Henman Hill watching on a vast television screen were basking in a hot July sun when the players walked on court to begin a match that was will not be remembered as a classic—just as a moment of history. Inevitably, between these two boyhood rivals who knew each other's games inside out, there were some long rallies, great defensive lunges, and sudden explosive moments of brilliance. But despite establishing a briefly held 4–1 lead in the second set, Djokovic could never get a grip on the match. With sections of the crowd in a perpetual state of hysterics, it seemed inevitable that Murray would find himself serving for the title, which he did at 6–4, 7–5, 5–4. Triumph seemed a foregone conclusion when he moved easily to 40–0, but he squandered all three match points, losing one of them when he hit a forehand two feet long with an arm as rigid as a caber.

Lungs bursting with held breath, hands in front of faces, and all manner of fingers crossed, a collective groan erupting around the famous arena as Djokovic reached break back point once, twice, no less than three times. The second was won after a rasping rally of more than a dozen shots that saw Murray's forehand twice hit the Serb's baseline, but Murray recovered and reached his fourth match point. He admitted later that his arm was literally shaking as he threw the ball up to serve. "I had no control over it," he said. "I can hardly remember what happened."

What happened was that Djokovic hit his second shot into the net, and Andrew Murray from Dunblane, Scotland, removed "since Fred Perry" from the lexicon of British sport to became the first home-grown Wimbledon champion in seventy-seven years.

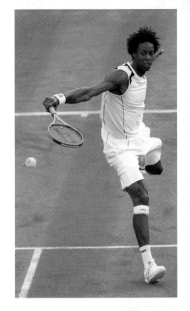

(opposite) *Born in Le Mans, where they race cars through the night, Jo-Wilfried Tsonga has been roaring around the tennis circuit for longer than most. He was a finalist at the Australian Open in 2008. Twice a semi-finalist at Roland Garros, Tsonga, a whole-hearted gentle giant, has engendered verve and excitement especially in France where he has won ten of his eighteen ATP Tour finals.*

(top) *Frenchman Gaël Monfils, an all-court acrobat and crowd favorite whose long career was blighted by injury.*

(bottom) *If you want core strength, Jez Green is your man. The Englishman who lived in South Florida for many years put Andy Murray through his demanding paces while building up the Scot during his US Open and Wimbledon winning years. After a year with Tomáš Berdych, he moved to the Alexander Zverev camp to put some muscle on his slender frame. (All photos by camerawork USA)*

To his immense credit, Djokovic not only behaved like a champion in defeat, praising his rival in fulsome terms, but also became a champion again, winning Wimbledon for the next two years by beating Federer, no less, in both finals. But Murray, making an important statement concerning the stature of player he had become, returned to receive further accolades in 2016, by winning his second Wimbledon, beating Federer in the semi-final and the big serving Canadian Milos Raonic in the final. Then, it was down to Rio to secure that second Olympic gold. Retaining an Olympic gold medal in tennis had never been done before. Soon, the Scot would a rise to number one in the world rankings. Recognizing these achievements, which made the boy from Dunblane the outstanding individual British athlete of his era and noting his dedicated work with charity, the Queen made him a knight in her 2016 Honors List. Arise, Sir Andrew!

Astounding as it may seem, there were just two years between 2005 and 2020, when one of the Big Four did not appear in a Grand Slam final. One of those years produced one of the most brilliant, if oft forgotten, matches of the era. It was 2005, the year that the incredibly talented Marat Safin beat local favorite Lleyton Hewitt in the Australian Open final.

The big Russian was just too powerful for Hewitt on finals day, beating the South Australian in four sets, but it was Safin's win over Roger Federer in the previous round that Dutch journalist Yoeri Nieuwland described on the peRFect Tennis website as "a master class of no holds barred aggressive power hitting …perhaps the most attractive match ever to have been played Down Under."

High praise and, for four hours and thirty-eight minutes, the crowd were held in thrall by the incredible quality of shot-making by two men who would forge such disparate career paths.

Safin had been crushed by Federer in his second Melbourne final the year before, but now he had Peter Lundgren, Federer's former coach at his side. After a magnificent duel, the result was very different as the Russian hung on the secure to a 5–7, 6–4, 5–7, 7–6, 9–7 victory.

The 2014 US Open was the other occasion when a Grand Slam in this era failed to produce a final involving the Big Four. Roger Federer and Novak Djokovic were odds-on favorites to get there; however, neither could handle Marin Čilić and Kei Nishikori at the semi-final stage.

In an extraordinary performance in which he mixed great serving with power hitting off the ground, Čilić crushed Federer 6–3, 6–4, 6–4. "He played with no fear," Federer said afterward. Nishikori took full advantage of some careless Djokovic errors in the fourth set tiebreak to beat the Serb 6–4, 1–6, 7–6, 6–3, thus becoming the first Japanese player to reach a Grand Slam men's singles final.

Nishikori's performance was all the more remarkable given the fact that he had only just recovered from a bad cyst on his foot and then had spent eight and a half hours battling past Milos Raonic and Stan Wawrinka in two grueling five-set matches. On another day of immense heat with temperatures in New York touching 100 degree Fahrenheit, Nishikori had little left to offer in the final. Čilić was able to follow his coach, Goran Ivanišević, as Croatia's second Grand Slam champion with a 6–3, 6–3, 6–3 win.

Čilić, a man of quiet charm with an intimidating game, would continue to be a threat at the highest level in the following years, reaching the Wim-

It is tough to get a twitch out of coach Ivan Lendl as he watches Andy Murray play, but off court, the bad jokes never stop coming. (Photo by camerawork USA)

bledon final in 2017, and the final of the Australian Open in 2018, losing to Federer on both occasions.

A decade before, the tall Shuzo Matsuoka seemed to be on the path to becoming Japan's greatest player when he won an ATP title in Seoul and reached the final on grass at the Queen's Club in London. Injuries, however, ruined his career, if not his popularity with the Japanese public. Nishikori also struggled to keep his body fit for the physically demanding ATP tour after bursting onto the scene at Delray Beach in 2008, winning the title at the age of seventeen after losing the first set of the final to America's powerful James Blake. Happily, Nishikori, who had arrived to train at the IMG Academy in Florida three years earlier without a word of English, was able to battle through physical difficulties. Guided later in his career by former French Open champion Michael Chang, Nishikori rose to a ranking high of number four in 2015.

Like so many players, the sturdy Swiss Stan Wawrinka struggled with injuries after becoming a force at Grand Slam level with his upset victory over Nadal in the 2014 Australian Open final. Having joined Magnus Norman's Stockholm-based "Good to Great" Academy, Wawrinka, who was always having to live in Federer's shadow, was able to put personal doubts aside and started to release that beautiful one-handed backhand to full effect. Any lingering doubts were erased the following year, when he outplayed Djokovic to win at Roland Garros and beat the Serb again to take the US title in 2016. By then, Wawrinka had established the strange record of beating players currently ranked at number one 5–4 in Slams but 0–17 elsewhere. Although injuries were undoubtedly a handicap—he underwent knee surgery in August 2017—Wawrinka seemed to require a big stage or a major opponent to bring out his best because he managed to reach just one ATP Masters final (at Indian Wells in 2017) between 2015 and 2019.

As for the other Swiss, Federer reached the semi-finals of the only two Grand Slams that he played in 2016 (Melbourne and Wimbledon) as injuries started to take their toll. He was having to brush off more and more questions about how long he thought he could continue as he moved past his thirty-fifth birthday. Not the least of Federer's talents is the ability to remain calm and courteous through repetitive questions at his post-match press conferences, which he goes through with great patience and good humor in English, French, and Swiss German—a task that would leave many people climbing the walls. Just occasionally, he looked as if he was having his patience tested.

The best, if not the easiest, way to stifle those questions was to win another Grand Slam, and Federer did just that at the start of 2017 in Melbourne with one of the most dramatic and satisfying victories of his entire career—surprising no one more than himself because he had taken six months away from the tour to let his body heal. Fittingly, it was achieved against his greatest rival, Nadal, after both had survived tough five setters in their semi-finals—Federer against Wawrinka, no less, and Nadal against the talented but generally under-achieving Bulgarian Grigor Dimitrov, who would go on to win the ATP Finals title in London at the end of the year.

The match would turn out to be a marker in both men's careers, for both were coming out of what, by their absurd standards, had been fallow periods.

From the days of Gary Cooper and Marlene Dietrich at the Los Angeles Tennis Club, the movie fraternity have always loved tennis. A new generation were on their feet in Wimbledon's royal box in 2015 led by Bradley Cooper (standing), Hugh Grant, and Benedict Cumberbatch. Having done it all themselves, Bjorn Borg (in front of Grant) and Stan Smith (behind Grant) seem less impressed. All England Club chairman Philip Brook is in the front row. (Photo by Art Seitz)

Neither had won a Grand Slam title for more than two years—Federer having to go back to Wimbledon in 2012 in that respect, while Nadal had last won at the highest level at Roland Garros in 2014. Critics were split as to who would go into the final at Rod Laver Arena as the favorite. Many pointed to the hard indoor surface favoring Federer, added to the fact that he had already won in Melbourne four times, whereas others felt that Nadal, with just one title Down Under, would draw on his excellent record against Federer on all surfaces to thwart the Swiss.

By this time, Federer had added the former world number three Ivan Ljubičić to his coaching staff. The highly intelligent Croat, himself mentored by the wise Monaco-based coach Ricardo Piatti, was able to offer Federer two pieces of advice that probably won him the match. The first was "Don't rush." Because of Nadal's great durability, Federer tended to feel that he had to win in three or four sets against Nadal. "Don't think like that," Ljubičić told him. "You can win in five if necessary."

The second came from the fact that Ljubičić had noticed how Federer was catching the net off his backhand slice far too often during his matches throughout the year. "If you're going to make a mistake on the backhand, go long," he was told. "Use that top spin. Better to go for it."

Even before the incredible finale, the match did not disappoint. Such had been the interest that black market tickets had been selling for well over $10,000 each. If punters expected value for money, Federer and Nadal quickly set about trying to give it to them.

Federer took the first set 6–4, lost his rhythm in the second, losing it 6–3, but recovered quickly and sailed through the third set 6–1 as his elegant winners flashed all over Rod Laver Arena, earning appreciative applause from the man himself. Nadal had seen it all before and did not panic. Edging forward to receive serve and smearing ever more top spin on his whirring ground strokes, the Spanish southpaw levelled the match by taking the fourth set 6–3 and breaking early in the fifth to lead 3–1. That might have been the moment when the advice offered by Ljubičić entered Federer's mind. "Don't think you can't win in five. Go for topped winners on your backhand."

The first point of the fifth game set the tone for what was to come. Federer saw the opportunity and unleashed a backhand cross-court winner of startling beauty, fizzing with top spin, way out of Nadal's reach. Nadal then netted a forehand to go 0–30 down and recovered by saving the first break point with a forehand winner. But at deuce, it was that Swiss backhand again, producing a second break point and another to take it. Back on serve—and the roar rippled down the Yarra River as Swiss flags waved and Mirka Nadal, in pink, leapt to her feet. Ljubičić was next to her, applauding with a satisfied look on his face.

Federer held to love to make it 3–3. When Nadal double-faulted to go 0–40 down, it was clear the tide had turned. With neither man showing any signs of fatigue, it was far from over and an incredible twenty-six-shot rally had people on their feet again. Federer won it, but he needed another advantage point before he could force the decisive break, forcing an error from Nadal with yet another forceful, topspun backhand.

Serving for the title was never going to be easy, and it wasn't. Nadal was at the net to score with a winner that made it 15–40. The Swiss reaction was so typical. Ace. A Nadal error made it deuce. The first match point was saved,

Not sure if Andy Murray was calling out "Catch!" to her Majesty, but the Queen, with the Duke of Kent on her right and All England Club chairman Tim Philipps on her left, seems to be saying "We are quite amused."

They Sit and Serve

From the days of well-meaning amateurs who struggled to control the outbursts of John McEnroe, Ilie Năstase, and their ilk back in the 1970s, the standard of umpiring in pro tennis has matched the rising standard of play set by the players themselves.

Prior to the formation of the ATP, there had been few court officials of the stature of Jacques Dorfman, who presided over numerous finals at Roland Garros. The French Federation created training programs that the ITF enveloped when Philippe Chatrier became president. Soon, the ATP had experts like Gayle Bradshaw, Ken Farrar, Tom Barnes, and Mark Darby moving on from chair duties to become supervisors.

Richard Ings, known as Skippy (because Australians have to have nicknames), was one of the youngest professional umpires in his early twenties and, before setting up his own company in Canberra, took charge of the tour's rules and regulations.

Later, officials such as a trio of Swedes, Lars Graff, Thomas Karlberg, and Mohamed Lahyani, as well the American Jake Garner, Brazil's Carlos Bernardes, Ireland's Fergus Murphy, France's Kader Nouni, Britain's James Keothavong and Gerry Armstrong, who would be appointed Wimbledon referee in 2020, became familiar faces to fans around the world.

Georgina Clark became the first woman to umpire a Wimbledon final in 1984. Opportunities for women officials have blossomed in recent years with Britain's Alison Hughes breaking the gender barrier and taking charge of the 2018 US Open men's final. Now, the likes of Eva Asderaki from Greece and France's Aurélie Tourte are routinely seen in charge of men's matches. Progress and respect—the least they deserve for a tough and thankless task.

(above) *Gerry Armstrong*

The Longest Match

If you had lost a tennis match that lasted three days, you would probably wear Nicolas Mahut's expression too. Even 103 aces were not enough for the Frenchman as John Isner finally closed it out 70–68 in the fifth set of a duel that lasted eleven hours and five minutes on Wimbledon's grass—a freak match that will never be repeated. Sweden's Mohamed Lahyani called every point from the chair and never lost concentration.

but the second, after a challenge that showed Federer's forehand hitting the line, brought down the curtain of a duel that will live in the memory.

A year later, Federer was back at Melbourne Park to claim his twentieth Grand Slam title, beating Marin Čilić in the final. The adulation was just washing over him by this stage of his career; he expected it, accepted it, and appreciated it. Life without it was prob-

ably difficult to imagine after so many years basking in the ever-present glow, but as Kevin Mitchell wrote in *The Guardian*, "He drinks from the cup of innocence. He plays a grown-up game with the freedom of a child and that is a rarity that defies proper description."

The phenomenon of Federer defies description because only a very few athletes have matched his longevity of success at the top of a very difficult sport.

Federer has done so with apparent ease. He carries his fans with him because of his charm and patience as they surround and frequently harass him and because he has become vulnerable with the passing years, agonizingly throwing away those split-second chances that would have made his record even more unbelievable than it is.

There was one more example of this to come before the game was shut down for those long months in 2020, and it came in yet another Wimbledon final, his twelfth, and once again against Djokovic. Just as he did in those semi-finals in New York, Federer had match points, this time for what would have been Slam number twenty-one. Again, he failed to nail them. It was not for lack of stamina, just one month short of his thirty-eighth birthday, that he failed. Credit must go to the Serb who had refocused his mind after various existential wanderings in 2017, and who simply refused to believe that match points represented the end of the road. Knowing that the Centre Court crowd would be heavily for his opponent, Djokovic had made a pact with himself to remain calm and accept whatever was in store.

The two match points arrived after Federer had broken through at 7–7 in the fifth set with a winning forehand to leave himself serving for the title. At 40–15, it seemed a foregone conclusion. In a split-second lapse, Federer mistimed a forehand and put it wide. Still match point. The Swiss who had been aggressive throughout, came in off Djokovic's service return and replied with a shot that did not carry quite enough weight. In a flash, the ball came like a bullet off the Djokovic racket and was gone cross court for a clean winner. Deuce. Two points later, he had bro-

ken back, and this fifth set would then create history by being the first decider to be ended at Wimbledon with a tie-break. It was played at 12–12. Making an error on the first point, Federer suddenly looked his age, losing it 7–3.

However, magnificently though he had played at Wimbledon, it was not Djokovic who finished the 2019 Grand Slam season in full flow but Nadal. It goes without saying that the Spaniard had won Roland Garros back in June— his twelfth French title—and now, having suffered with so many injury problems, he seemed determined to make the most of a rehabilitated body by storming through the US Open, winning his fourth title in New York with a pulsating 7–5, 6–3, 5–7, 6–3, 6–4 victory over Russia's Daniil Medvedev and so ensure that he would end the year as number one for the fifth time. Only Pete Sampras, with six year-end finishes, bettered him in a statistic that Nadal shared with Jimmy Connors, Federer, and Djokovic. Nadal's ravenous appetite for winning tennis matches remained unsated.

But note the man Nadal had to beat in the final. Lifting his game to previously unforeseen heights, Medvedev was appearing in his sixth consecutive ATP final by the time he reached Flushing Meadows, the culmination of a staggering display of stamina through the hot summer that had seen him to lose to Nadal in Montreal before beating Djokovic in the semi-final and then David Goffin to win his first ATP Masters 1000 title in Cincinnati. After Medvedev had fought his way back into the US Open final from two sets down, it took a rally of twenty-eight strokes for Nadal to show just how determined he was to grab his nineteenth Grand Slam title by break-

(opposite) *Few teenagers have made such an impact on the ATP Tour in recent years as Félix Auger-Aliassime, who beat Borna Ćorić to reach the semi-finals of the 2019 Miami Open at eighteen— the youngest to reach that stage in the tournament's history. The Quebecois with a Canadian mother and a father from Togo also beat Alexander Zverev at Indian Wells and made it to three ATP finals.*

(above) *Borna Ćorić shocked Roger Federer on his way to becoming Halle's youngest champion at twenty-one years old in 2018. He achieved his best Grand Slam result by reaching the US Open quarter-final when play resumed in 2020. (Both photos by camerawork USA)*

(above) *Walking onto Wimbledon Centre Court in 2014 as a nineteen-year-old ranked 144 in the world, Nick Kyrgios looked as if he owned the place by outplaying Rafael Nadal. In the following years, Kyrgios's attitude and behavior left much to be desired, and chances to do justice to his extraordinary talent were lost. Hopefully, the Australian still has much to offer the game.*

(below) *Covid-19 reality at Flushing Meadows in 2020: Reilly Opelka wears a mask.*

ing for 3–2 in the fifth and finally overcoming the Russian resistance.

Medvedev, with a mighty forehand and a special line in dry humor, was just one of a group of young male players who were suddenly emerging with enough talent and purpose to finally threaten the established trio of Nadal, Djokovic, and Federer. Stefanos Tsitsipas, the flamboyant Greek with an inquiring mind, had reached the semi-final of the Australian Open back in January and the final of Madrid four months later before establishing himself as a future super star by beating Dominic Thiem to win the ATP Finals in London in November. There were two Canadians of special promise, the left-handed Denis Shapovalov, a finalist at the Rolex Paris Masters, and the tall teenager Félix Auger-Aliassime, who became the Miami Open's youngest semi-finalist in March and reached the final at Lyon and Stuttgart. Shapovalov finished the year at number fifteen, and Auger-Aliassime at twenty-one.

Anyone wanting to spot future stars of the game will find plenty among this wealth of developing talent: Alexander Zverev, winner of the ATP Finals over Goffin in 2018; Italy's powerful Matteo Berrettini, who leapt from fifty-four to number eight in the world off the back of reaching the last four of the US Open in 2019; two more Russians in Karen Khachanov and Andrey Rublev; Australia's skilled Alex de Minaur; Croatia's Borna Ćorić; and two Americans, the six feet and eleven inches Reilly Opelka, who won Delray Beach in 2019, and Frances Tiafoe, winner of the same title the year earlier. Look out too for the strapping South Korean Chung Hyeon, an Australian Open semi-finalist in 2018, who seemed on the verge of greater things before injuries impeded his rise.

And then there was Dominic Thiem, who is two or three years older than the young brigade previously mentioned, but well mentored in the art of winning tennis matches by the seasoned

Austrian coach Günter Bresnik, who had helped the rugged Thomas Muster win Roland Garros in 1995 and rise to number one in the world. Thiem had started to make his mark on European clay in 2015, winning titles in Nice, Gstaad and Umag before becoming a threat on the South American swing, adding Rio de Janeiro and Buenos Aires to his growing list of titles.

Then, at Roland Garros in 2018, Thiem announced himself as a genuine contender for top honors by reaching the final. Djokovic had been taken out of his path as a result of a stunning performance by the unheralded Italian Marco Cecchinato, who won a thrilling battle on Court Suzanne Lenglen 13–11 in the fourth-set tiebreak to become the first Italian semi-finalist at Roland Garros since Corrado Barazzutti in 1978. After losing two desperately tight sets, Cecchinato ran out of steam against Thiem, who was able to make his big move to Grand Slam finalist status 7–5, 7–6, 6–1.

Despite offering glimpses of how he had got there, Thiem was unable to wobble Nadal's throne and lost a one-sided final 6–4, 6–3, 6–2. In 2019, Thiem won a grueling semi-final encounter of massive back-court hitting against Djokovic 7–5 in the fifth, which led to the Austrian's second Roland Garros final. The score was only marginally better with Nadal winning 6–3, 5–7, 6–1, 6–1 to claim his twelfth French Open title, a staggering achievement in an era.

(above) *Kyle Edmund, a South African–born Yorkshireman, became the British number one after reaching the Australian Open semi-final in 2018. The Liverpool fan struggled with a knee injury the following year.*

(below) *Frances Tiafoe's parents emigrated to the United States from Sierra Leone, settling in Maryland, where Frances was born. His father became head of maintenance at College Park Academy, allowing Frances and his twin brother free time on the courts. Tiafoe won his first ATP title at Delray Beach, Florida, in 2018 and reached the Australian Open quarter-finals in 2019. (Photo by camerawork USA)*

The Future

NEW STARS SHINE IN CANADA, RUSSIA, ITALY

Fortunately, the Covid-19 break that forced much disruption, including the cancellation of Wimbledon in 2020, did not stem the flow of young talent. The Russian trio of Daniil Medvedev, Andrey Rublev, and Karen Khachanov continued to force their way up the rankings. Things were stirring in Italy too, as the teenage skier Jannik Sinner left the Alpine slopes and immediately attracted attention with a racket, reaching the quarter-final of the autumnal Roland Garrros after beating Alexander Zverev. Lorenzo Musetti also suggested big things by qualifying for the delayed Italian Open and then beating Stan Wawrinka and Kei Nishikori.

However, for a nation that had never competed successfully at the highest level, nothing compared with the explosion of talent that thrust Canada into the tennis spotlight after the turn of the century.

Canada's tennis had been held back by no proper infrastructure, but that changed when Mark McCormack's IMG signed a deal in 1978 to do something about it. Their first act was to call over John Beddington from England to revamp the Canadian Open. For a start Beddington, an Old Etonian who played his tennis at the All England Club, realized that French-speaking Canada could no longer be ignored, so it was decided to alternate years for the men and women between Toronto and Montreal. Thanks to a little clever financial persuasion, it worked. Camouflaging the fact that in the 1980s women would not draw as well as the men, Beddington sold box seats in two-year packages. You got the men the first year and the women the next, and that was it.

If Greg Rusedski's decision to become a British citizen just when he was starting to become a force on the ATP tour was a blow to Canadian tennis, it did not take that long for an immigrant from Montenegro to make the opposite journey. Milos Raonic had been brought to Canada at the age of three. He soon grew up to be a six-feet-and-five-inch athlete of great power. When he won the San Jose title Silicone Valley in 2011, and retained it the following year with a serve that was quickly recognized as one of the most powerful in the game, his future as a top player seemed assured. Sadly, the injuries started early for him: hip surgery later in 2011, right foot surgery in 2015, and left wrist surgery in 2017. However, it said much for Raonic's hard work off court that he managed to get to the Wimbledon semi-final in 2015 and the final the following year, losing to Andy Murray. By the end of 2016, he was ranked number three in the world.

The rise of Raonic came very soon after the creation of a national center for Canadian tennis in Montreal in 2007 and, with it, the appointment of Louis Borfiga from the French Federation as head of development. Not long afterward, Bob Brett was invited to spend weeks every summer working with young players. They could hardly have had a better mentor. Brett, who grew up under Harry Hopman's tutelage in Australia, went on to become one of the most impressive coaches of his era, guiding Boris Becker and Goran Ivanišević at the height of their careers before taking charge of Marin Čilić.

However, it would be simplistic to suggest that Borfiga and Brett, long-serving Davis Cup captain Martin Laurendeau, or even the innovative chief executive Mike

(clockwise from left) *Bianca Andreescu, Andrey Rublev, Leylah Annie Fernandez, Eugenie Bouchard, Denis Shapovalov, Bob Brett, Jannik Sinner, Bjorn Borg, and John Beddington.*

Downey were totally responsible for the tidal wave of talent that was appearing on the horizon. The most eye-catching, Eugenie Bouchard, had been developed to a large extent by Nick Saviano at his Plantation, Florida, academy. Saviano's detailed teachings enabled Bouchard to burst onto the circuit in the most amazing fashion in 2014. She not only reached the semi-final of the Australian Open and repeated the feat at Roland Garros but then went on to conquer a third surface by going one better at Wimbledon, where she lost in the final Petra Kvitová. She finished the year ranked number five in the world.

But then the candle flickered and died. Too much celebrity distorted Bouchard's focus and when Saviano said he could no longer help her, a career of immense promise melted away. To her great credit, Bouchard stuck at and started to make some progress in 2020.

Another bright spark lit on the scene in a blaze of glory in 2017 when Denis Shapovalov, whose Russian parents had arrived in Canada by way of Israel, overcame Rafael Nadal to reach the semi-final of the Canadian Open at Montreal. As an entrance onto the world stage, it was tough to beat. An eighteen-year-old at the time with a shock of blond hair and the kind of perky personality that immediately corralled a huge fan following, the left-handed Shapovalov made further progress by winning the Stockholm Open in 2019.

Canada's next star to shine also had roots in faraway places. Félix Augier-Aliassime's father, Sam, emigrated from Togo, and Félix was born in Montreal on August 8, 2000, a birthdate that he shares with the man who would become his idol, Roger Federer. Standing six feet and four inches and physically mature beyond his years, Augier-Aliassime released his talent on the tour in 2019 by reaching the final at Rio de Janeiro, Lyon on clay, and Stuttgart on grass before his nineteenth birthday. By November that year, this articulate and quietly confident young man had risen to number seventeen in the world.

Eclipsing even Bouchard's shooting star appearance in the women's game, Bianca Andreescu became the next Canadian teenager to shock the tennis world by succeeding Naomi Osaka as champion at the BNP Paribas at Indian Wells when, as a wild card entry, she overpowered Angelique Kerber in the final. It was stunning performance of pure power tennis from this precocious five-feet-and-seven-inches athlete, but the warnings were immediate. A shoulder injury took her off the WTA tour soon afterward, and Andreescu missed the entire clay-court season.

Returning in time for the Canadian Open in Toronto, she wowed her ecstatic fans by winning the title, albeit over an injured Serena Williams in the final. Any suggestion that the victory might have been fortuitous vanished when Andreescu blasted her way through the US Open a few weeks later to become Canada's first Grand Slam singles champion by beating Williams in straight sets in the final.

A seventeen-year-old named Leylah Annie Fernandez popped up in February 2020 to reach the final of Acapulco before beating former US Open champion Sloane Stephens to reach the quarter-finals at Monterey, Mexico. Much promise there too. With a multilingual cast, Tennis Canada was claiming center stage.

(clockwise from top left) *Having lost in three Grand Slam finals, Austria's Dominic Thiem finally nailed down a title by beating Alexander Zverev in the US Open final, fighting back from two sets to love down in a five-hour marathon.*

Victória Azárenka, a force on the tour again with her young son in tow, won the Cincinnati title, which was played in New York because of Covid-19 in August, and then reached the final of the US Open, where she lost to Naomi Osaka.

Alexander Zverev led Dominik Thiem by two sets to love at the US Open in his first Grand Slam final, but the young German couldn't complete the job and lost in five.

Back on Court

To the cavernous sound of balls being hit in empty stadiums, tournament tennis returned in August 2020, beginning with the Cincinnati event being switched to New York to act as a curtain raiser for the US Open.

The strangest period in the game's history survived the initial weeks without the bubble bursting. The players, who were restricted to hotel rooms or corporate suites at Arthur Ashe Stadium, proved one thing above all else: that they could produce thrilling tennis of high intensity without the stimulus of crowd support.

The final two rounds of the women's draw, in particular, produced tennis of startling quality. By the time Naomi Osaka had grabbed her second US Open title from a rejuvenated Victória Azárenka, the fact that stars like Ashleigh Barty and Simona Halep had chosen not to travel to New York was forgotten.

Serena Williams did her best to equal Margaret Court's record of twenty-four Grand Slam titles, but she faded physically after winning the first set 6–1 against Azárenka while an American newcomer, Jennifer Brady, pushed Osaka to three sets in the other semi-final.

Once Novak Djokovic got himself disqualified for unintentionally hitting a ball that struck a lineswoman in the throat, leaving the men's field bereft of the Top Three, the moment had come for the new generation to make their breakthrough. Dominic Thiem grabbed it, shaking off a nervous start against Alexander Zverev to become the first man since Pancho Gonzales in 1949 to win the US title from two sets down in the final.

Roland Garros managed to get permission for one thousand spectators,

huddled against the cold, to watch the delayed French Open and the Championships offered something new and something very familiar: Rafael Nadal crushing Djokovic in the final to win his thirteenth title after Iga Świątek, an unknown nineteen-year-old from Poland, had outplayed Sofia Kenin in astonishing fashion. With pin-point placements and unfussed efficiency, Świątek had not conceded more than four games in any set throughout the tournament.

Like the incredibly mature Coco Gauff, who beat Venus Williams on Wimbledon's Centre Court at the age of fifteen in 2019, Świątek threw herself into the mix of youthful women's players who will adorn the game for years to come.

Poland had never had a Grand Slam champion, male or female, and then, out of nowhere, nineteen-year-old Iga Świątek stunned one opponent after the next, including Sofia Kenin in the final. "You hear me?" she seems to be joking with the one thousand spectators allowed under Covid-19 restrictions on the Philippe Chatrier Centre Court. (They did.) We will be hearing more from Świątek in the future.

(clockwise from top left) *Two of the best forehands in history linking history. It was Manuel Santana's triumph at Wimbledon in 1966 that inspired future generations in Spain by forcing the game to burst out of the confines of the upper-class country clubs and allow the populace to play. Manuel Orantes, José Higueras, Arantxa Sánchez Vicario and her brothers Emilio and Javier, Albert Costa, Àlex Corretja, and Carlo Moyá followed. And then there was Rafael Nadal. Nadal's thirteenth Roland Garros title in the chilly autumn of 2020 warmed the game's heart.*

Yes, Manuel Santana did it with a wood racket as he explains to Nadal when they meet at a reception for the Rafa Nadal Foundation in Barcelona in 2009.

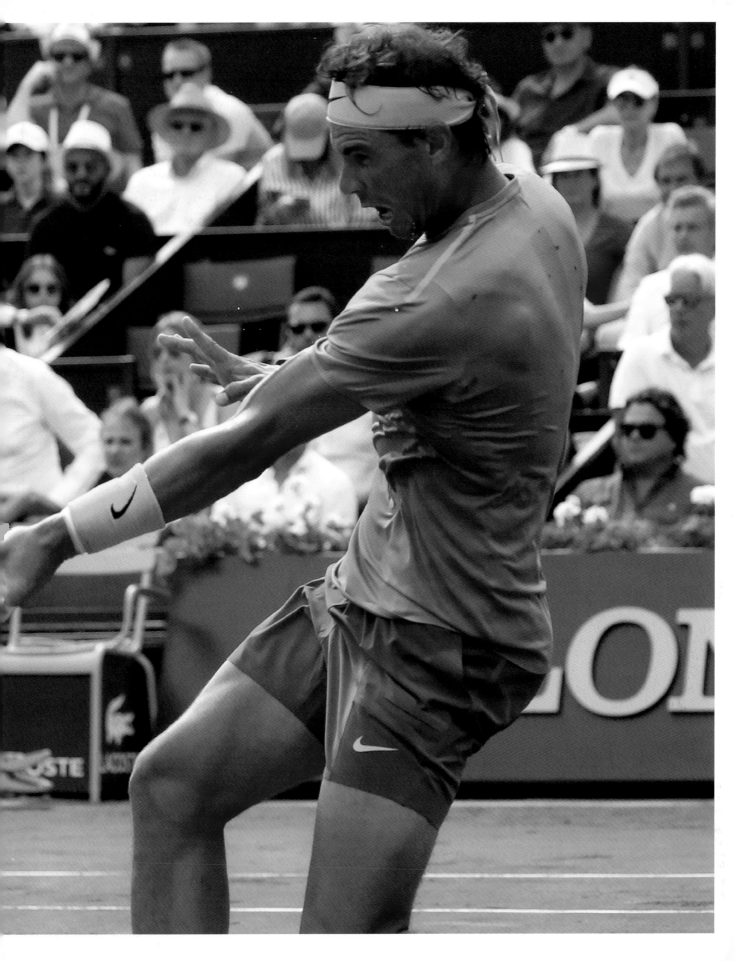

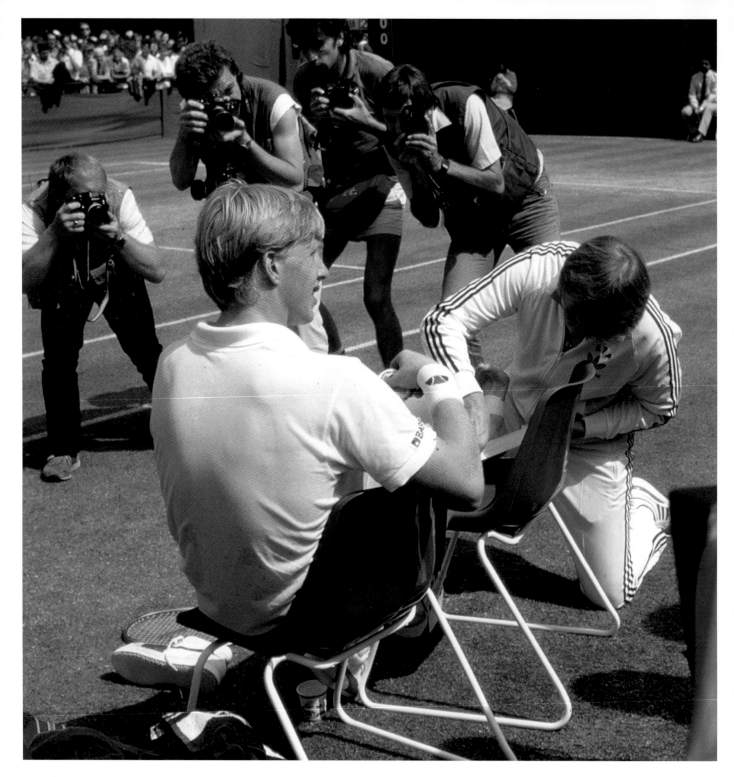

The Moment History Could Have Changed

At Wimbledon in 1985, Tim Mayotte was leading Boris Becker by two sets to one when, in the twelfth game of the fourth, the young German slipped and hurt his ankle. It was the same ankle that had required treatment the year before, and his immediate reaction was to signal to Mayotte at the far end of the court that he needed to default. But, as the American advanced towards him to shake hands, Becker's manager Ion Țiriac and his coach Gunther Bosch yelled out in unison, "NO! Get the trainer!" Becker stopped and Bill Norris was called from the locker. Luckily Norris, who career extended from treating Rod Laver to Roger Federer, had been treating the ankle and was in the best position to make a decision that would affect tennis history. Assessing Becker's reaction to having the foot manipulated, Norris made the snap decision that he could play on. Had he said "No", Wimbledon would not have had a seventeen-year-old Wimbledon champion. After fighting back to beat Mayotte 6-2 in the fifth, Becker eventually defeated Kevin Curren in the final.

Acknowledgments

From Frank Sedgman, the first tennis player I recognized as a schoolboy to Althea Gibson and Jaroslav Drobný, from whom I learned so much while writing their copy at Wimbledon to every other person in the game who has befriended and helped me, all I can say is "Thank you!" The knowledge required to put this all-embracing story together has come from you.

Of course, much appreciation and thanks to Anthony Petrillose and his team at Rizzoli, Gisela Aguilar, who is a very patient editor, and our talented designers, Reed Seifer and Chris Burnside, for helping to make the journey fun and fulfilling.

Casting an eagle eye over the text, Chris Bowers's historical knowledge was also invaluable. And to Raymond Moore, who had a great idea and supported us all the way.

Bibliography

Captain Anthony Wilding by A. Wallis Myers – Hodder & Stoughton

The Davis Cup: The First Hundred Years by Richard Evans – Ebury Press/ITF

Fred Perry by Jon Henderson – Yellow Jersey Press

Kitty Godfree by Geoffrey Green – Kingswood Press

The Game by Jack Kramer with Frank Deford

Portrait in Motion by Arthur Ashe with Frank Deford

Ahead of the Game by Owen Williams with zRichard Evans

Big Bill Tilden by Frank Deford – Gollancz

Tennis Rebel by Mike Davies – Stanley Paul

Vijay! by Vijay Amritraj with Richard Evans

From Where I Sit by Dan Maskell – Collins

Taming the Talent by Richard Evans – Bloomsbury

Wimbledon by John Barrett – Collins Willow

George Hillyard by Bruce Tarran – Matador

A Terrible Splendor by Marshall John Fisher – Crown

Open by Andre Agassi – Harper Collins

Unstoppable by Maria Sharapova – Sarah Crichton Books

Novak Djokovic: The Sporting Statesman by Chris Bowers – John Blake

ATP & WTA Tour Guides – Various editions.

Photo Credits

Richard Evans has written twenty-two books, including his autobiography *The Roving Eye: A Reporter's Love Affair with Paris, Politics & Sport*

First published in the United States of America in 2021 by

RIZZOLI INTERNATIONAL PUBLICATIONS, INC.

300 Park Ave So. New York, NY 10010

RIZZOLIUSA.COM

Visit us online:

Facebook.com/ RizzoliNewYork

Twitter @Rizzoli_ Books

Instagram @ RizzoliBooks

Pinterest.com/ RizzoliBooks

Youtube.com/user/ RizzoliNY

Issuu.com/Rizzoli

Front cover (left to right): **top row** © Rapp Halour / Alamy Stock Photo, Norman Brookes, undated © Historic Collection / Alamy Stock Photo, © Smith Archive / Alamy Stock Photo, © Historic Collection / Alamy Stock Photo. **Middle row** © PA Images / Alamy Stock Photo, © PA Images / Alamy Stock Photo, © Adam Stoltman / Alamy Stock Photo. **Bottom row** © REUTERS / Alamy Stock Photo, © Henk Koster / Alamy Stock Photo.

Back cover (clockwise from left): © New York Public Library, © UPI / Alamy Stock Photo; © Adam Stoltman / Alamy Stock Photo, © PA Images / Alamy Stock Photo.

Endsheets image: Suzanne Lenglen in 1926 © George Rinhart/Corbis via Getty Images.

2021 2022 2023 2024 / 10 9 8 7 6 5 4 3 2 1

ISBN: 978-0-8478-6987-9

Library of Congress Control Number 2020948289

Publisher: **CHARLES MIERS**

Associate Publisher: **ANTHONY PETRILLOSE**

Editor: **GISELA AGUILAR**

Image Research & Design: **BURNSIDE & SEIFER**

Production: **MARIA PIA GRAMAGLIA**

Design Coordinator: **OLIVIA RUSSIN**

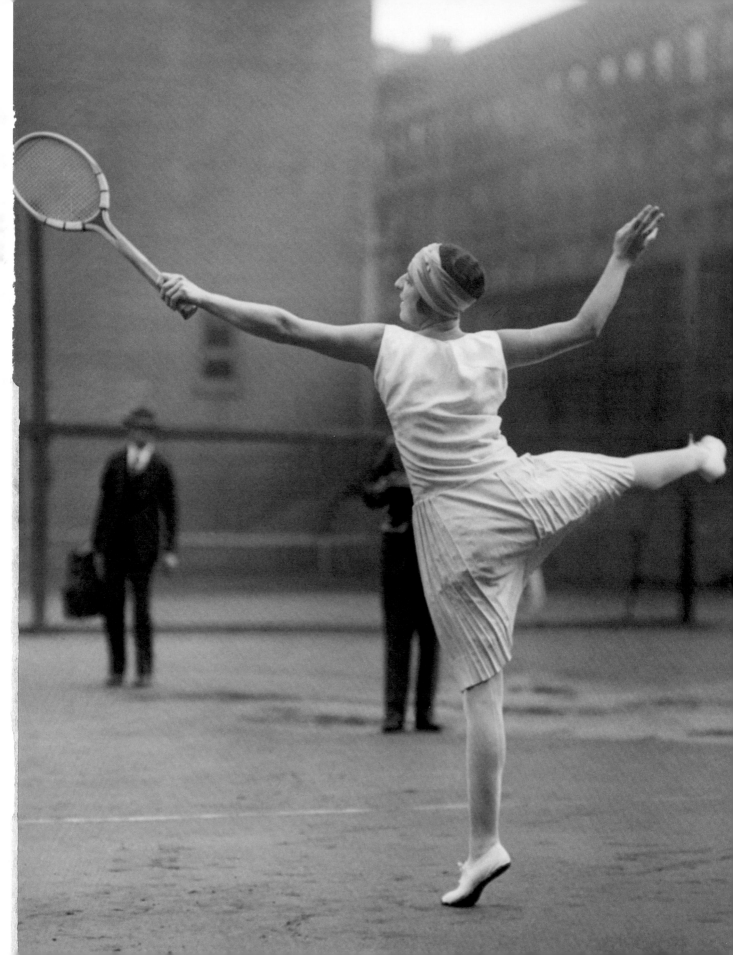

WIMBLEDON MEN'S DOUBLES CHAMPIONS

				
1884	GBR	Ernest Renshaw	GBR	William Renshaw
1885	GBR	Ernest Renshaw	GBR	William Renshaw
1886	GBR	Ernest Renshaw	GBR	William Renshaw
1887	GBR	Patrick Bowes-Lyon	GBR	Herbert Wilberforce
1888	GBR	Ernest Renshaw	GBR	William Renshaw
1889	GBR	Ernest Renshaw	GBR	William Renshaw
1890	GBR	Joshua Pim	GBR	Frank Stoker
1891	GBR	Herbert Baddeley	GBR	Wilfred Baddeley
1892	GBR	Harry Barlow	GBR	Ernest Lewis
1893	GBR	Joshua Pim	GBR	Frank Stoker
1894	GBR	Herbert Baddeley	GBR	Wilfred Baddeley
1895	GBR	Herbert Baddeley	GBR	Wilfred Baddeley
1896	GBR	Herbert Baddeley	GBR	Wilfred Baddeley
1897	GBR	Laurence Doherty	GBR	Reginald Doherty
1898	GBR	Laurence Doherty	GBR	Reginald Doherty
1899	GBR	Laurence Doherty	GBR	Reginald Doherty
1900	GBR	Laurence Doherty	GBR	Reginald Doherty
1901	GBR	Laurence Doherty	GBR	Reginald Doherty
1902	GBR	Frank Riseley	GBR	Sydney Smith
1903	GBR	Laurence Doherty	GBR	Reginald Doherty
1904	GBR	Laurence Doherty	GBR	Reginald Doherty
1905	GBR	Laurence Doherty	GBR	Reginald Doherty
1906	GBR	Frank Riseley	GBR	Sydney Smith
1907	AUS	Norman Brookes	NZL	Anthony Wilding
1908	GBR	Major Ritchie	NZL	Anthony Wilding
1909	GBR	Arthur Gore	GBR	Herbert R. Barrett
1910	GBR	Major Ritchie	NZL	Anthony Wilding
1911	FRA	Max Decugis	FRA	André Gobert
1912	GBR	Charles Dixon	GBR	Herbert R. Barrett
1913	GBR	Charles Dixon	GBR	Herbert R. Barrett
1914	AUS	Norman Brookes	NZL	Anthony Wilding
1915–1918	NO COMPETITION (Due to World War I)			
1919	AUS	Pat O'Hara Wood	AUS	Ronald Thomas
1920	USA	Chuck Garland	USA	R. Norris Williams
1921	GBR	Randolph Lycett	GBR	Max Woosnam
1922	AUS	James Anderson	GBR	Randolph Lycett
1923	GBR	Leslie Godfree	GBR	Randolph Lycett
1924	USA	Francis Hunter	USA	Vincent Richards
1925	FRA	Jean Borotra	FRA	René Lacoste
1926	FRA	Jacques Brugnon	FRA	Henri Cochet
1927	USA	Francis Hunter	USA	Bill Tilden
1928	FRA	Jacques Brugnon	FRA	Henri Cochet
1929	USA	Wilmer Allison	USA	John Van Ryn
1930	USA	Wilmer Allison	USA	John Van Ryn
1931	USA	George Lott	USA	John Van Ryn
1932	FRA	Jean Borotra	FRA	Jacques Brugnon
1933	FRA	Jean Borotra	FRA	Jacques Brugnon
1934	USA	George Lott	USA	Lester Stoefen
1935	AUS	Jack Crawford	AUS	Adrian Quist
1936	GBR	Pat Hughes	USA	Raymond Tuckey
1937	USA	Don Budge	USA	Gene Mako
1938	USA	Don Budge	USA	Gene Mako
1939	USA	Elwood Cooke	USA	Bobby Riggs
1940–1945	NO COMPETITION (Due to World War I)			
1946	USA	Tom Brown	USA	Jack Kramer
1947	USA	Bob Falkenburg	USA	Jack Kramer
1948	AUS	John Bromwich	AUS	Frank Sedgman
1949	USA	Pancho Gonzalez	USA	Frank Parker
1950	AUS	John Bromwich	AUS	Adrian Quist
1951	AUS	Ken McGregor	AUS	Frank Sedgman
1952	AUS	Ken McGregor	AUS	Frank Sedgman
1953	AUS	Lew Hoad	AUS	Ken Rosewall
1954	AUS	Rex Hartwig	AUS	Mervyn Rose
1955	AUS	Rex Hartwig	AUS	Lew Hoad
1956	AUS	Lew Hoad	AUS	Ken Rosewall
1957	USA	Gardnar Mulloy	USA	Budge Patty
1958	SWE	Sven Davidson	SWE	Ulf Schmidt
1959	AUS	Roy Emerson	AUS	Neale Fraser
1960	MEX	Rafael Osuna	US	Dennis Ralston
1961	AUS	Roy Emerson	AUS	Neale Fraser
1962	AUS	Bob Hewitt	AUS	Fred Stolle
1963	MEX	Rafael Osuna	MEX	Antonio Palafox
1964	AUS	Bob Hewitt	AUS	Fred Stolle
1965	AUS	John Newcombe	AUS	Tony Roche
1966	AUS	Ken Fletcher	AUS	John Newcombe
1967	RSA	Bob Hewitt	RSA	Frew McMillan
1968	AUS	John Newcombe	AUS	Tony Roche
1969	AUS	John Newcombe	AUS	Tony Roche
1970	AUS	John Newcombe	AUS	Tony Roche
1971	AUS	Roy Emerson	AUS	Rod Laver
1972	RSA	Bob Hewitt	RSA	Frew McMillan
1973	USA	Jimmy Connors	ROM	Ilie Năstase
1974	AUS	John Newcombe	AUS	Tony Roche
1975	AUS	Vitas Gerulaitis	AUS	Sandy Mayer
1976	US	Brian Gottfried	MEX	Raúl Ramírez
1977	AUS	Ross Case	AUS	Geoff Masters
1978	RSA	Bob Hewitt	RSA	Frew McMillan
1979	USA	Peter Fleming	USA	John McEnroe
1980	AUS	Peter McNamara	AUS	Paul McNamee
1981	USA	Peter Fleming	USA	John McEnroe
1982	AUS	Peter McNamara	AUS	Paul McNamee
1983	USA	Peter Fleming	USA	John McEnroe
1984	USA	Peter Fleming	USA	John McEnroe
1985	SWI	Heinz Günthardt	HU	Balázs Taróczy
1986	SWE	Joakim Nyström	SWE	Mats Wilander
1987	USA	Ken Flach	USA	Robert Seguso
1988	USA	Ken Flach	USA	Robert Seguso
1989	AUS	John Fitzgerald	SWE	Anders Järryd
1990	USA	Rick Leach	USA	Jim Pugh
1991	AUS	John Fitzgerald	SWE	Anders Järryd
1992	USA	John McEnroe	FRG	Michael Stich
1993	AUS	Todd Woodbridge	AUS	Mark Woodforde
1994	AUS	Todd Woodbridge	AUS	Mark Woodforde
1995	AUS	Todd Woodbridge	AUS	Mark Woodforde
1996	AUS	Todd Woodbridge	AUS	Mark Woodforde
1997	AUS	Todd Woodbridge	AUS	Mark Woodforde
1998	NLD	Jacco Eltingh	NLD	Paul Haarhuis
1999	IND	Mahesh Bhupathi	IND	Leander Paes
2000	AUS	Todd Woodbridge	AUS	Mark Woodforde
2001	USA	Donald Johnson	USA	Jared Palmer
2002	SWE	Jonas Björkman	AUS	Todd Woodbridge
2003	SWE	Jonas Björkman	AUS	Todd Woodbridge
2004	SWE	Jonas Björkman	AUS	Todd Woodbridge
2005	AUS	Stephen Huss	RSA	Wesley Moodie
2006	USA	Bob Bryan	USA	Mike Bryan
2007	FRA	Arnaud Clément	FRA	Michaël Llodra
2008	CAN	Daniel Nestor	SRB	Nenad Zimonjić
2009	CAN	Daniel Nestor	SRB	Nenad Zimonjić
2010	AUT	Jürgen Melzer	FRG	Philipp Petzschner
2011	USA	Bob Bryan	UAS	Mike Bryan
2012	GBR	Jonathan Marray	DNK	Frederik Nielsen
2013	USA	Bob Bryan	USA	Mike Bryan
2014	CAN	Vasek Pospisil	USA	Jack Sock
2015	NLD	Jean-Julien Rojer	ROM	Horia Tecău
2016	FRA	Pierre-Hugues Herbert	FRA	Nicolas Mahut
2017	POL	Łukasz Kubot	BRA	Marcelo Melo
2018	USA	Mike Bryan	USA	Jack Sock
2019	COL	Juan Sebastián Cabal	COL	Robert Farah
2020	NO COMPETITION (due to COVID-19 pandemic)			